take away

take away

TEXT AND PHOTOGRAPHS BY
JEAN-FRANÇOIS MALLET

CHRONICLE BOOKS
SAN FRANCISCO

First published in the United States of America in 2012 by Chronicle Books LLC.
First published in France in 2009 by Editions de La Martinière.

Library of Congress Cataloging-in-Publication Data available.

ISBN 978-1-4521-0624-3

Manufactured in China

10 9 8 7 6 5 4 3 2 1

Chronicle Books LLC
680 Second Street
San Francisco, California 94107
www.chroniclebooks.com

For Sandrine and Jeanne,
to devour with your eyes the things I tasted without you.

INTRODUCTION

I remember shish kebabs grilling at a market in Yalta, a quick bowl of pho at a Hanoi sidewalk stand, spiced lamb in Marrakesh, a pretzel seller in front of a New York skyscraper, a "hot dog" in Montreal that contained finely chopped lettuce in place of the customary sausage. We dissected this object as if it were a strange beast. The woman who sold it to us said it was called either a *moineau* or a *spoutnik,* a distinction based on the topping.

For over ten years now Jean-François and I have been roaming the globe, tasting local cuisine all over the world. Paging through the many articles and books we brought back from our peregrinations, I came to understand the originality of his method. Its power. Every time we find ourselves in a bar or eatery that tells a country's story, Jean-François takes the time to savor its offerings. The photograph comes later, on a second visit. First, he must taste. He is seeking not to judge things, but to find their story, to make the connections that inform his role as cook-photographer-traveler. He needs this time, these moments of reflection, so that his photos are not just shots of food, but shared moments in life.

This curiosity is in his nature. If he had wished to become a cook, he would have followed the career he embarked on quite brilliantly at age twenty. A graduate of the highly prestigious Grégoire-Ferrandi school of French cuisine, he began working in the best kitchens, then became a chef at the Élysée Lenôtre in Paris. But no. Not content to know how to make fine foods, he wanted to reveal them, to extract their essence, to make us salivate, yes, but also to make us dream.

But we never fully leave our past behind. Cooks everywhere, professionals or not, would quickly recognize as one of their own this foreigner wielding a lens rather than a ladle. This confers on him, as the shutter clicks, the privileged position of colleague and spectator at the same time, an intimate of the people as well as the material of their trade. And it is the byroads of his memory that, in the end, give meaning to that potato from Noirmoutier or that slice of basturma from Yerevan.

—JEAN-LOUIS ANDRÉ

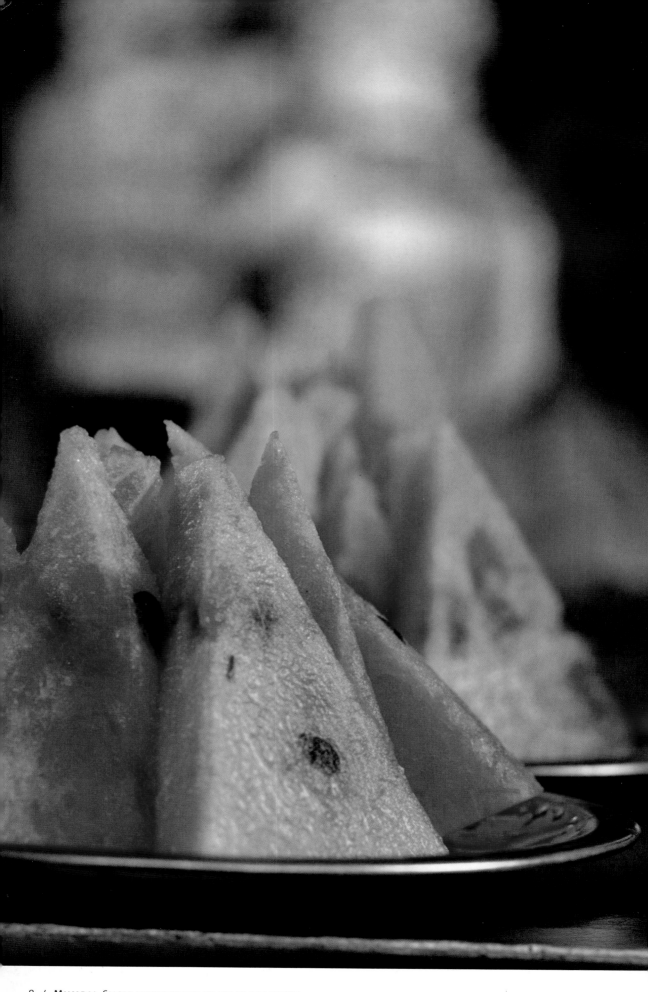

8 / **MUMBAI.** SLICED WATERMELON TO EAT IN THE STREET.

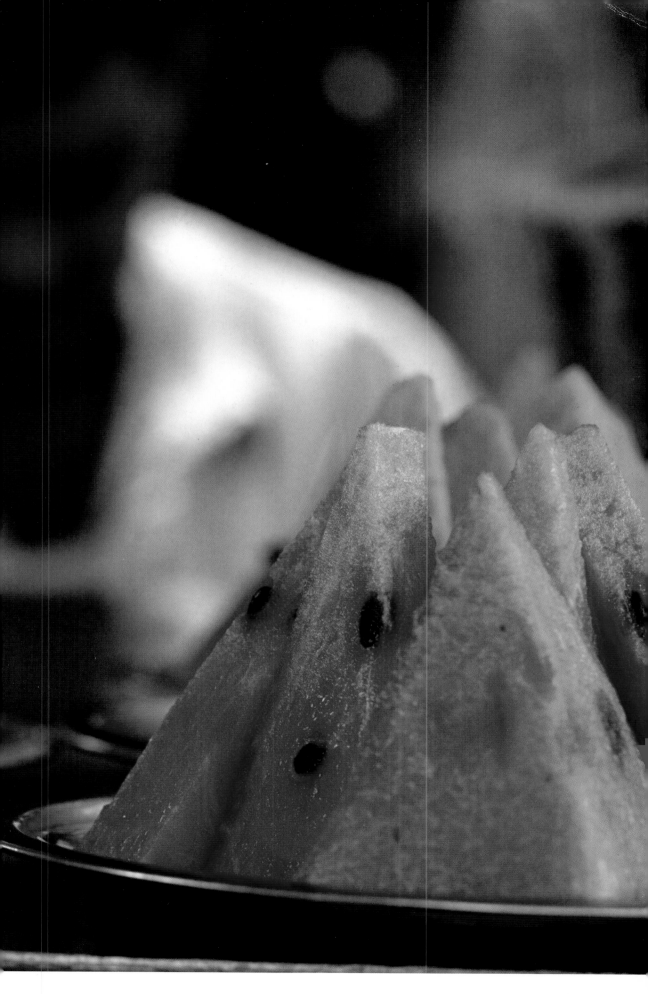

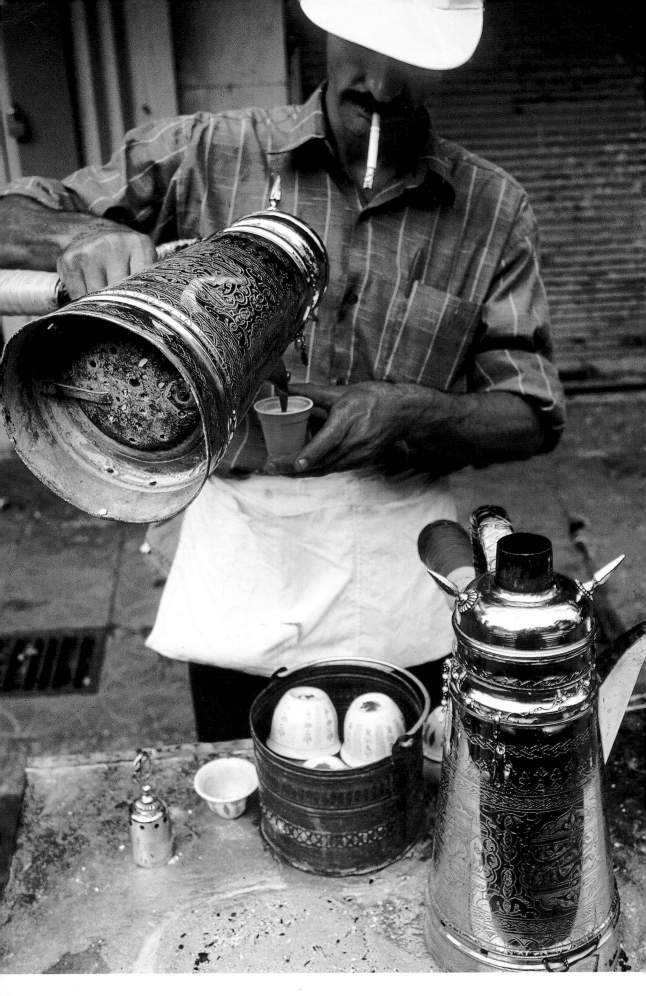

10 / **Lebanon.** In this northern city you'll find no alcohol, but coffee is available on every street corner. Illegal vendors hawk it to drivers in traffic jams.

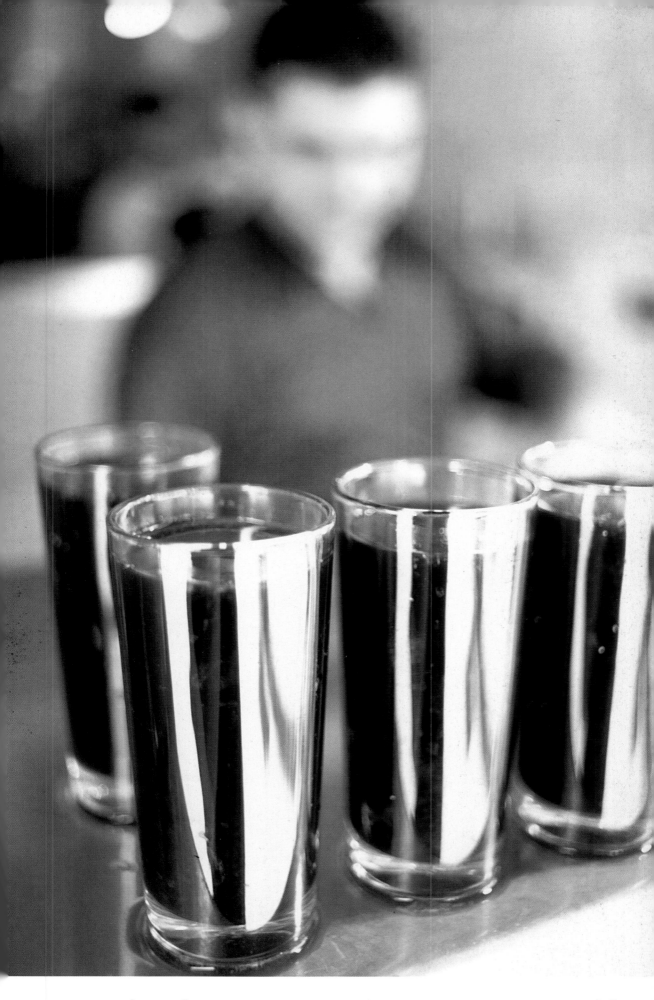

LEBANON. FRESH GRAPE JUICE IS SERVED IN A GLASS—WITHOUT ICE, SO IT RETAINS ITS FULL FLAVOR. \ 11
YOU STOP AT THE VENDOR'S STAND TO DRINK IT ON THE SPOT.

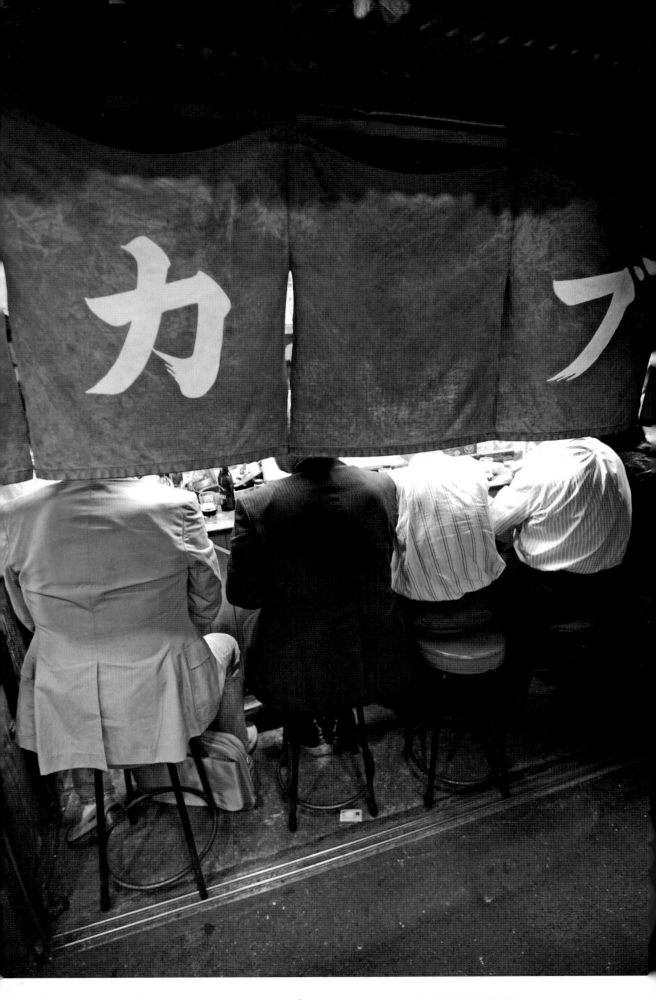

12 / **Tokyo.** In the Shinjuku district, streets are crowded with restaurants where executives have dinner before catching the last subway train home to the suburbs.

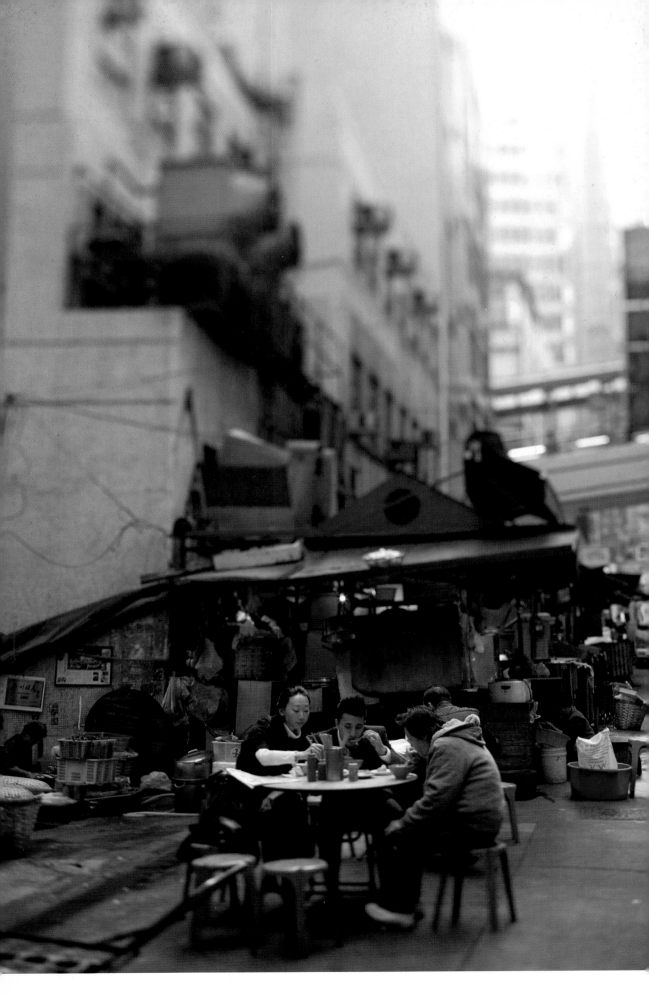

14 / **HONG KONG.** A STREET BREAKFAST CONSISTS OF *WEY WAI KEE* FRITTERS, MADE OF PASTA. TEA WITH MILK IS A TRADITIONAL ACCOMPANIMENT.

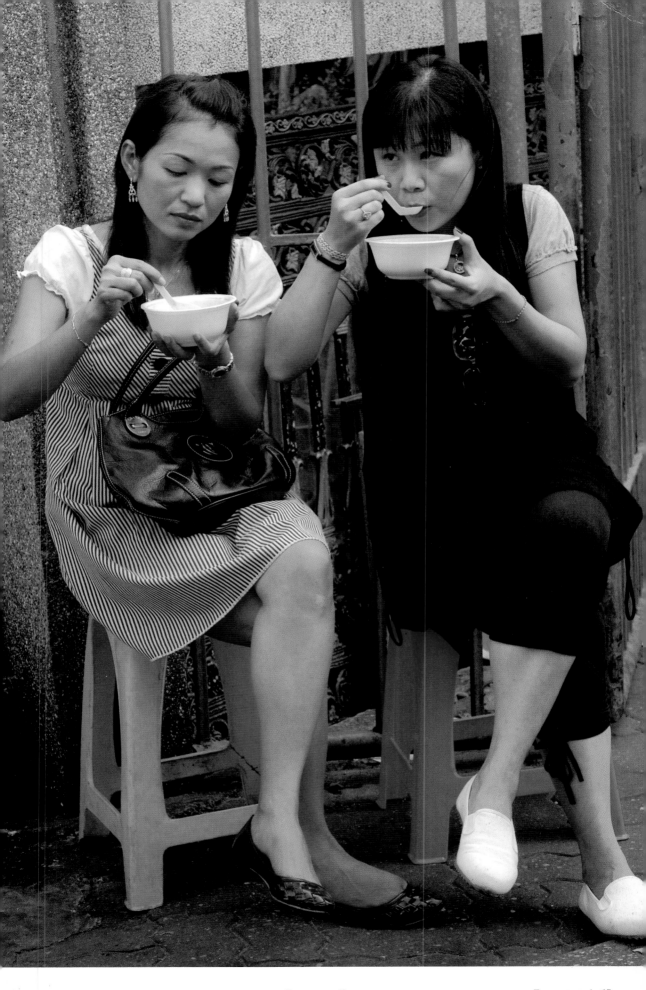

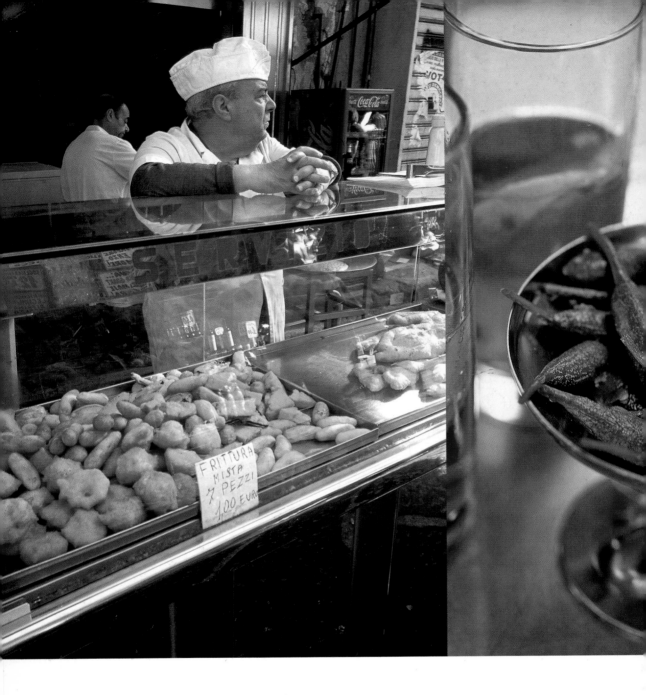

NAPLES. (LEFT) VENDORS SELL *FRITTI MISTI* AND CALZONE PIZZA FROM STANDS AT THE TRAIN STATION.
(CENTER) LONG SALT-CURED SALINA CAPERS ARE PERFECT WITH CAMPARI AS AN APERITIF.

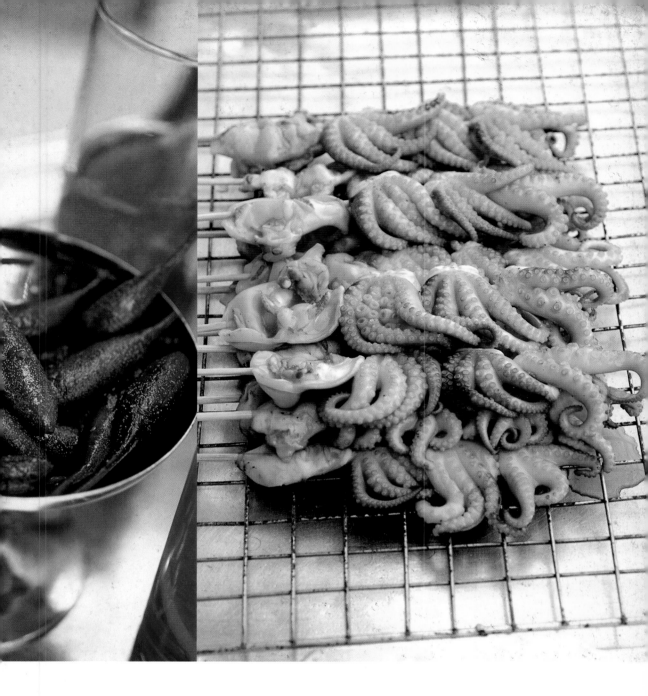

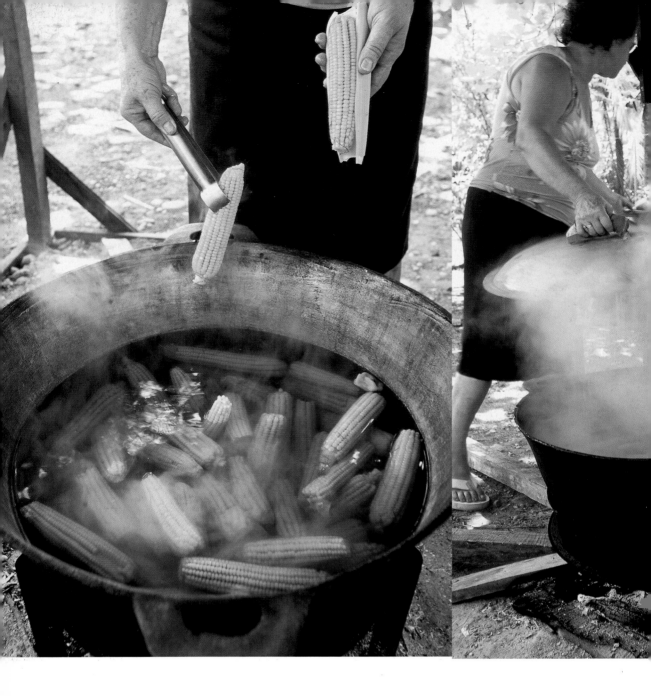

18 / **COSTA RICA.** IN THE BRIBRI REGION, EARS OF CORN ARE BOILED AND SOLD TO PASSERSBY.

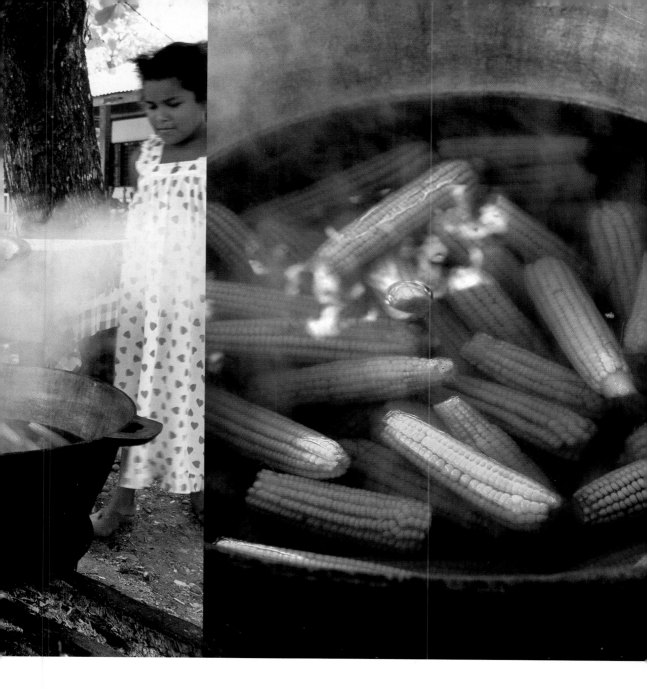

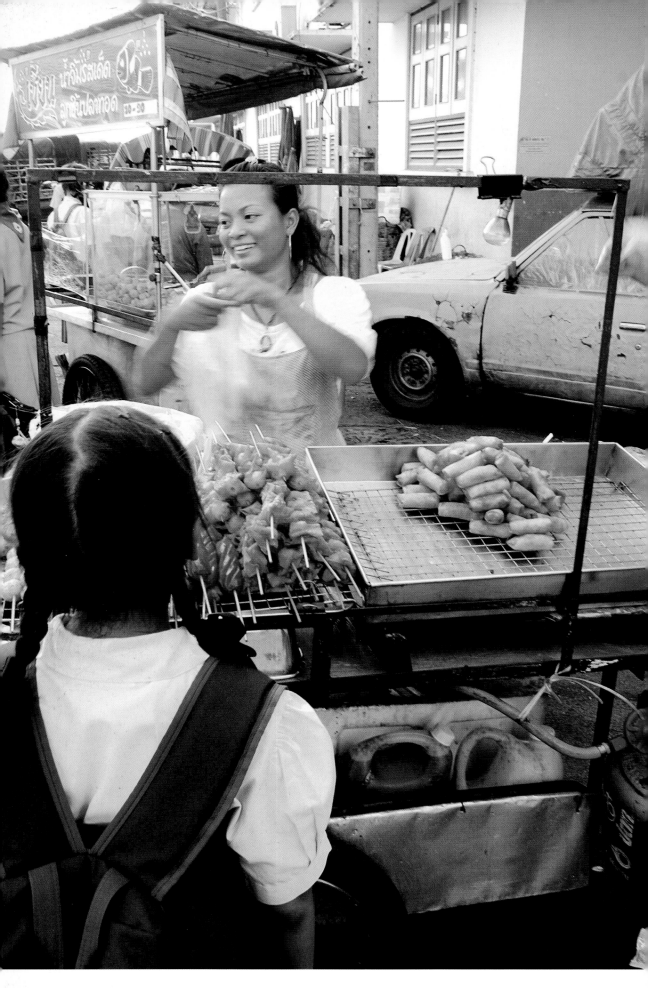

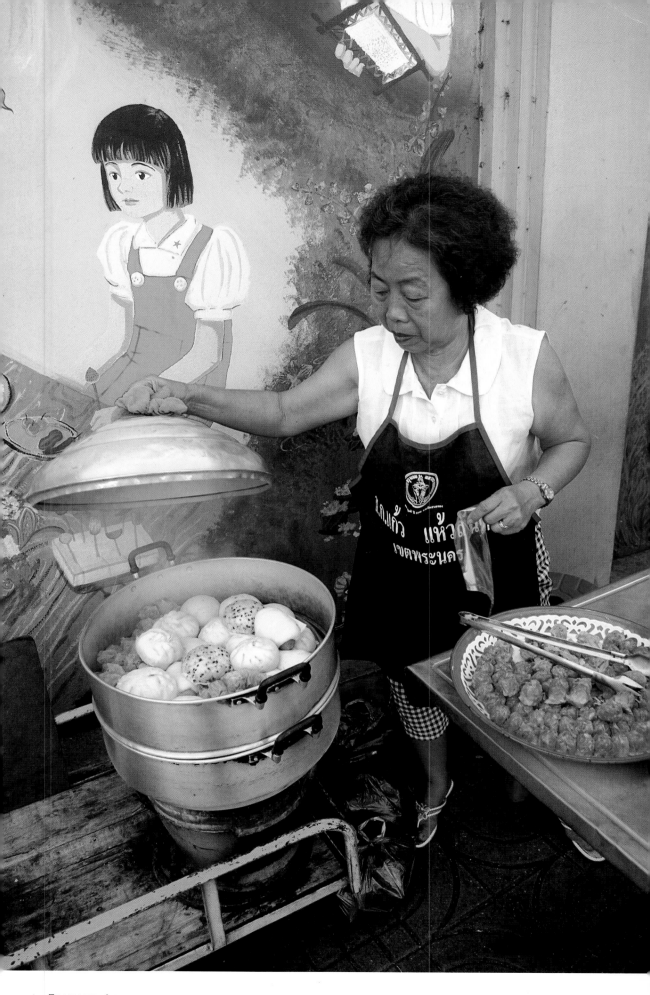

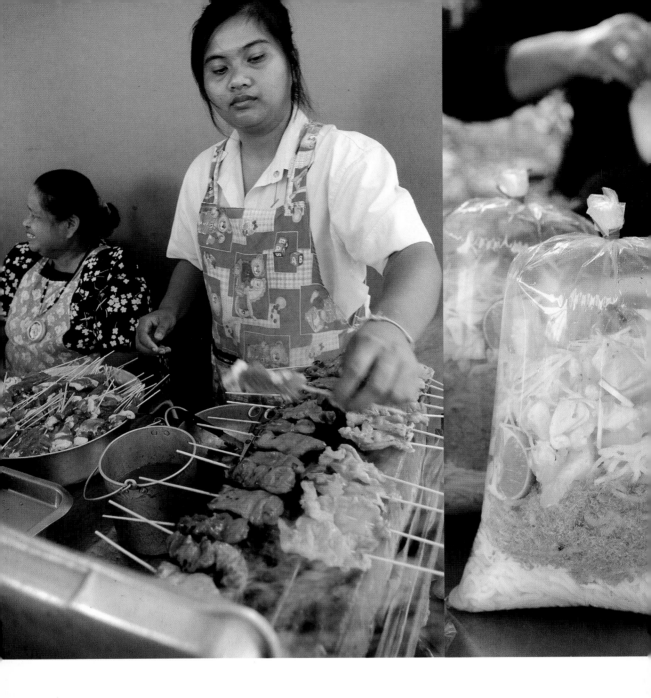

BANGKOK. (LEFT) THIS WOMAN AND HER DAUGHTER PREPARE CRUNCHY PORK BROCHETTES USING A FAMILY RECIPE.
22 / (CENTER) RICE NOODLES, PINEAPPLE, AND RAW VEGETABLES WITH LIME. THEY ARE SOLD IN PLASTIC BAGS INFLATED
WITH AIR TO PRESERVE THEIR VIBRANT COLOR AND FLAVOR.

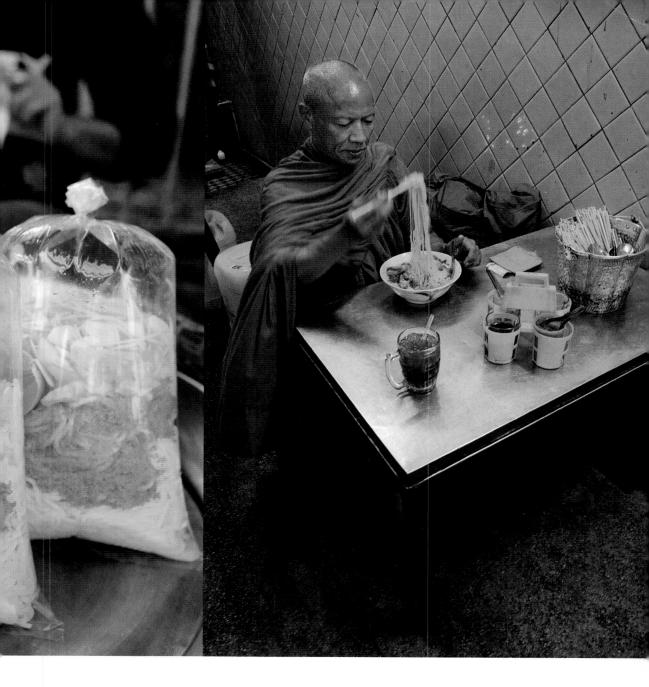

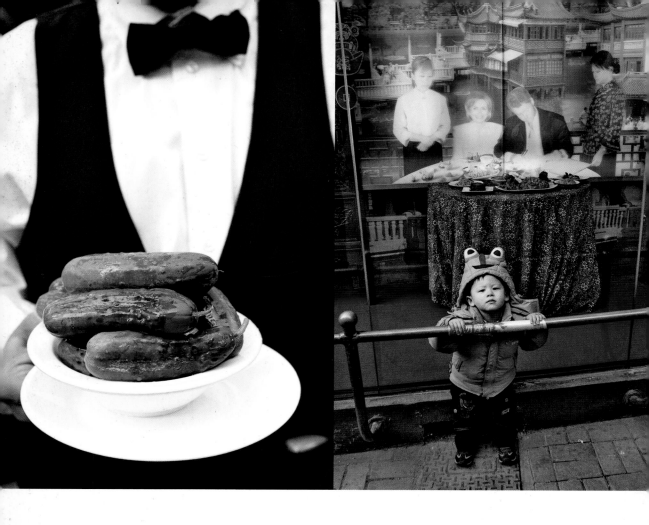

MANHATTAN. (LEFT) A TAKE-OUT PORTION OF PICKLES FROM CARNEGIE DELI.
24 / **SHANGHAI.** (CENTER) THE MEAL SERVED TO THE CLINTONS AT THIS RESTAURANT DURING THEIR VISIT
IS AVAILABLE AS TAKE-OUT IF DESIRED.

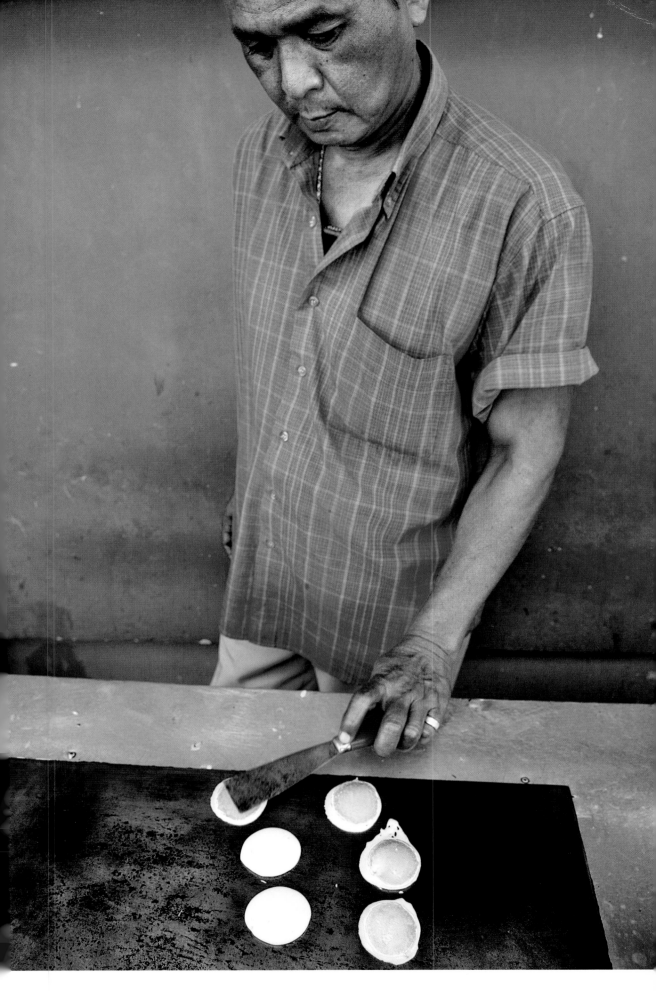

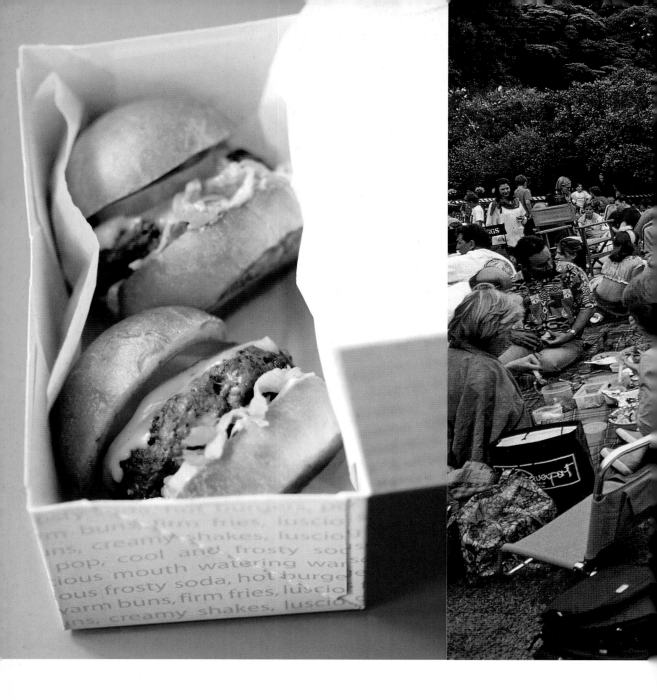

26 / **MANHATTAN.** AT POP BURGER IN THE MEATPACKING DISTRICT, THESE BITE-SIZE
MINI-HAMBURGERS MAKE A QUICK MEAL.

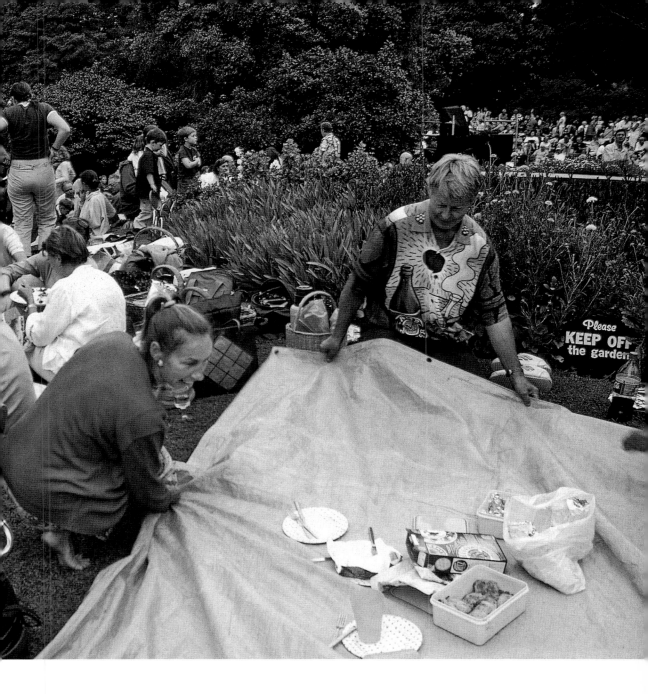

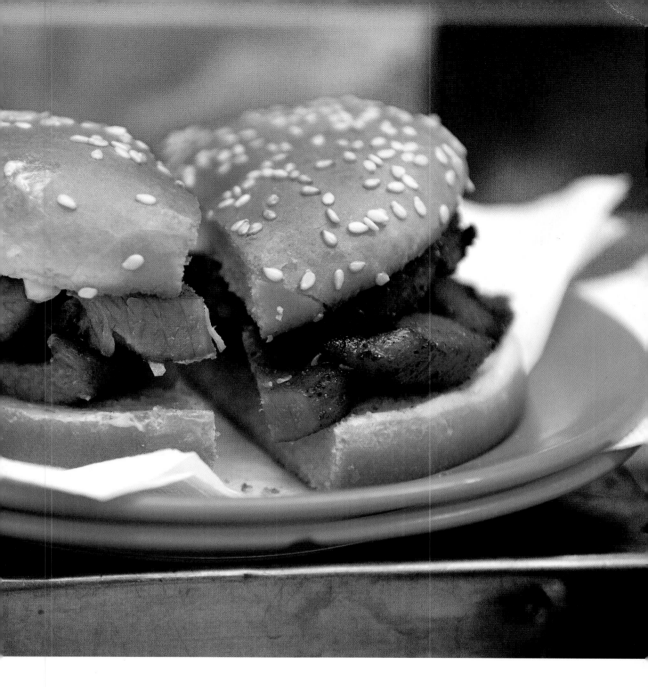

HONG KONG. GRILLED PORK BURGER WITH COCKTAIL SAUCE IS THE MUST-HAVE DISH AT THE FAMOUS LAN FONG YUEN, \ 29
STYLED AFTER AN ENGLISH TEA SALON.

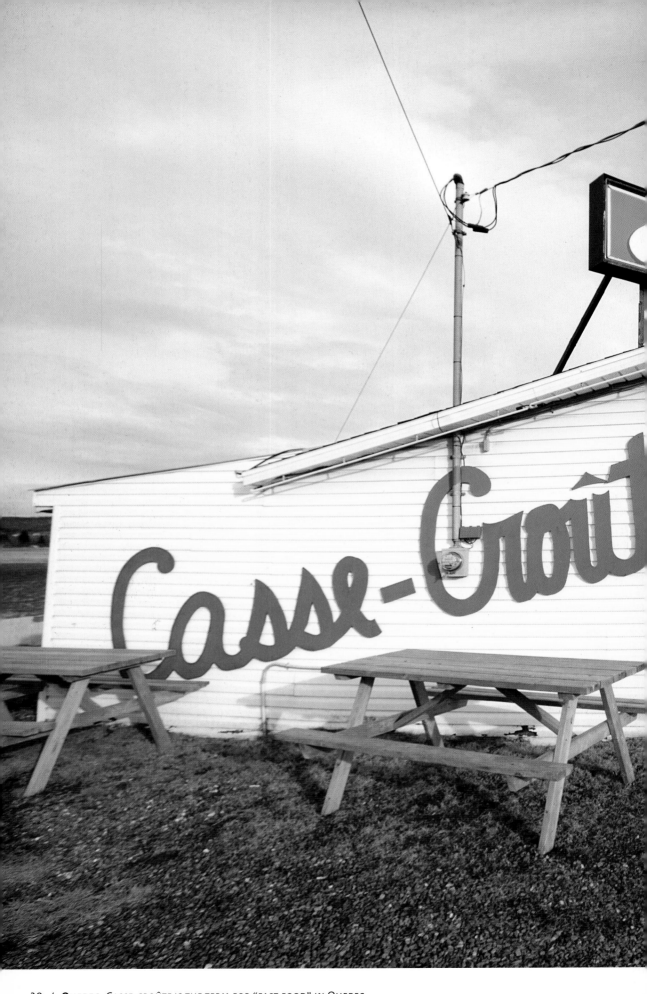

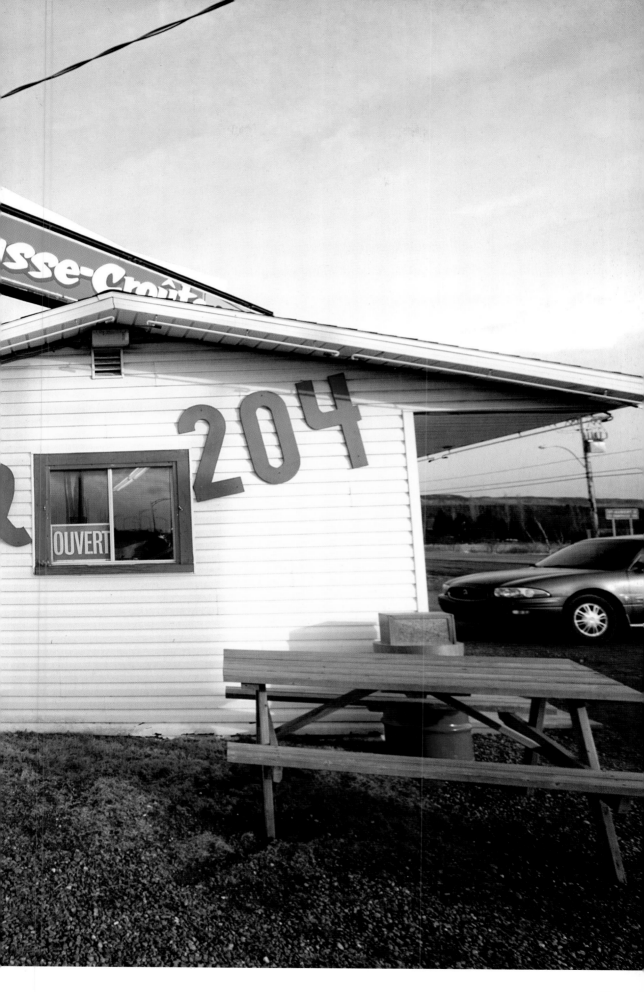

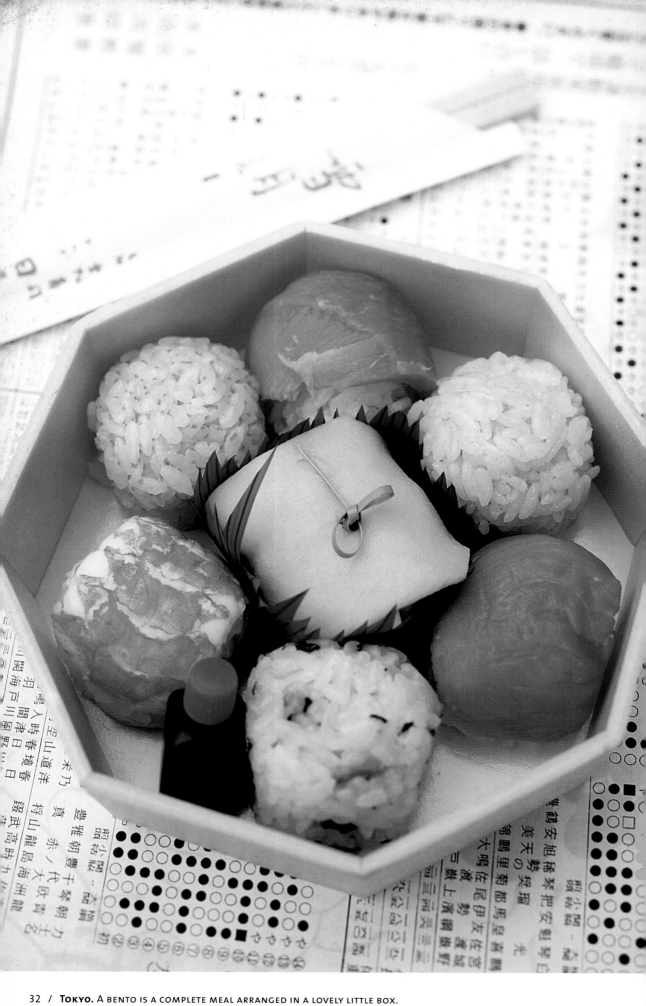

32 / **TOKYO.** A BENTO IS A COMPLETE MEAL ARRANGED IN A LOVELY LITTLE BOX. IT'S AN ALL-OCCASION SOLUTION FOR A QUICK BITE.

 กองละ: **10** บาท

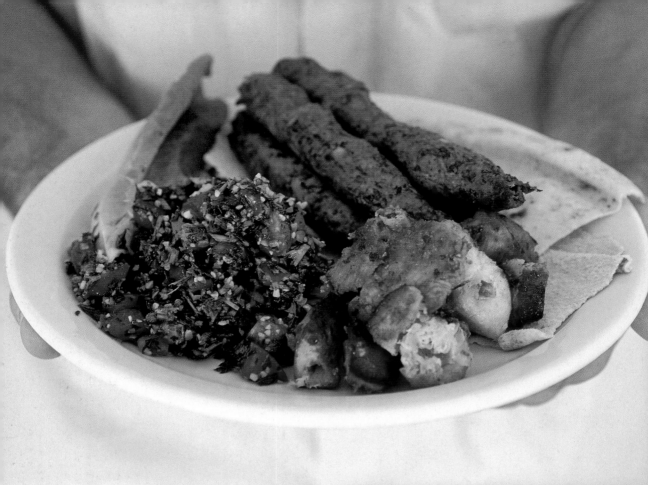

36 / **LEBANON.** (TOP) A PLATTER OF LAMB KEFTA AND TABOULI; (ABOVE) GARLIC AND OLIVE OIL DIP TO ACCOMPANY FISH OR CHICKEN FRITTERS.

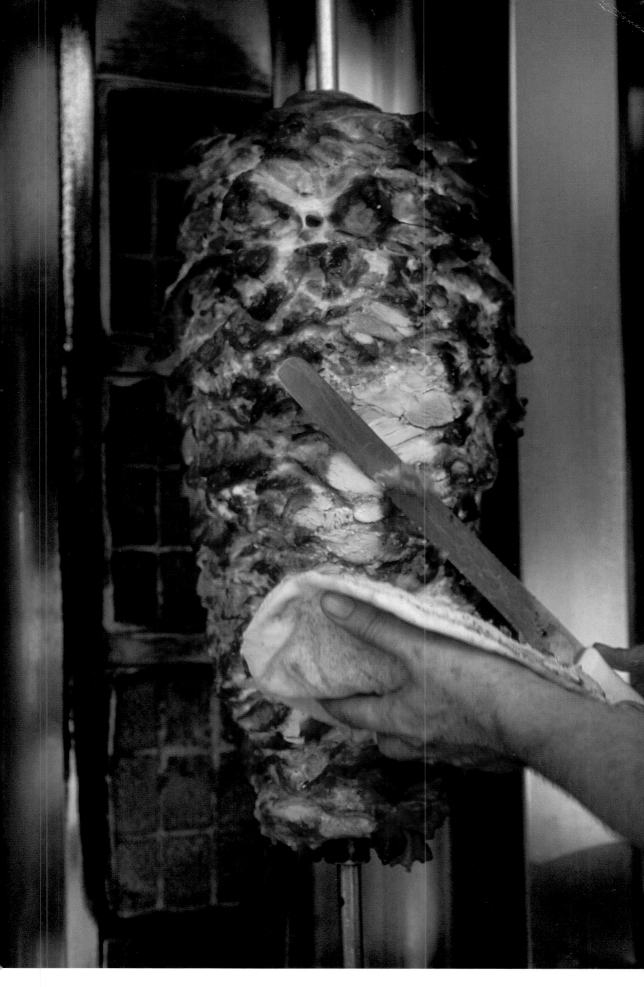

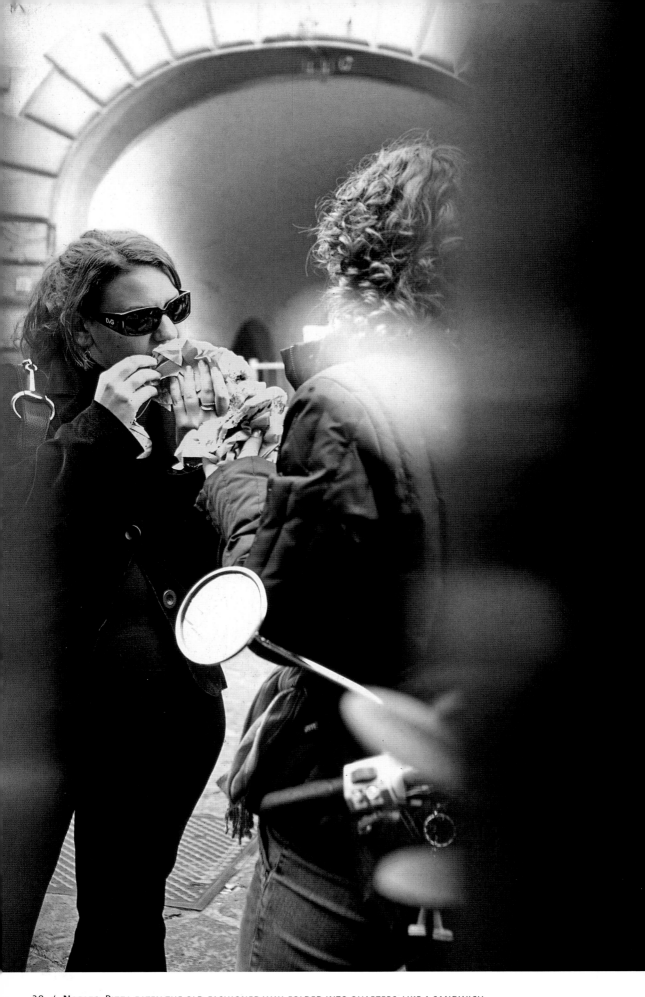

NAPLES. PIZZA EATEN THE OLD-FASHIONED WAY, FOLDED INTO QUARTERS, LIKE A SANDWICH.

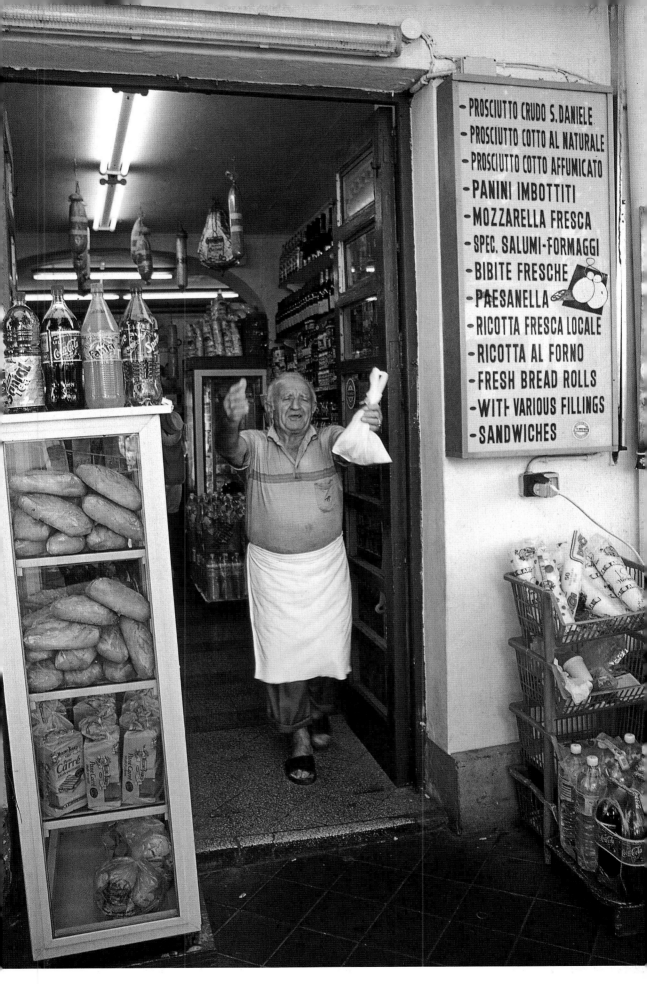

- PROSCIUTTO CRUDO S.DANIELE
- PROSCIUTTO COTTO AL NATURALE
- PROSCIUTTO COTTO AFFUMICATO
- PANINI IMBOTTITI
- MOZZARELLA FRESCA
- SPEC. SALUMI-FORMAGGI
- BIBITE FRESCHE
- PAESANELLA
- RICOTTA FRESCA LOCALE
- RICOTTA AL FORNO
- FRESH BREAD ROLLS
- WITH VARIOUS FILLINGS
- SANDWICHES

LIPARI. IN THE AEOLIAN ISLANDS, A GROCER SELLS MORTADELLA SANDWICHES. \ 39

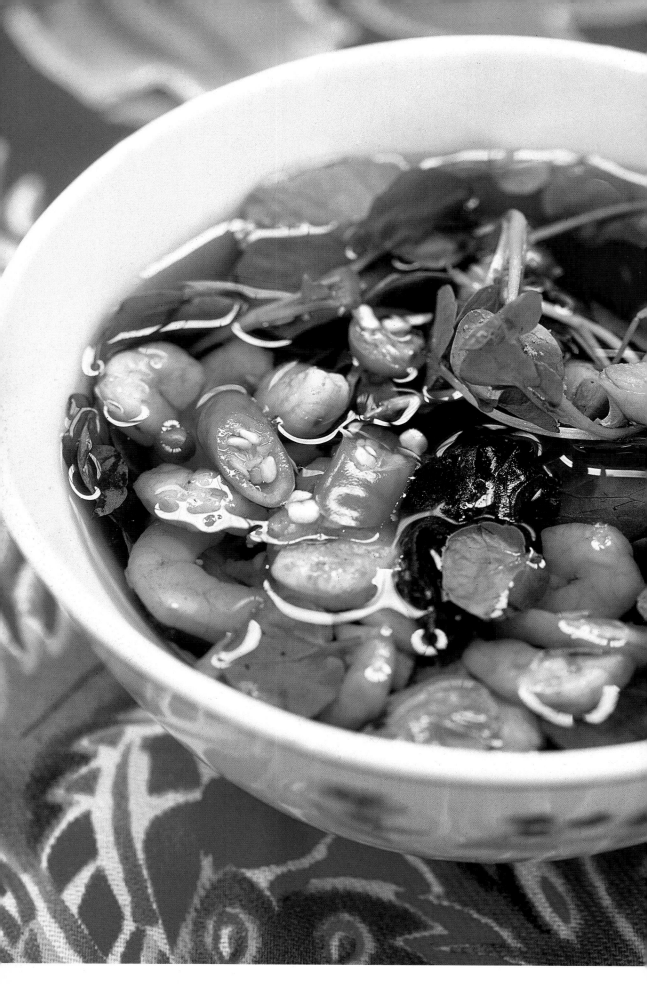

FRANCE. A SEASIDE PICNIC GROUND NOT FAR FROM MONT-SAINT-MICHEL.

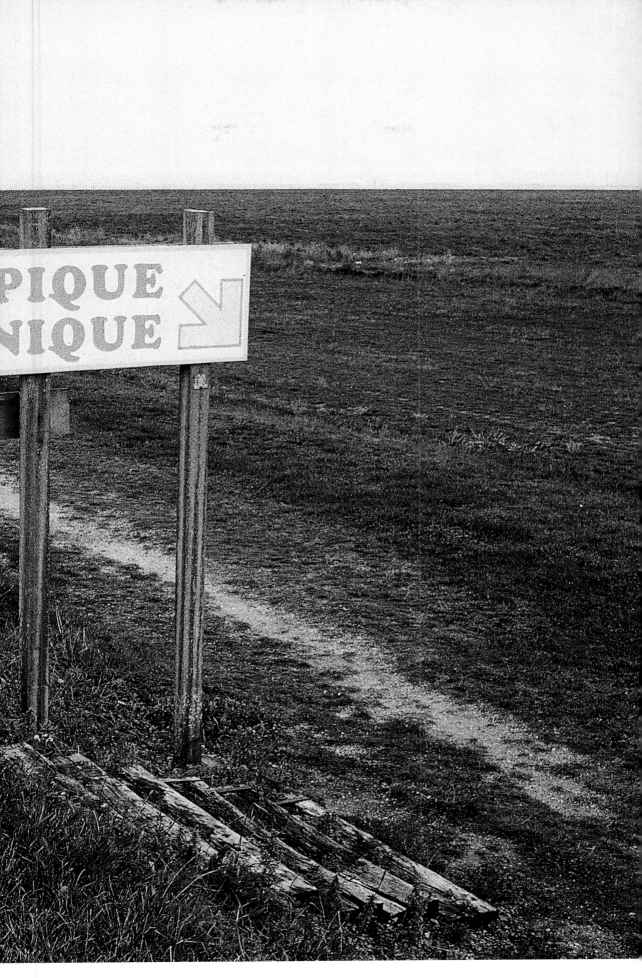

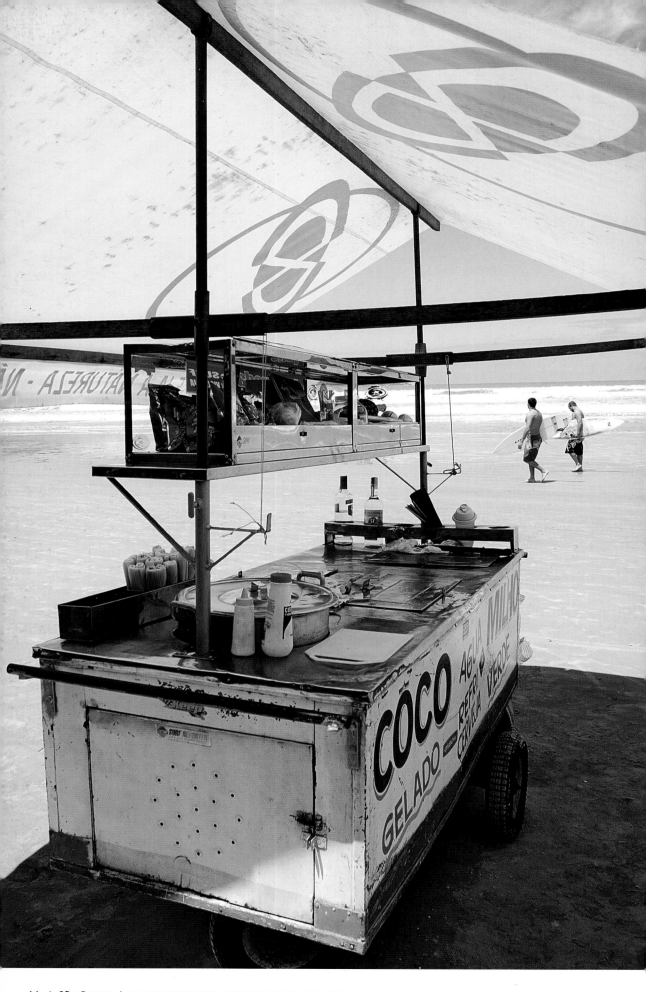

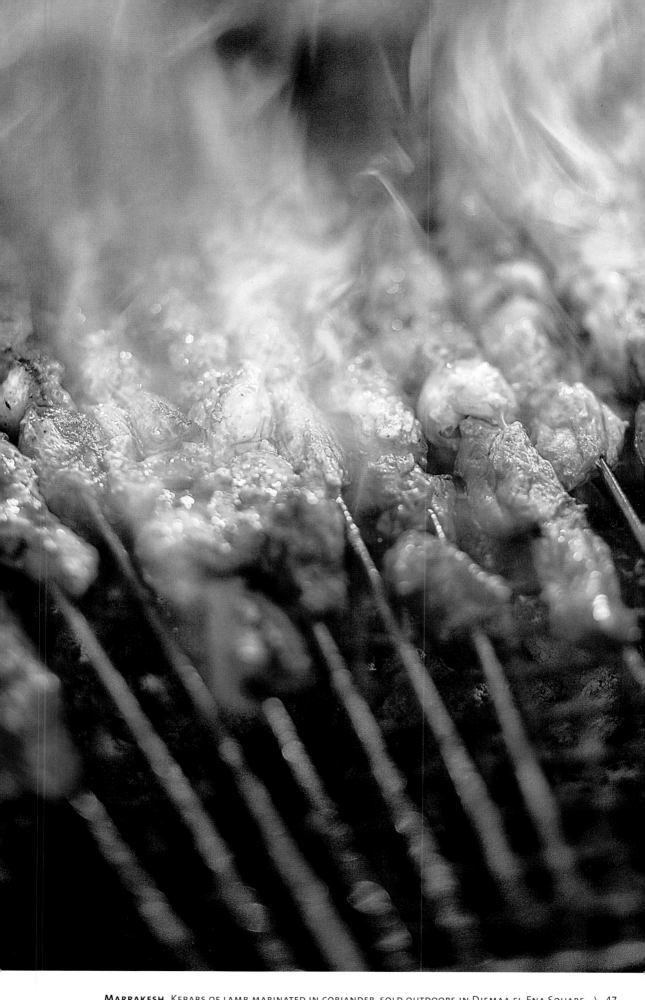

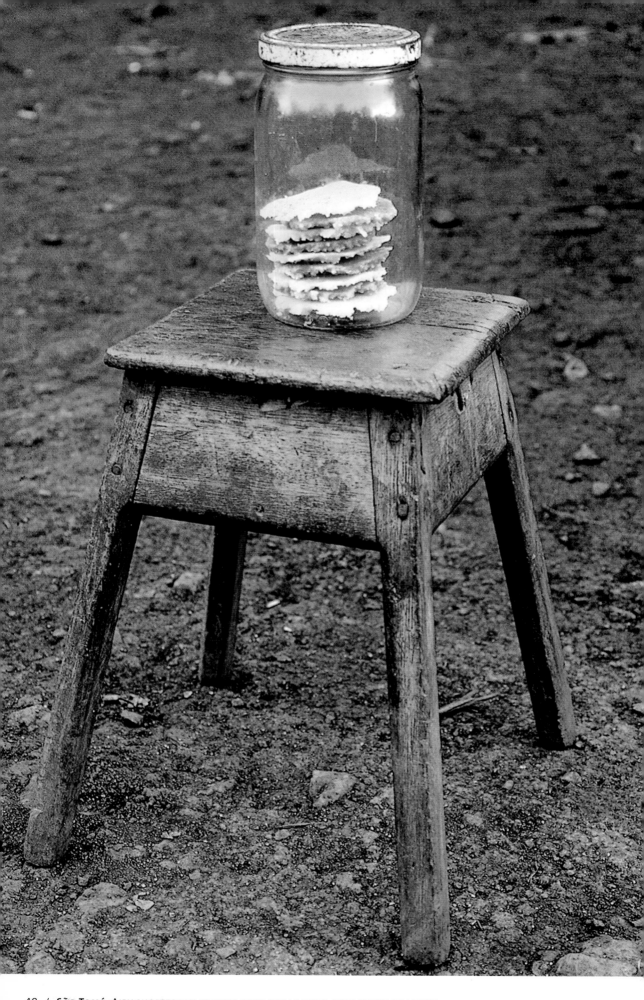

São Tomé. Airy shortbread cookies with sugar icing, sold by the roadside.

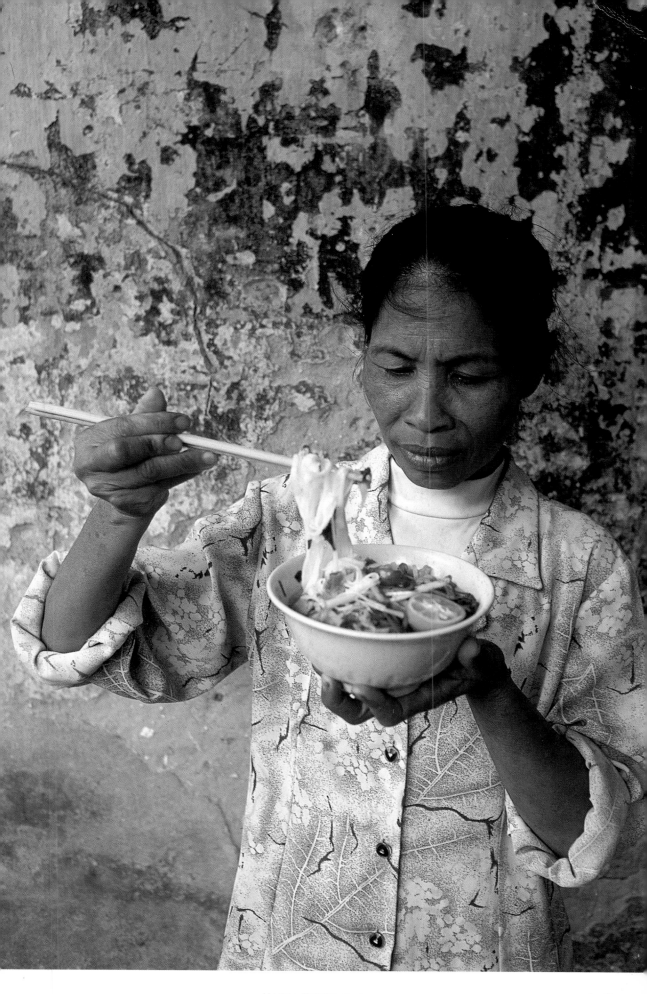

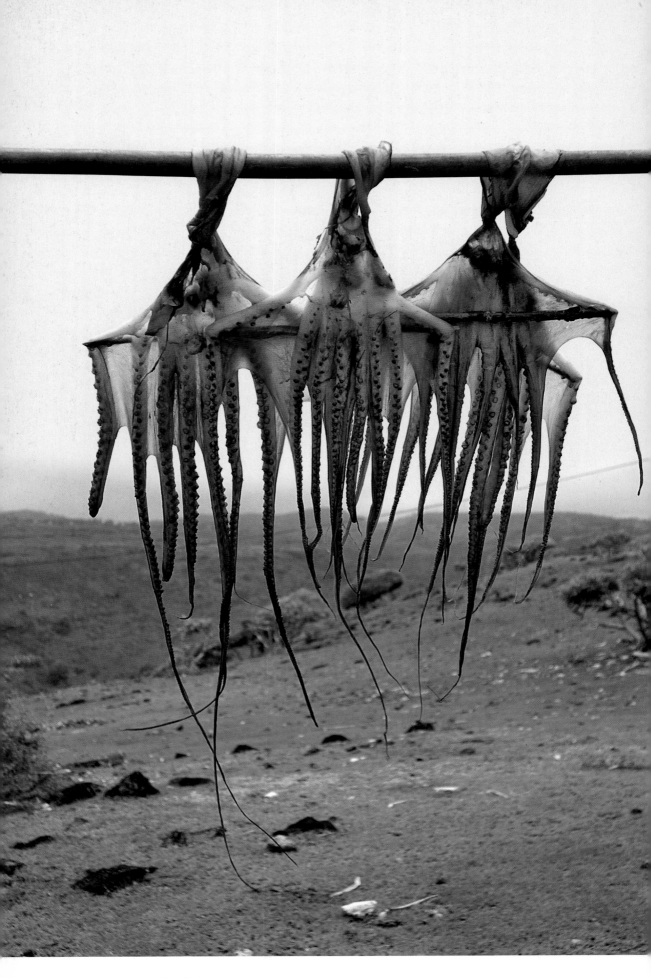

50 / **RODRIGUES ISLAND.** (LEFT) OCTOPUS DRYING,
(RIGHT) LATER TO BE STEWED AND SOLD AS TAKE-OUT.

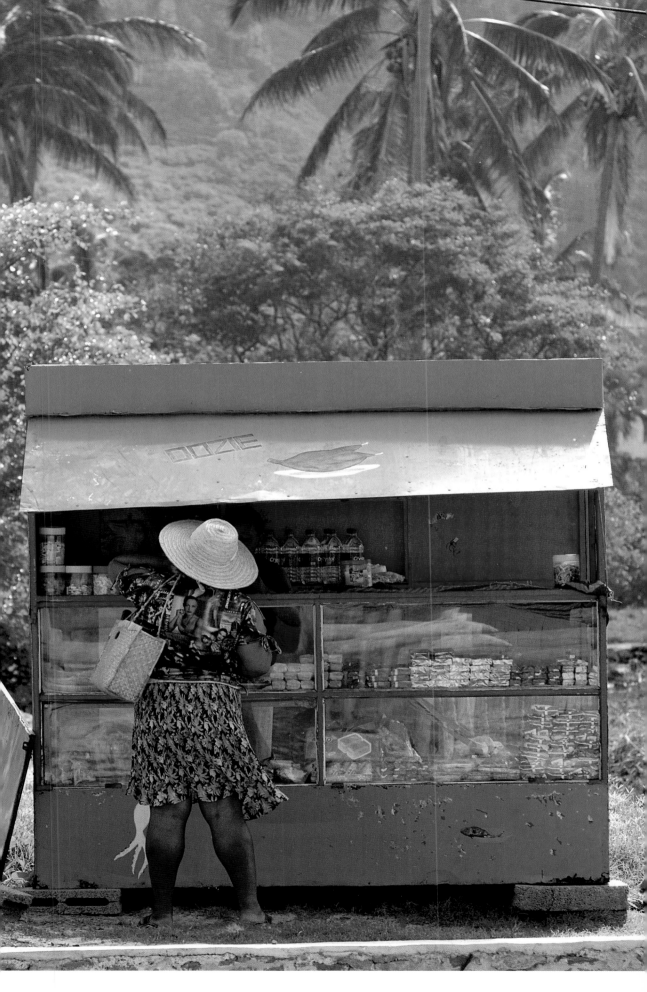

BANGKOK. CATFISH COOKED IN BANANA LEAVES.

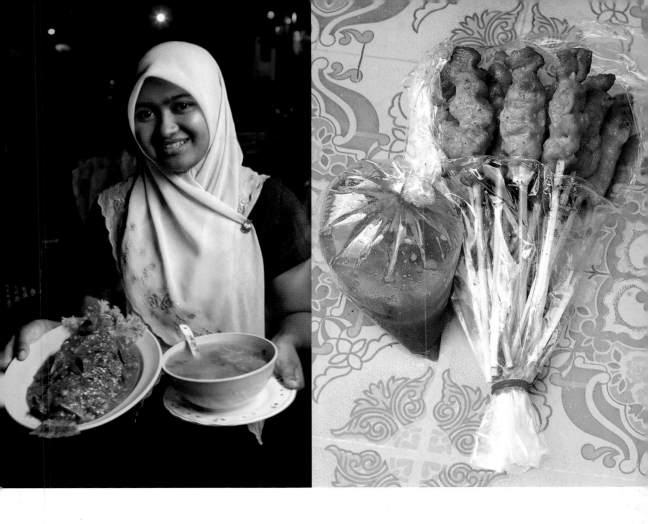

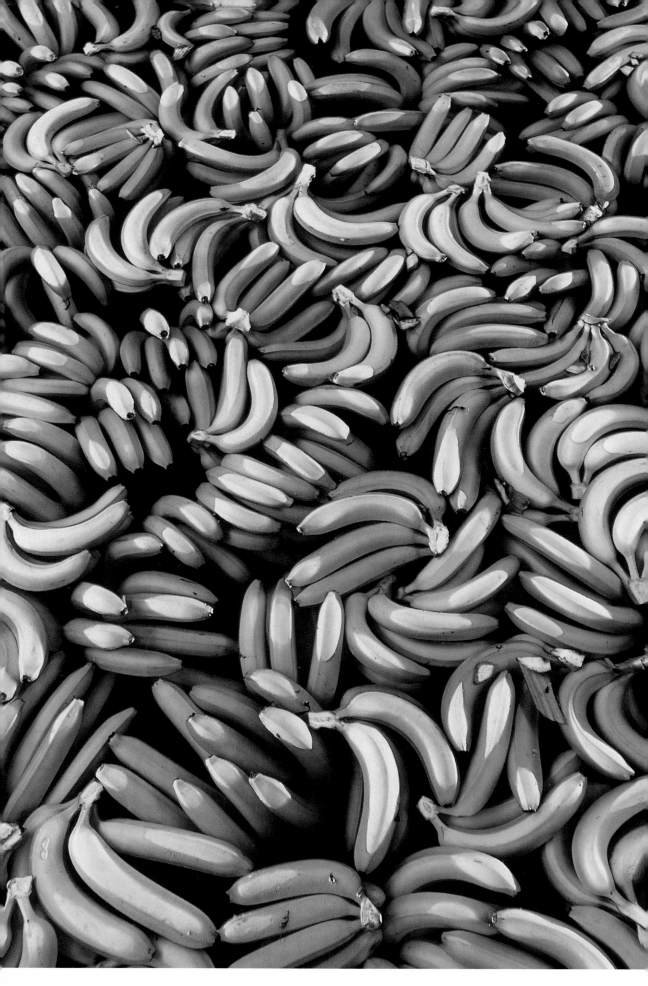

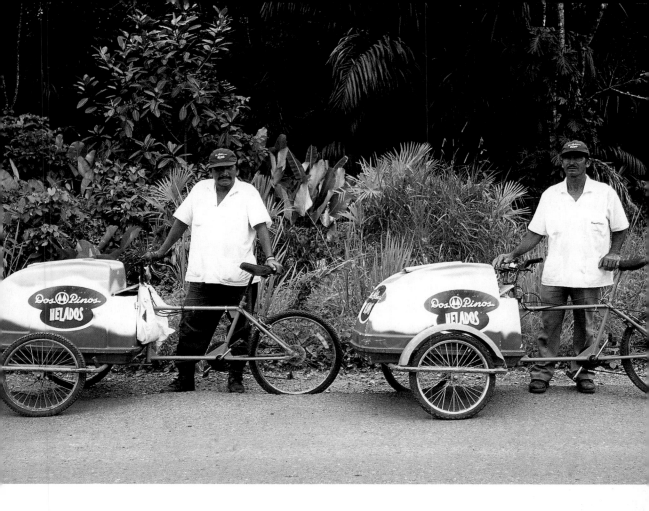

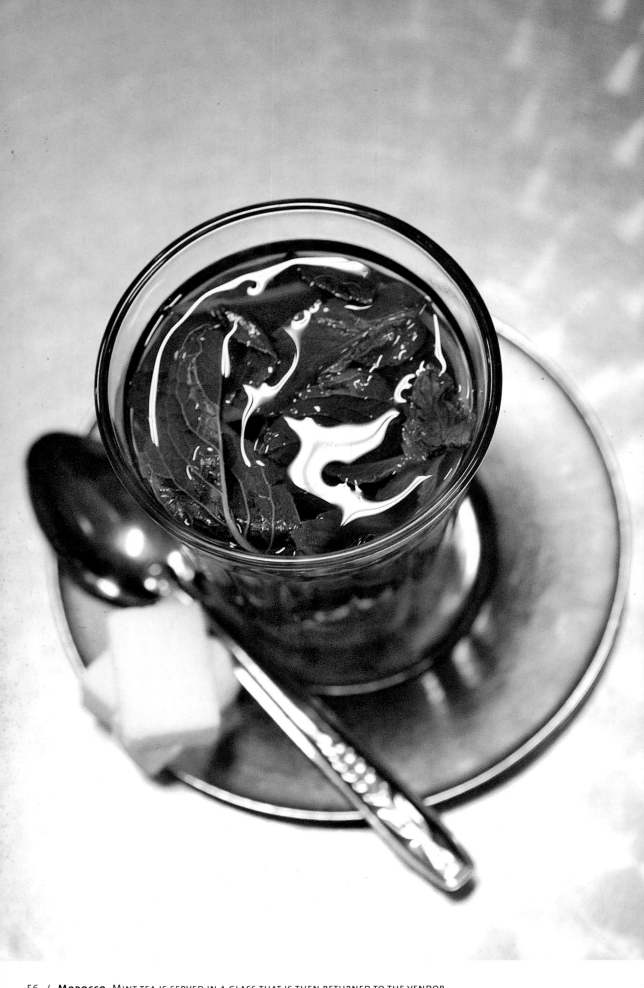

Morocco. Mint tea is served in a glass that is then returned to the vendor. No plastic for this drink.

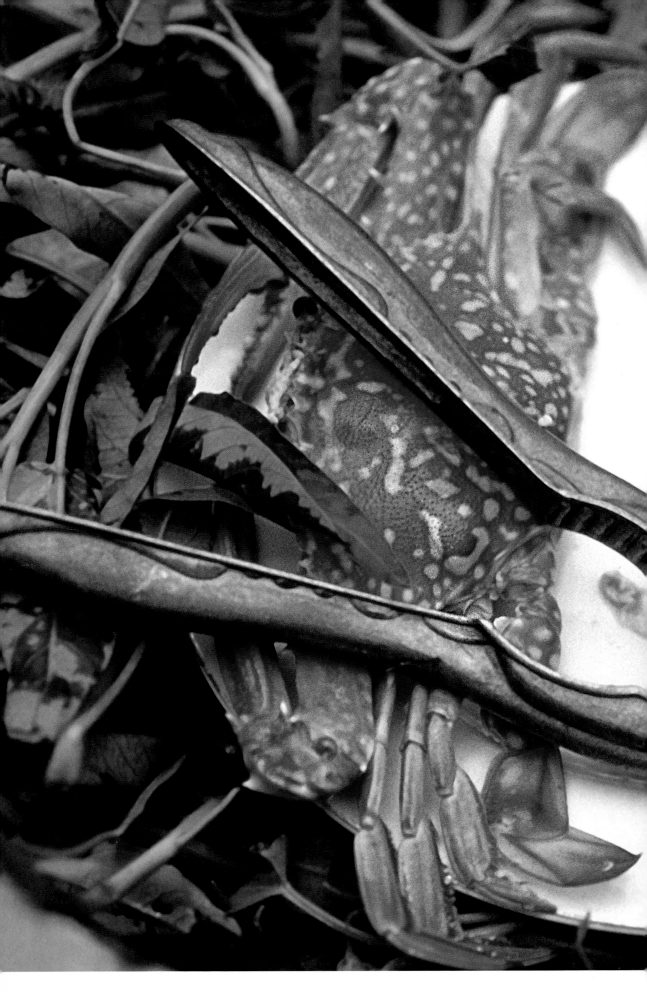

ON THE FERRY, CRAB SALAD IS PREPARED BEFORE YOUR EYES.

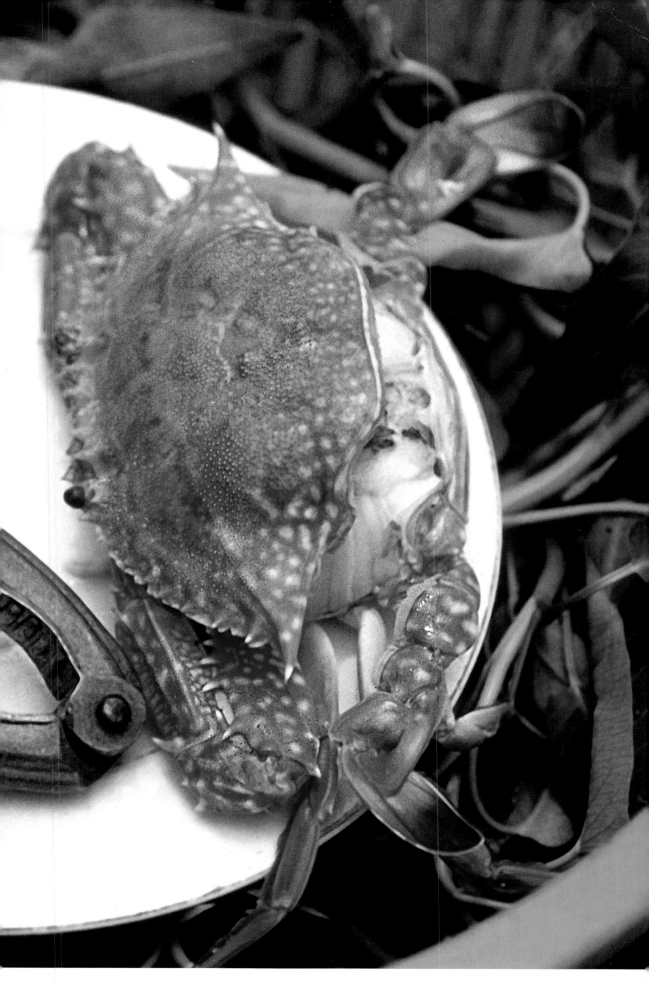

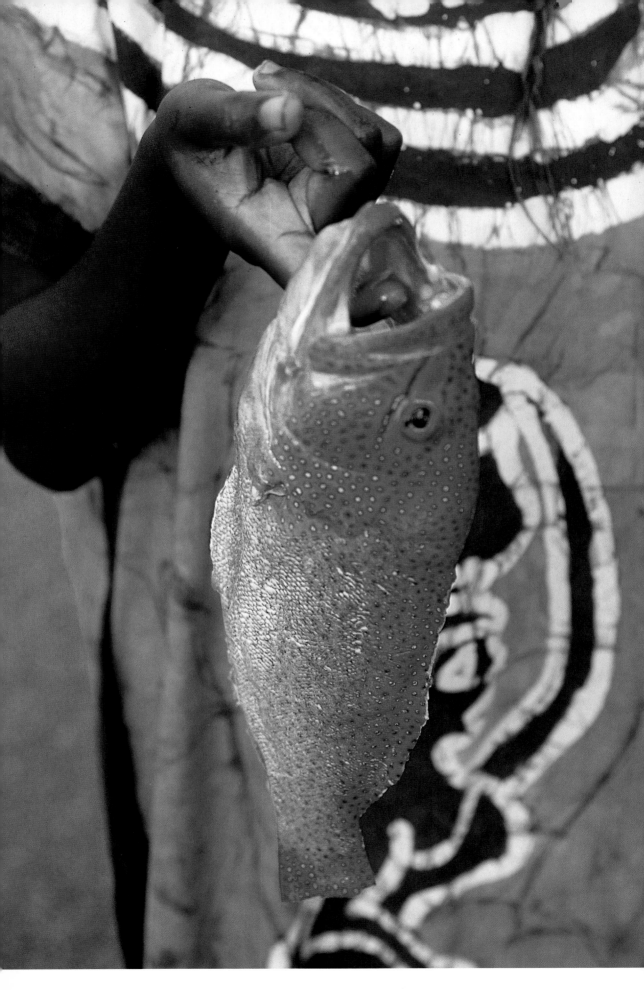

SÃO TOMÉ. FRESH FISH ARE SOLD RIGHT ON THE STREET.

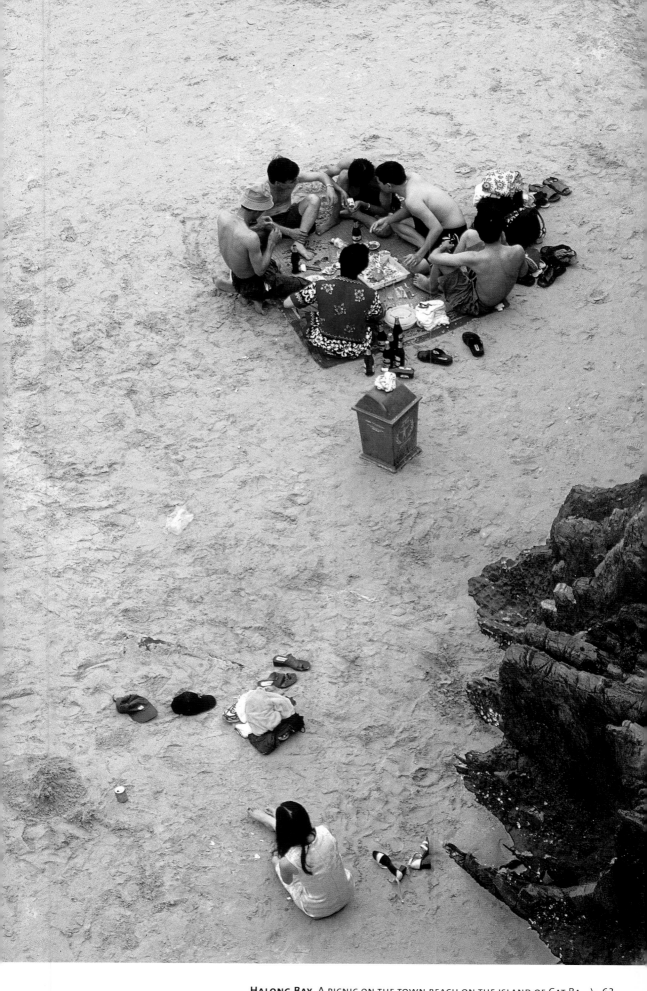

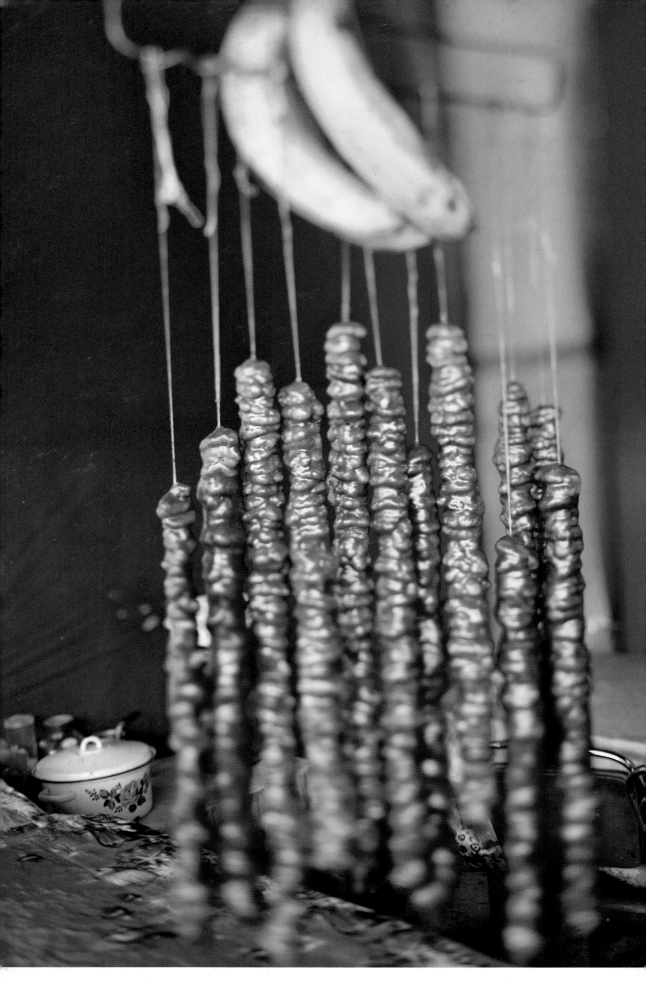

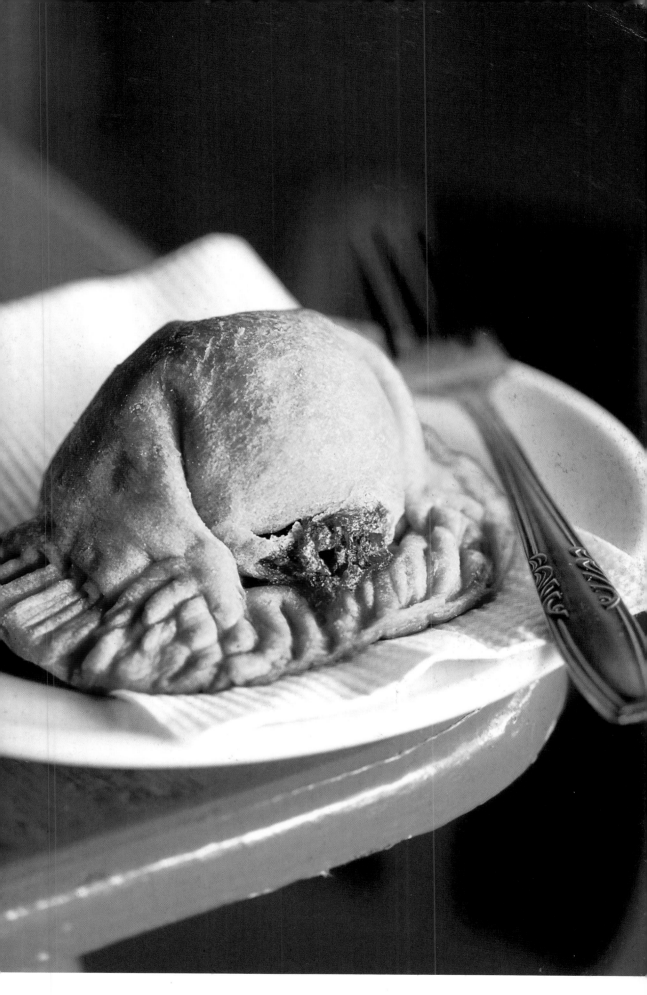

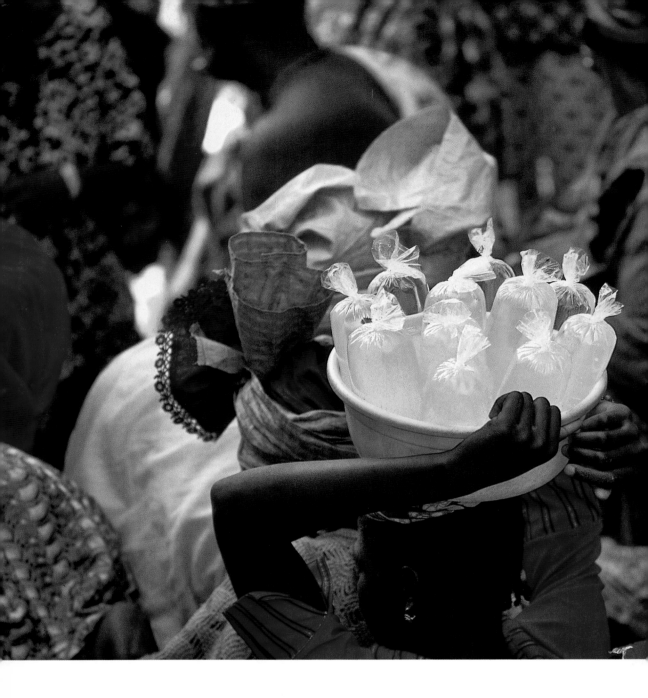

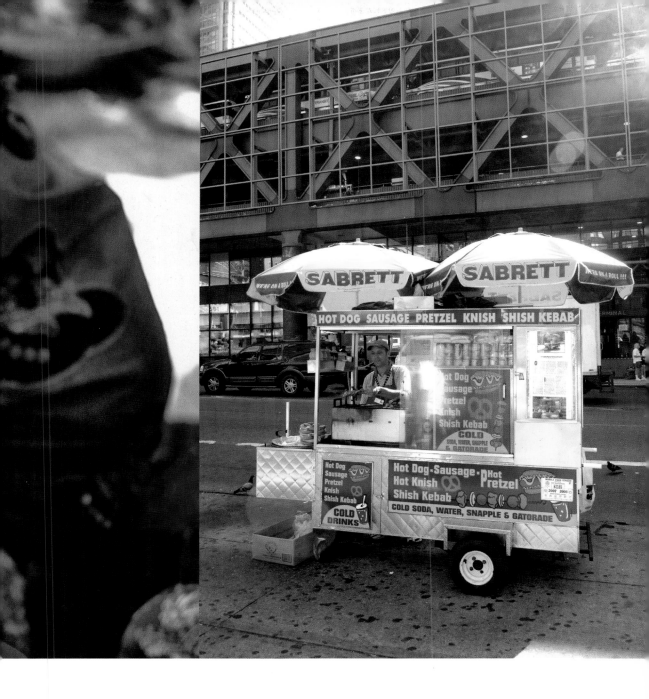

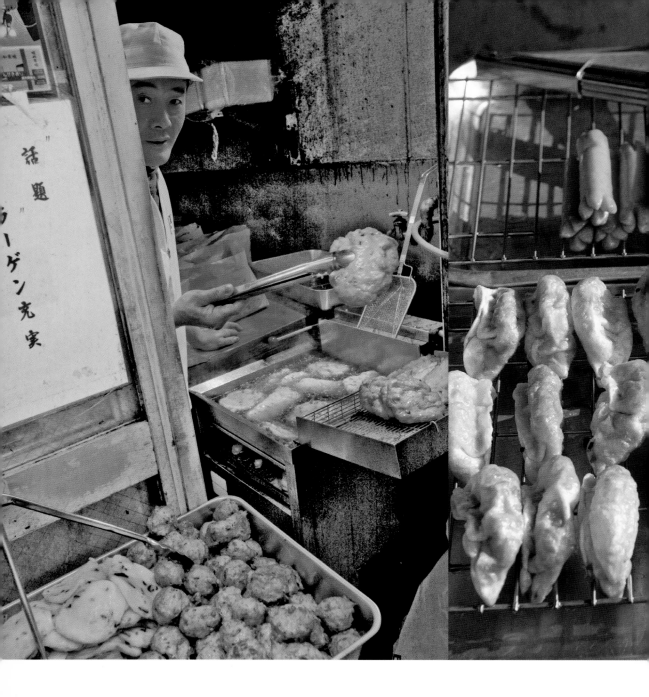

68 / **TOKYO.** (LEFT) SHOPS NEAR TSUKIJI FISH MARKET SELL THESE DELICIOUS FRITTERS.
BANGKOK. (CENTER) FRIED PORK DUMPLINGS AND GRILLED SAUSAGES SOLD BEHIND THE ORIENTAL PALACE.

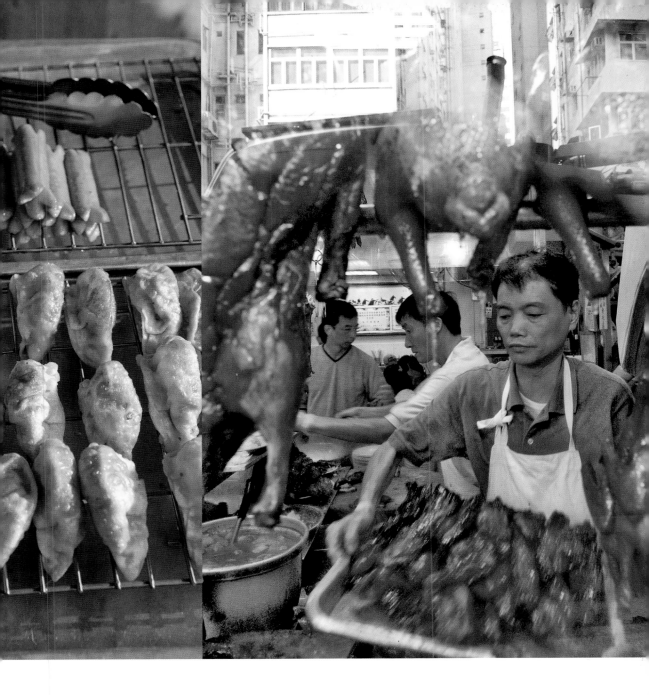

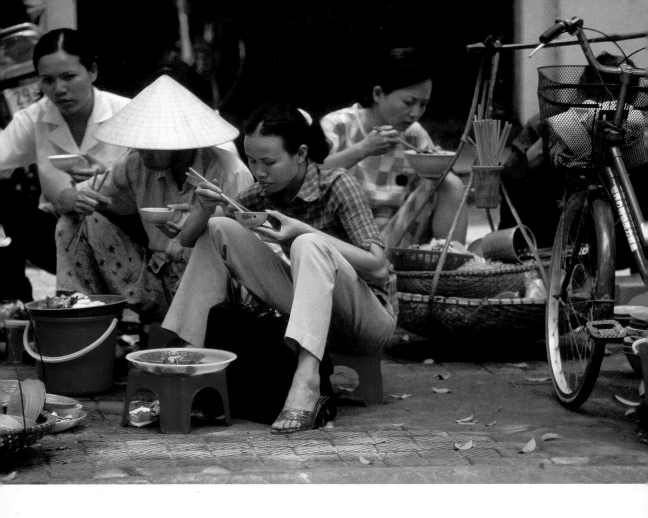

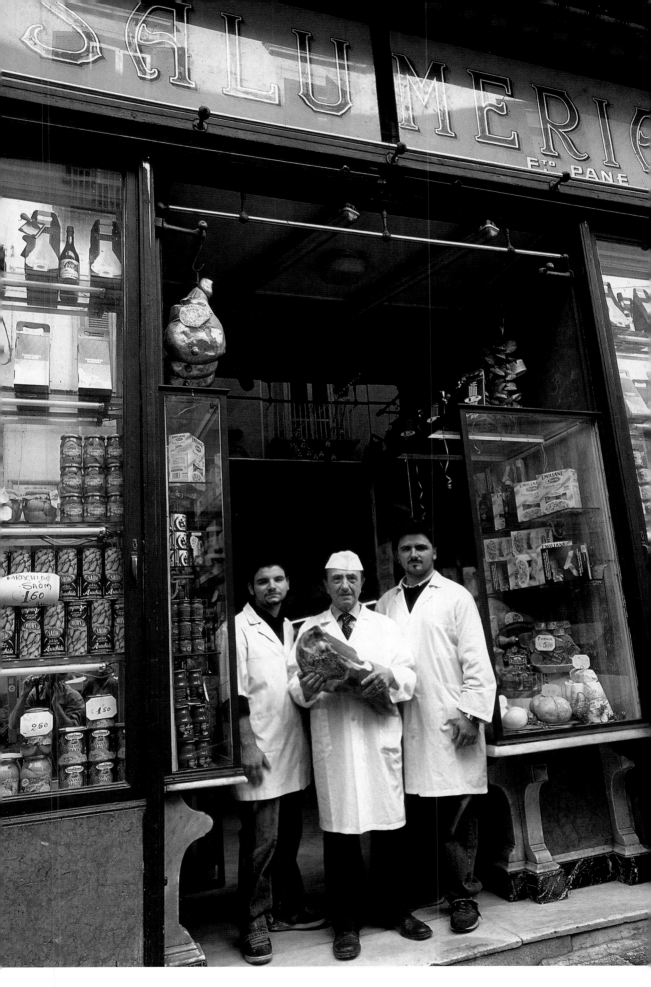

Naples. This traditional salumerie sells mozzarella, coppa, mortadelle, and prosciutto. \ 71

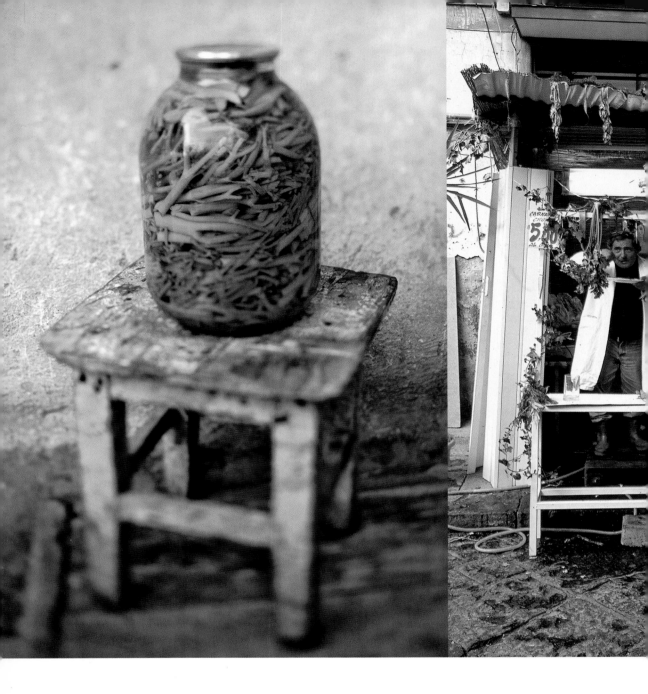

74 / **ARMENIA.** (LEFT) PORTIONS OF *TOURCHI* (MARINATED VEGETABLES) WITH WILD FENNEL ARE SOLD TO ACCOMPANY VODKA.
NAPLES. (CENTER) OFFAL FOR SALE ON THE STREET.

HANOI. (LEFT) CRUNCHY PASTRY PURSES WITH DUCK FILLING. THE INGREDIENTS ARE DELIVERED ON FOOT THROUGH THE NARROW STREETS. (RIGHT) A WOMAN CARRIES EGGS.

ARMENIA. CHIVES AND RED BASIL ARE INDISPENSABLE GARNISHES FOR LAVASH BREAD HOT FROM THE OVEN.

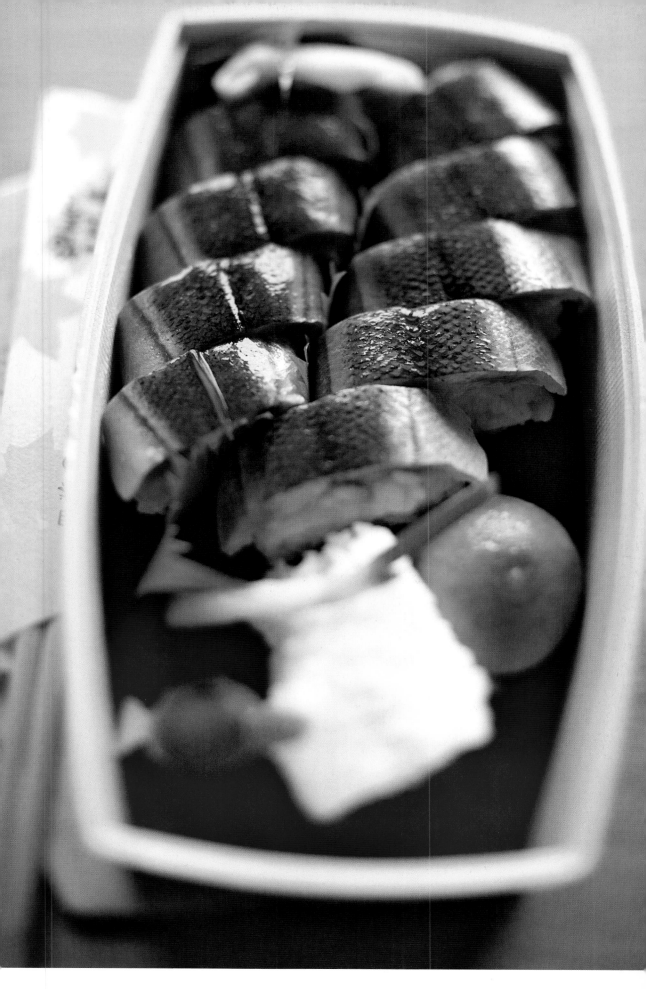

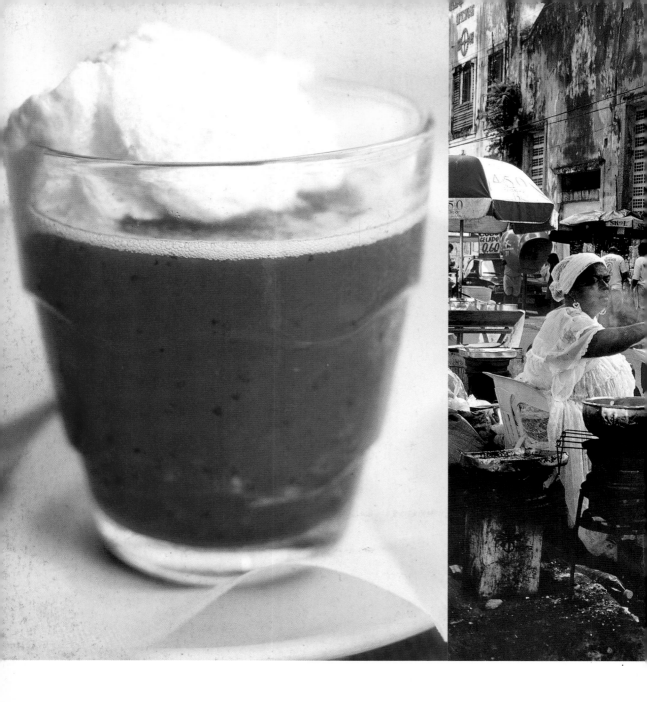

AEOLIAN ISLANDS. (LEFT) DON'T MISS THE FAMOUS STRAWBERRY SLUSH AT ALFREDO'S IN SALINA.
SALVADOR DA BAHIA. (CENTER) WOMEN COOK TRADITIONAL DRIED-SHRIMP FRITTERS,
SOLD TO PASSERSBY TO EAT ON THE NEARBY BEACH.

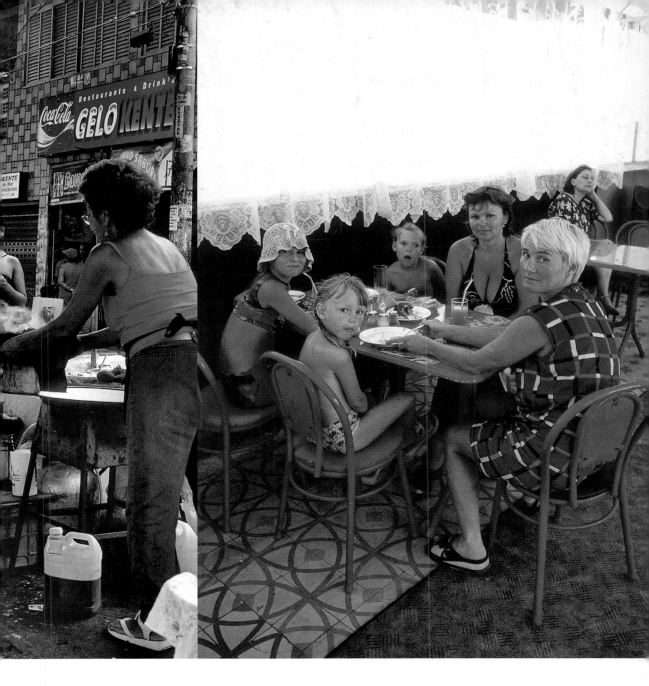

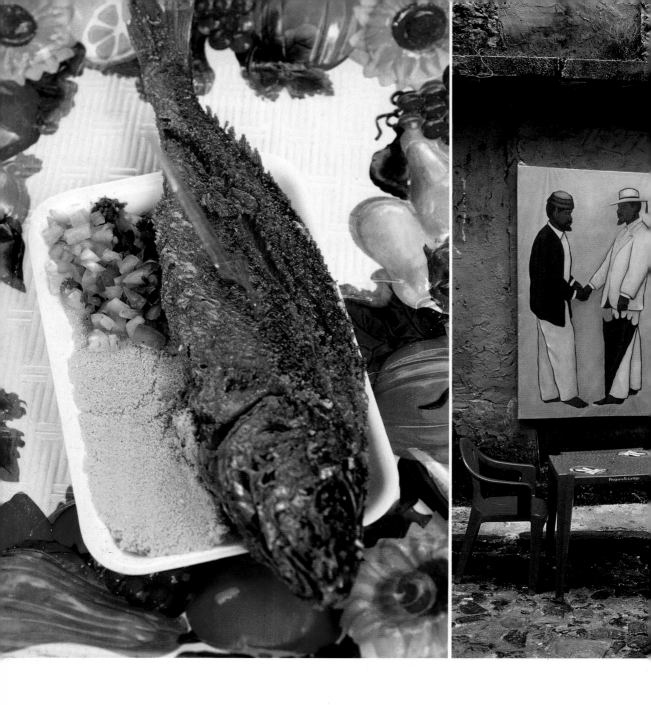

SALVADOR DA BAHIA. FISH IS FRIED IN BATTER AND EATEN ON THE SPOT AT THESE LITTLE POP-UP RESTAURANTS.

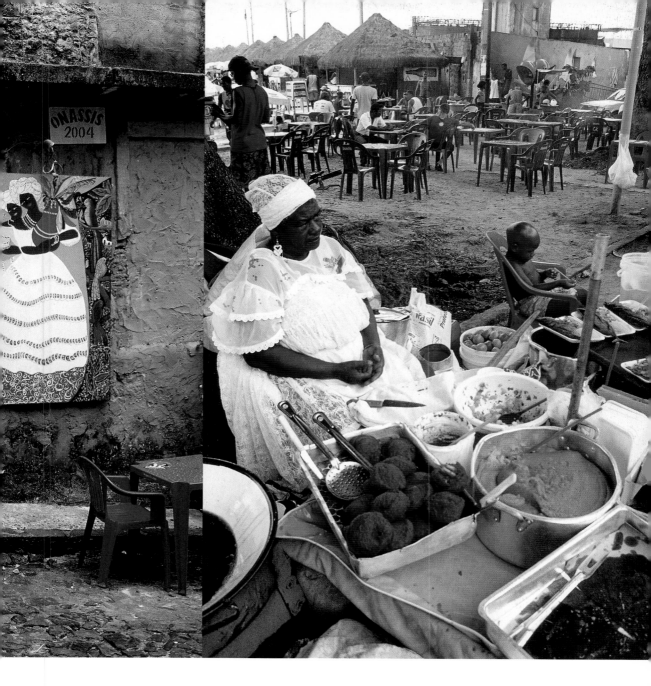

84 / **MUMBAI.** A TIFFIN, A LUNCH PAIL, IS KEPT WARM WRAPPED IN CLOTH.

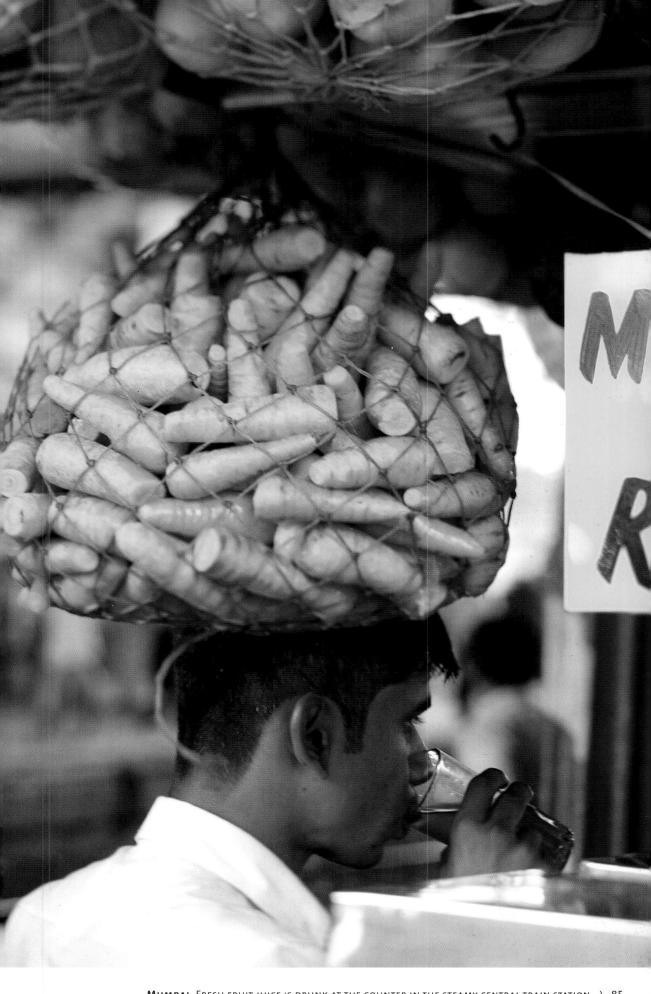

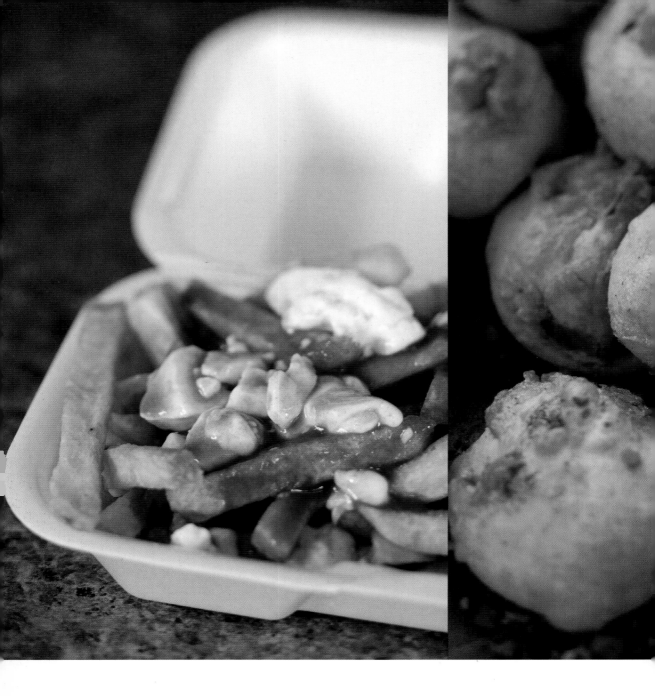

QUEBEC. (LEFT) *POUTINE*—FRENCH FRIES TOPPED WITH CHEESE CURDS AND GRAVY—IS QUEBEC'S MOST FAMOUS FOOD.

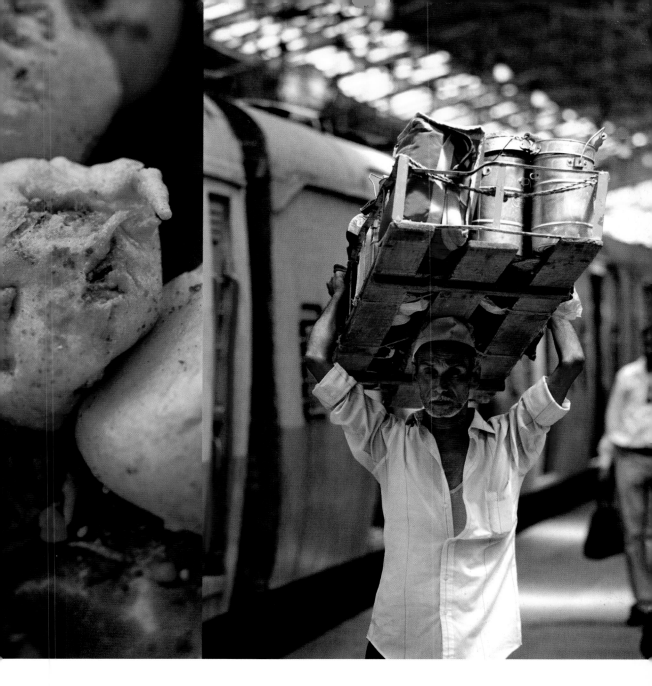

MUMBAI. (CENTER) *VADA PAV* ARE LITTLE PANCAKES WRAPPED AROUND POTATOES AND CORIANDER.
(RIGHT) A *DABBAWALLA* LEAVES THE TRAIN STATION WITH HIS LOAD OF LUNCH CONTAINERS \ 87
TO DELIVER TASTY SNACKS TO BUSINESSPEOPLE IN THE CITY CENTER.

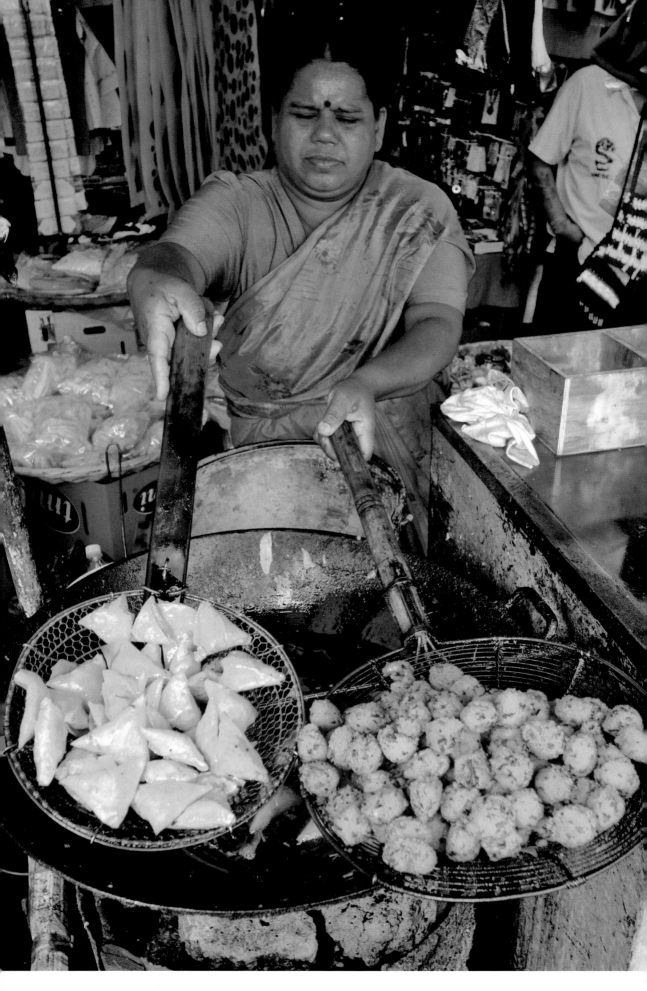

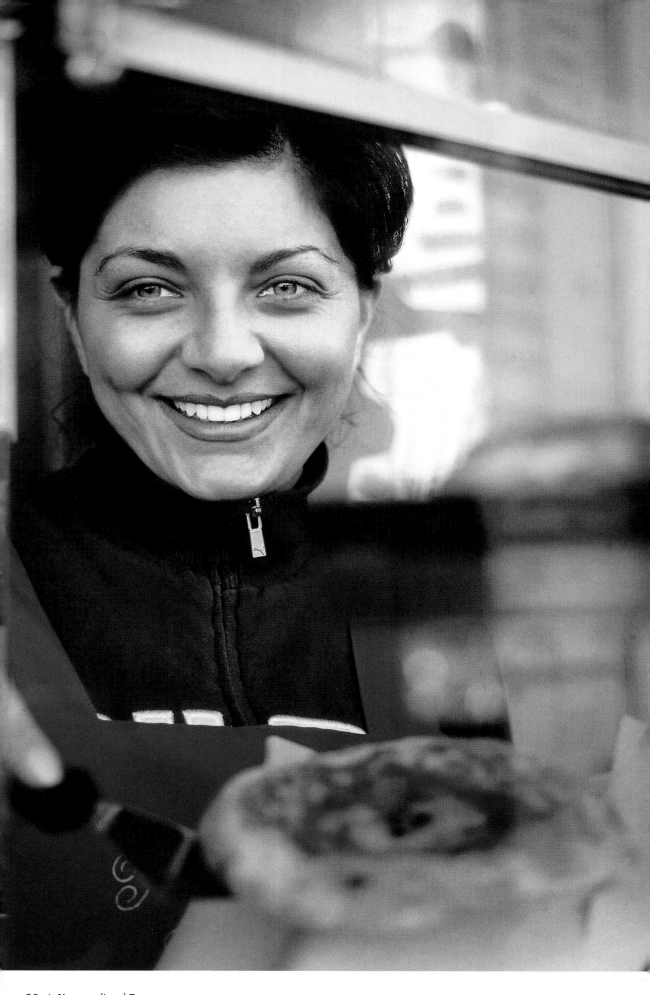

90 / **Naples.** (Left) This woman prepares individual margherita pizzas. (Right) Pizzas eaten on the go, folded over like sandwiches.

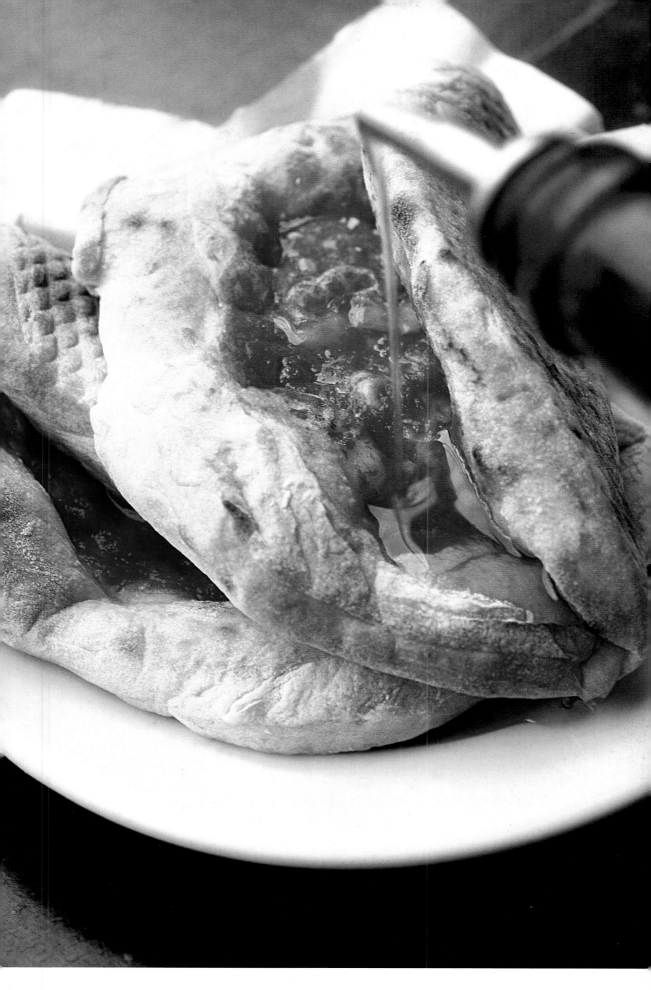

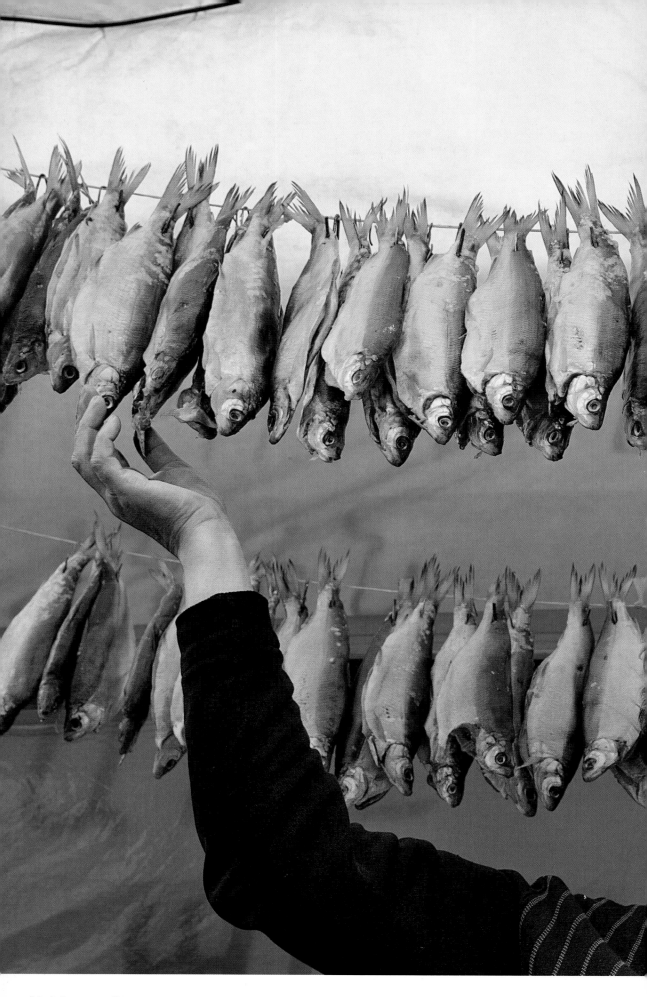

ARMENIA. DRIED FISH FOR SALE AT A CROSSROADS NEAR LAKE SEVAN.

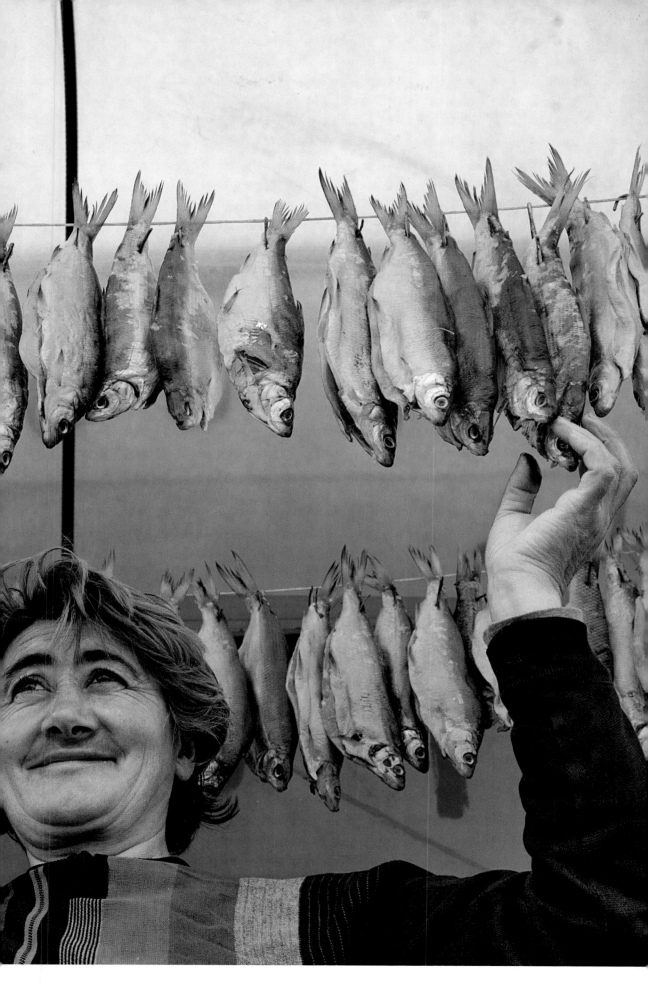

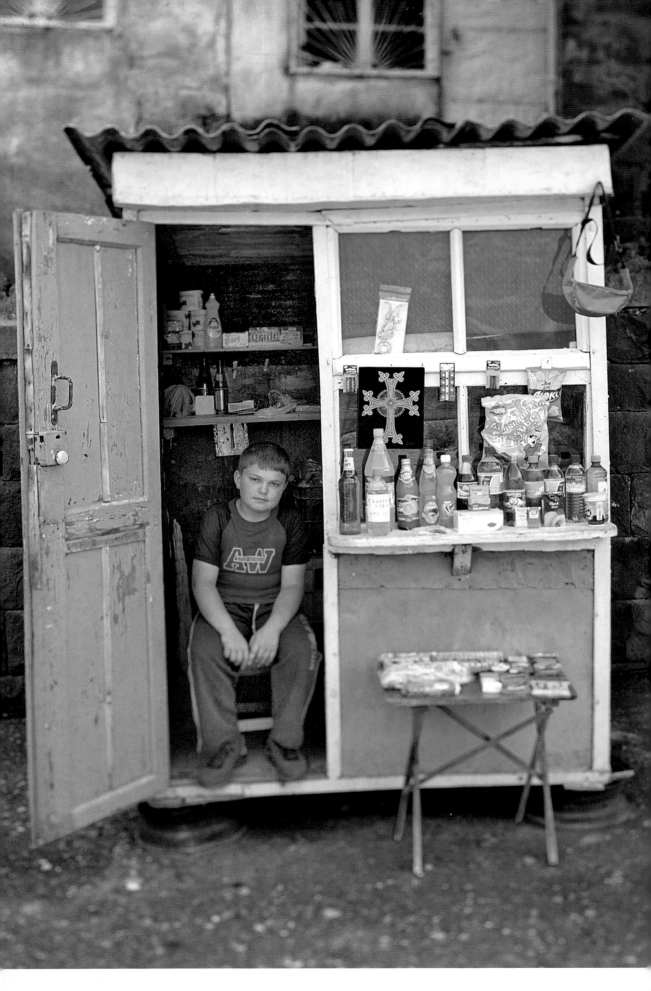

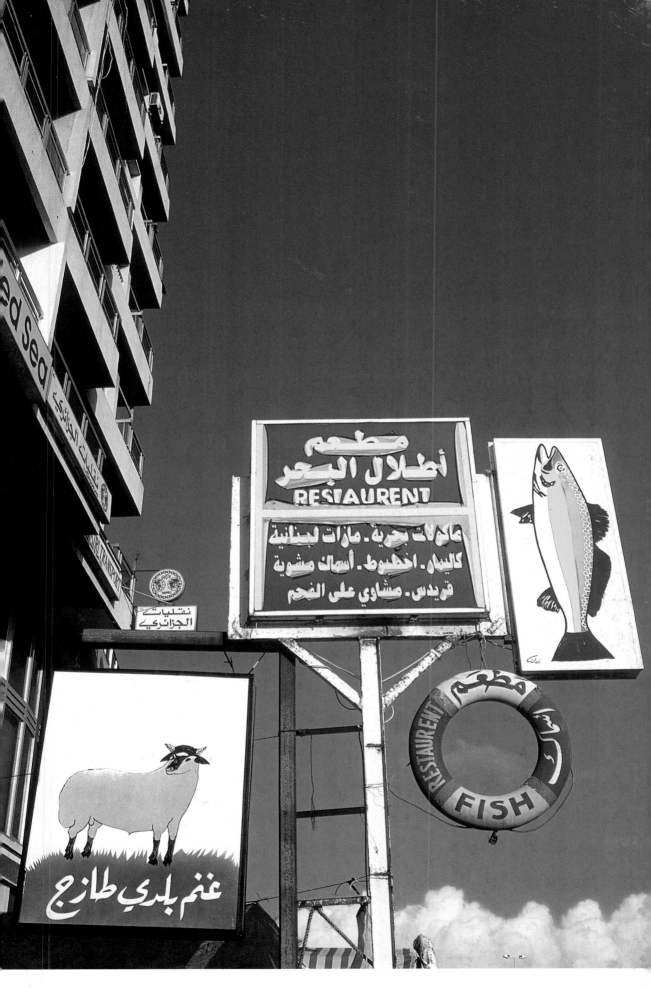

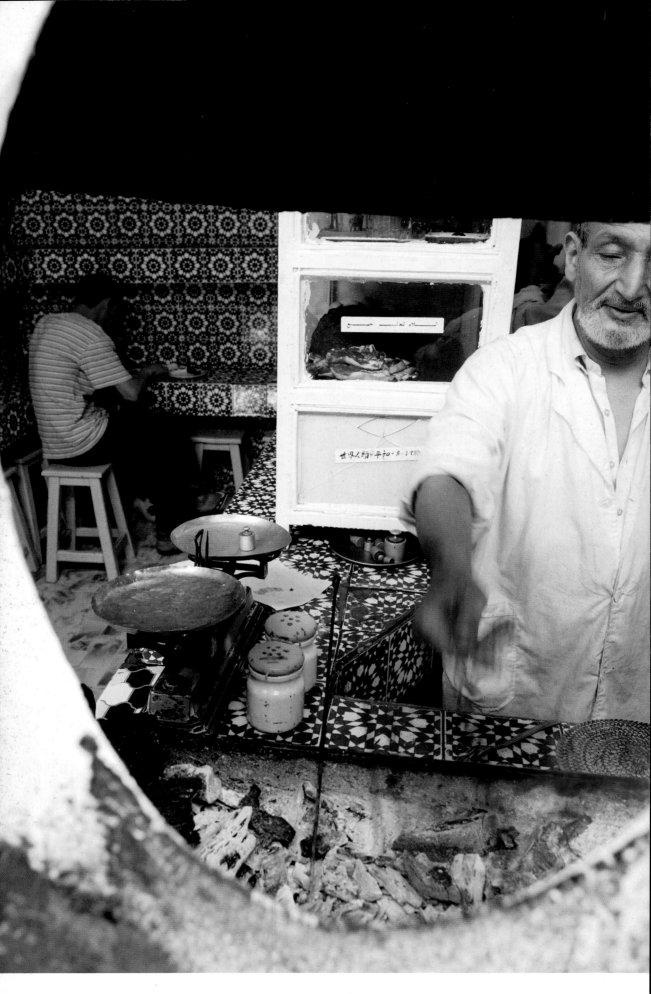

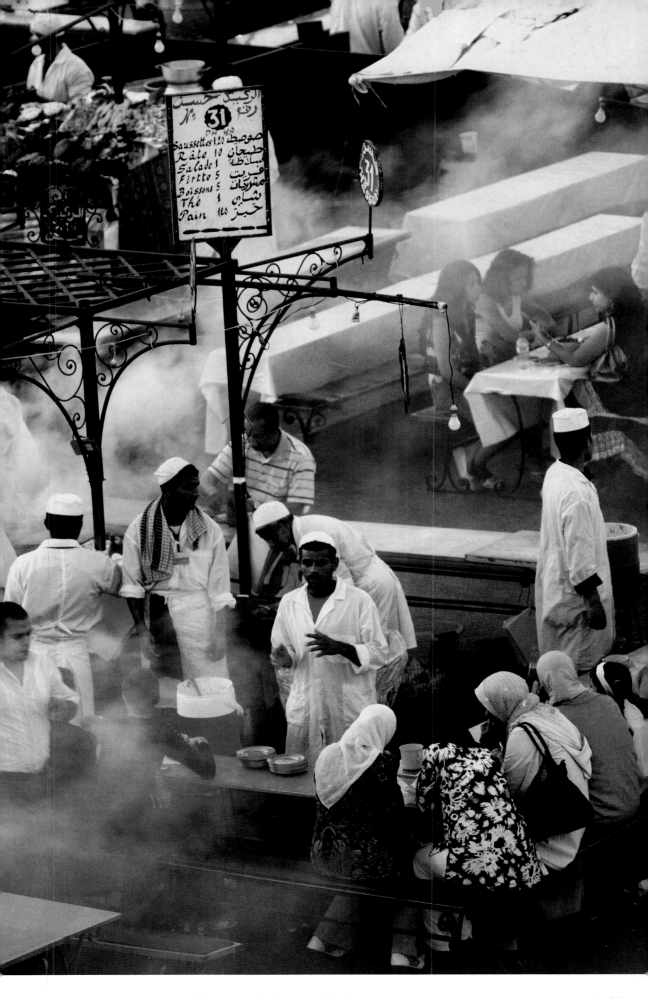

على الواقف حسن

Nº **31**

DH 45

Saussettes 120 صوصيط

Râte 10 طبخان

Salade 1 سلاطة

Fritte 5 قرية

Boissons 5 مشروبات

Thé 1 شاي

Pain 110 خبز

Marrakesh. In Djemaa el-Fna Square, the perfect meal consists of chickpeas, \ 99
roast goat head, and mint tea.

THAILAND. *NUOC MÂM,* A THAI HOT SAUCE, IS THE PERFECT ACCOMPANIMENT TO SHRIMP BROCHETTES.

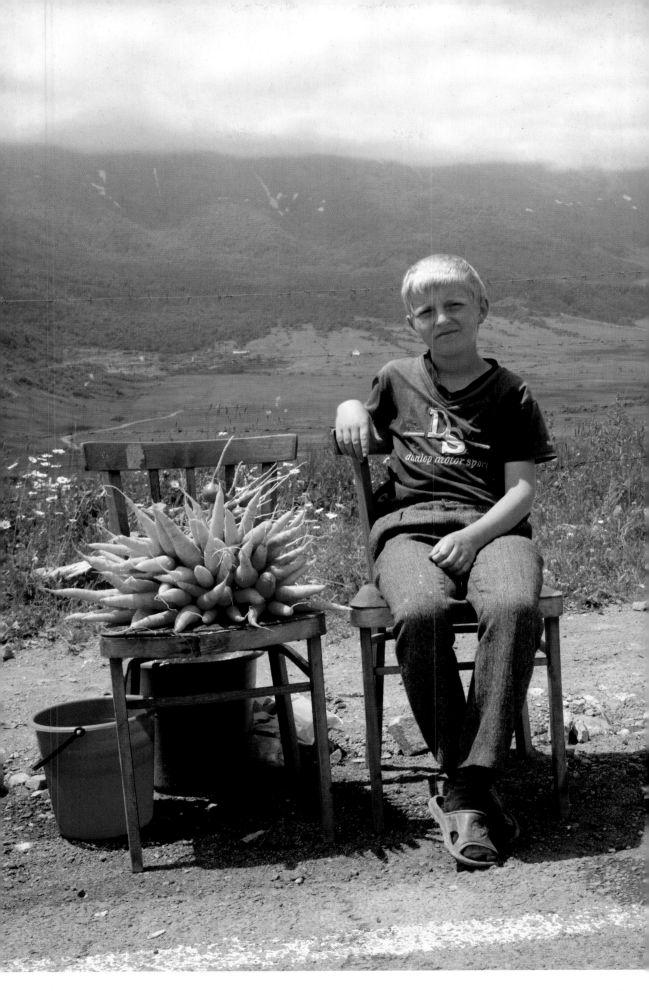

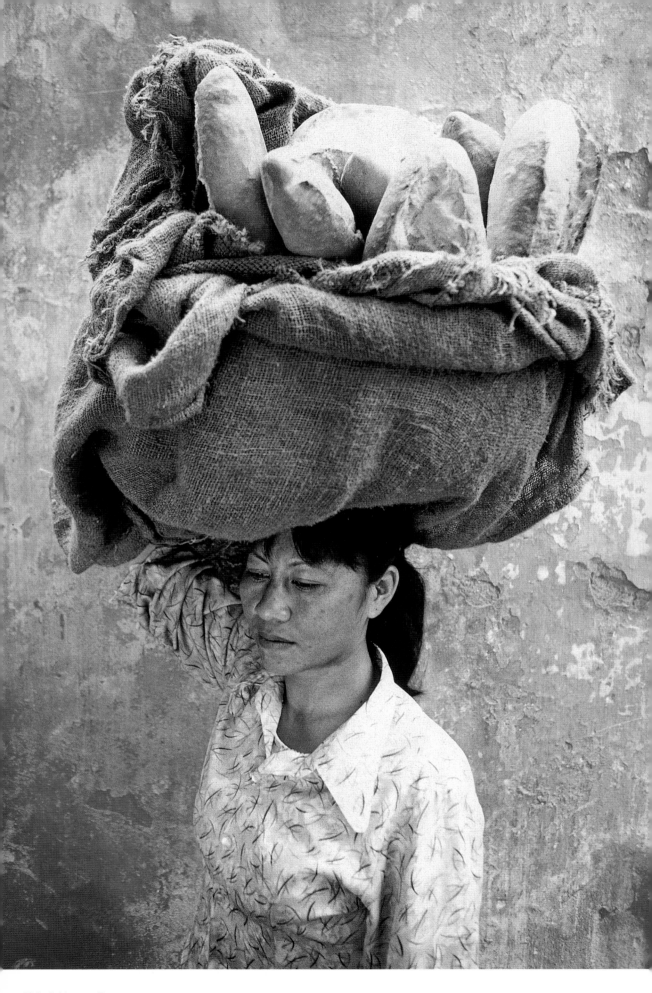

HANOI. THIS WOMAN SELLS HER ROLLS AND LOAVES IN THE STREETS.

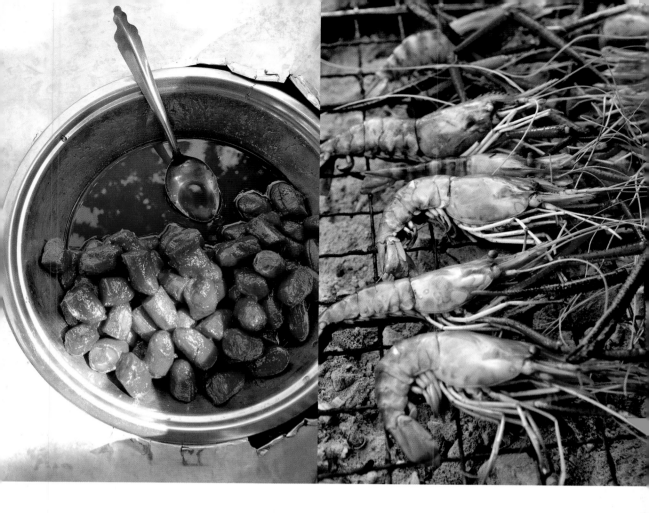

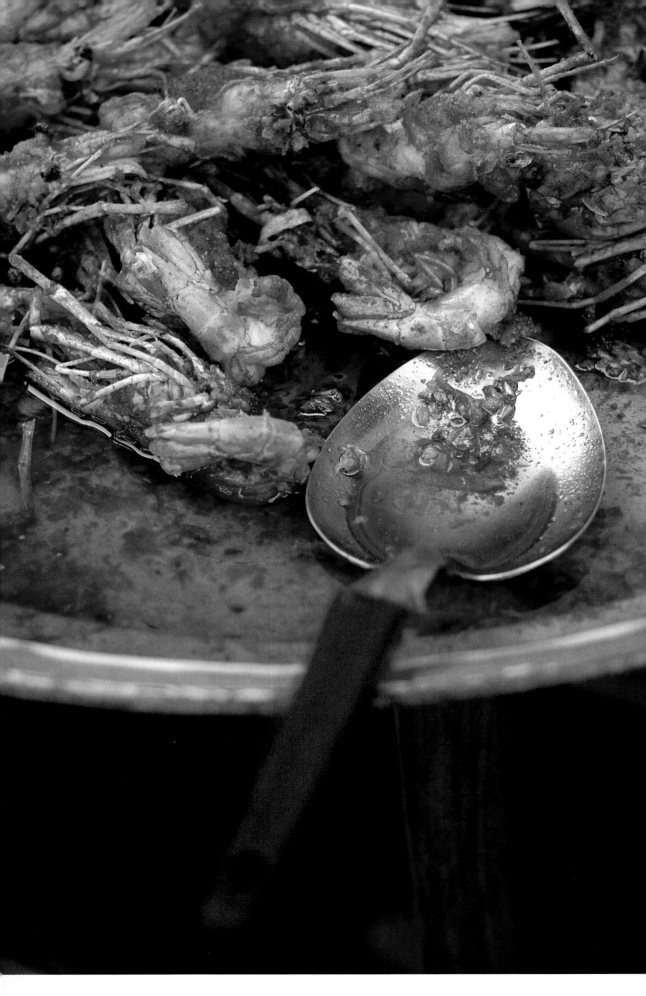

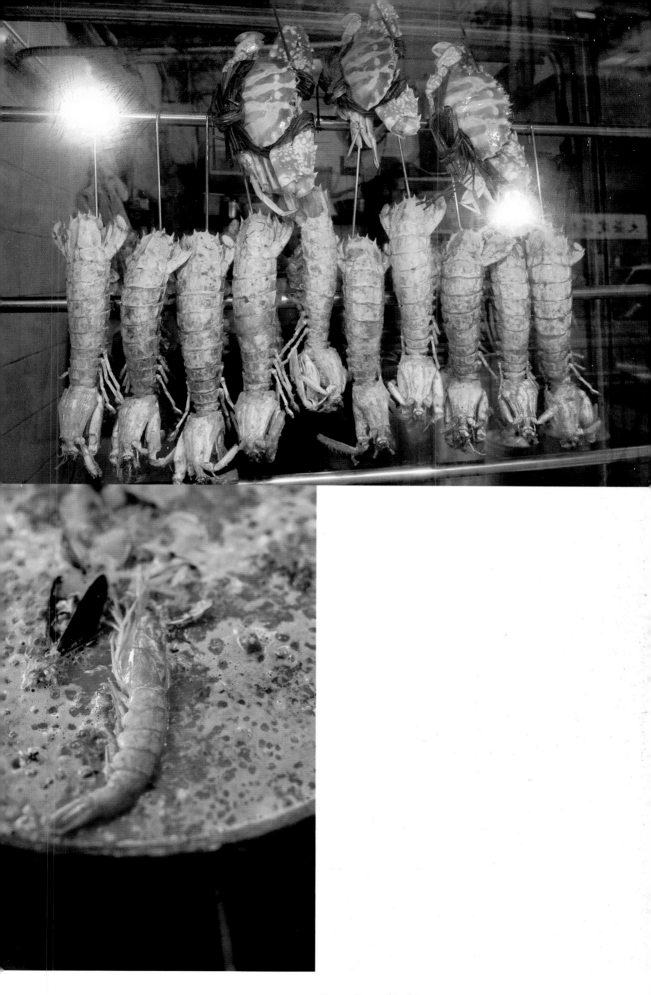

BARCELONA. (ABOVE) PAELLA FROM A GREASY SPOON NEAR THE BEACH.

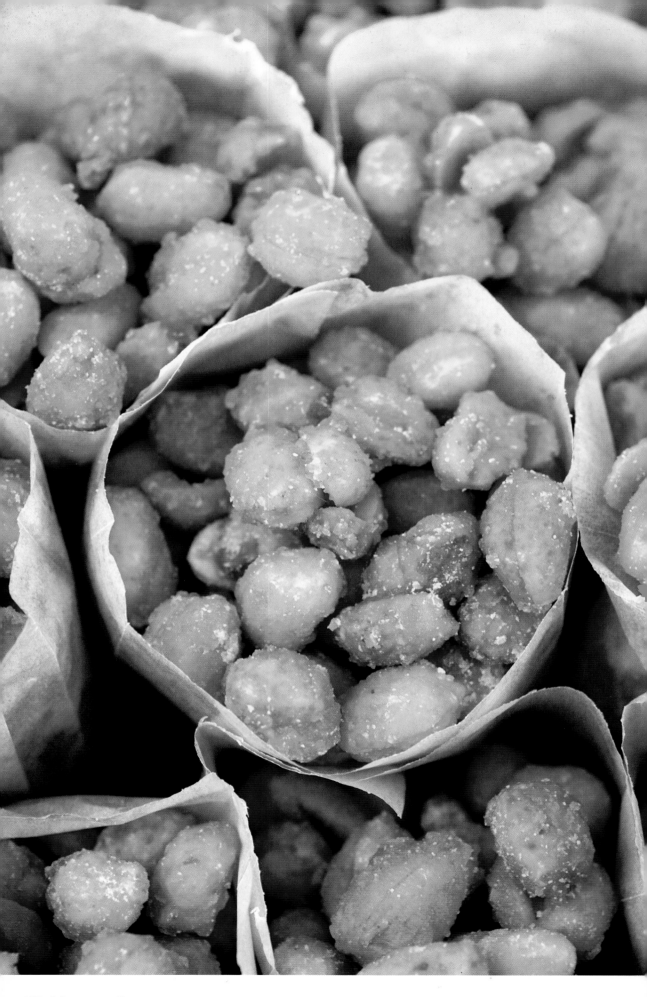

BROOKLYN. BAGS OF *CHOU-CHOU*, SUGAR-COATED PEANUTS AND OTHER NUTS.

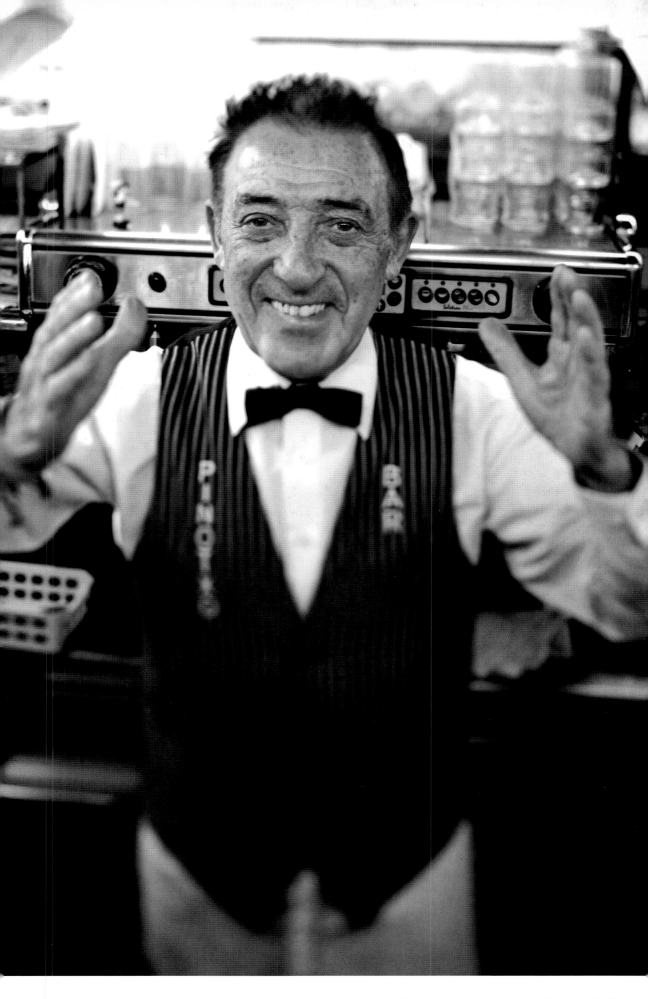

The owner serves fresh-squeezed orange juice at any time of day or night.

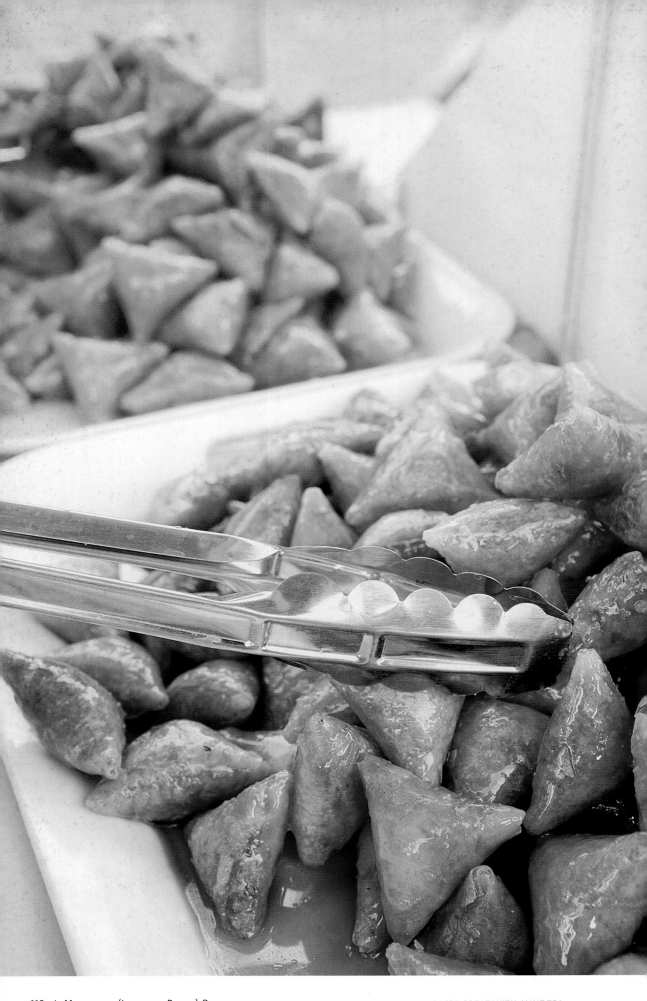

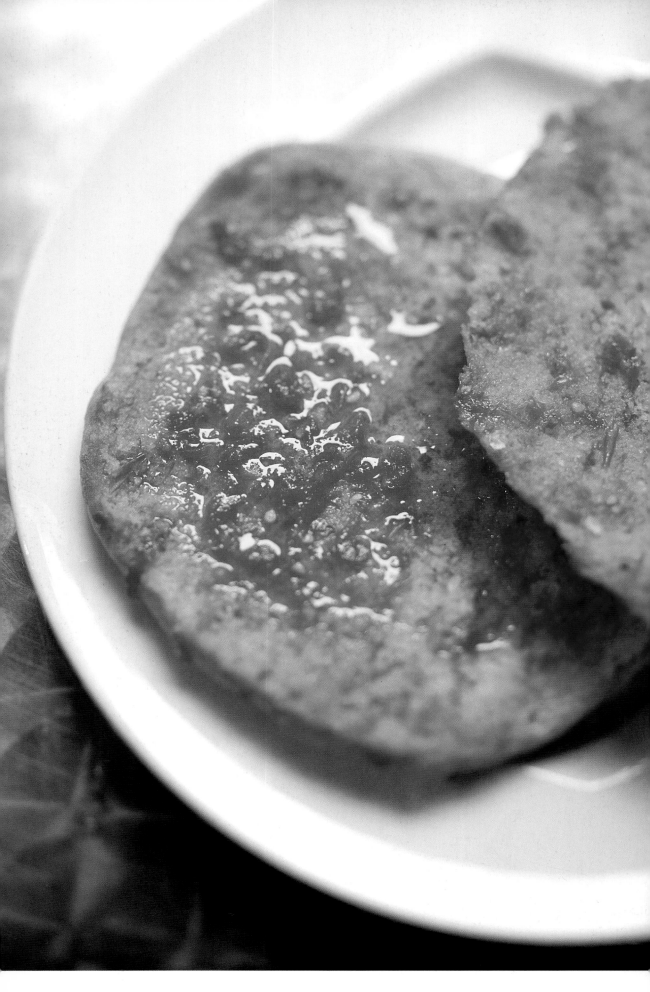

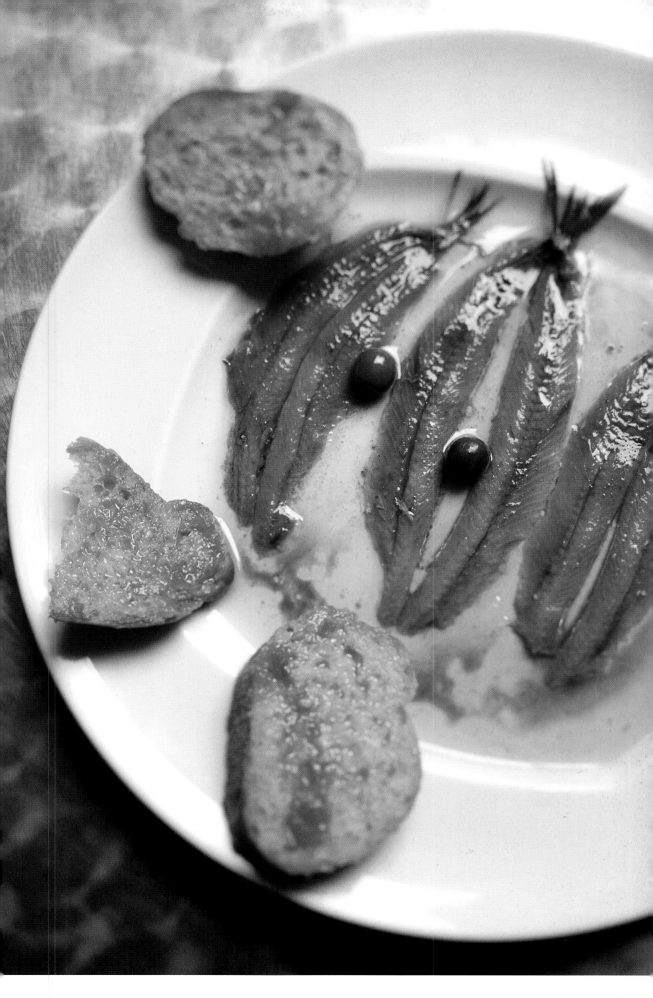

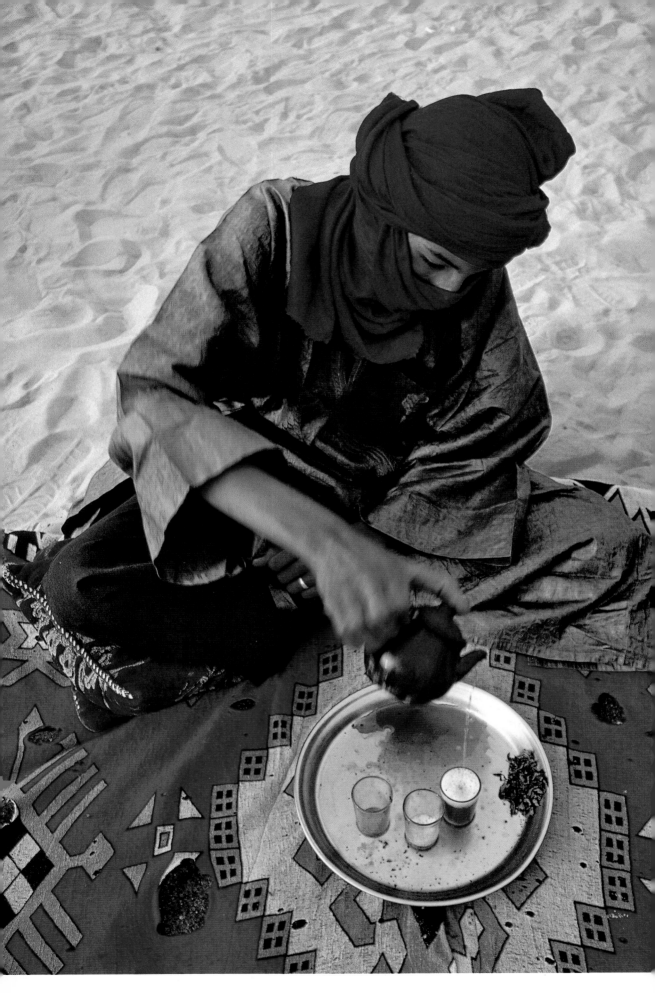

116 / **MALI.** THE TUAREGS PREPARE STRONG MINT TEA IN THE DESERT NEAR TIMBUKTU.

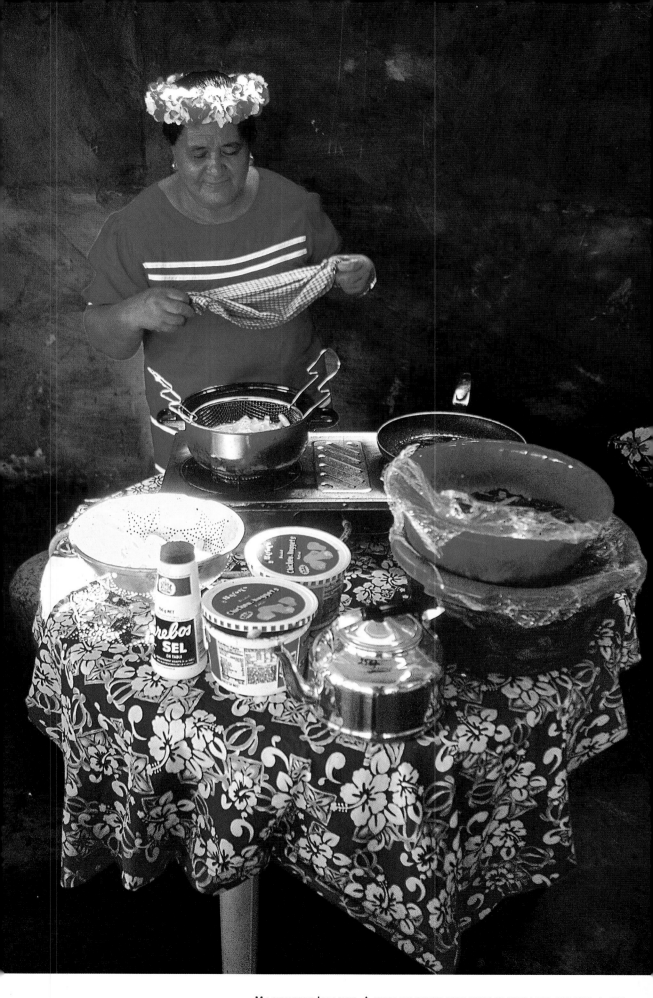

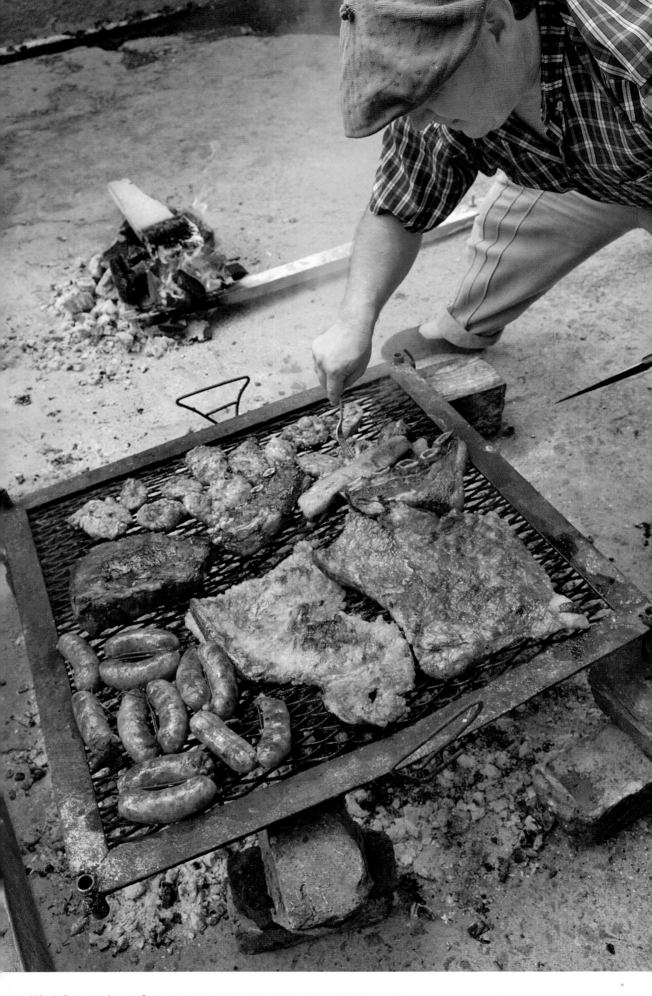

BUENOS AIRES. GAUCHOS GRILL MEAT AT THE WEEKLY LIVESTOCK MARKET.

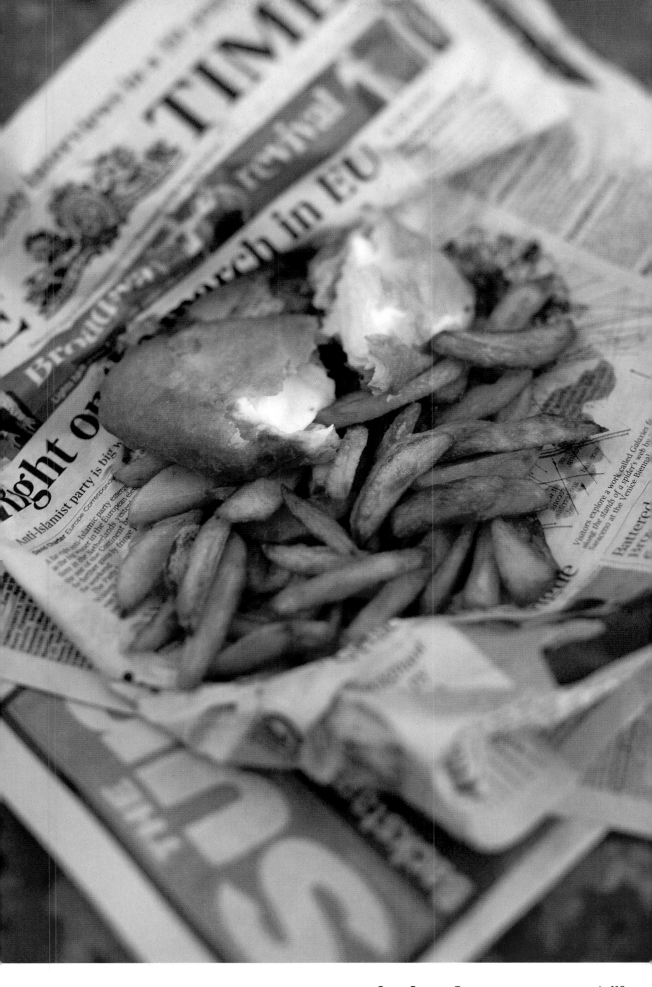

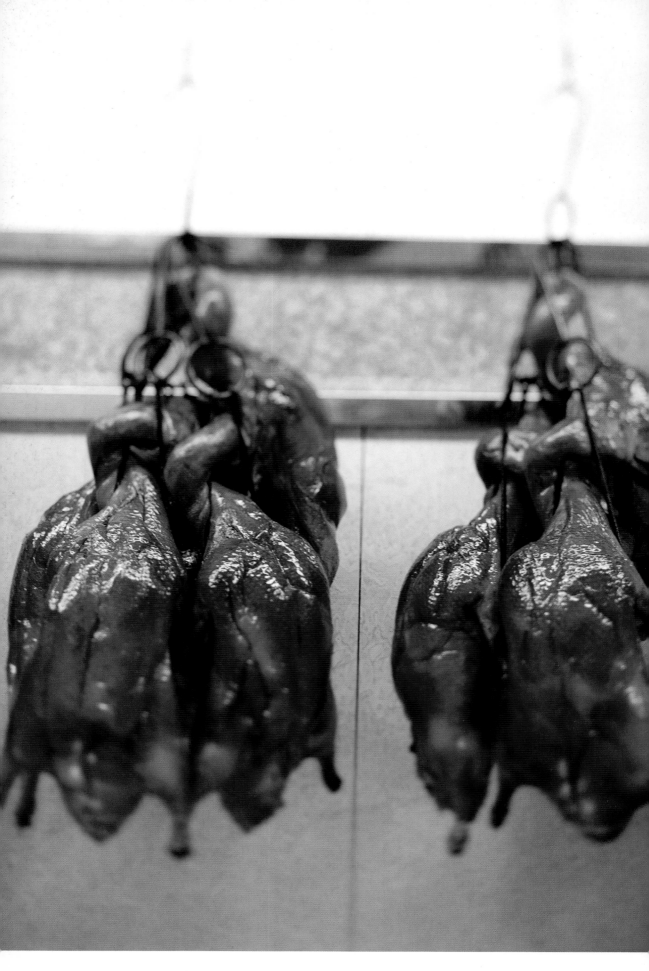

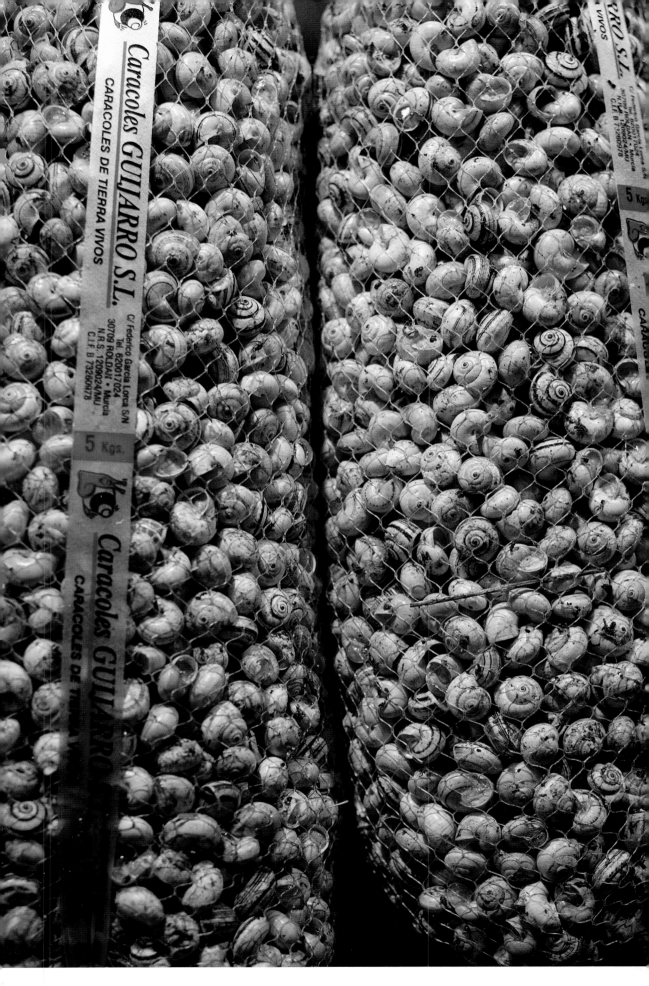

Caracoles GUIJARRO S.L.
CARACOLES DE TIERRA VIVOS

C/ Federico García Lorca S/N
30709 ROLDAN · Murcia
Tel. 62001/024
N.R.S. 1209024/MU
C.I.F. B 73260478

5 Kgs.

Caracoles GUIJARRO
CARACOLES DE TIERRA

5 Kgs.

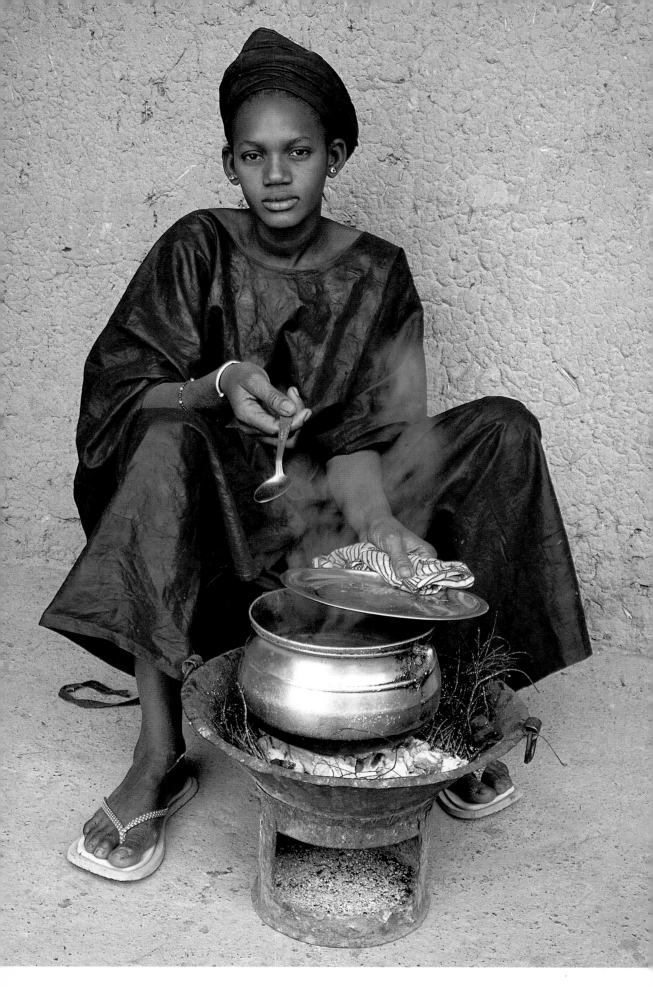

122 / **MALI.** (LEFT) DJENEBA TRAORÉ COOKS NILE PERCH IN TION-TION SAUCE.
HERE, (RIGHT) TWO VIEWS OF THE PREPARATION OF THIS DELICIOUS FISH.

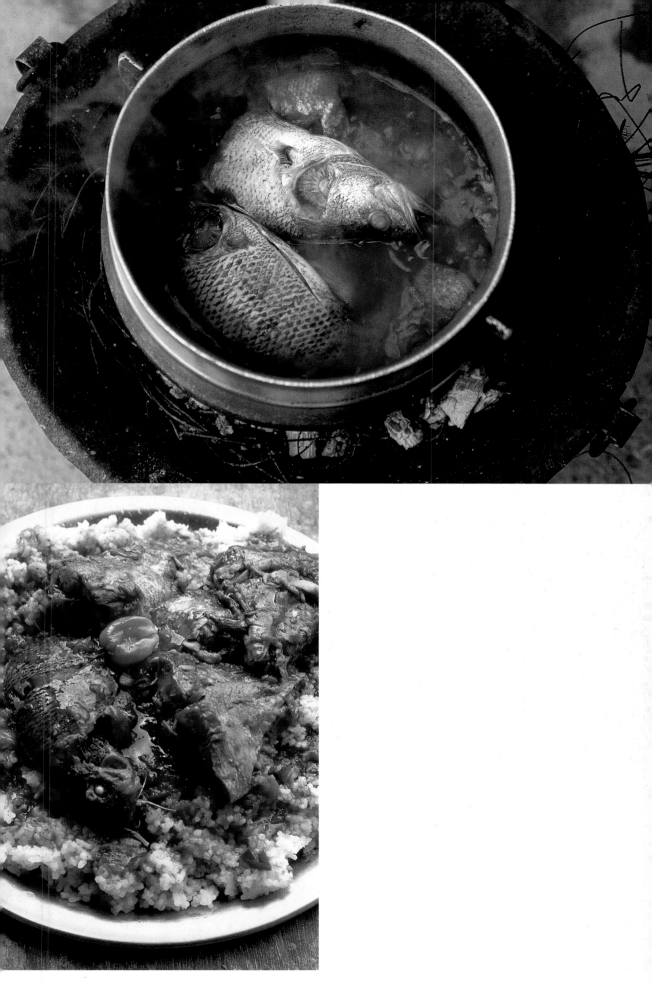

124 / **TOKYO.** CARAMELIZED TUNA SERVED WITH SOY SAUCE AND SESAME.

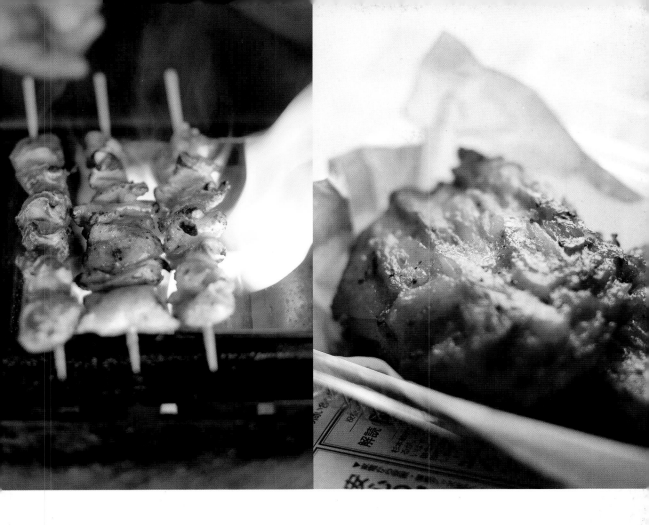

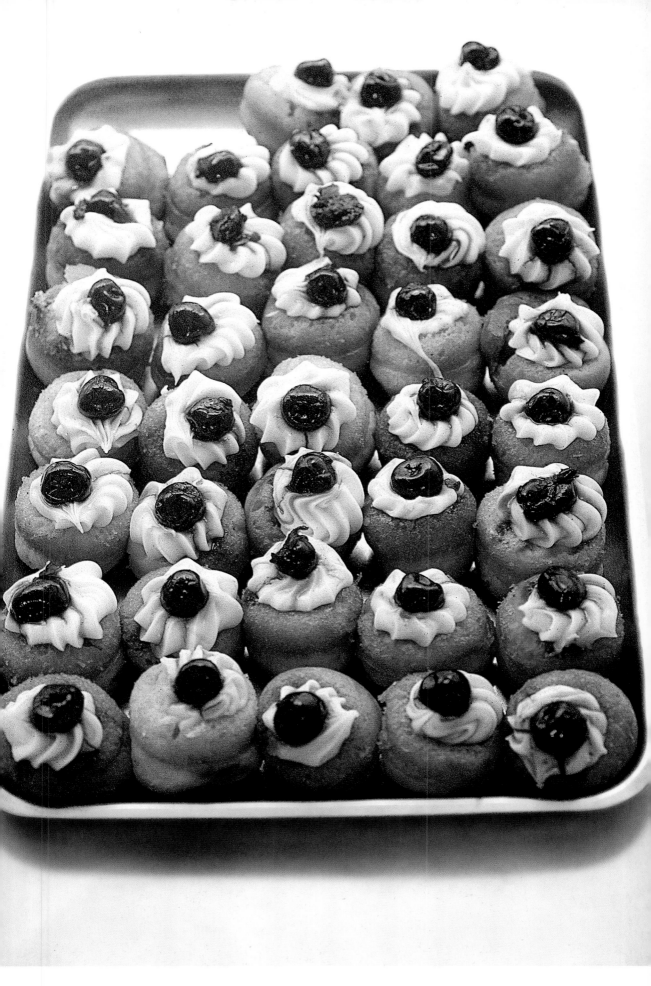

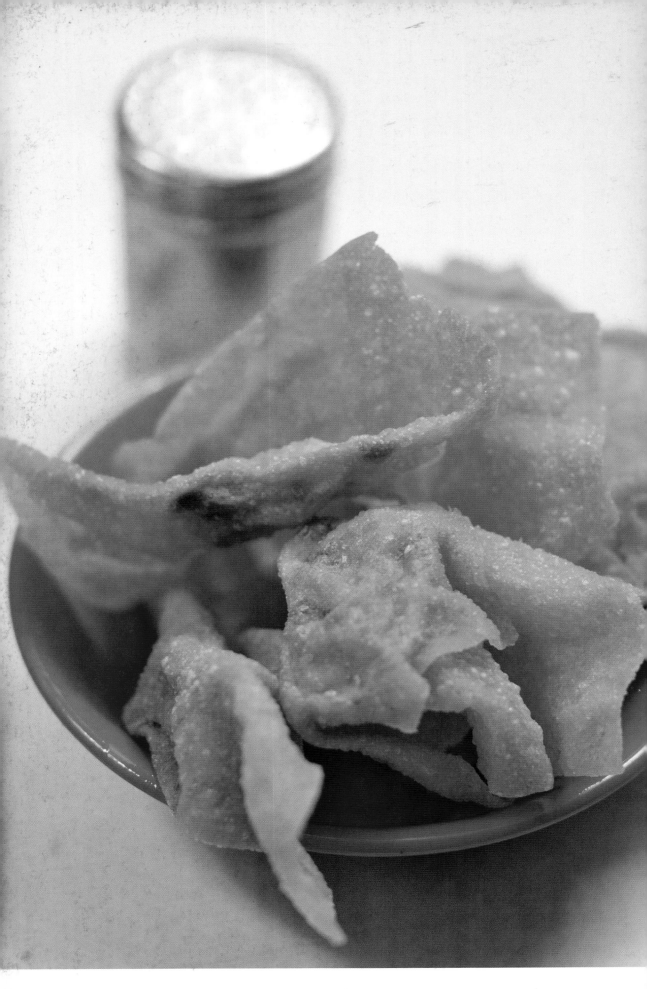

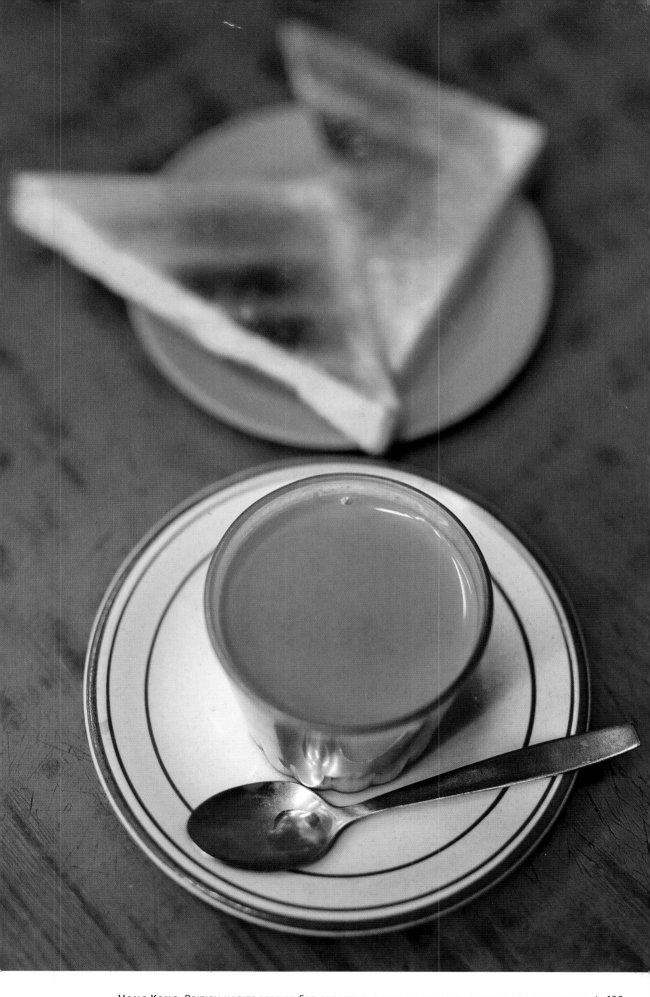

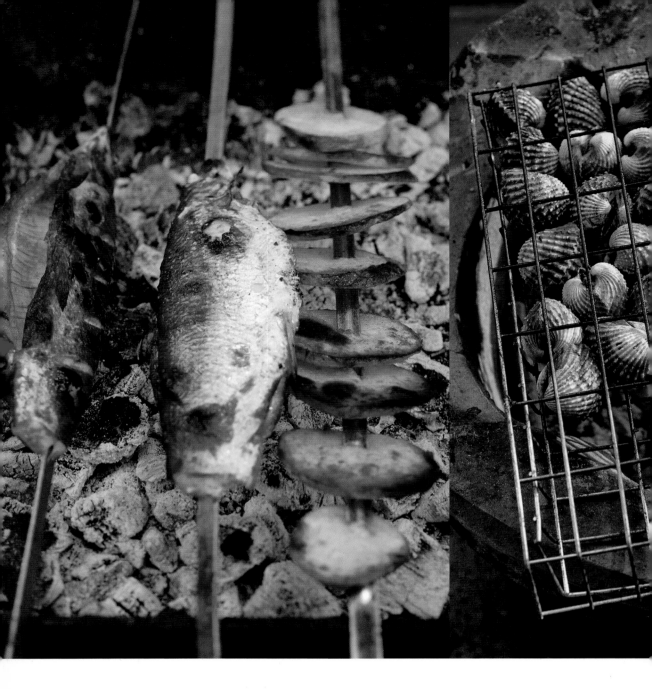

130 / **ARMENIA.** (LEFT) FISH FROM LAKE SEVAN AND SLICED POTATOES ON THE BARBECUE.
BANGKOK. (CENTER) COCKLES COOKED ON A WOOD FIRE.

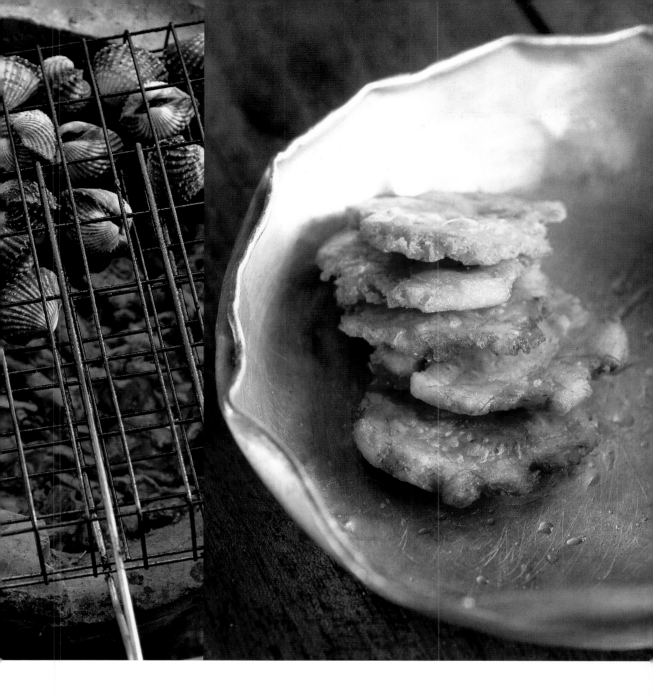

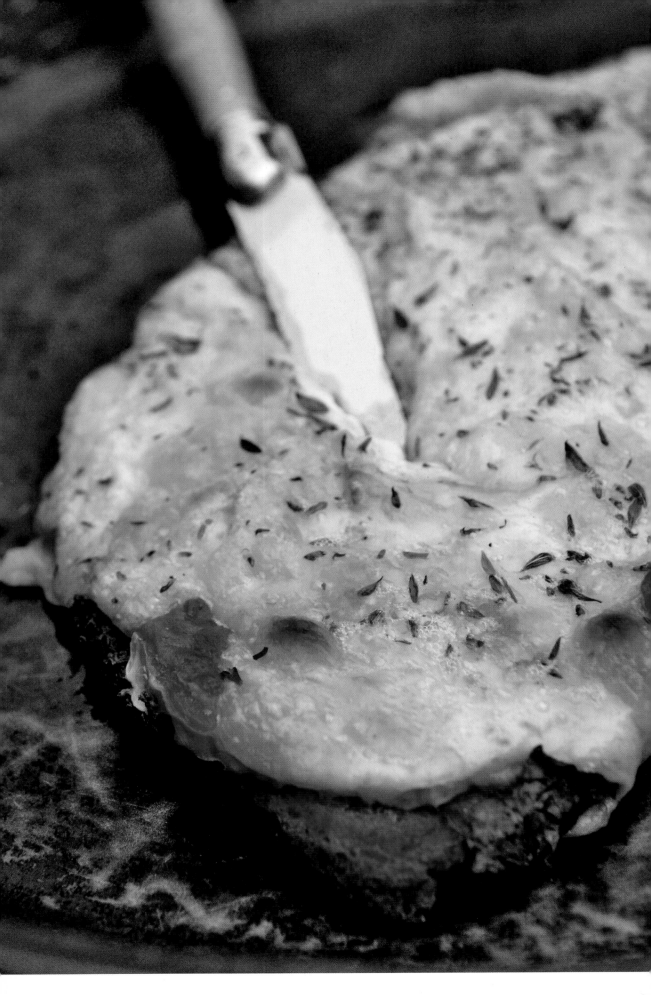

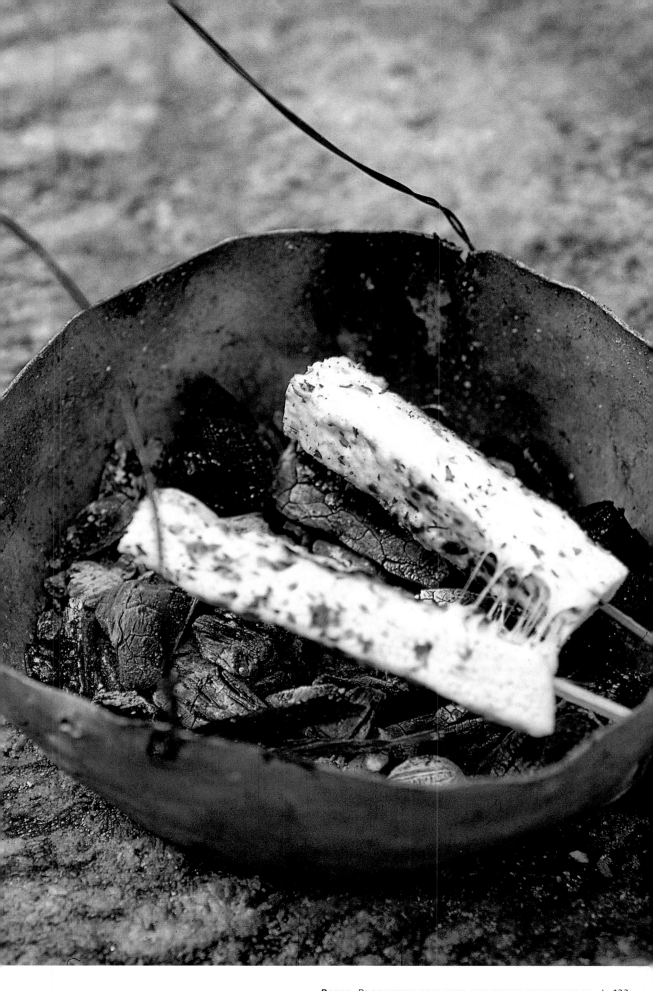

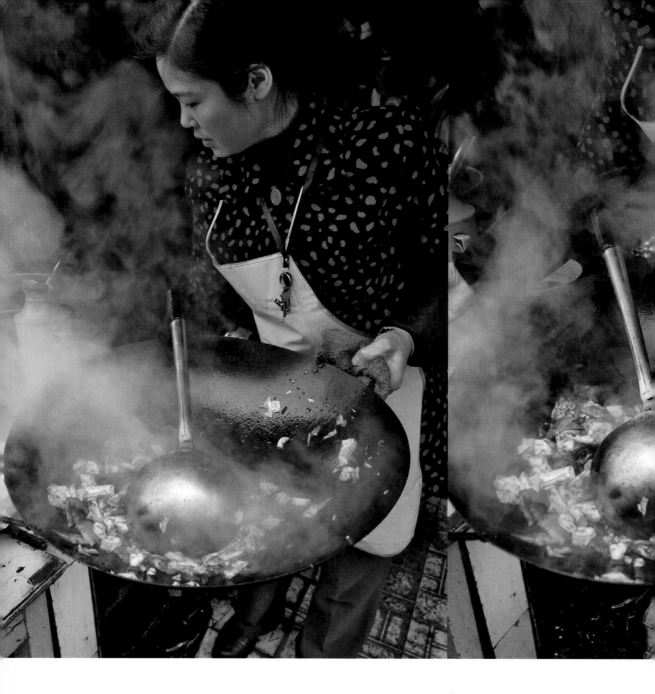

SHANGHAI. THE ART OF WOK COOKING IS PRACTICED IN THE STREET. HERE, CABBAGE AND MINCED PORK WITH SOY SAUCE.

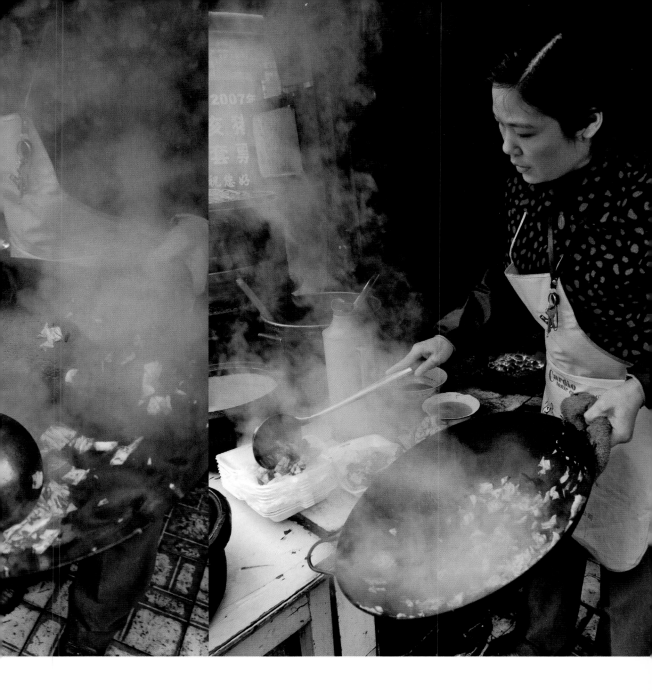

136 / **Barcelona.** (Left) Paella prepared at the seaside.

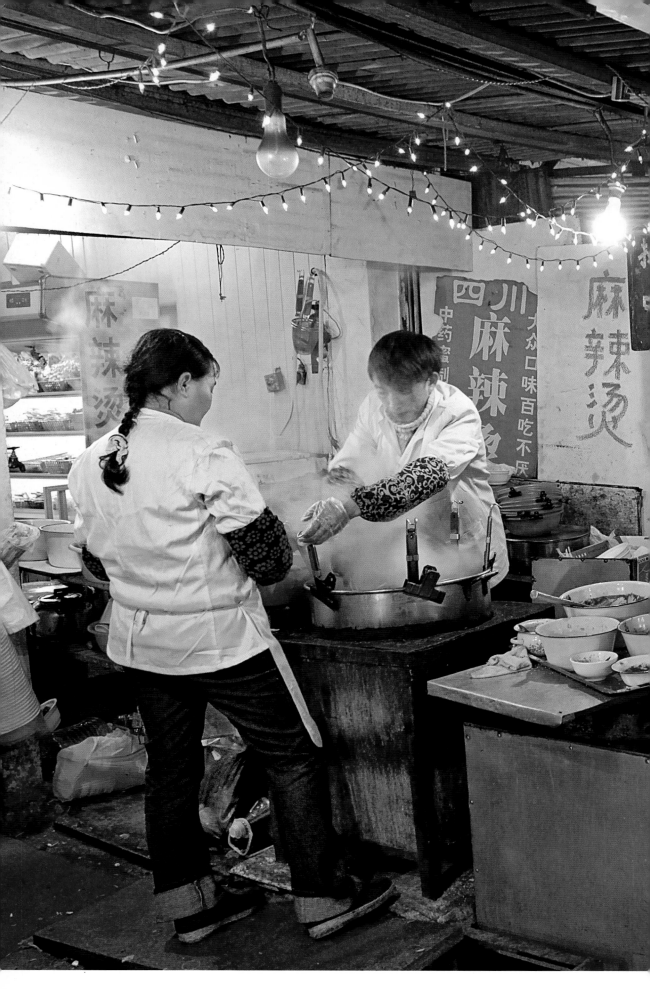

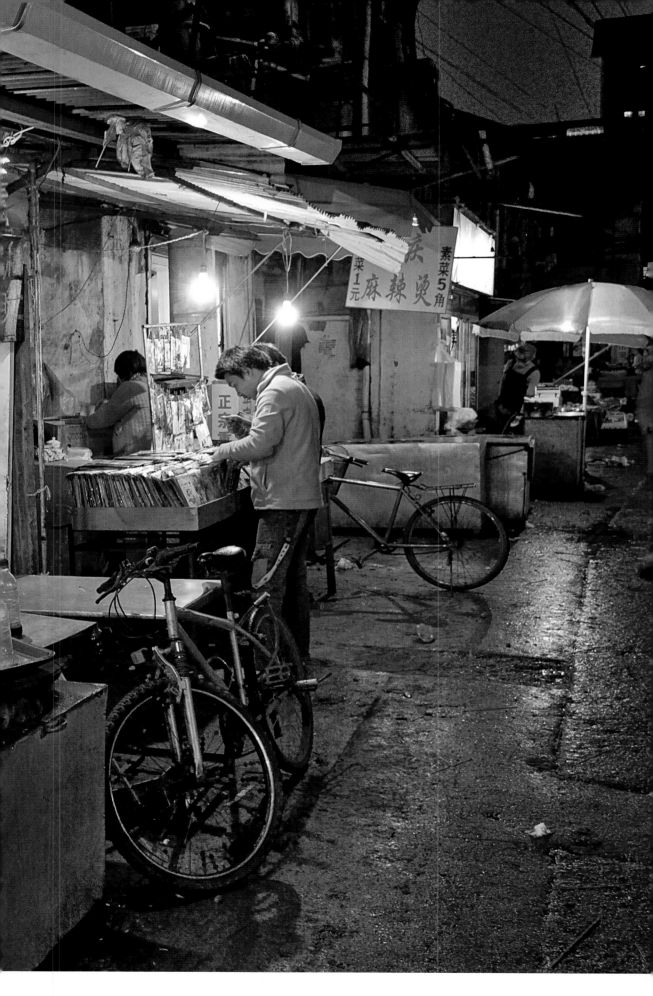

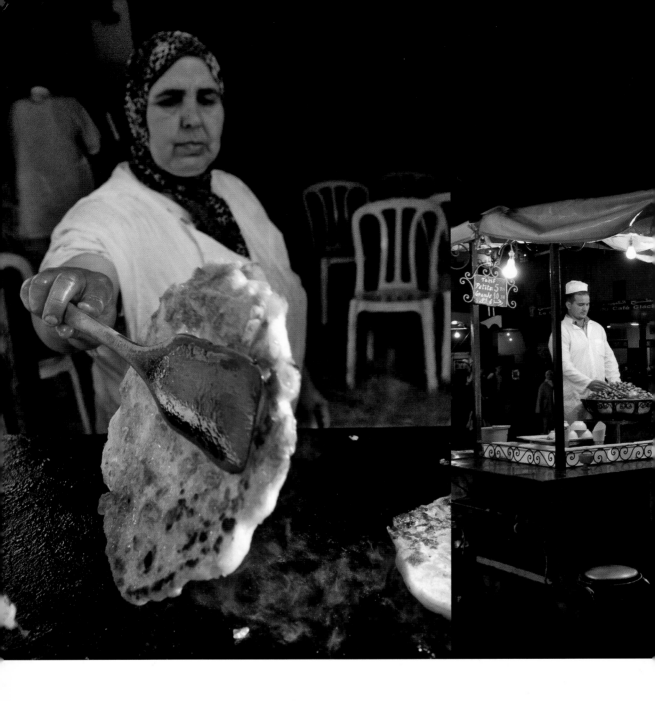

140 / **MARRAKESH.** PANCAKE (LEFT) AND SNAIL (CENTER) VENDORS IN THE MEDINA.

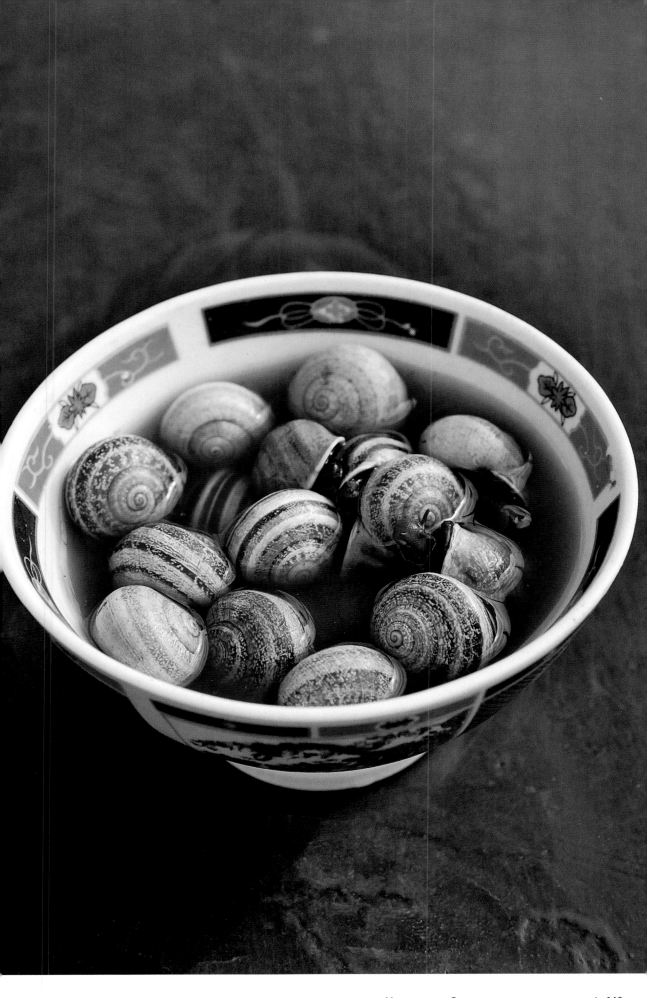

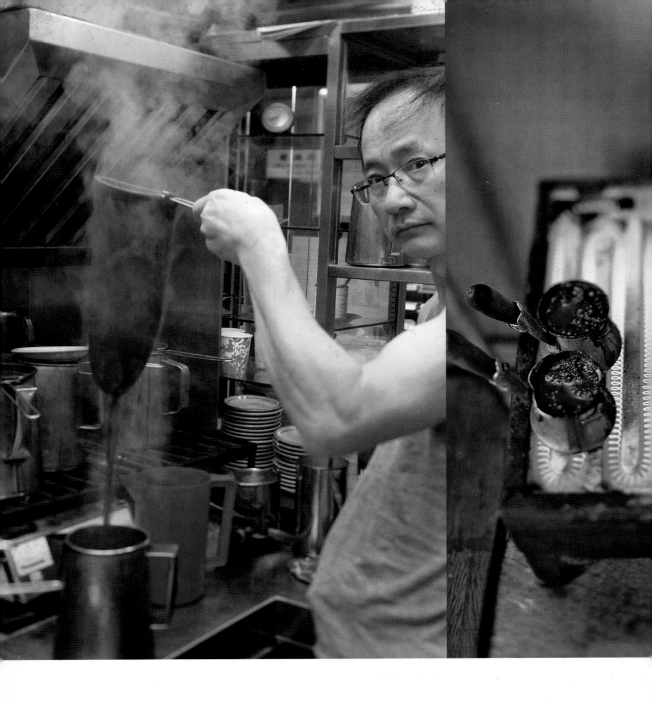

144 / **HONG KONG.** (LEFT) ENGLISH-STYLE TEA, SERVED ON THE STREET.
ARMENIA. (CENTER) COFFEE BREWED IN THE CENTRAL MARKET OF YEREVAN.

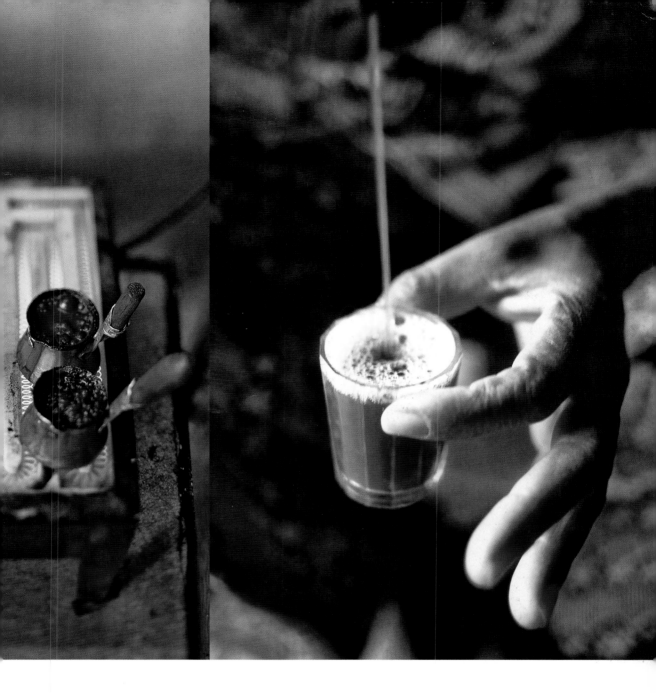

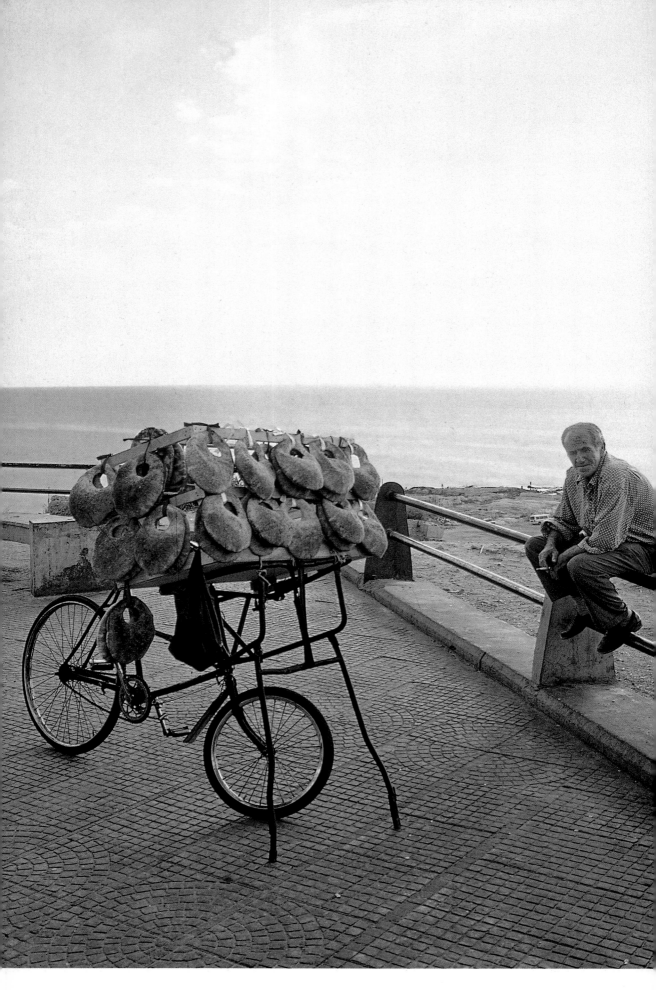

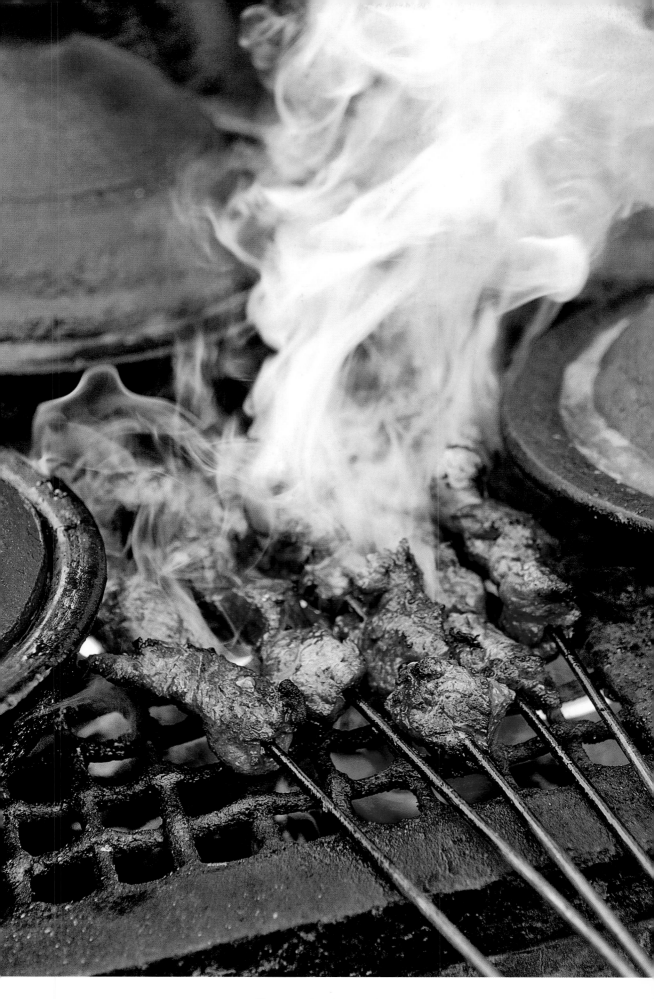

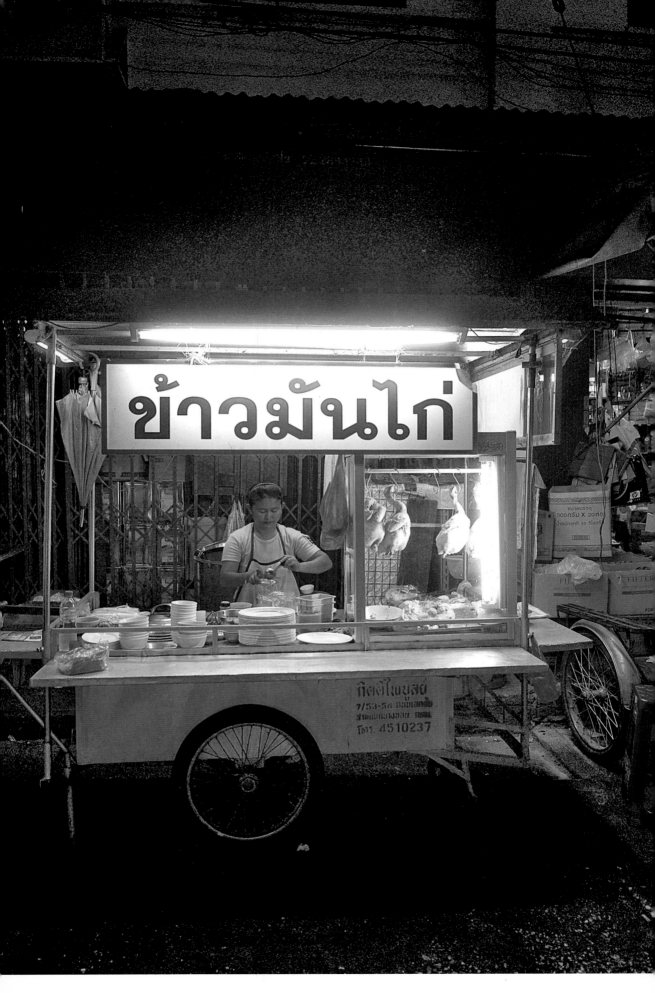

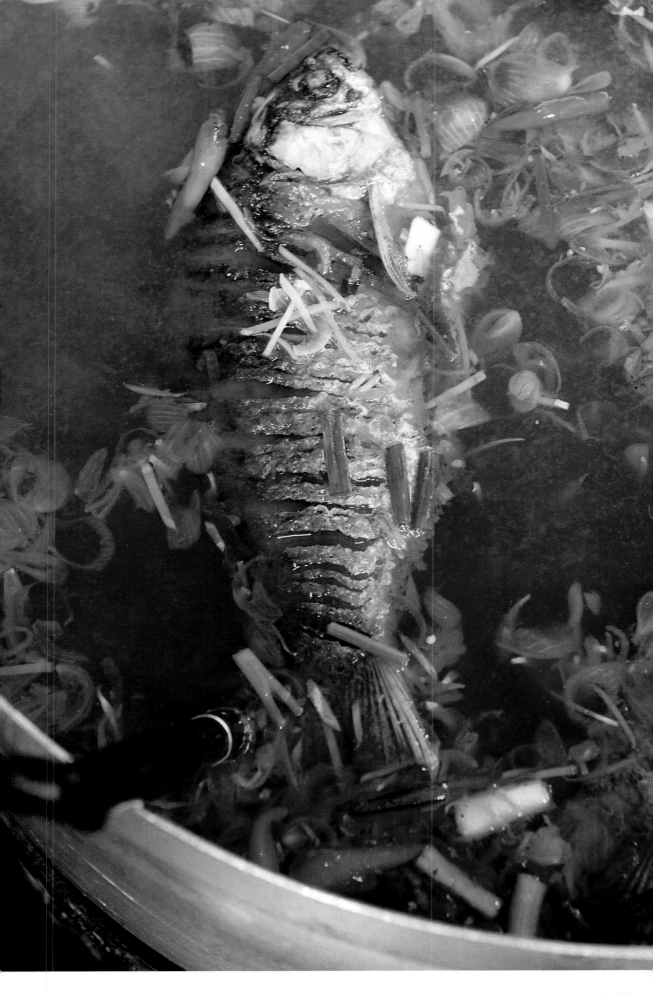

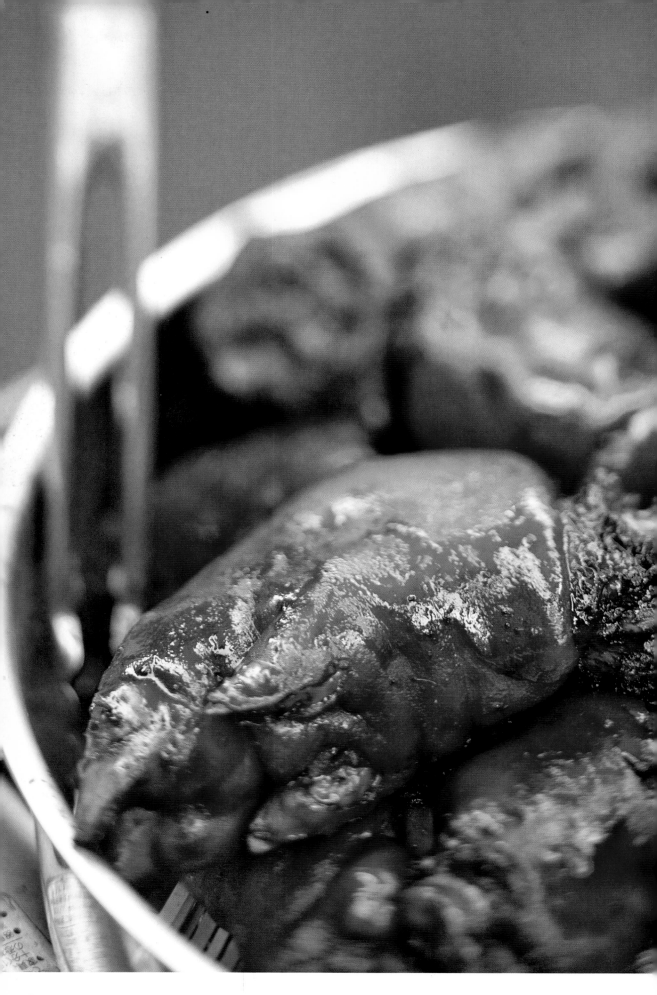

150 / **TOKYO.** GLAZED PIGS' FEET FOR SALE.

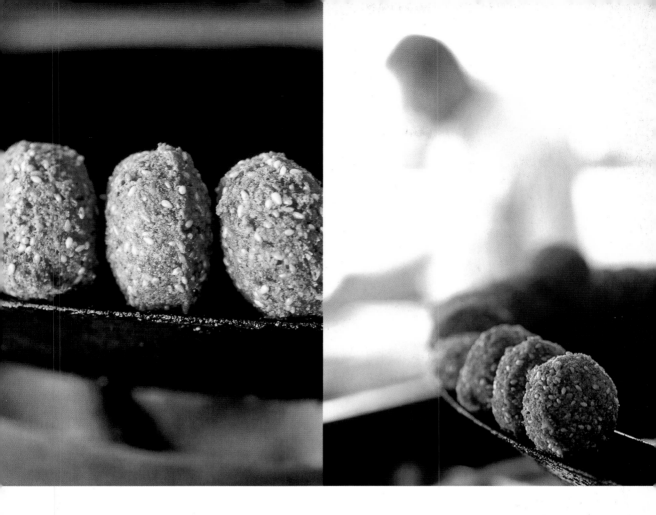

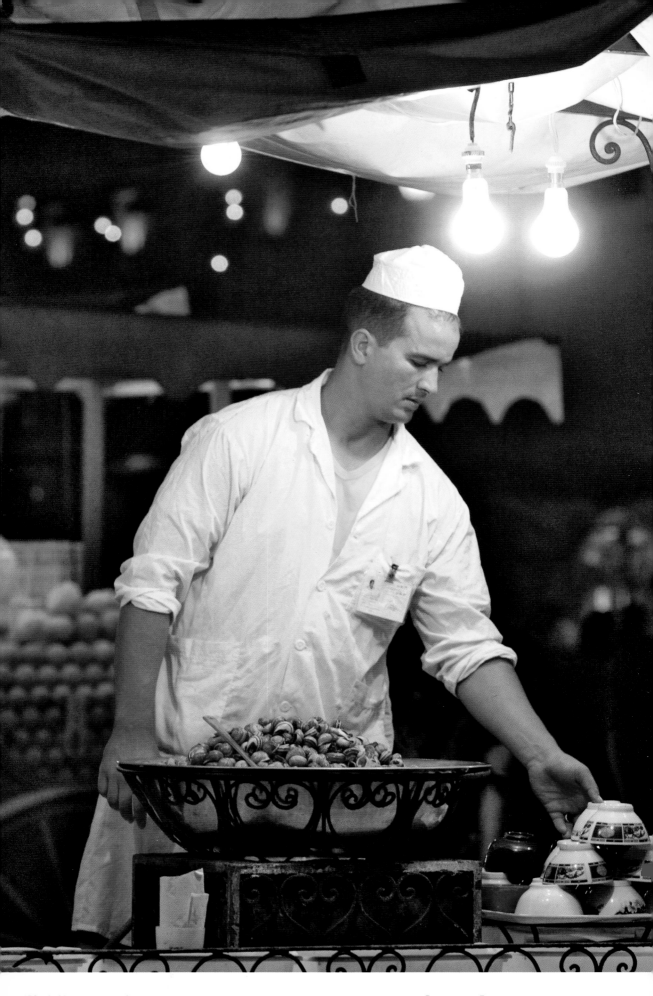

MARRAKESH. A SPECIALIST IN THE SEASONING AND COOKING OF SNAILS AT THE DJEMAA EL-FNA MARKET.

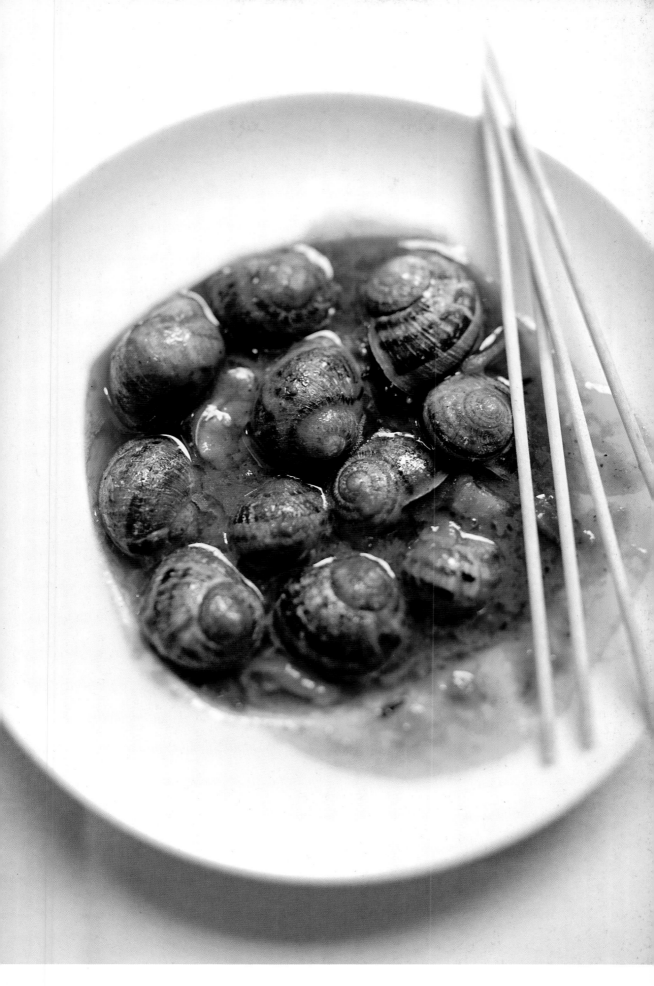

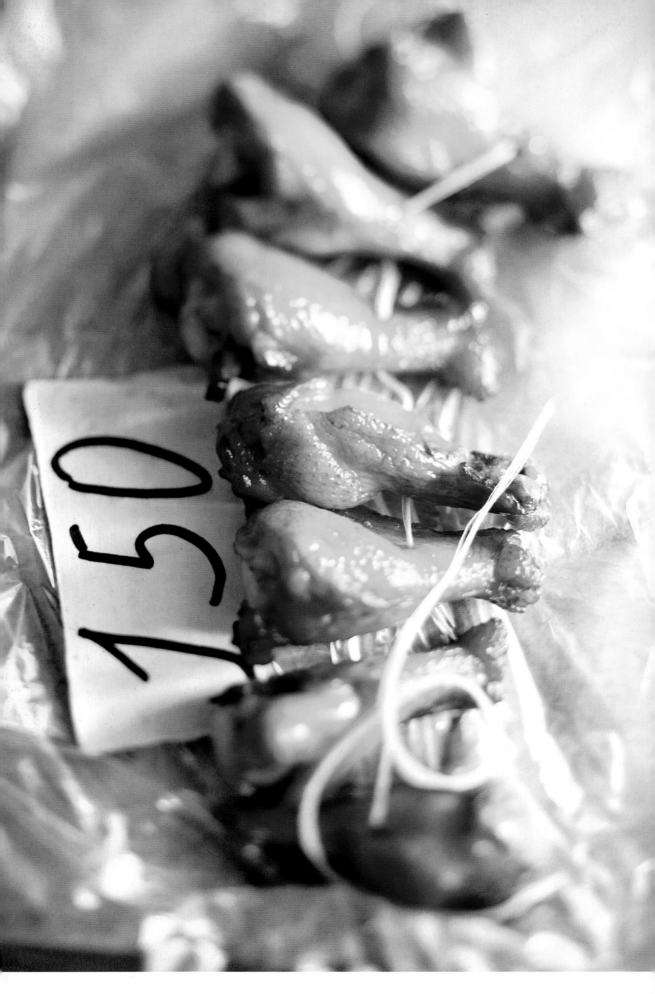

ARMENIA. BY THE SHORES OF LAKE SEVAN, CHICKEN COOKED IN THE SMOKEHOUSES WHERE FISH ARE PROCESSED.

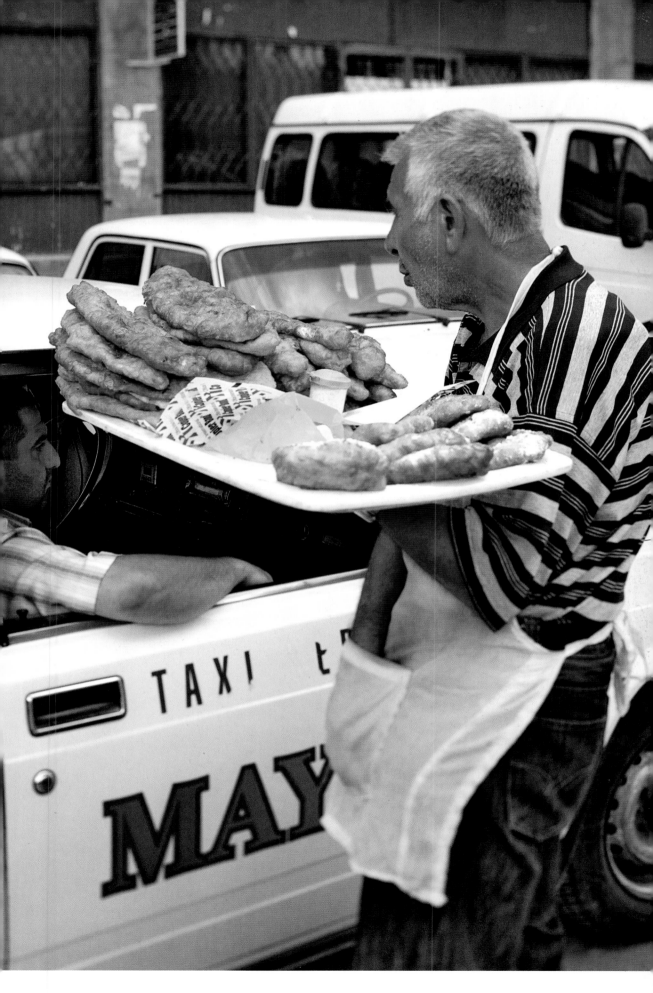

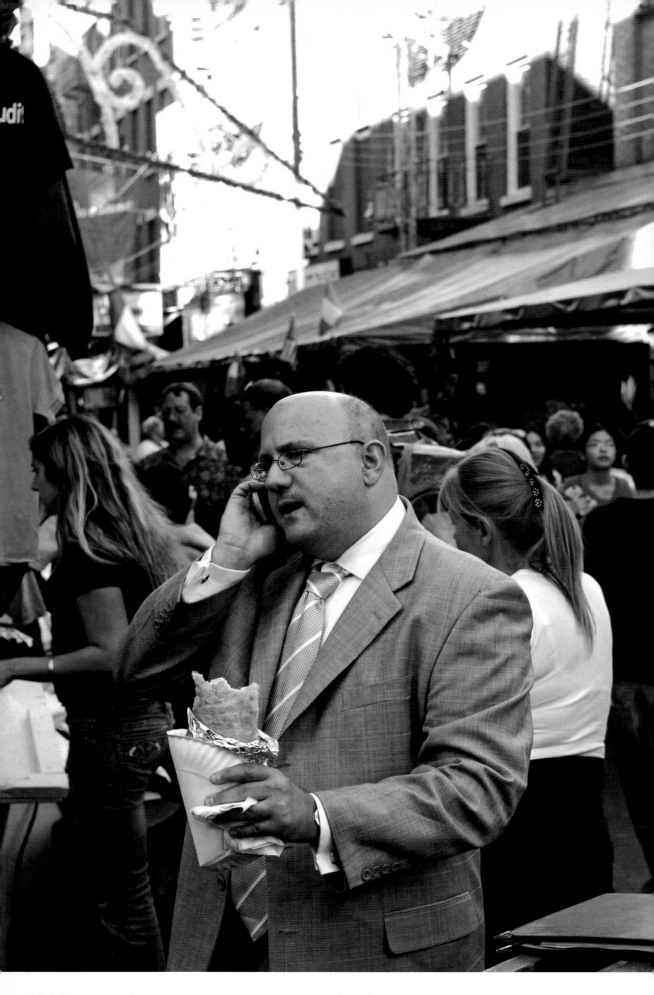

MANHATTAN. A BUSINESSMAN GRABS A HOT SANDWICH IN LITTLE ITALY.

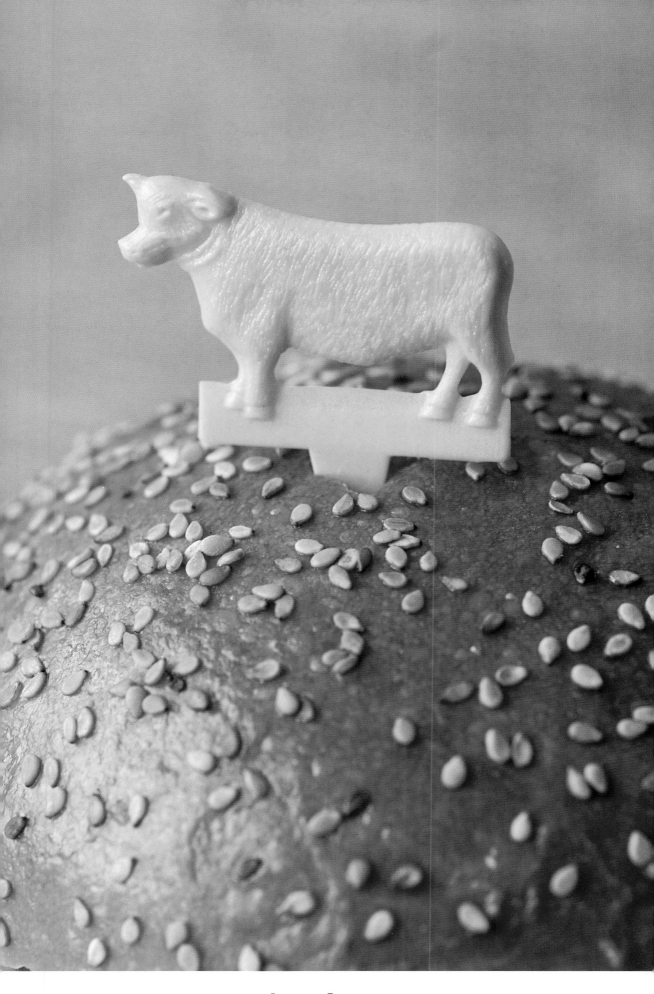

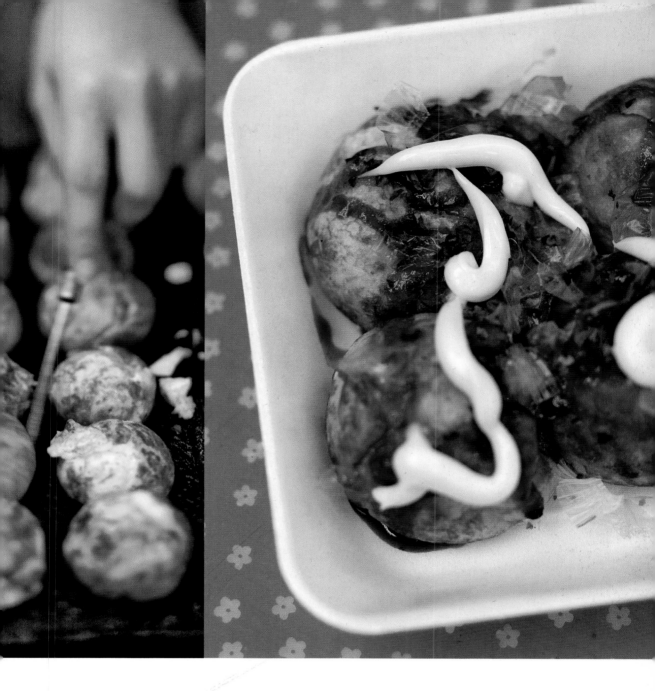

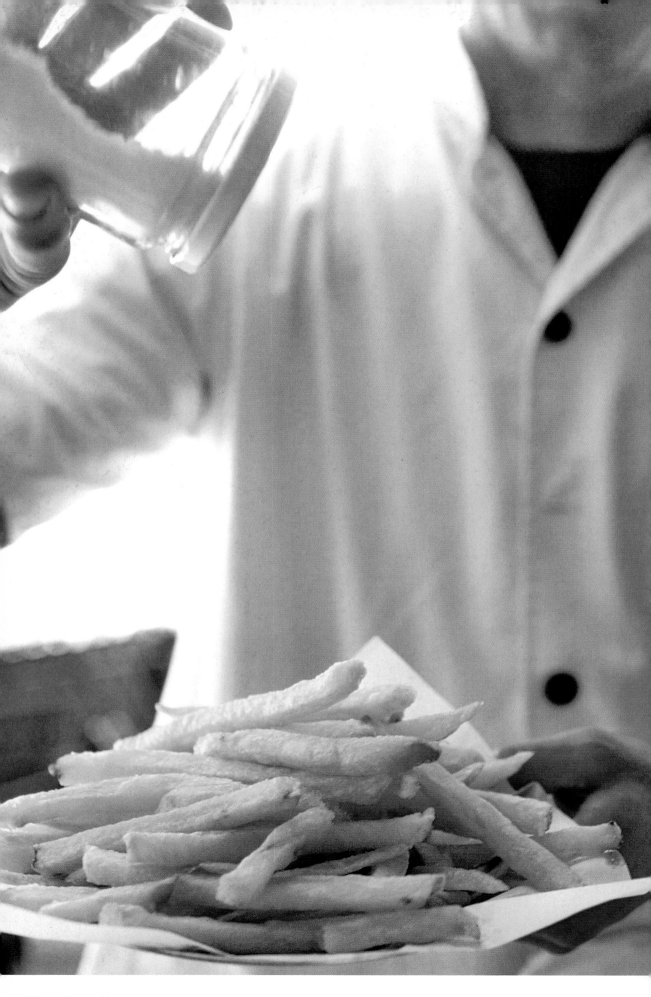

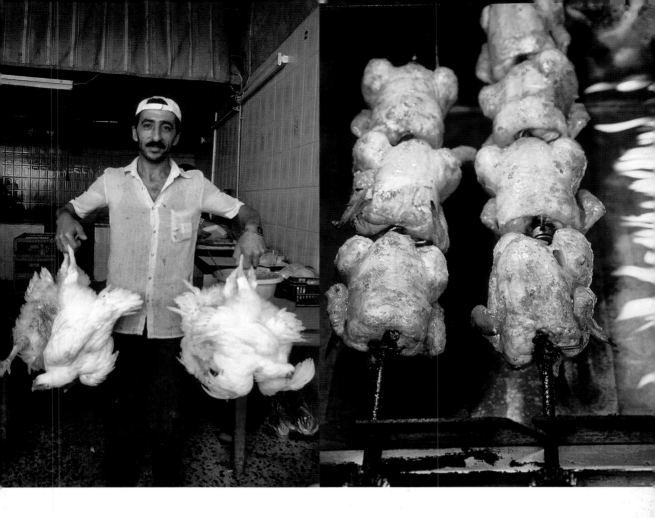

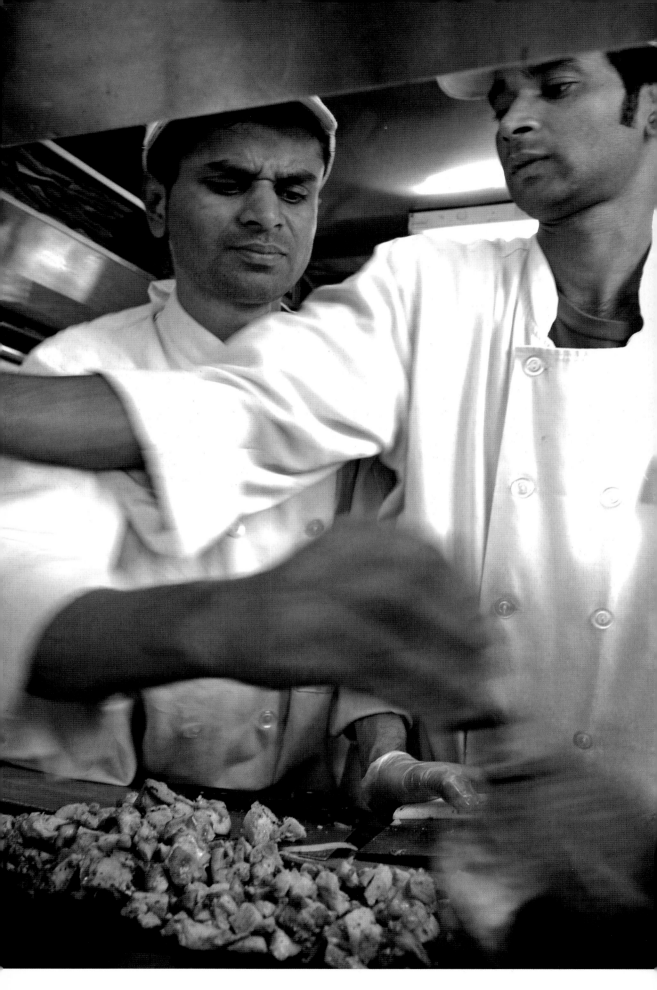

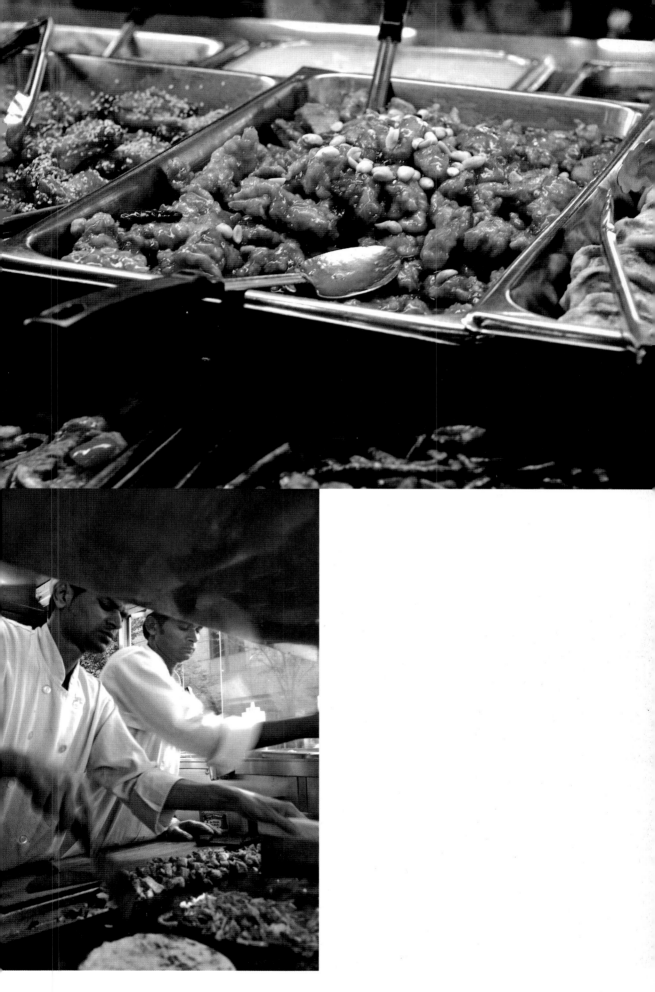

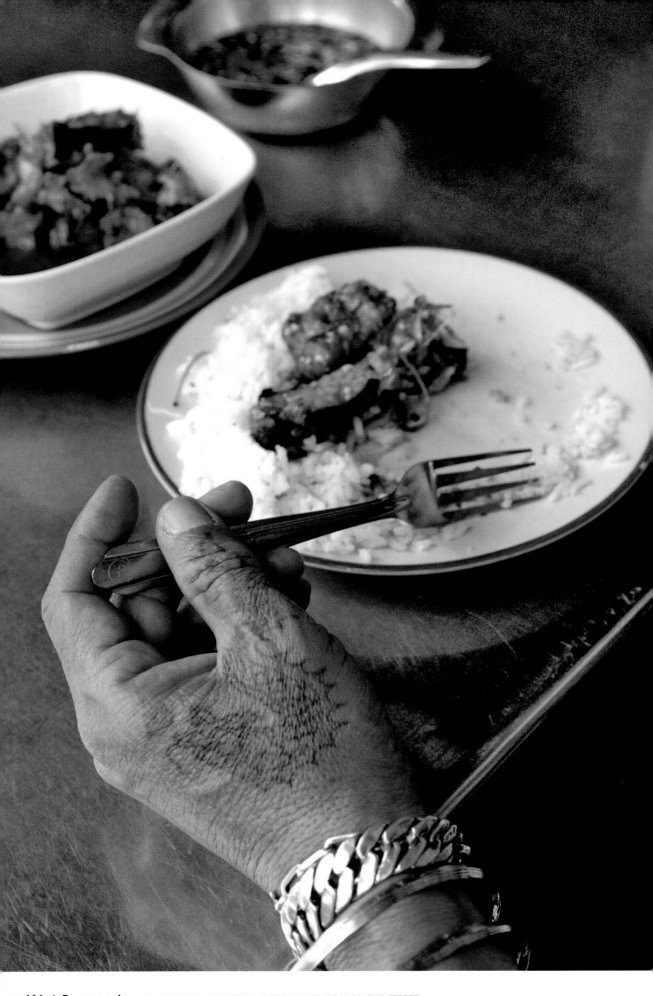

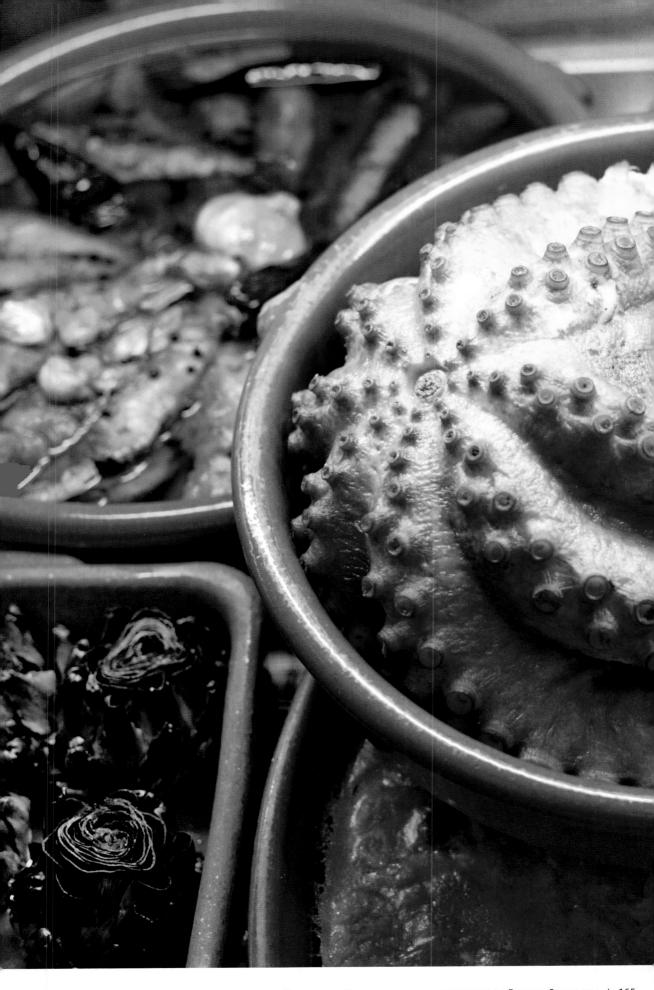

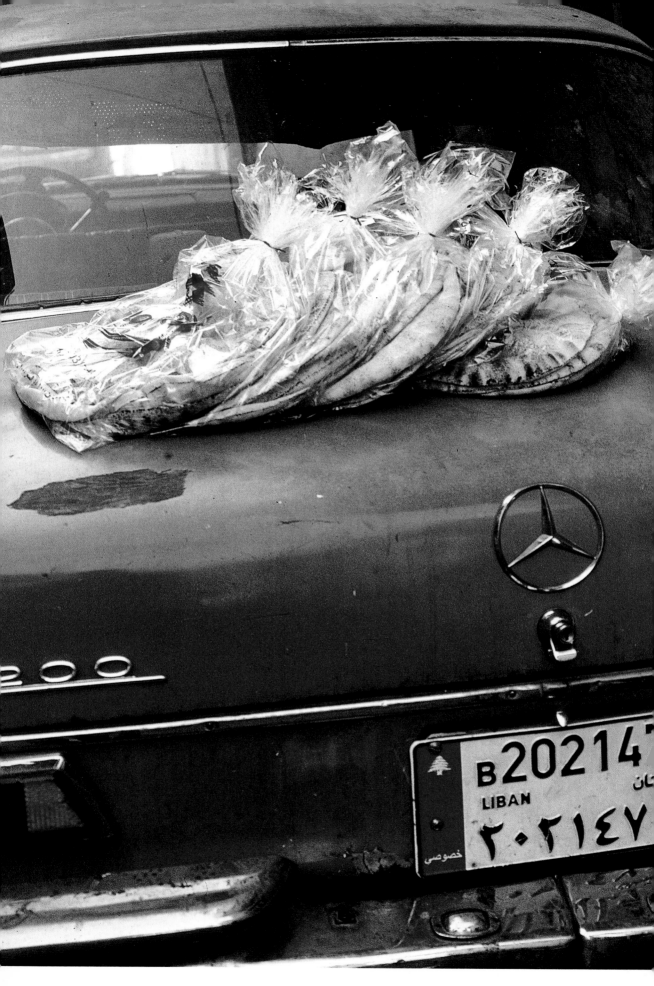

166 / **BEIRUT.** IN THE ARMENIAN QUARTER, BREAD IS LINED UP ON THE TRUNK OF A MERCEDES.
HEATED AND GARNISHED, IT SERVES AS A TAKE-OUT MEAL.

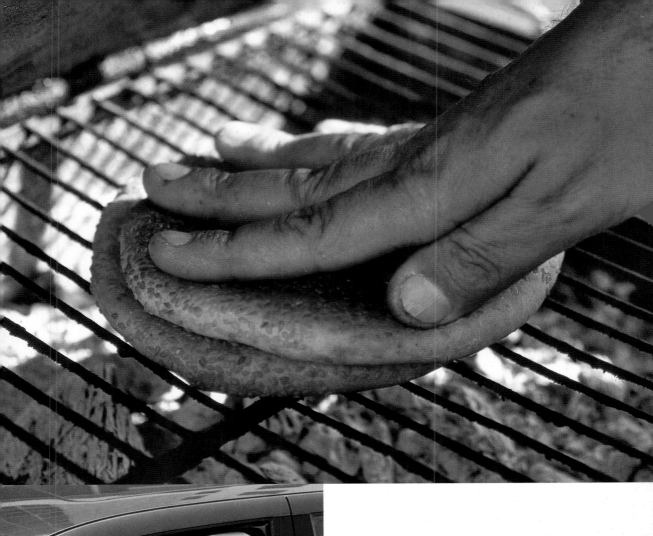

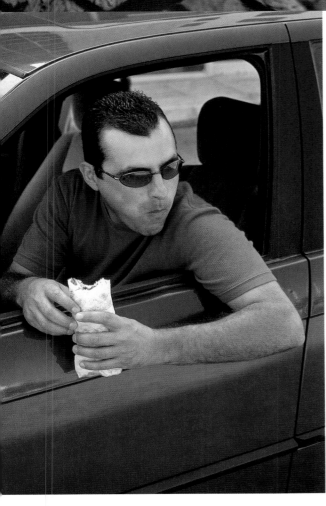

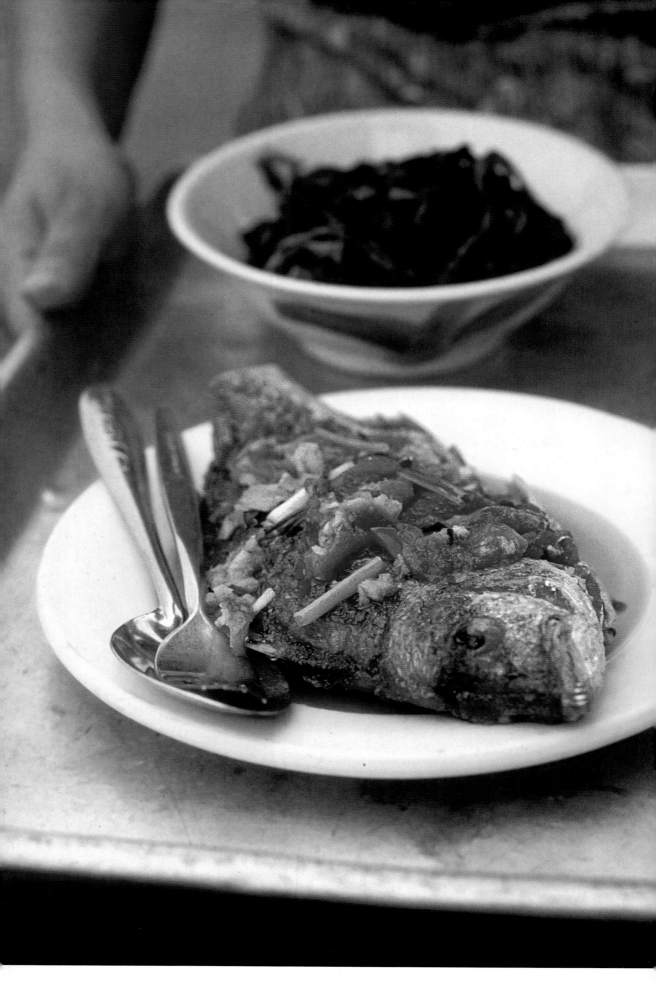

Halong Bay. Fried fish with sweet and sour sauce prepared on the boat.

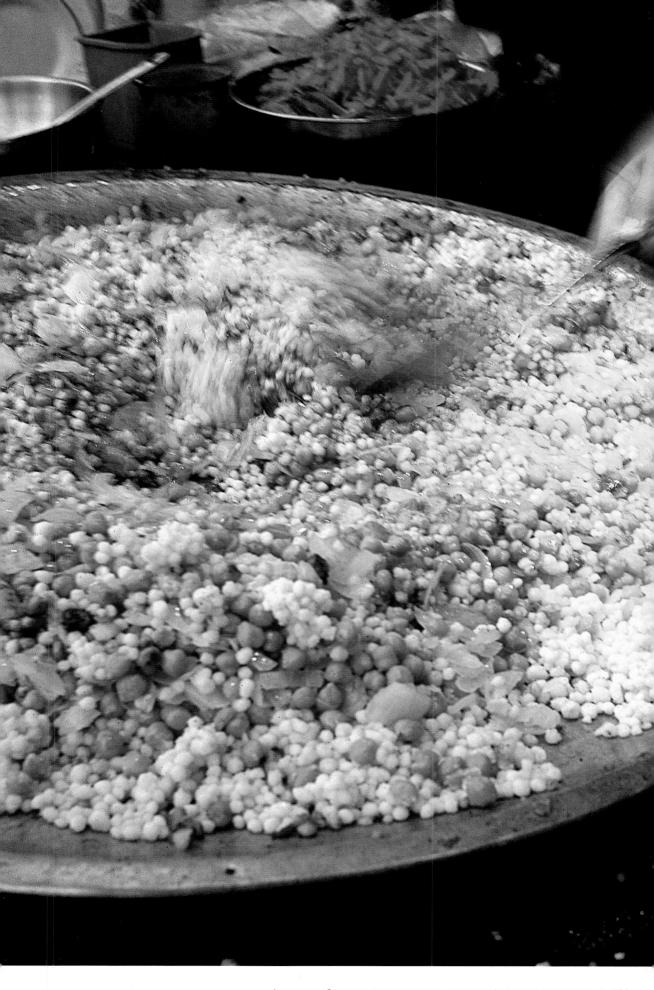

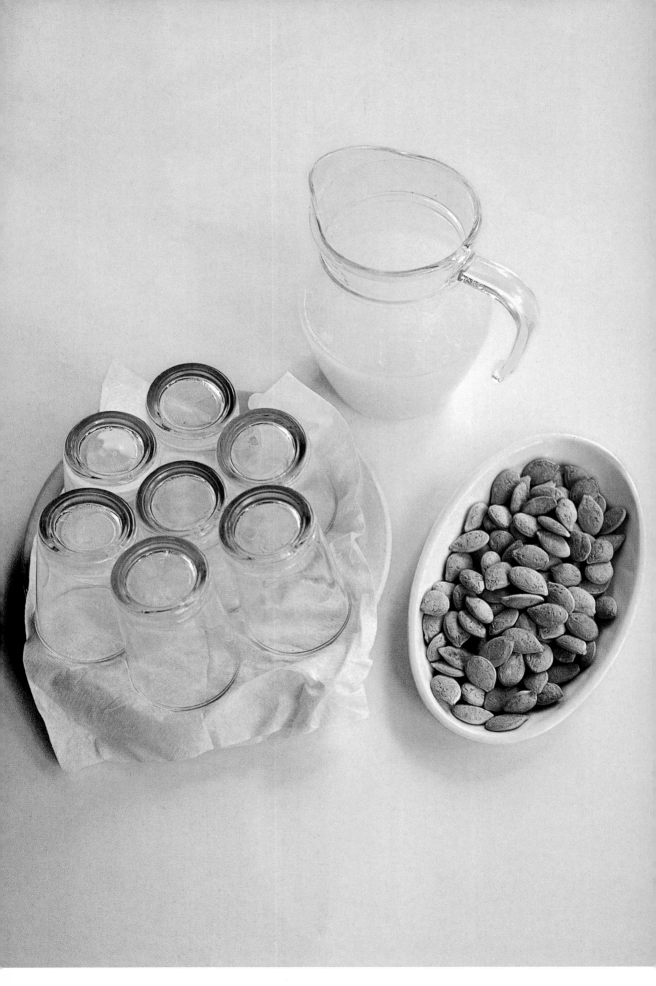

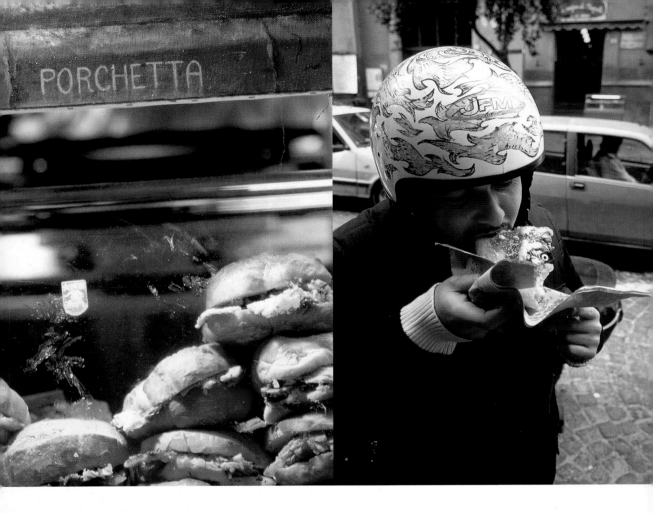

172 / **FLORENCE.** (LEFT) PORCHETTA IS SERVED FROM A CART IN THE CENTER OF THE CITY.
NAPLES. (CENTER) PIZZA EATEN ON THE GO.

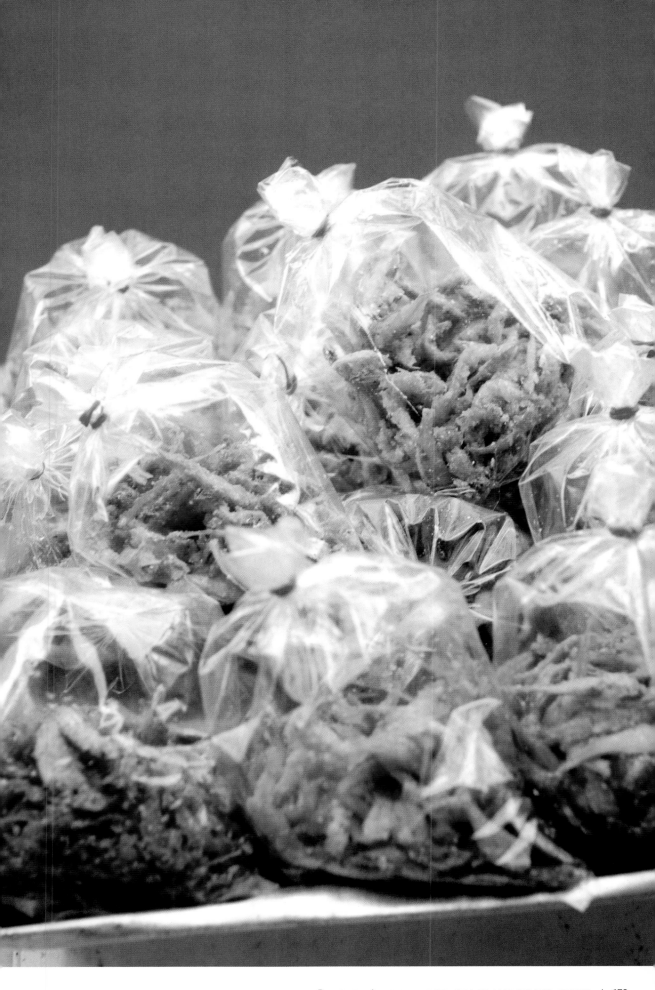

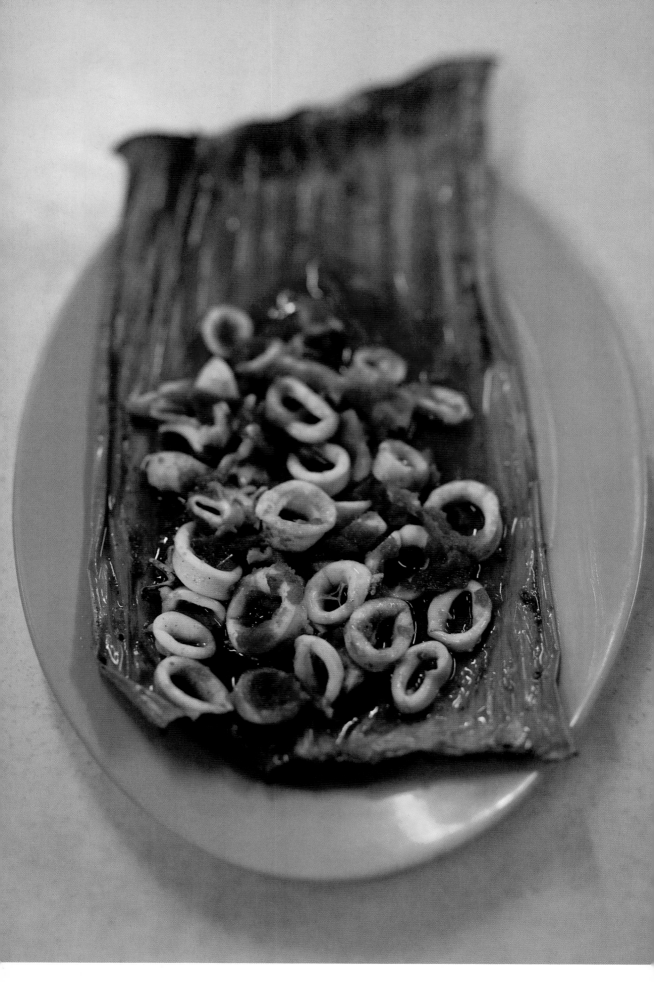

MALAYSIA. FRIED SQUID WITH LEMONGRASS SAUCE AND DRIED PEPPERS.

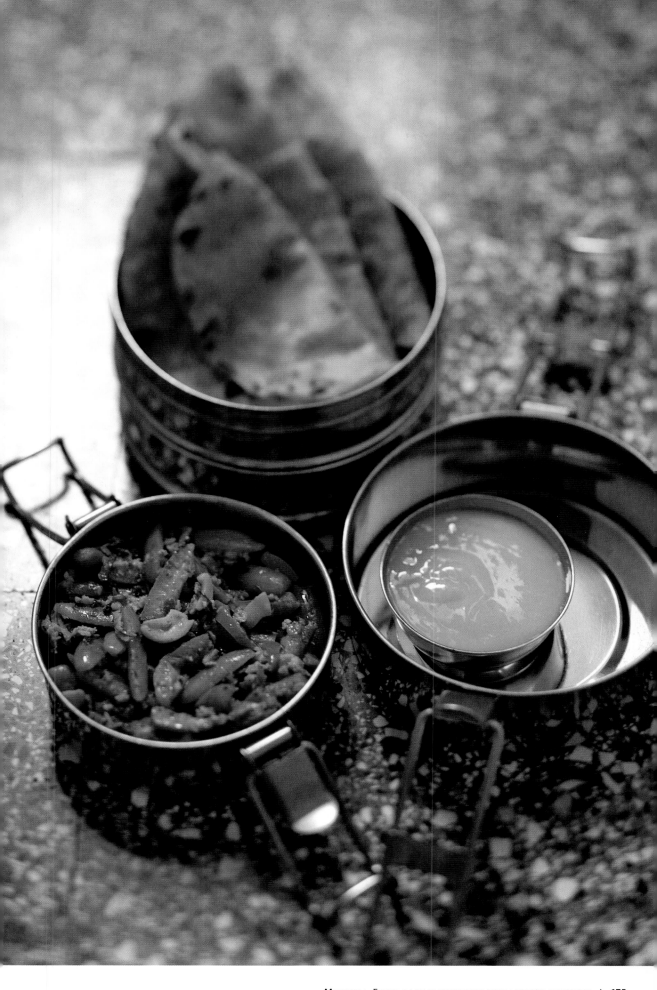

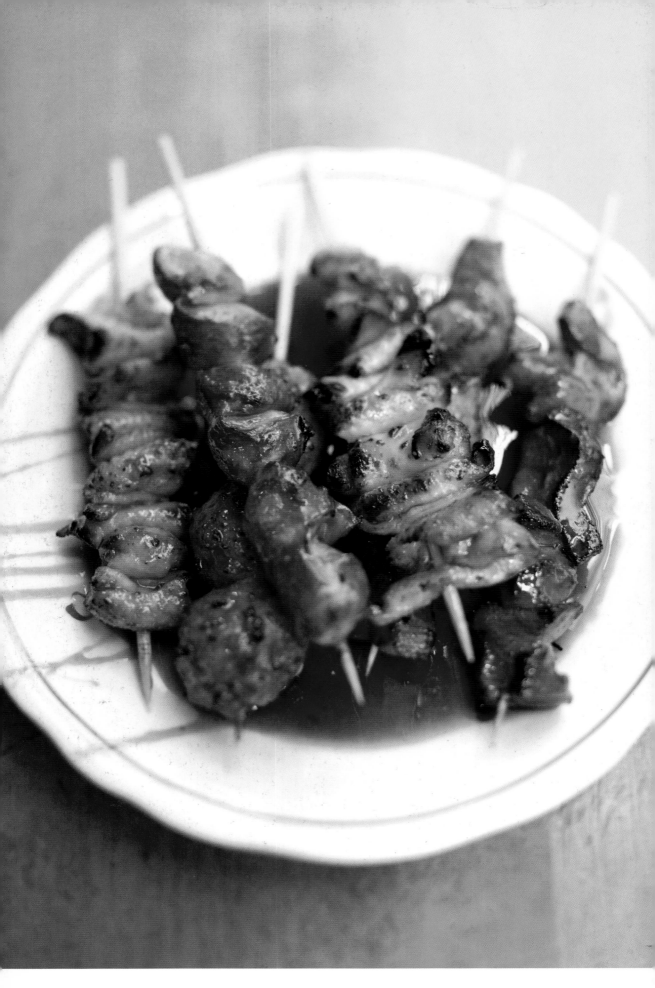

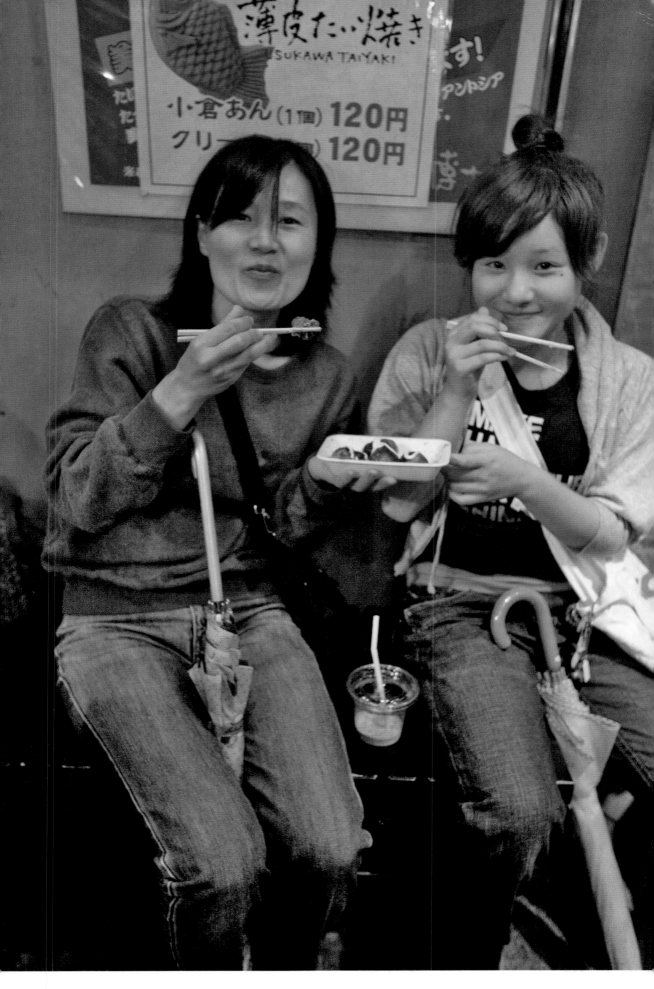

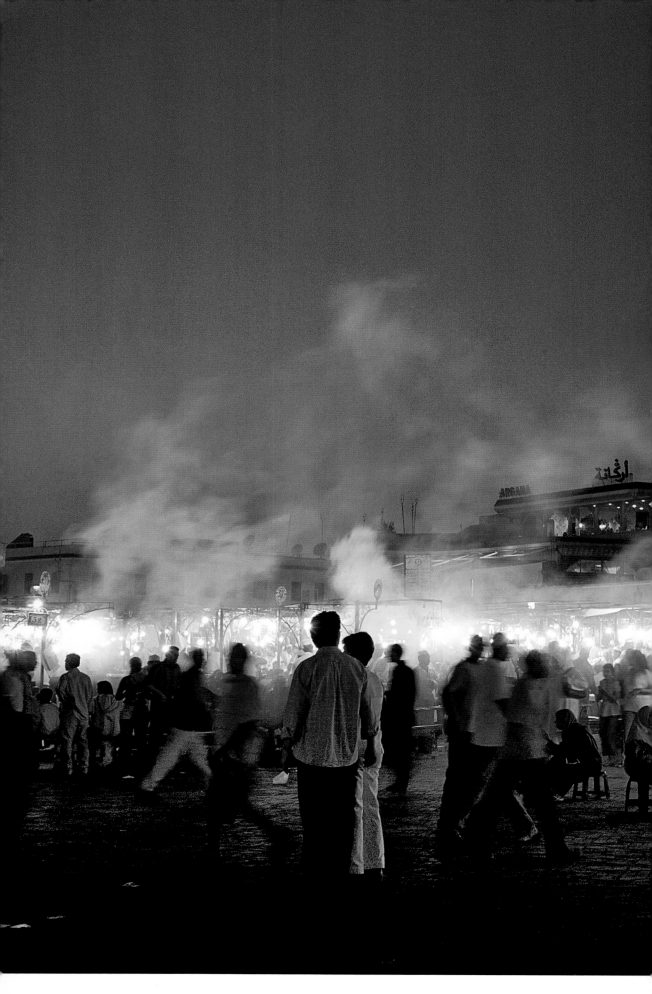

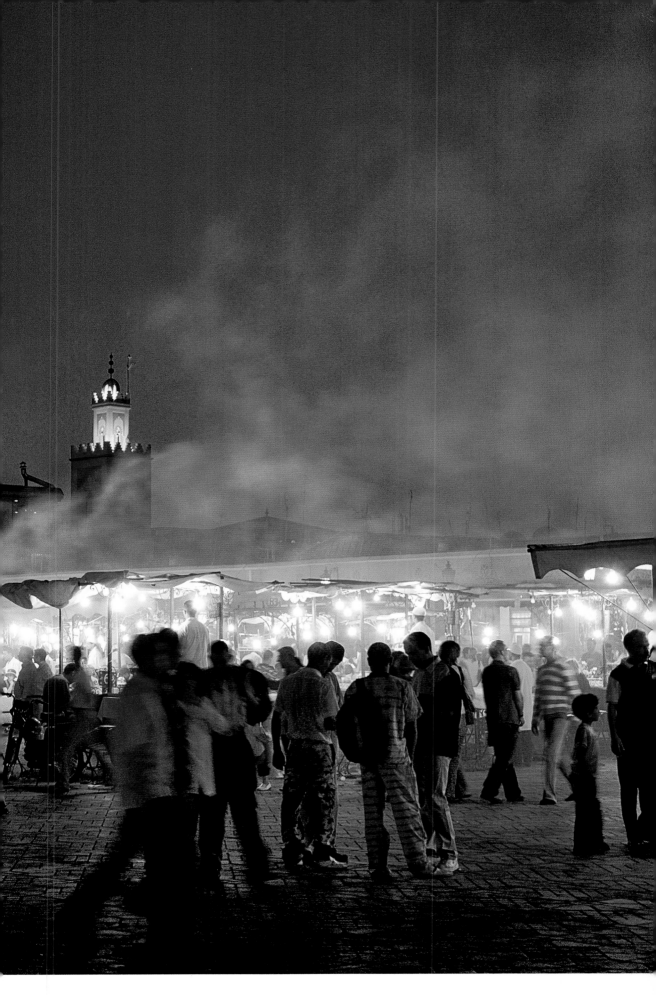

BANGKOK. TWO WOMEN DINE ON POACHED CHICKEN WITH BROTH AND RICE.

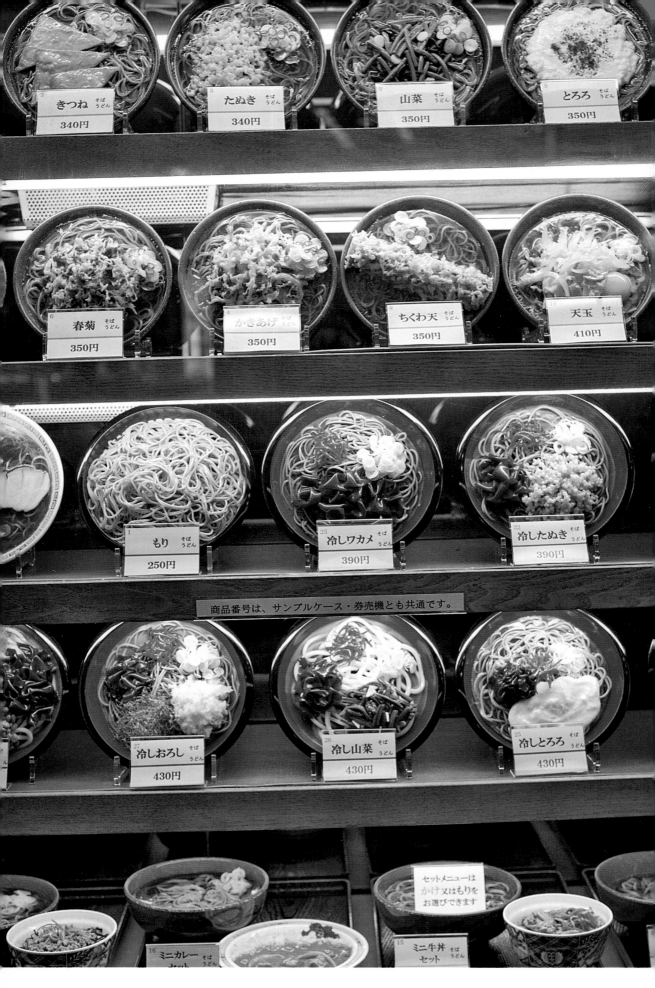

きつね そば うどん
340円

たぬき そば うどん
340円

山菜 そば うどん
350円

とろろ そば うどん
350円

春菊 そば うどん
350円

かきあげ そば うどん
350円

ちくわ天 そば うどん
350円

天玉 そば うどん
410円

もり そば うどん
250円

冷しワカメ そば うどん
390円

冷したぬき そば うどん
390円

商品番号は、サンプルケース・券売機とも共通です。

冷しおろし そば うどん
430円

冷し山菜 そば うどん
430円

冷しとろろ そば うどん
430円

セットメニューは
かけ 又はもりを
お選びできます

ミニカレー そば うどん
セット

ミニ牛丼 そば うどん
セット

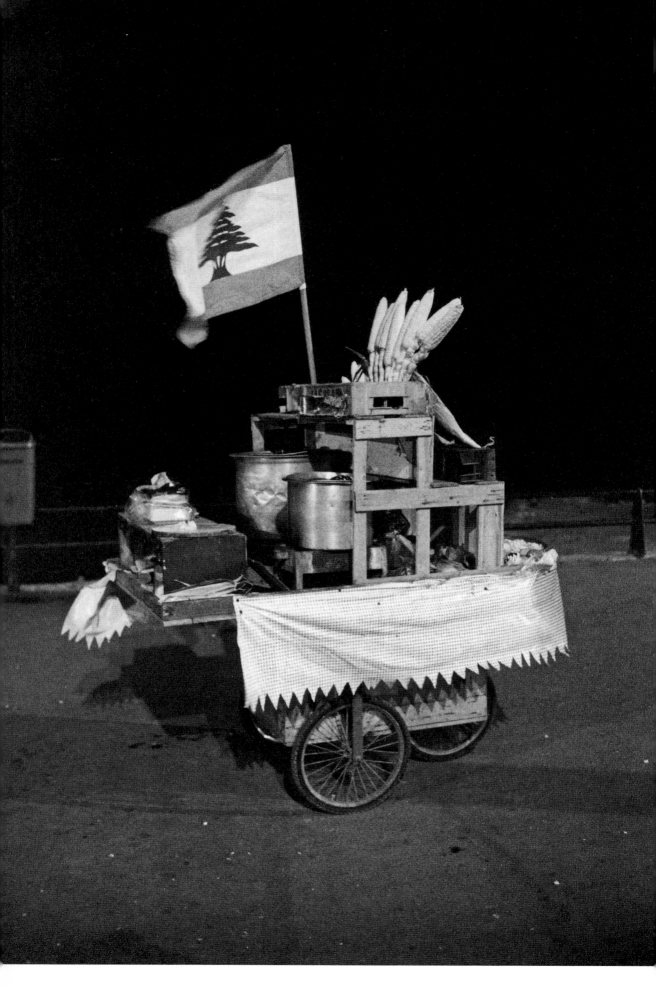

184 / **BEIRUT.** ON THE PROMENADE, THIS VENDOR SELLS BUTTERED CORN AND SESAME ROLLS.

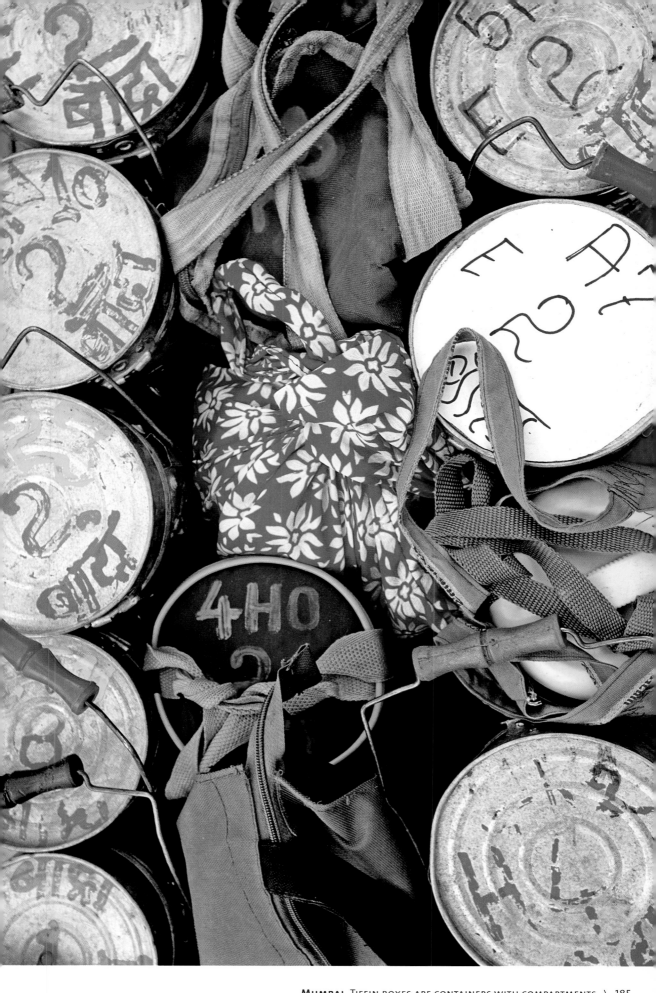

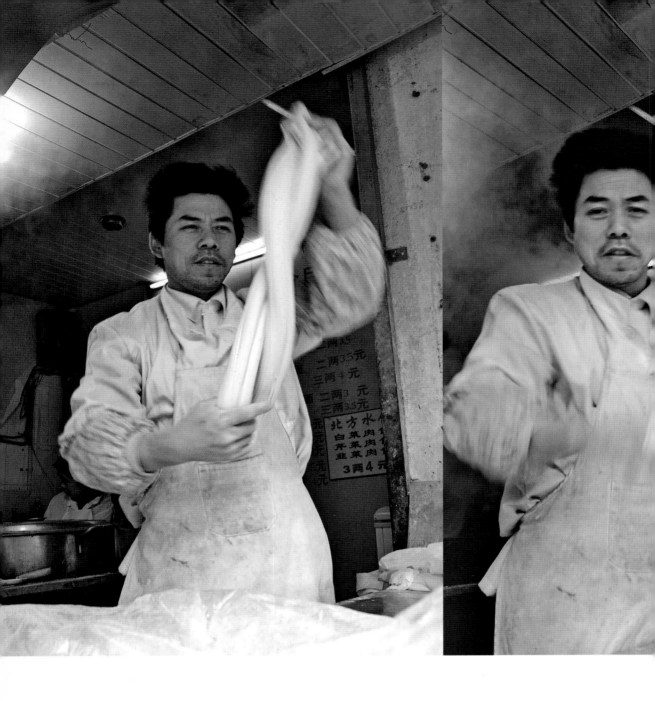

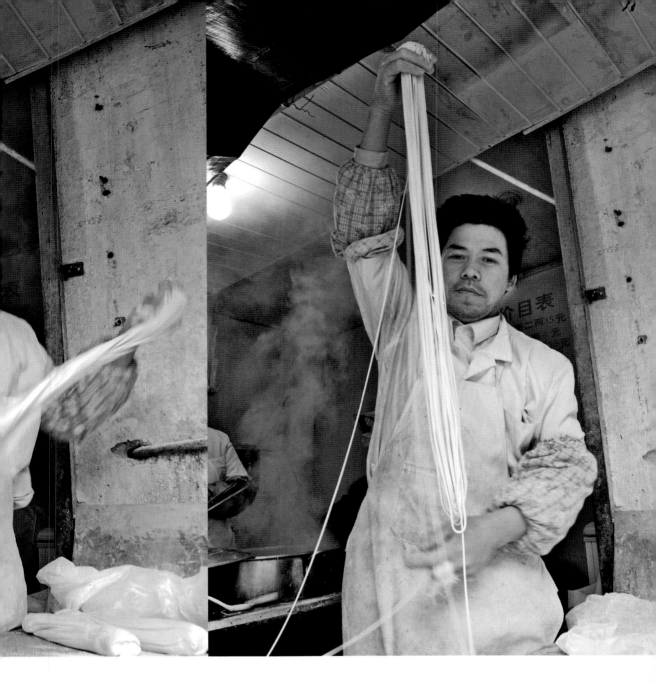

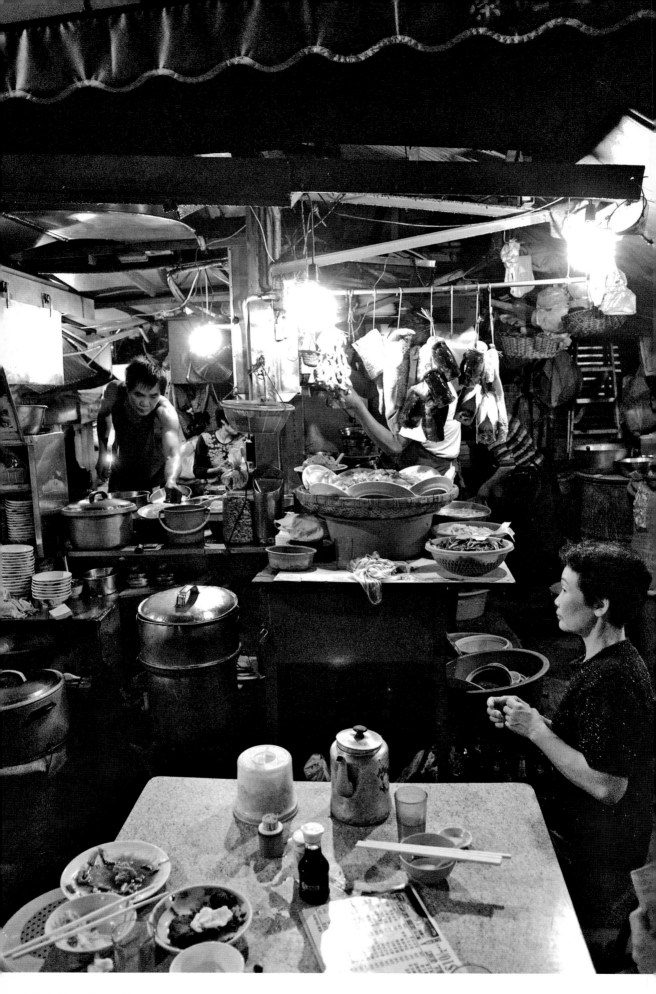

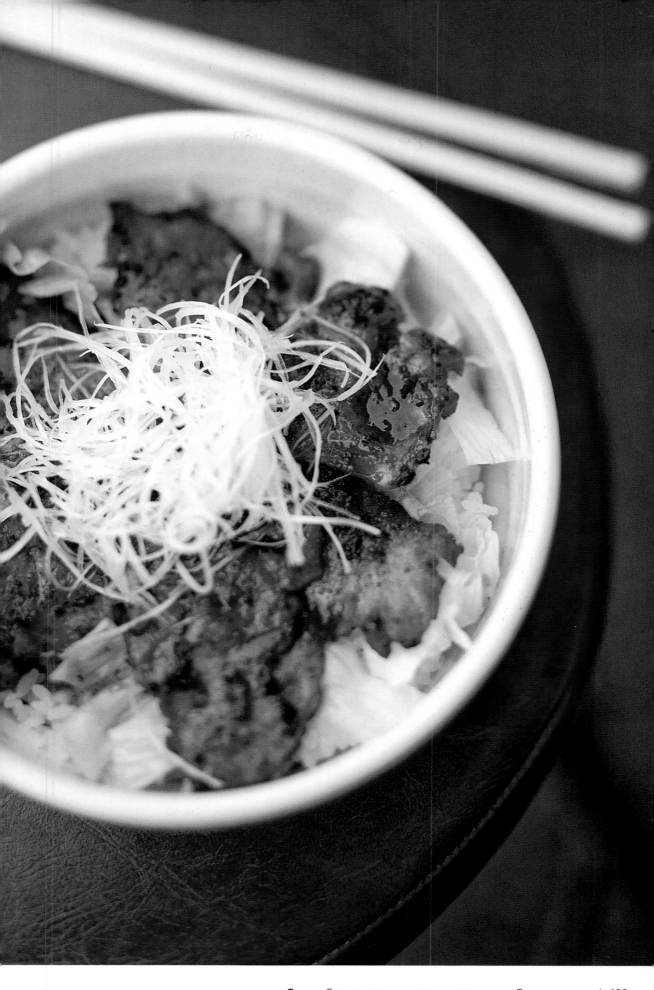

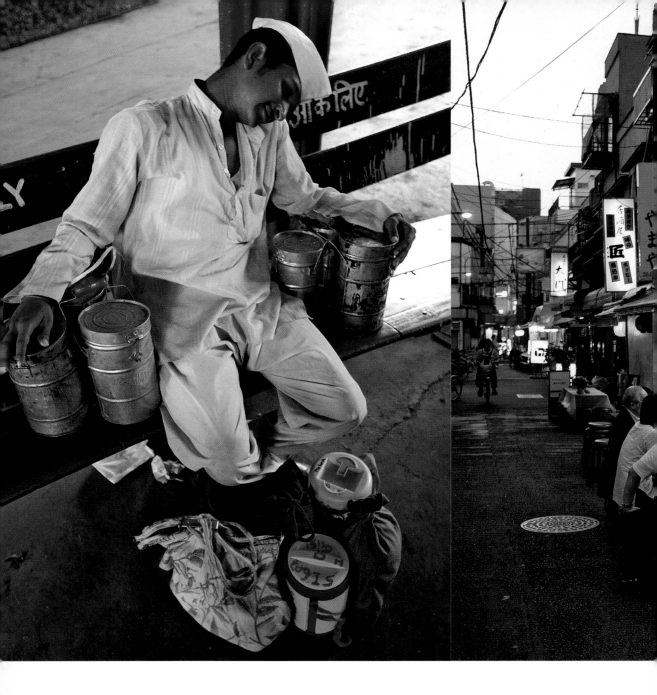

190 / **MUMBAI.** (LEFT) A *DABBAWALLA* TAKES A REST AFTER DELIVERING TIFFIN BOXES IN THE BUSINESS DISTRICT.
TOKYO. (CENTER) A SHOP IN THE ASAKUSA DISTRICT.

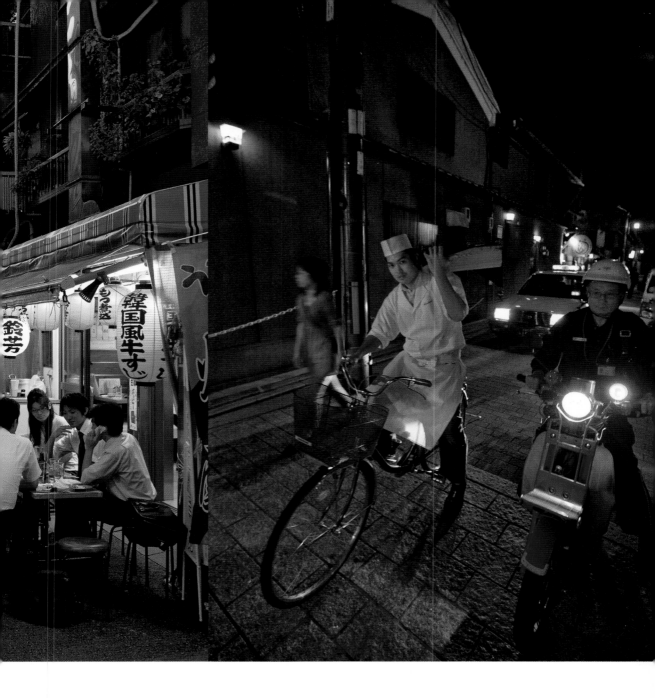

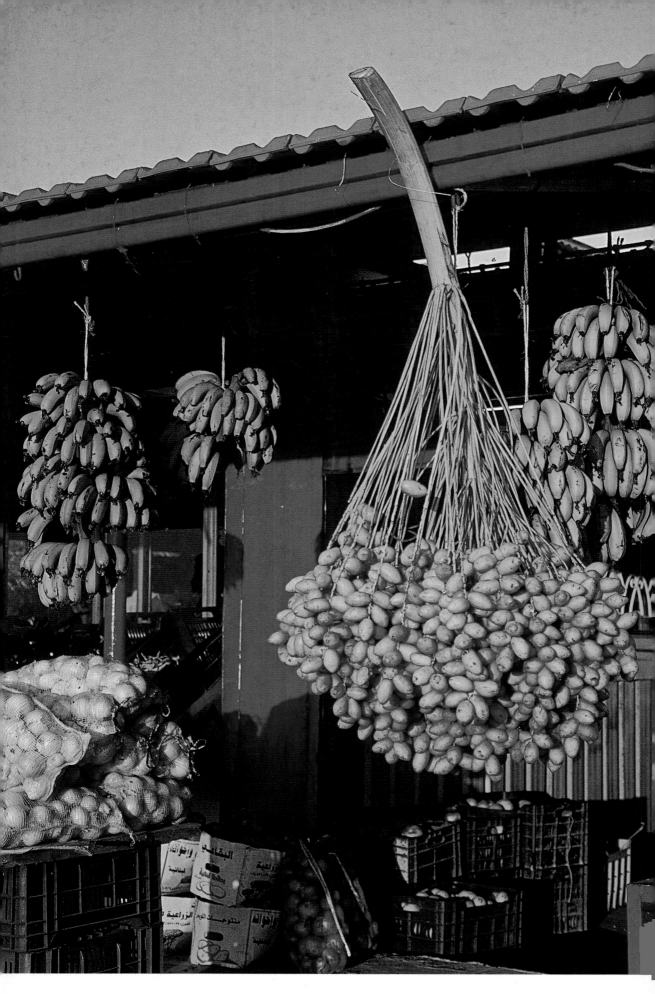

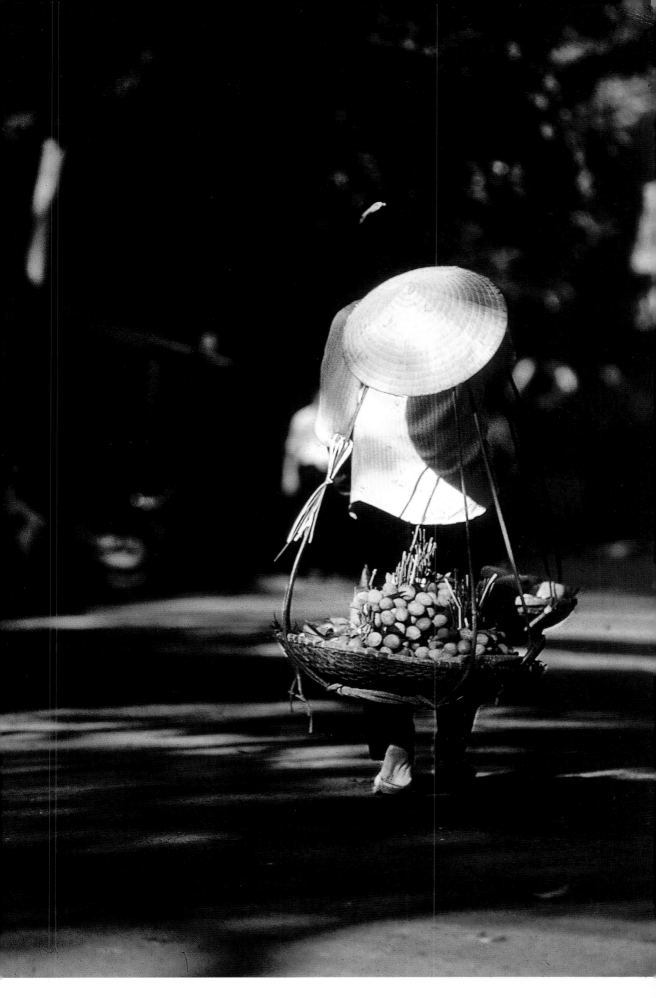

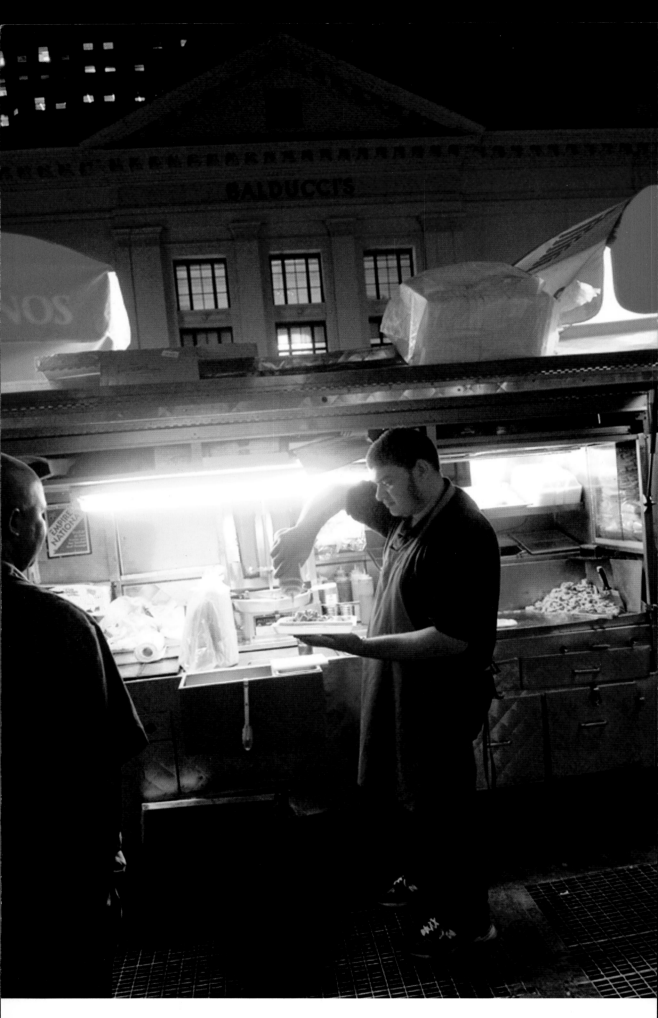

194 / **MANHATTAN.** A VENDOR OF MEXICAN FOOD ON A STREET IN CHELSEA.

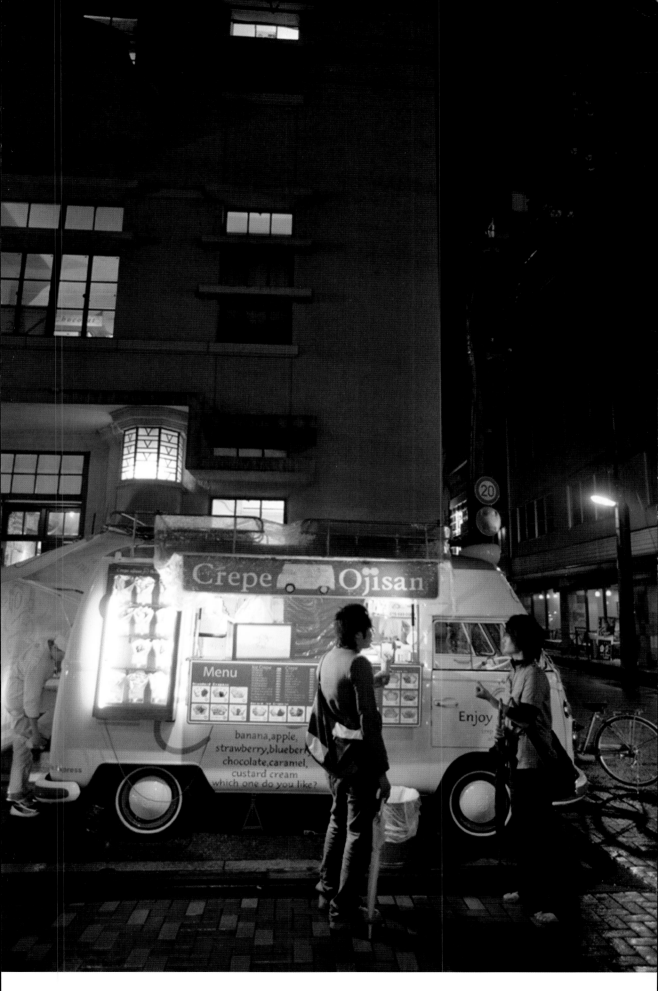

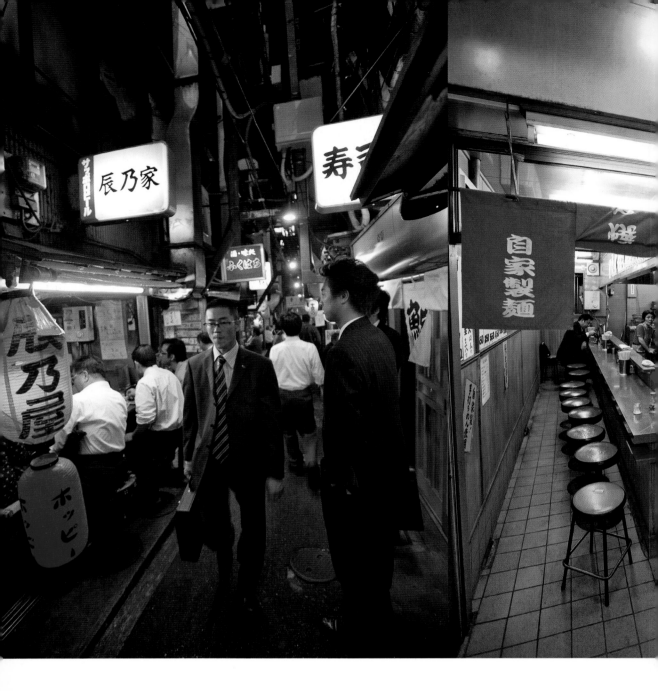

196 / **Tokyo.** On their way to and from work, Japanese executives stop at their favorite food stands.

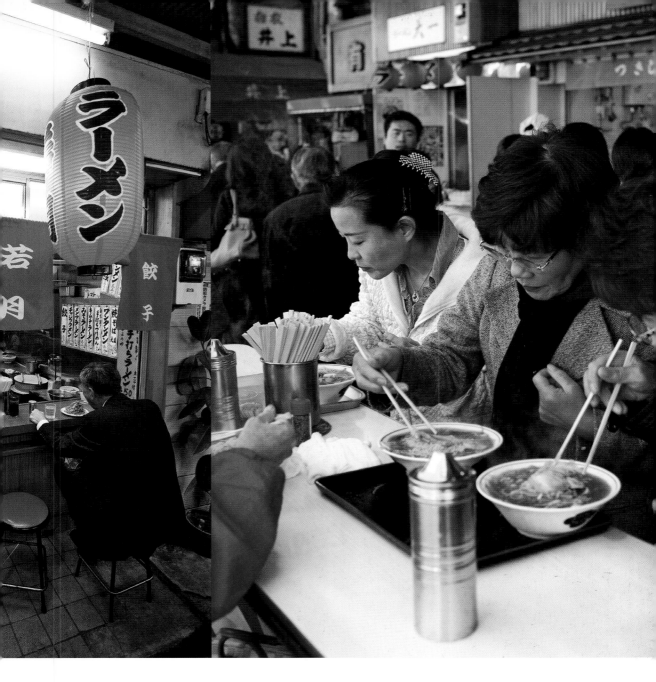

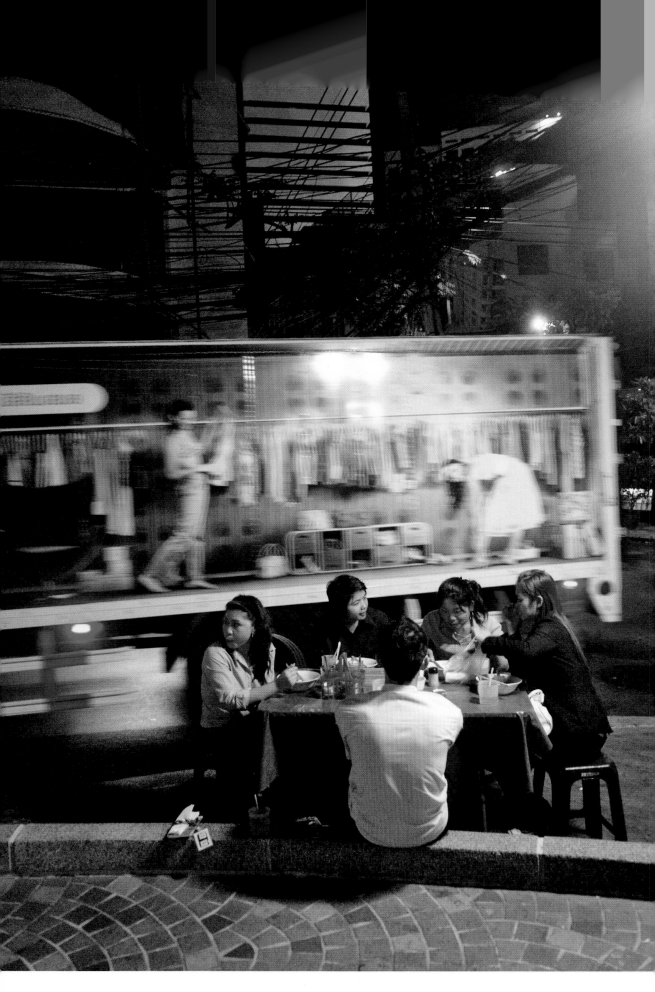

BANGKOK. AT THE FOOT OF THE BUILDING THAT IS HOME TO THE SIROCCO BAR, A STREET VENDOR SERVES THE BEST SOUP IN THE CITY.

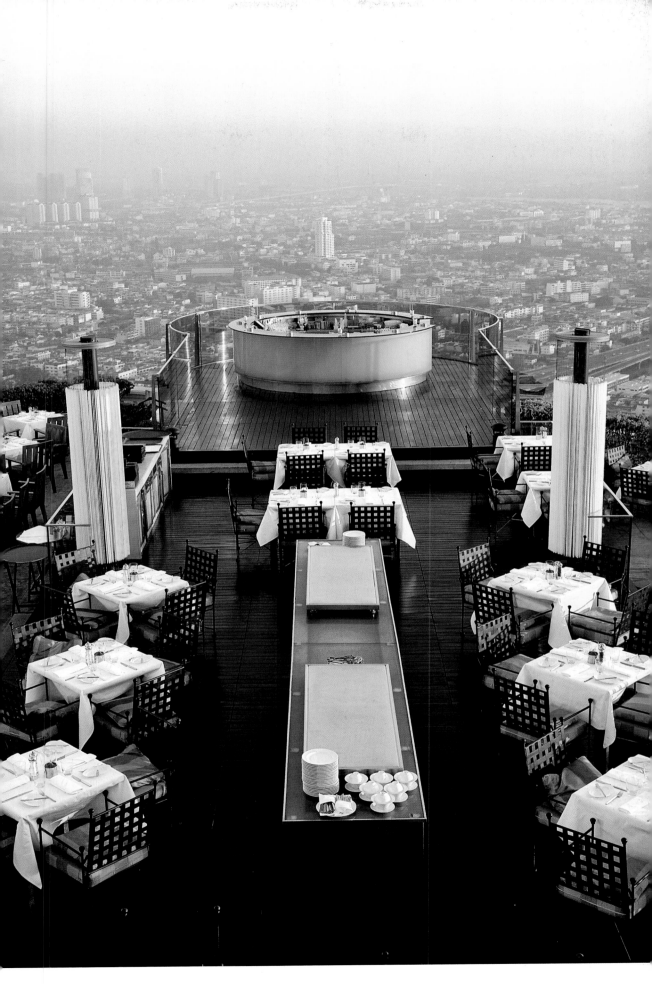

200 / **QUEBEC.** (LEFT) MAPLE CANDY ON ICE.
BANGKOK. (CENTER) CRUNCHY CRÊPES WITH SHREDDED COCONUT.

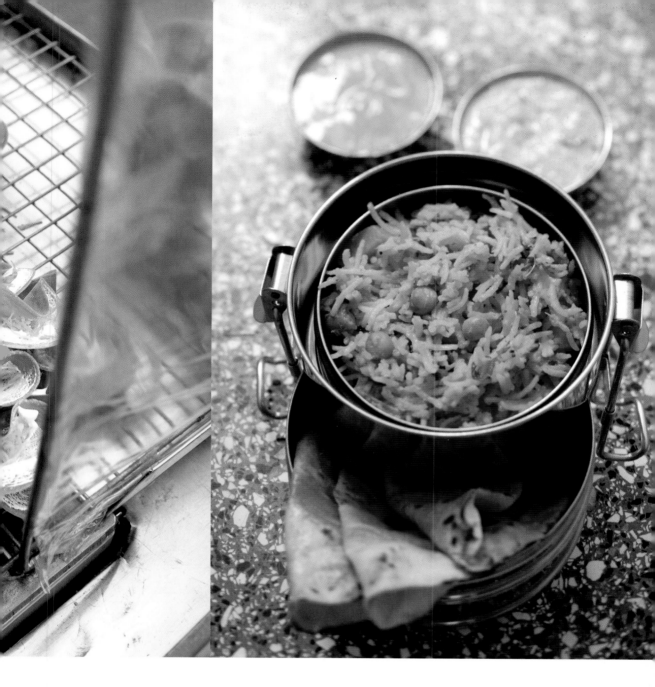

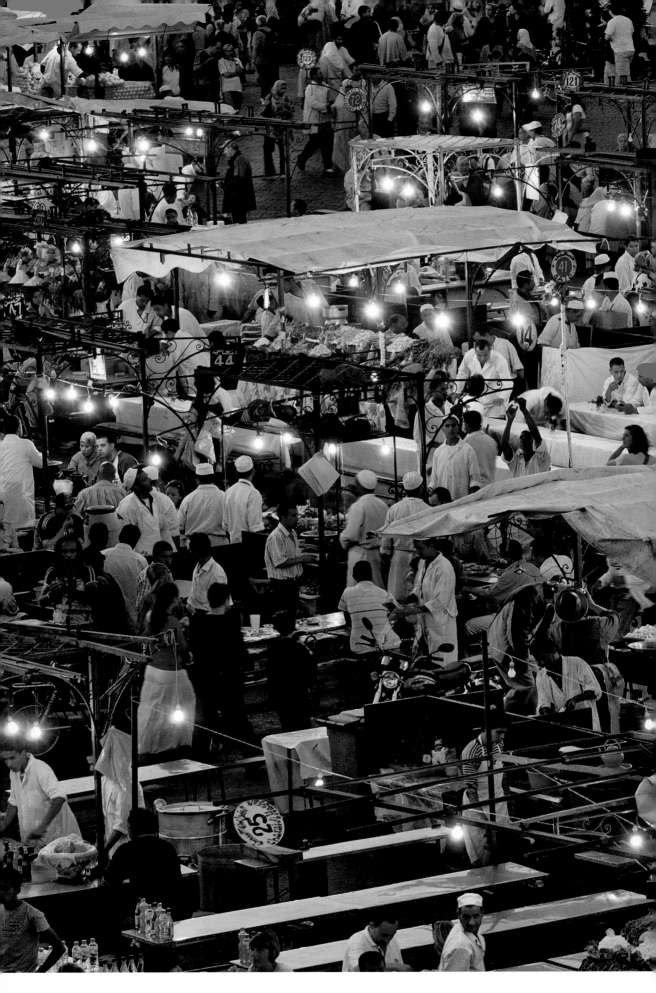

MARRAKESH. AFTER SIX IN THE EVENING, DJEMAA EL-FNA SQUARE IS FILLED WITH FOOD VENDORS.

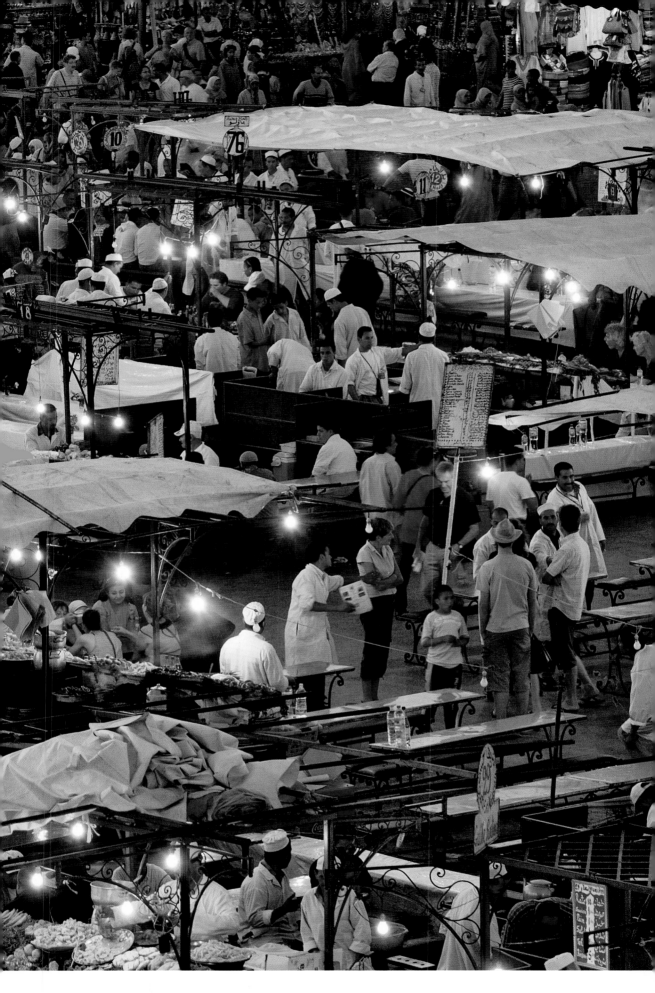

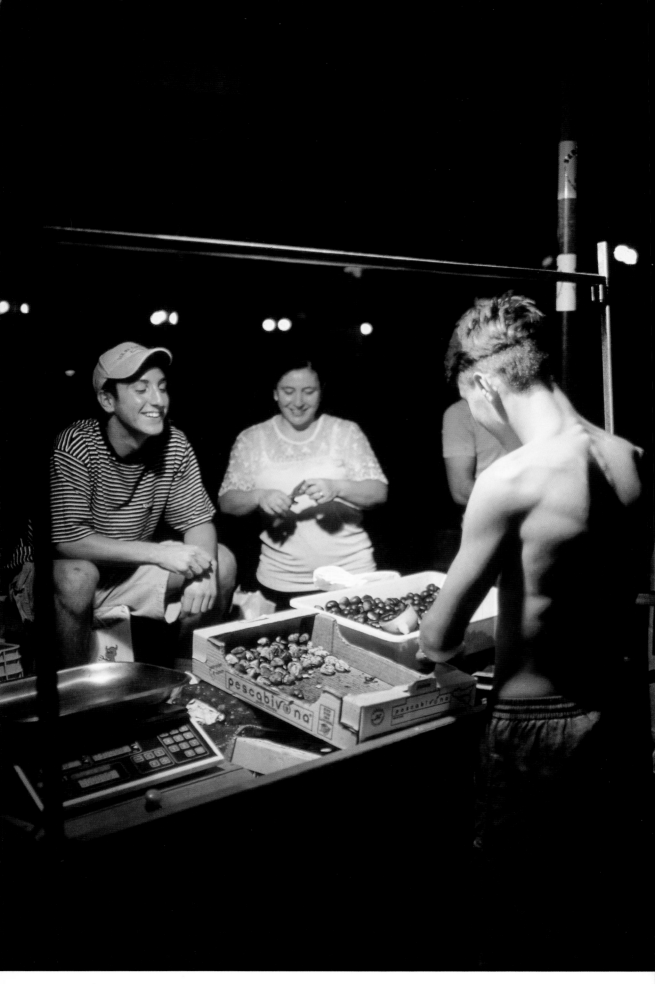

Lipari. A street vendor sells hot chestnuts on one of the Aeolian Islands.

COTTO
POMODORO

COTTO
MOZZARELLA

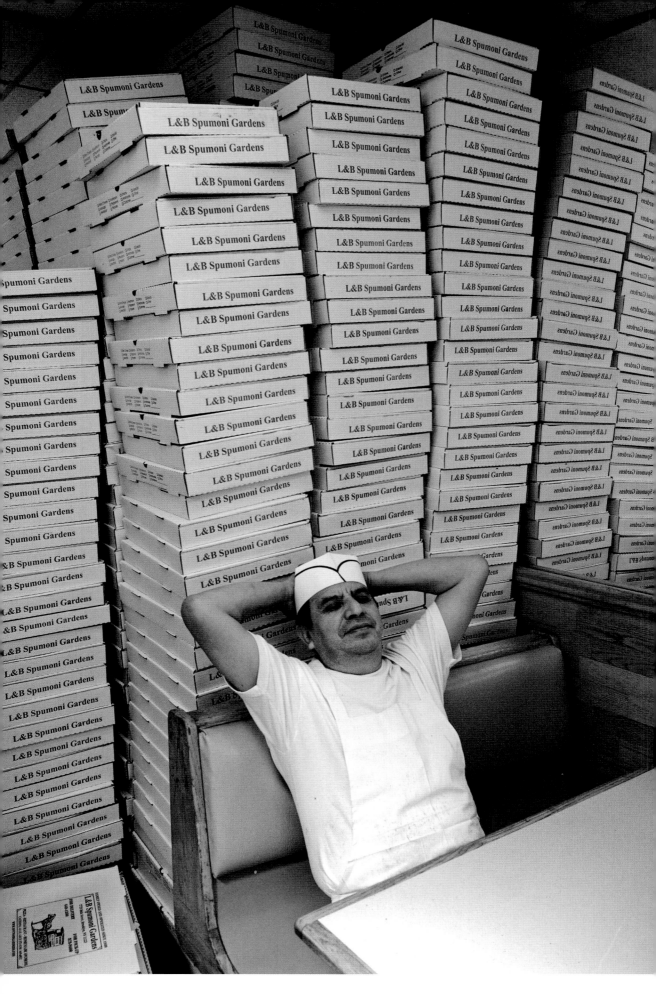

BROOKLYN. A MOMENT'S REST FOR THE PIZZAIOLO AT SPUMONI GARDENS.

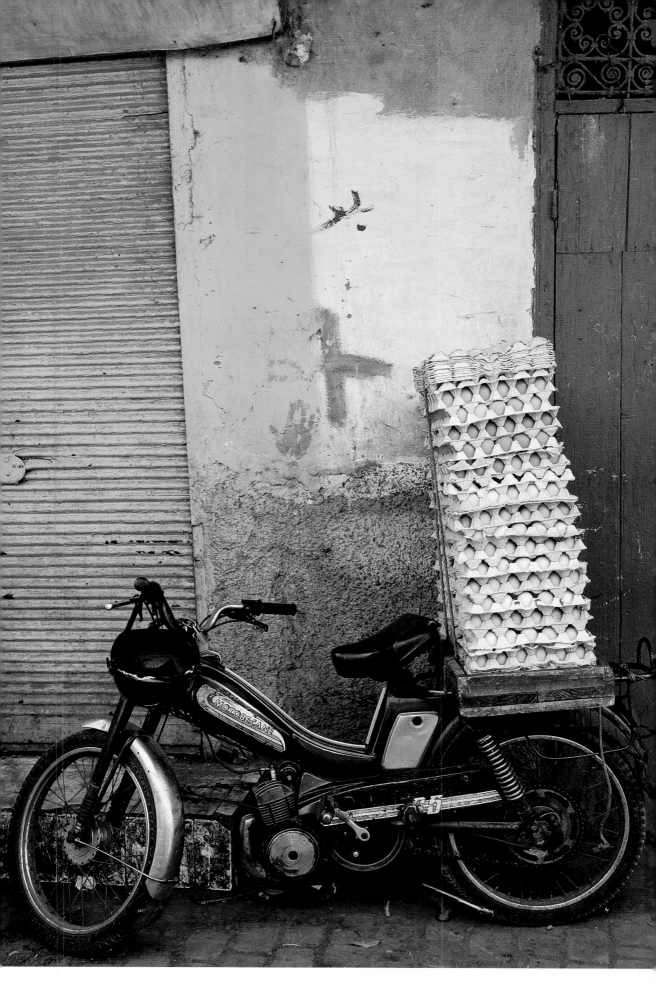

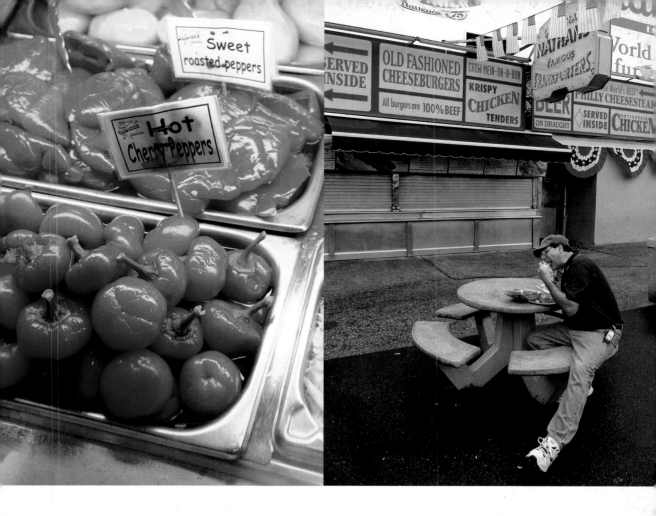

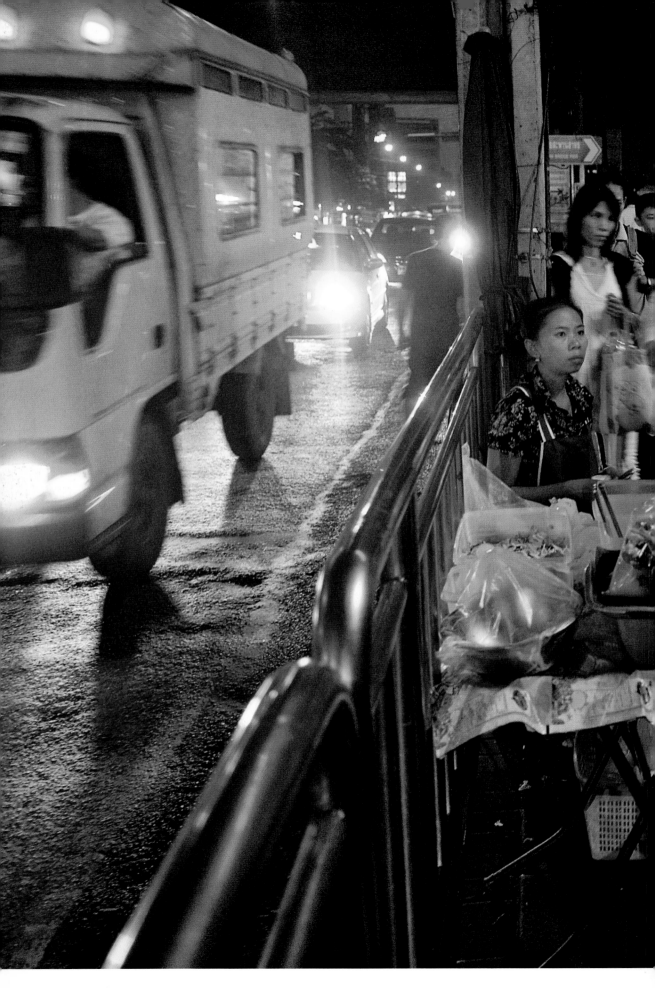

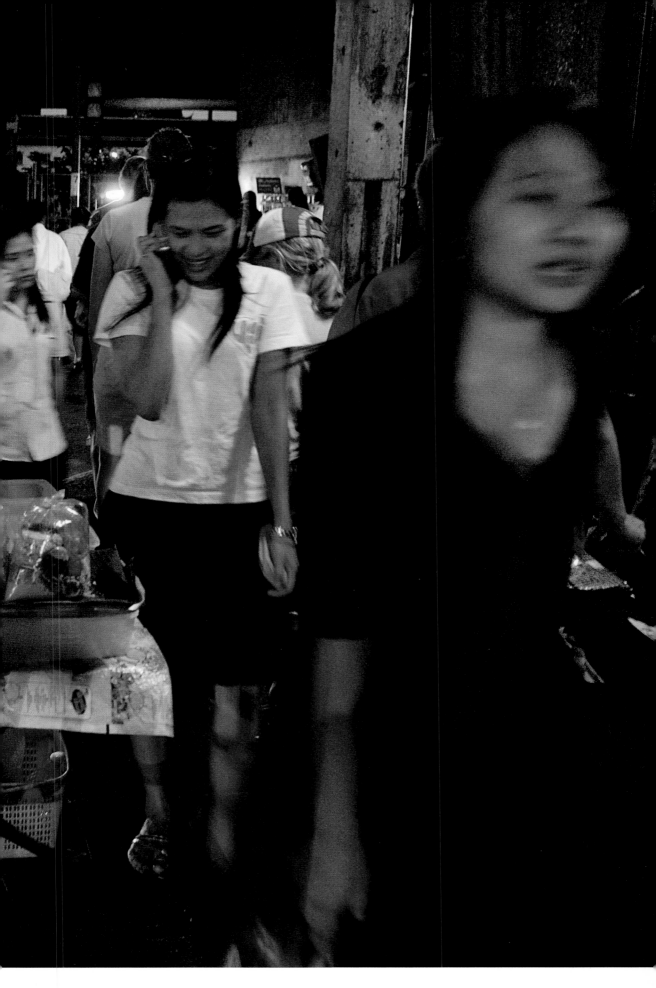

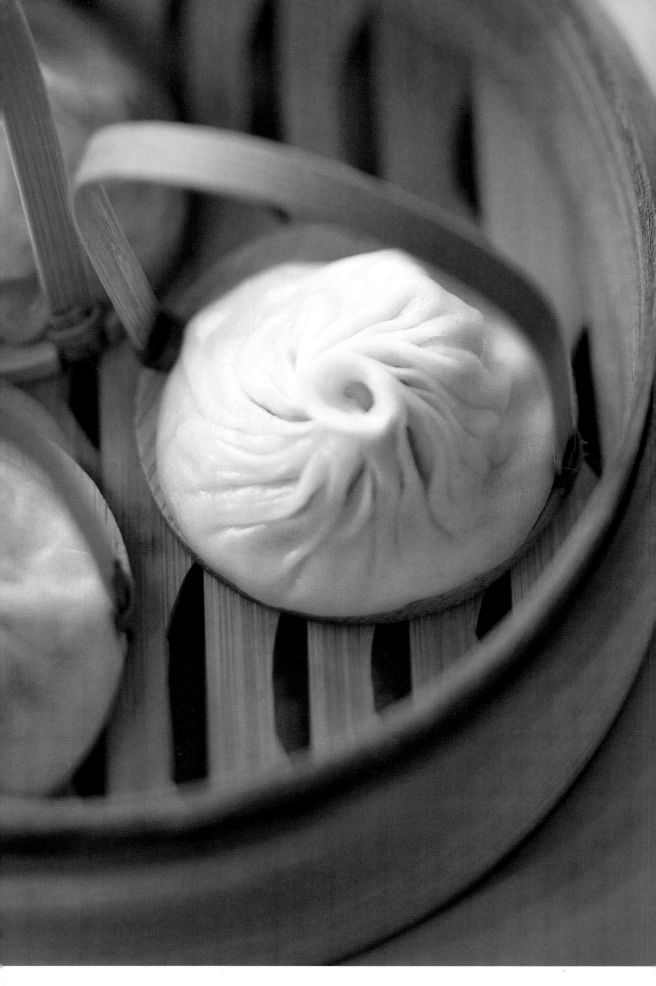

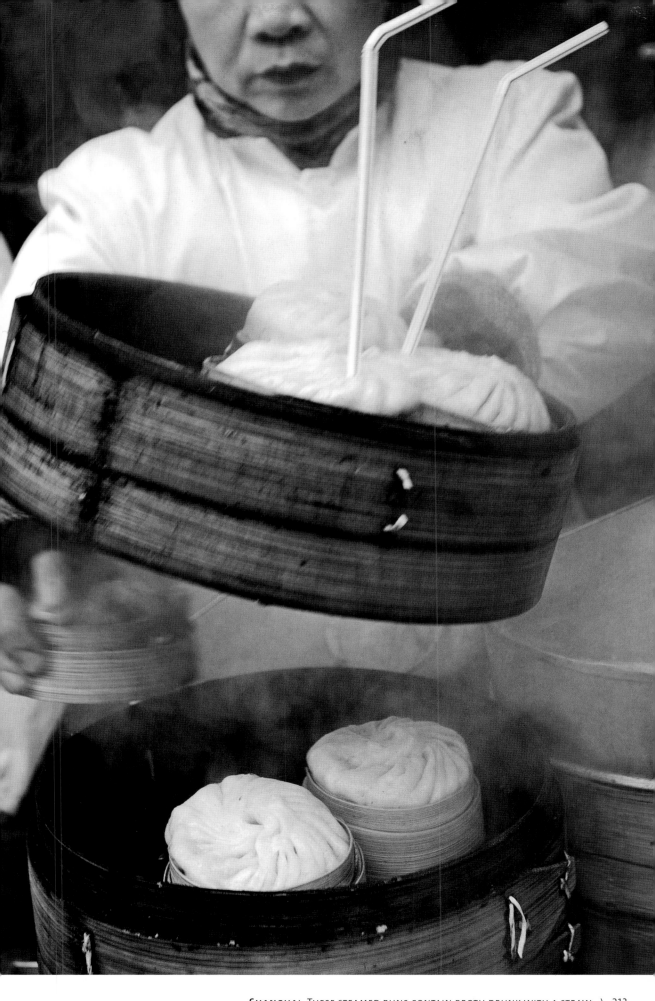

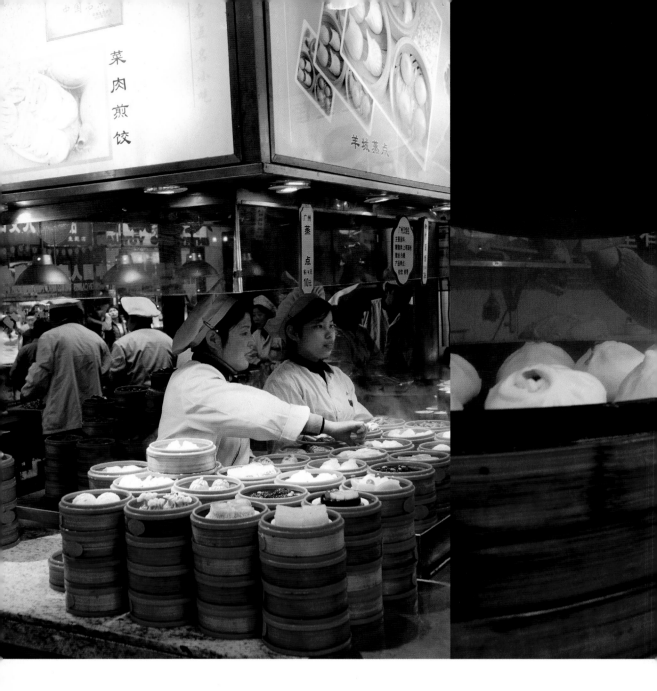

214 / **SHANGHAI.** A SHOP WITH A VARIETY OF STEAMED DIM SUM.

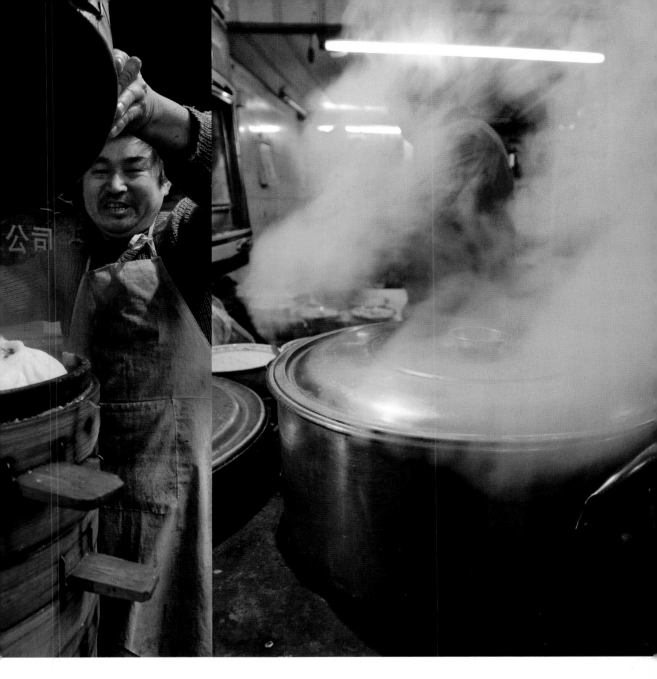

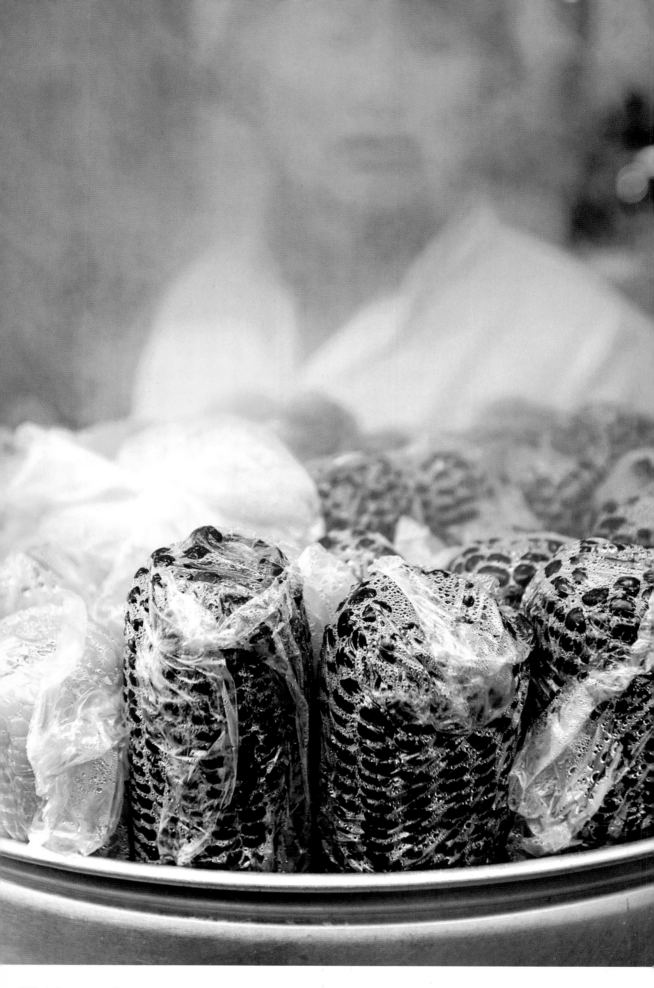

216 / **SHANGHAI.** EARS OF BLACK AND YELLOW CORN ARE COOKED IN PLASTIC BAGS.

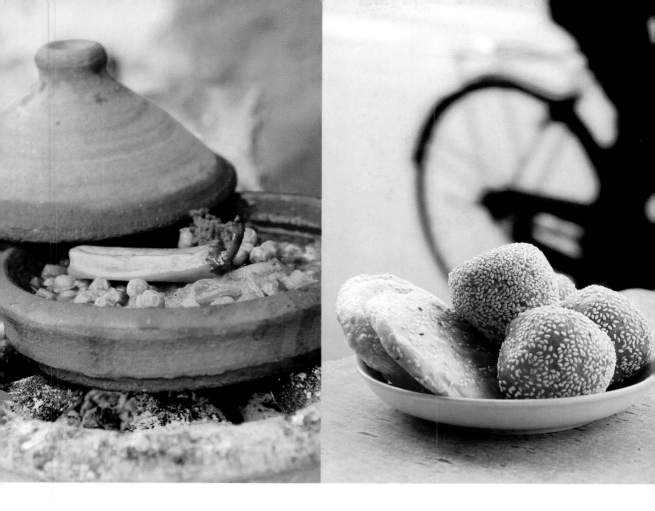

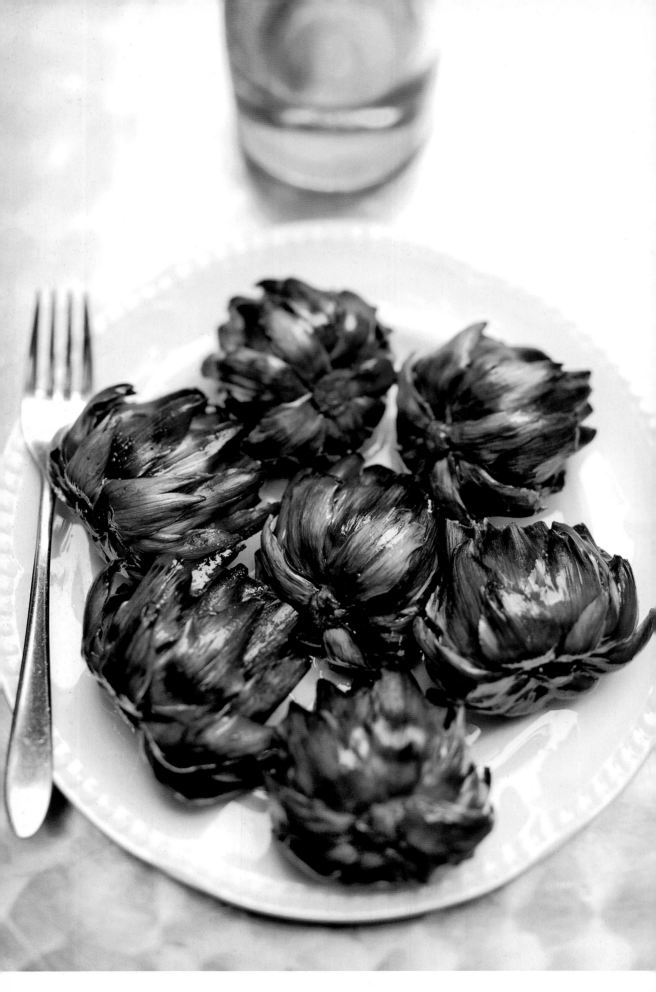

Barcelona. Artichokes fried in olive oil are served as tapas.

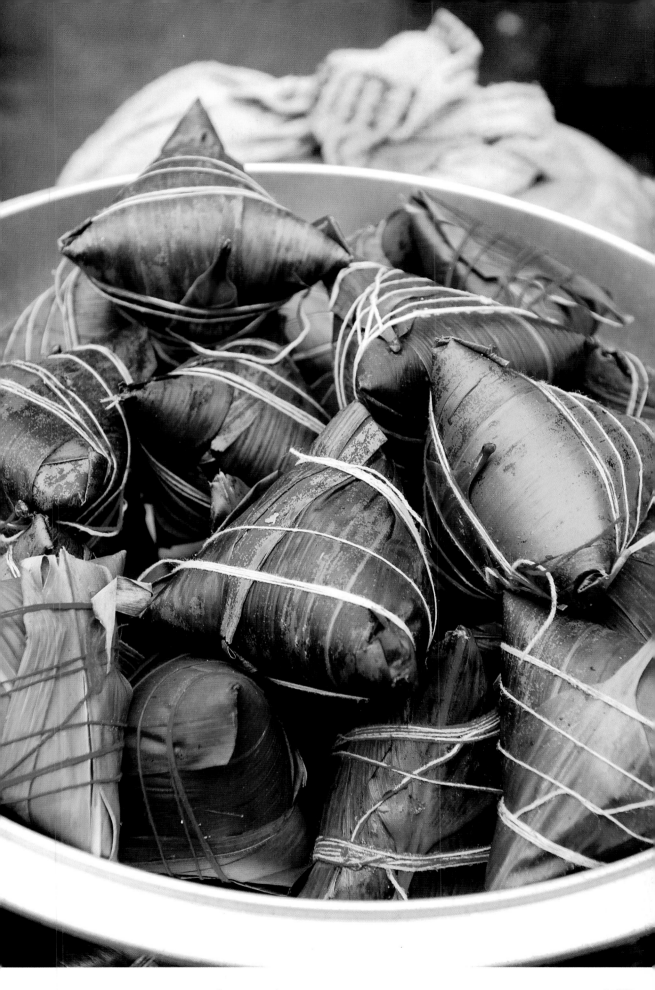

TOKYO. THESE COOKS PREPARE SOBA TEMPURA SOUP.

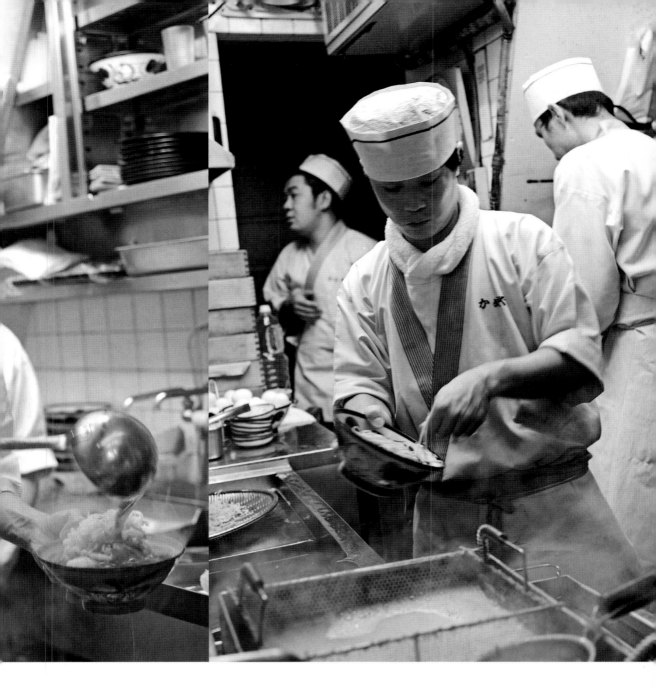

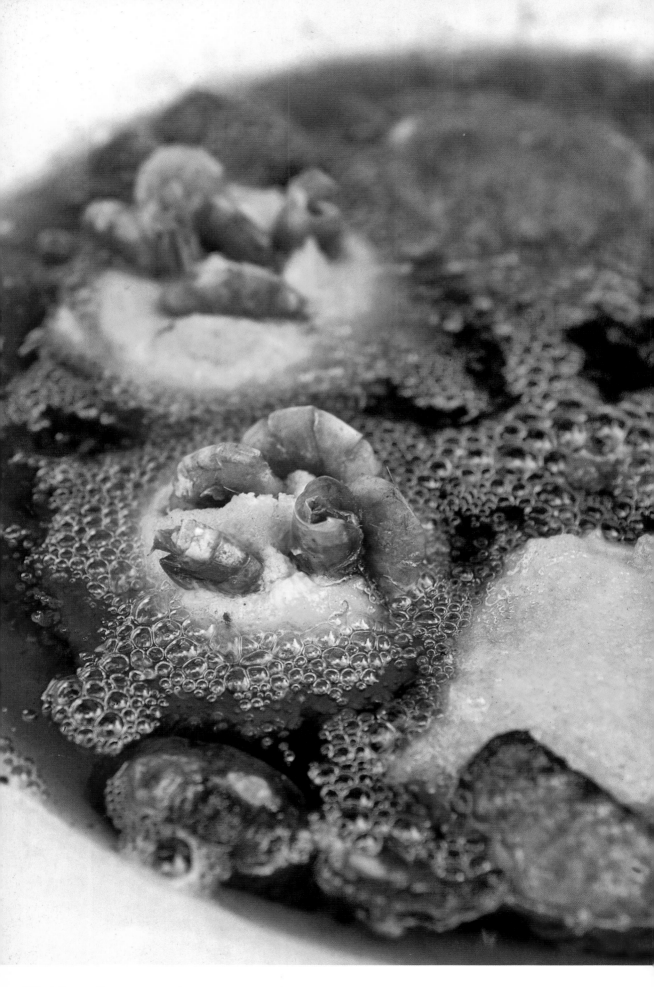

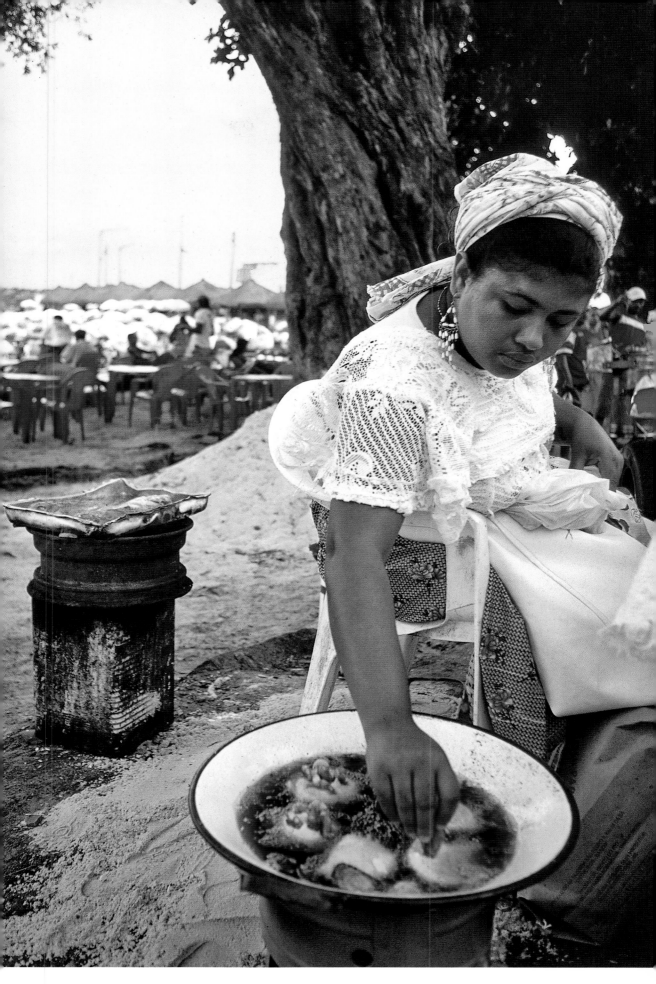

224 / MOPTI. STREET VENDOR WITH SQUASH SLICES.

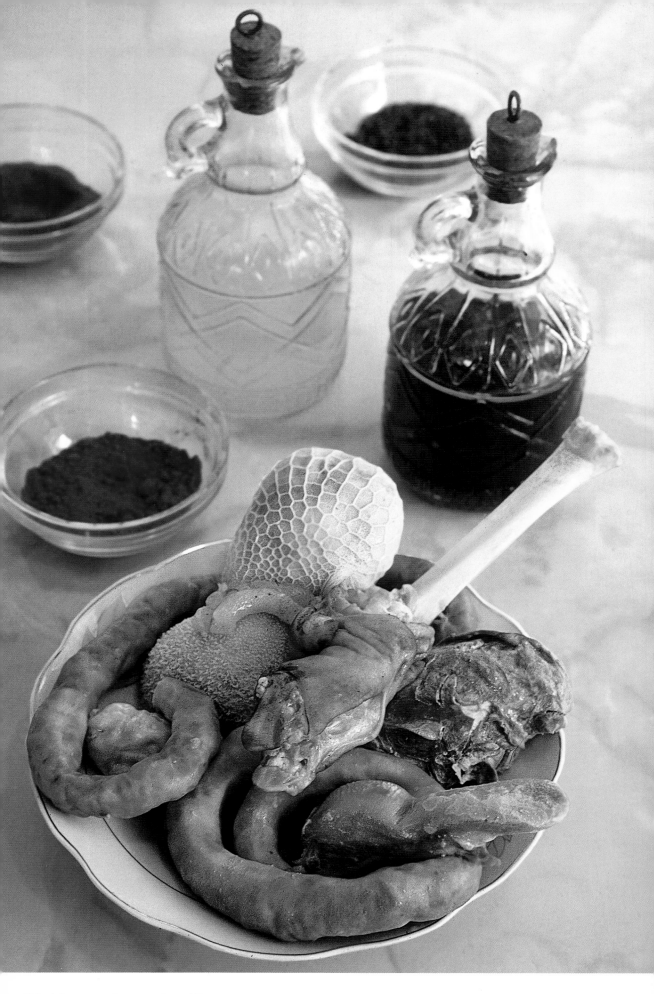

226 / **Lebanon.** (Left and Right) Boiled sheep's head and offal with garnishes: spice, lemon juice, and vinegar.

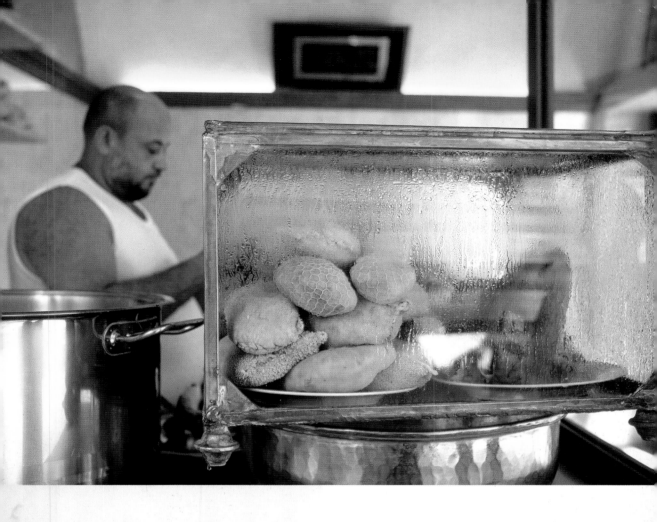

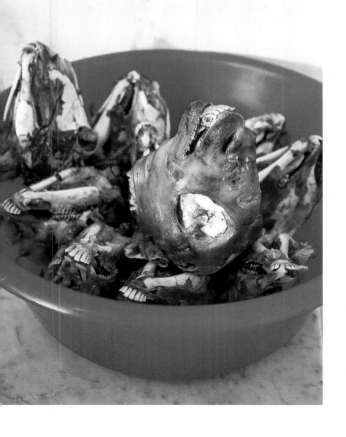

228 / **HONG KONG.** *WEY WAI KEE* FRITTERS PREPARED BY A VIRTUOSO.

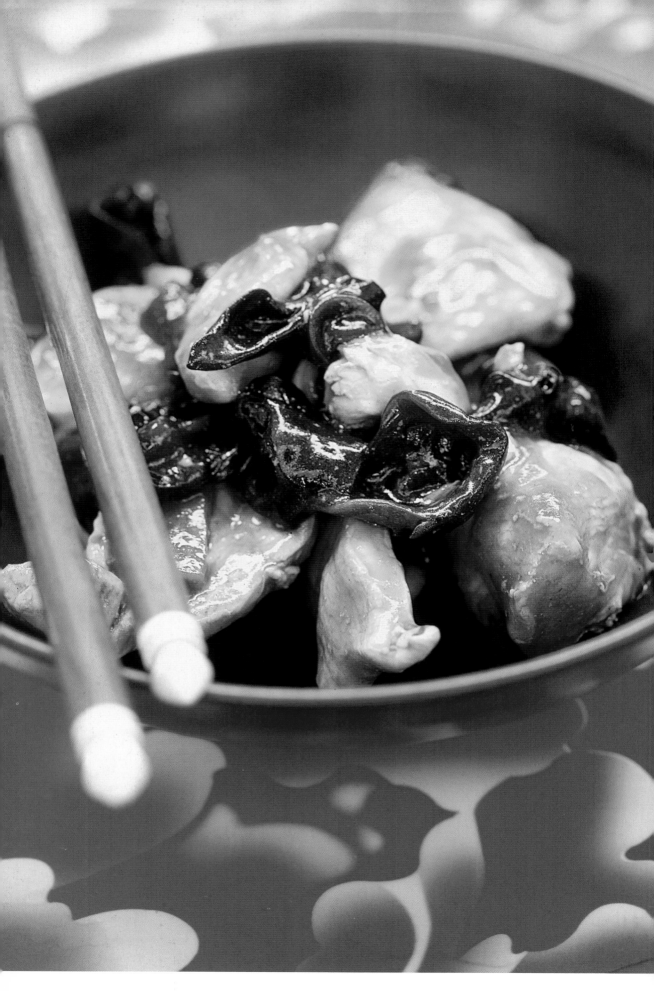

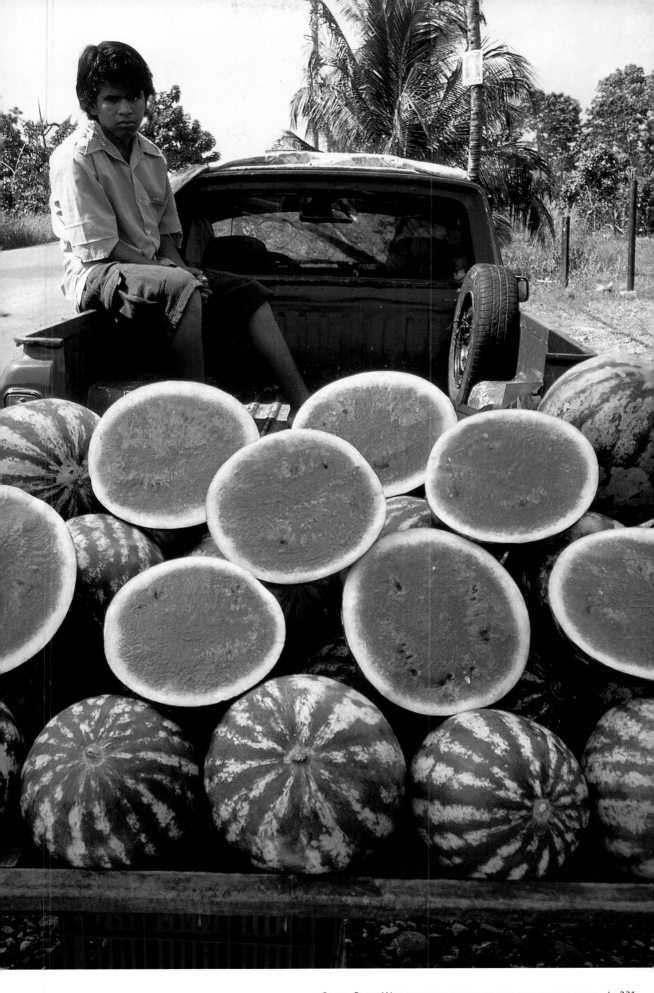

232 / **Naples.** (Left) Bunch of tomatoes hung in a window so they will crystallize in the sun. (Center) Caprese pizza. (Right) The sauce used on the pizza is made from peeled tomatoes preserved in jars.

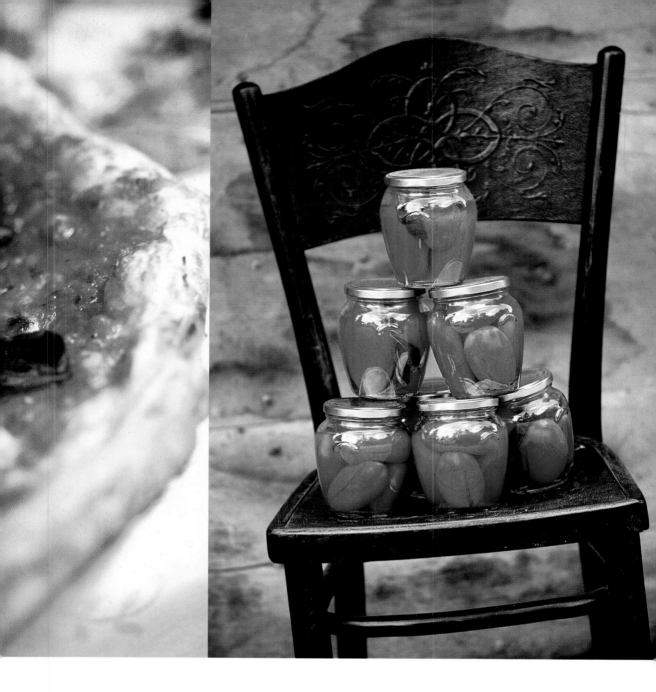

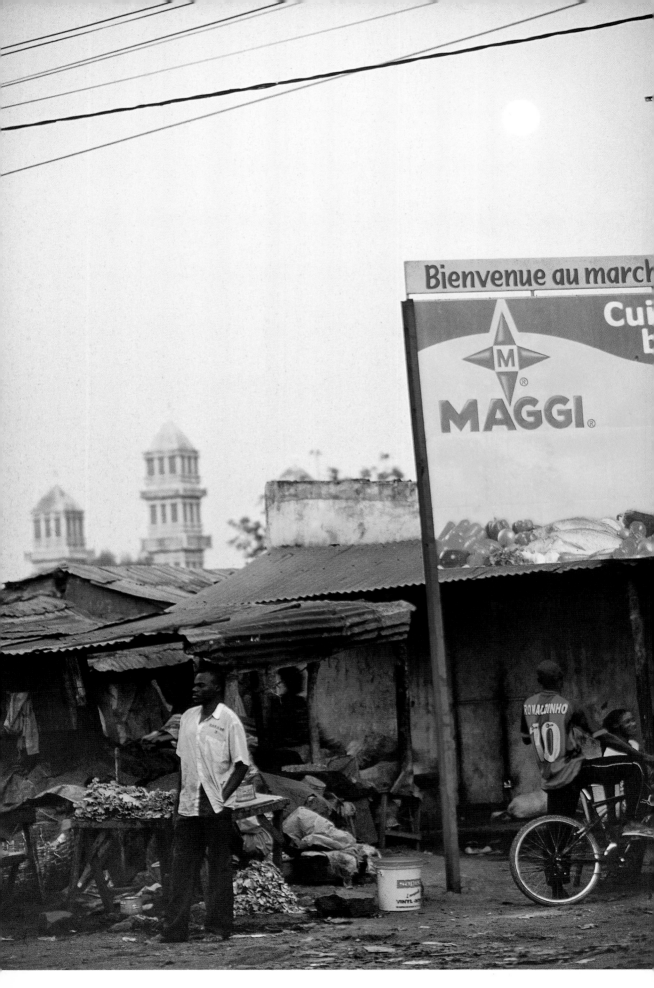

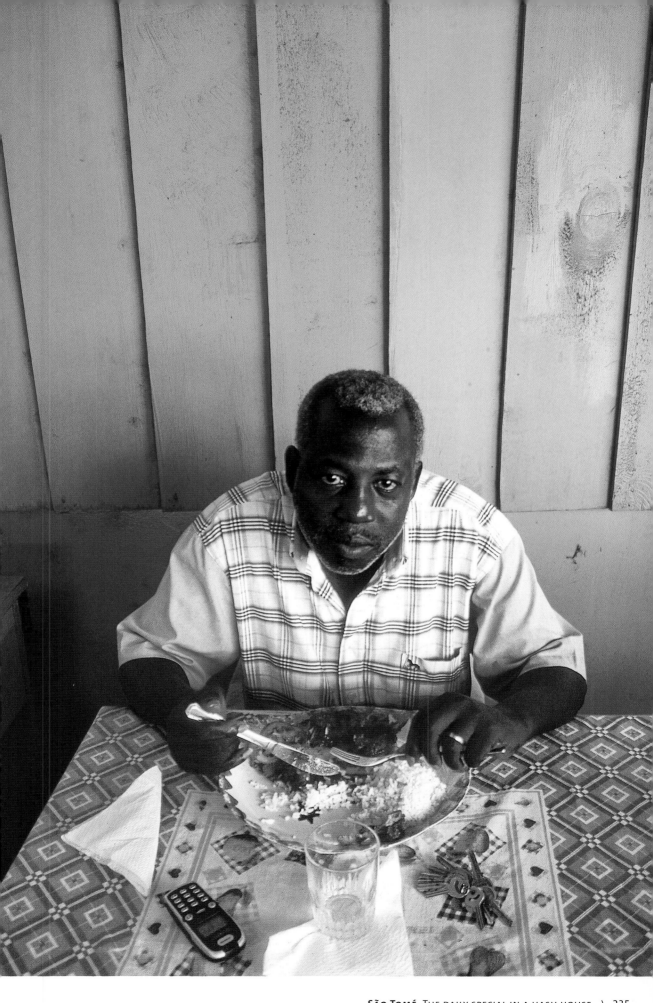

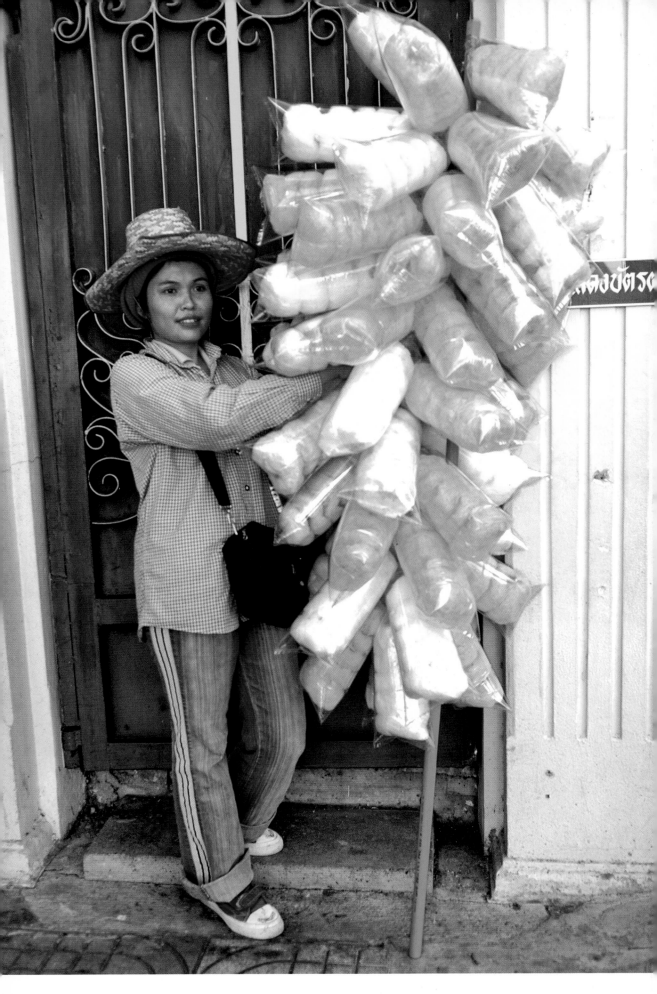

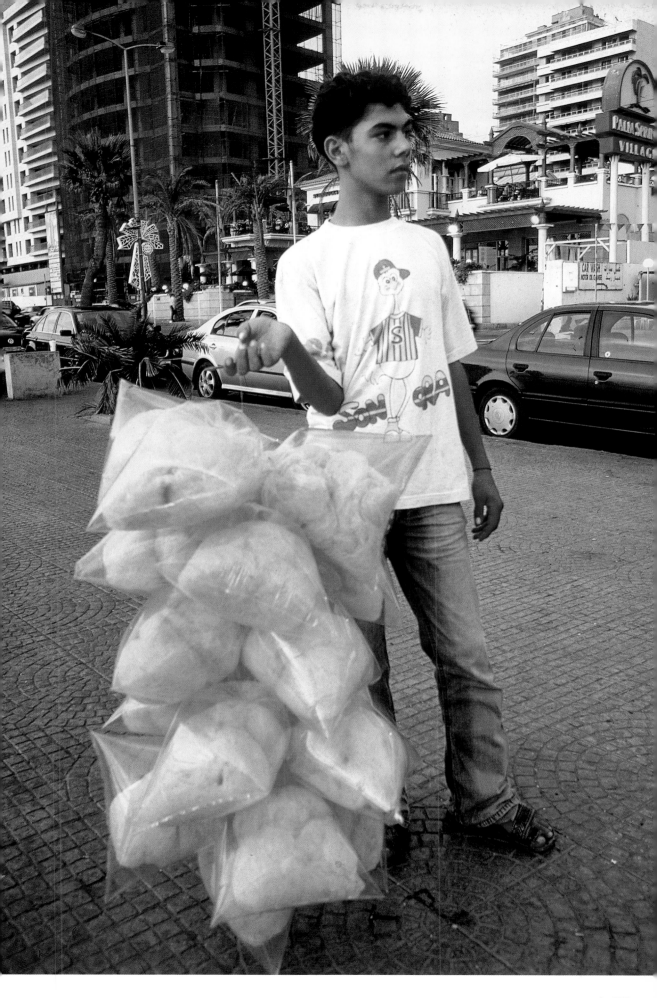

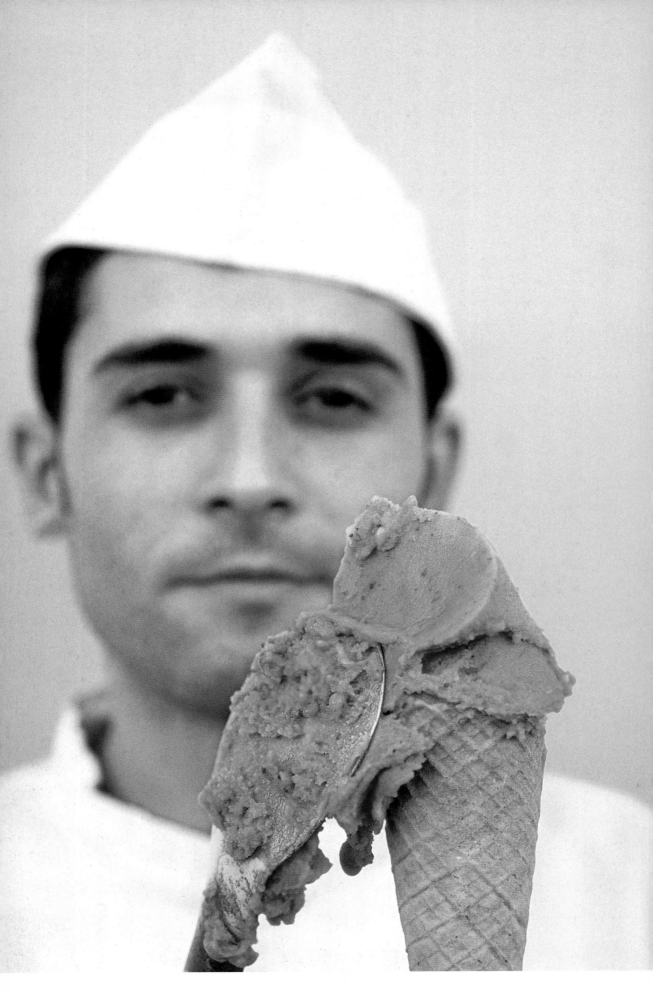

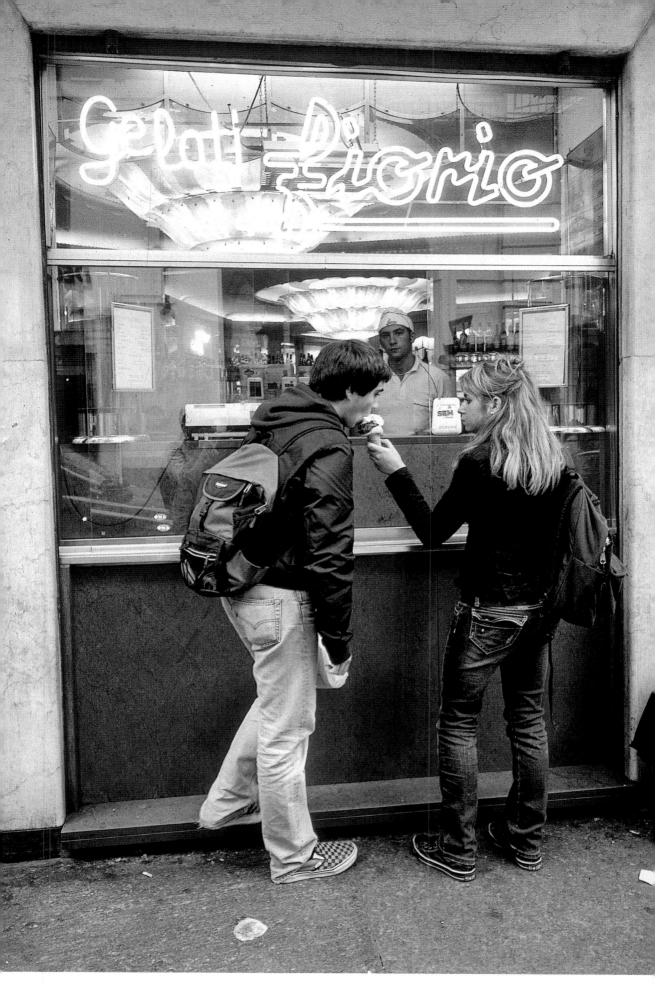

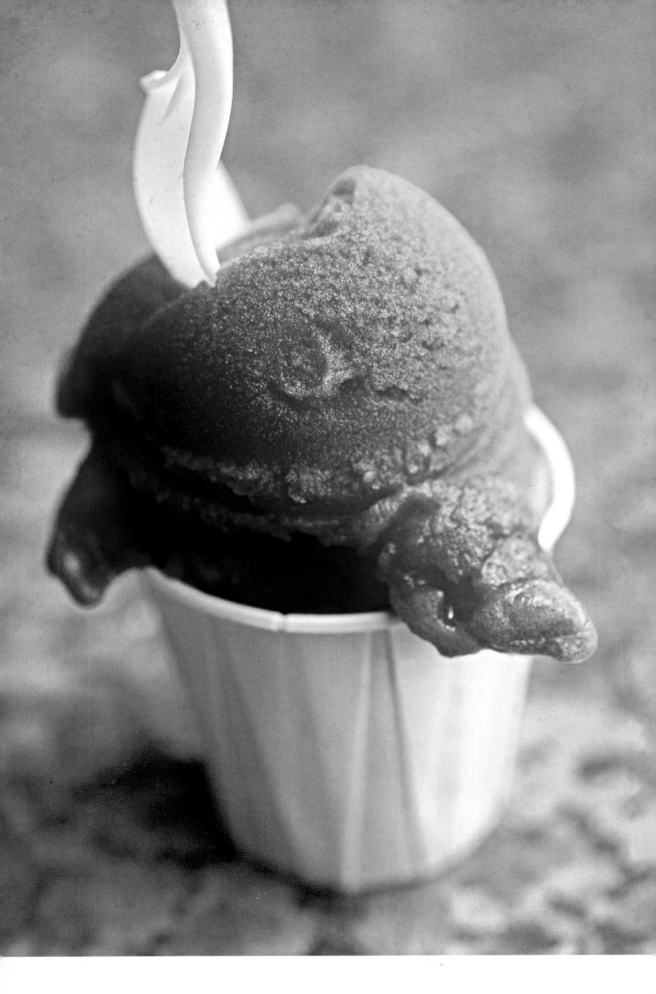

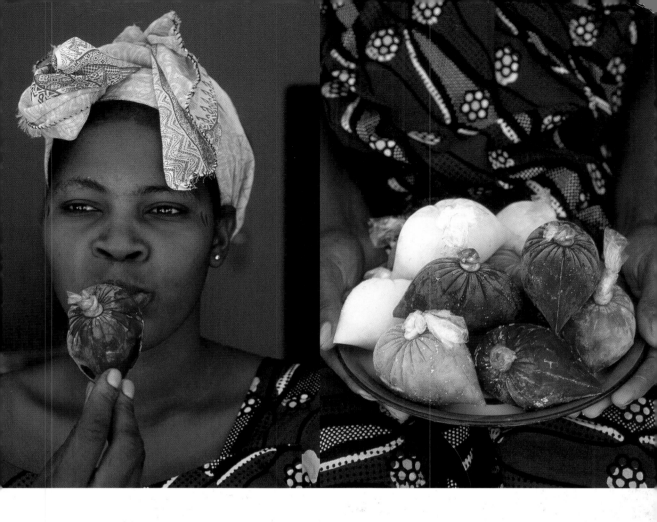

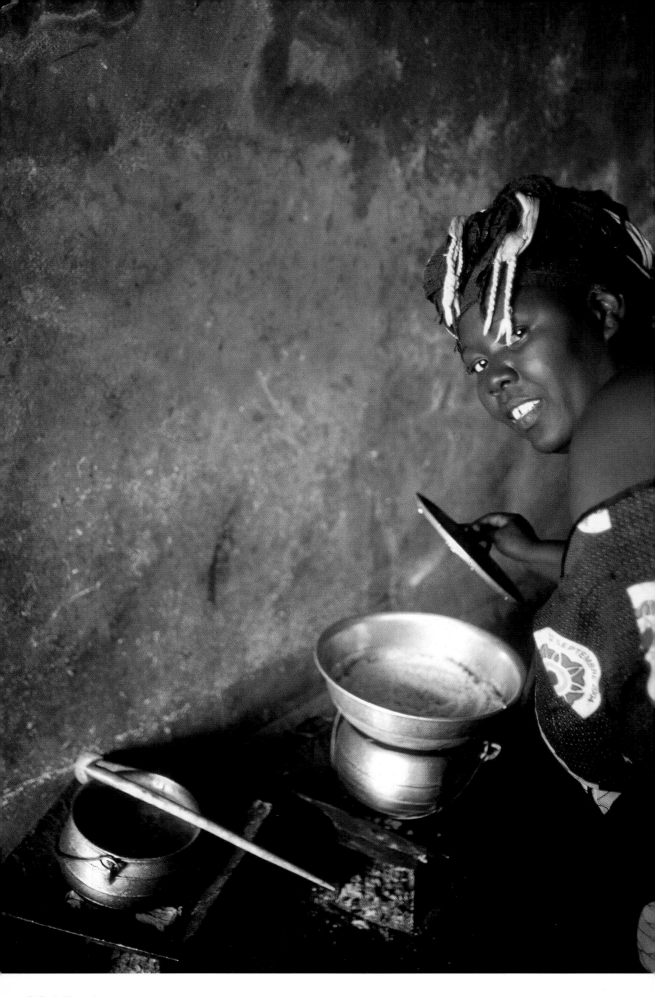

242 / **MALI.** IN THE COURTYARD OF A HOME, A COOK PREPARES *FONIO*, A LOCAL GRAIN, FOR SEVERAL FAMILIES.

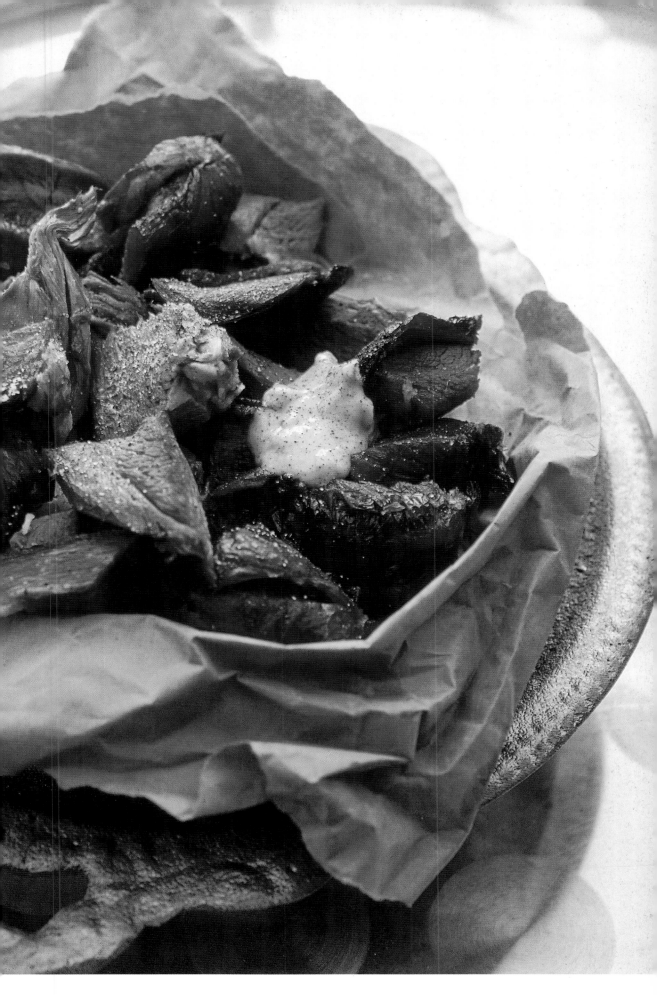

MALI. SMALL BANANA FRITTERS ARE MEANT TO BE EATEN WHILE HOT.

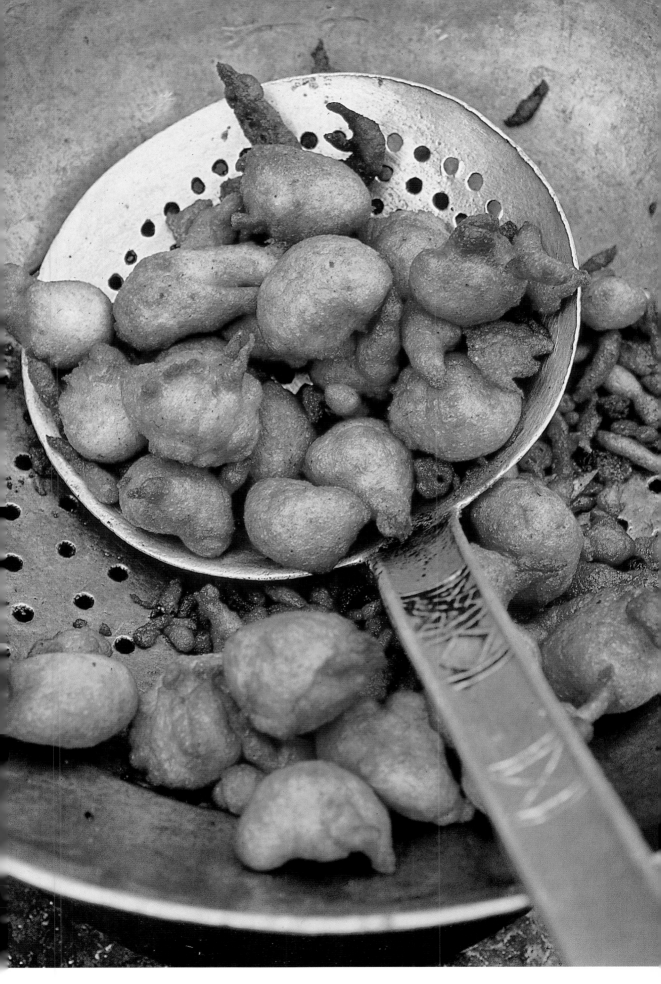

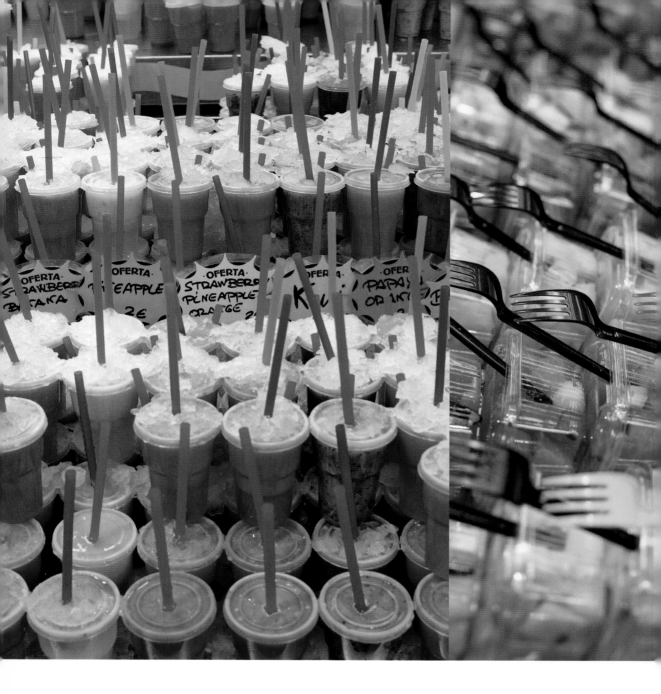

246 / **Barcelona.** (Left) At the Boquería market, multicolored fruit juices are labeled in English for tourists. (Center) Fruit is also sold in plastic containers.

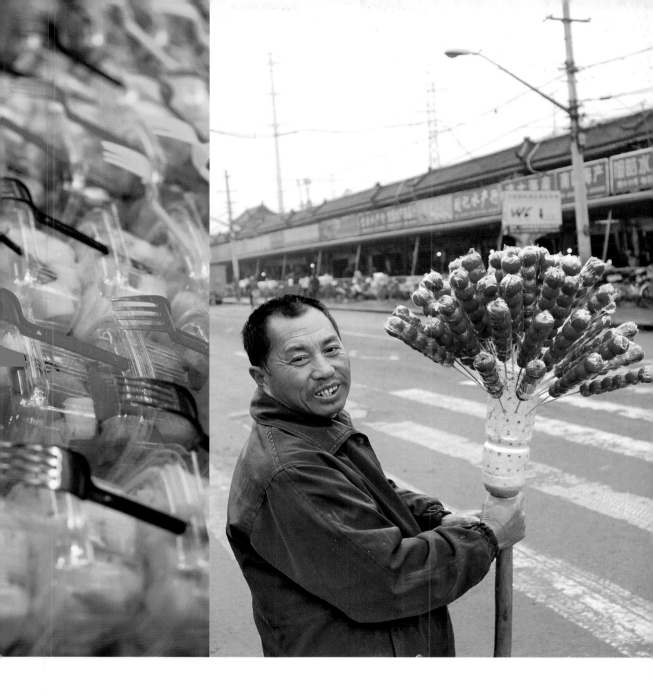

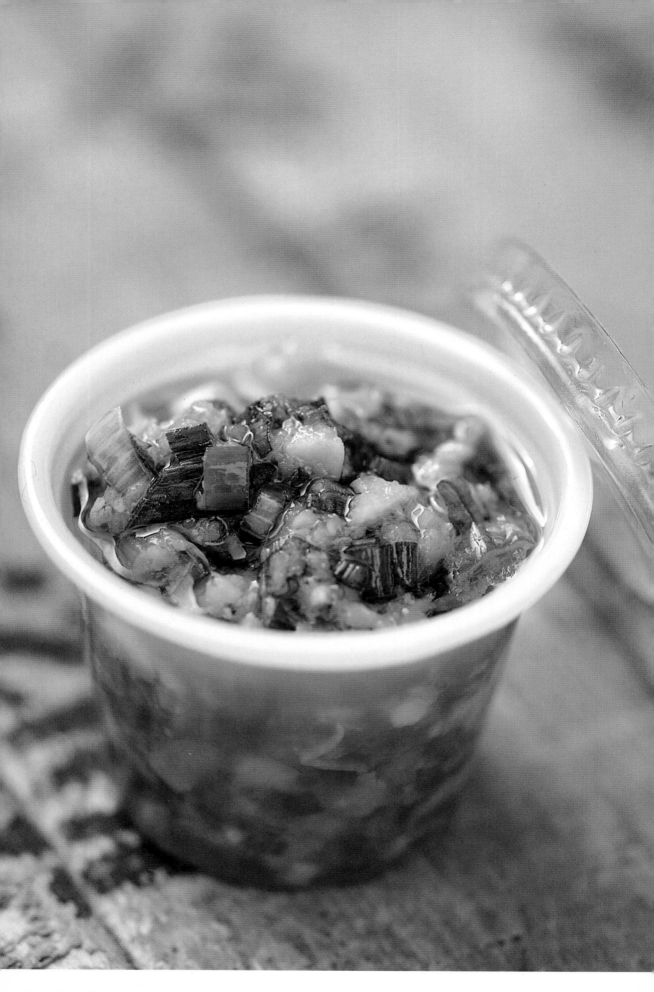

HONG KONG. SAUCE MADE OF GINGER AND FRESH ONIONS IS A PERFECT ACCOMPANIMENT FOR CHICKEN, PORK, AND PEKING DUCK.

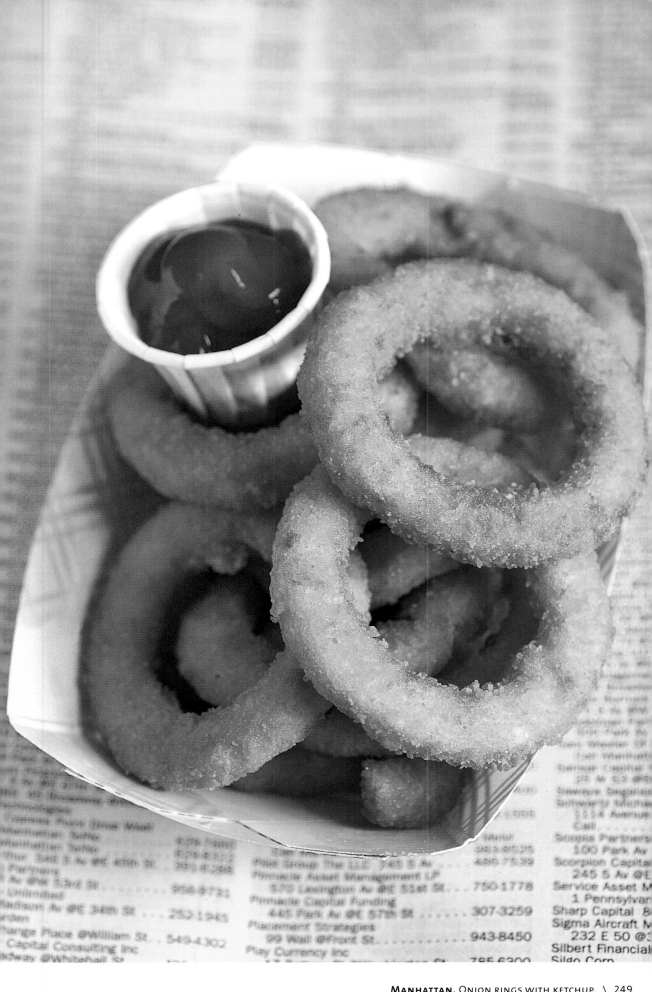

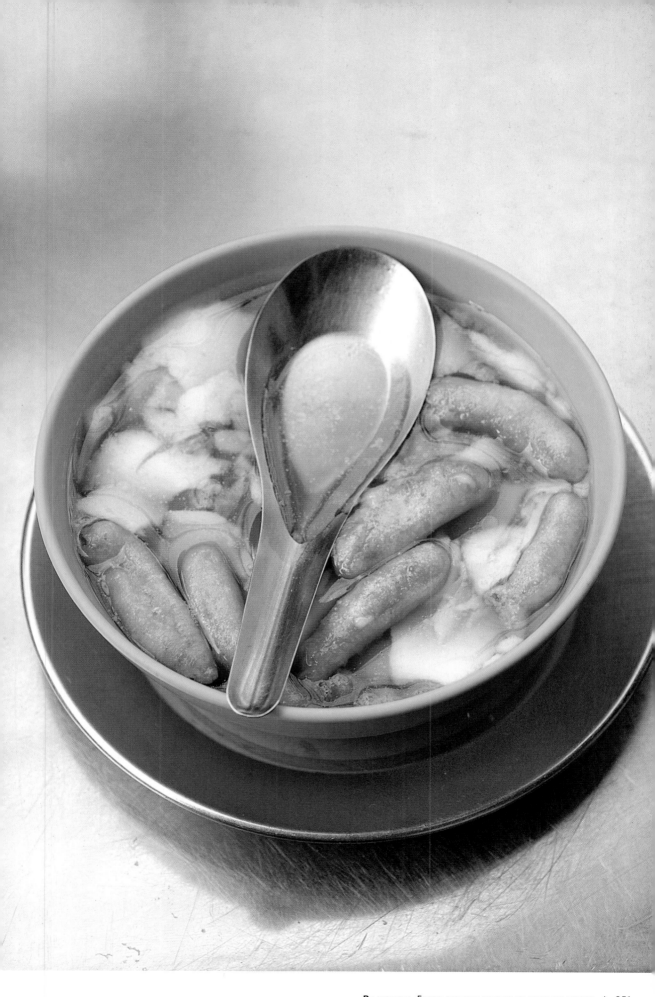

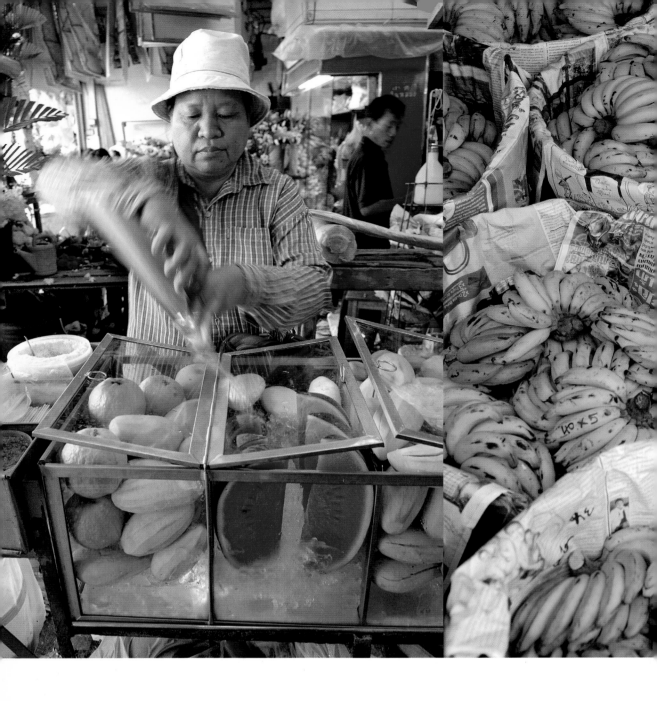

252 / **BANGKOK.** (LEFT) A ROVING VENDOR SELLS FRUIT CUT TO ORDER.
(CENTER) BANANAS SOLD IN BASKETS.

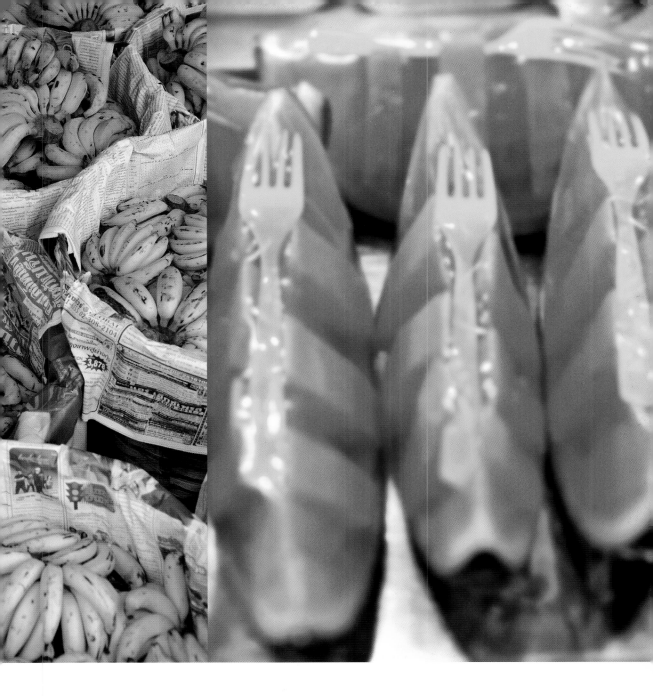

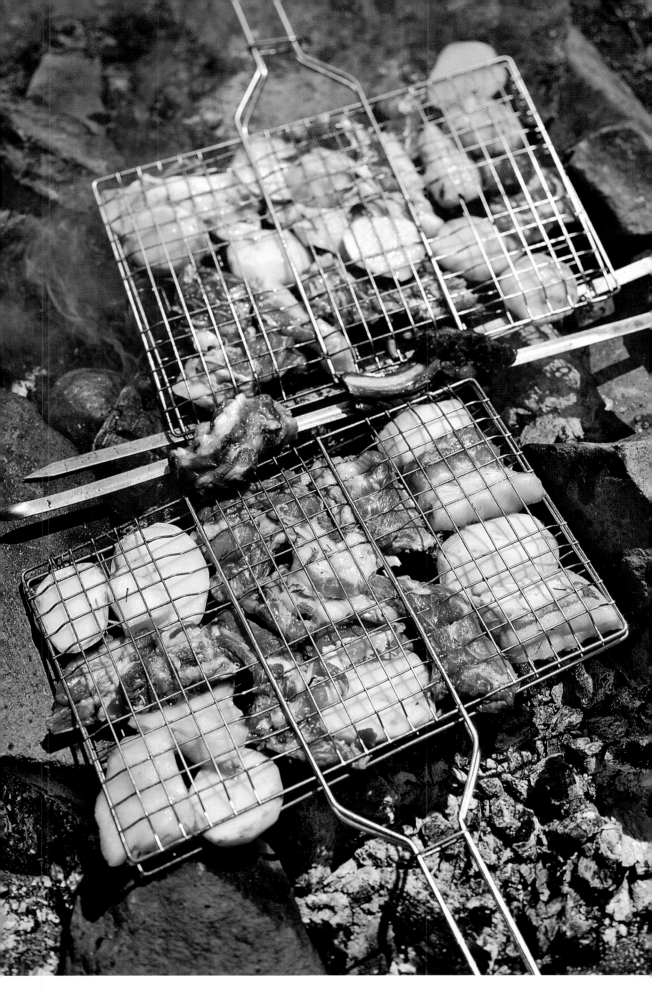

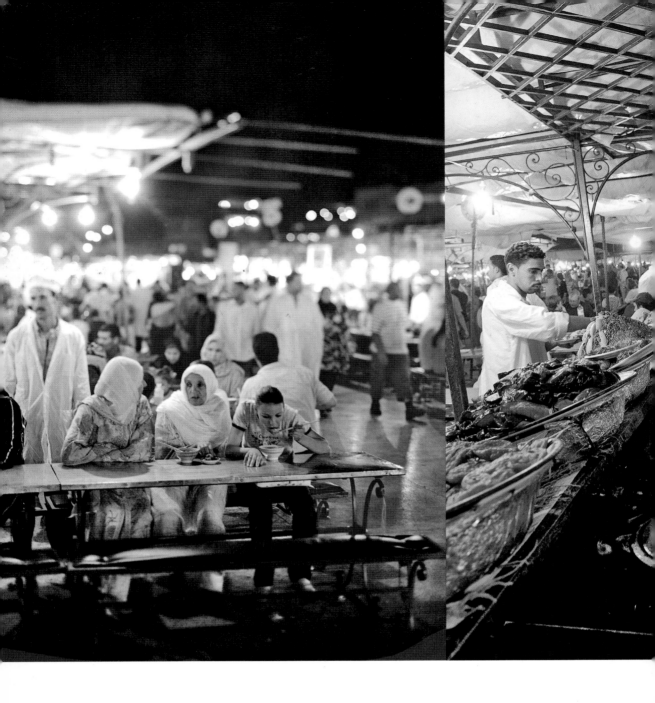

256 / **MARRAKESH.** (LEFT) IN DJEMAA EL-FNA SQUARE, FRIENDS GATHER AT SUNSET AROUND A BOWL
OF MOROCCO'S TRADITIONAL SOUP, *HARIRA*. (CENTER) STAND SELLING *TAGINE* AND (RIGHT) KEBABS.

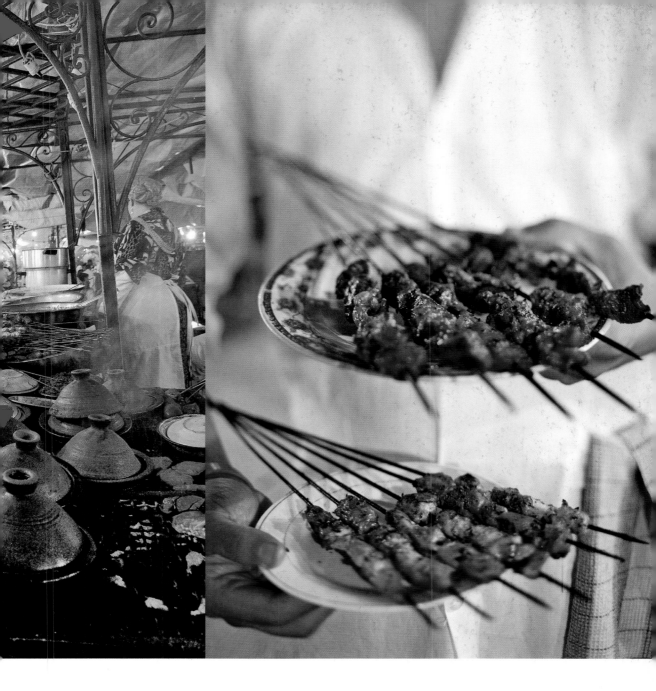

258 / **CHINA.** (LEFT) *WEY WAI KEE* FRITTERS.
BANGKOK. (CENTER) PORK SAUSAGES.

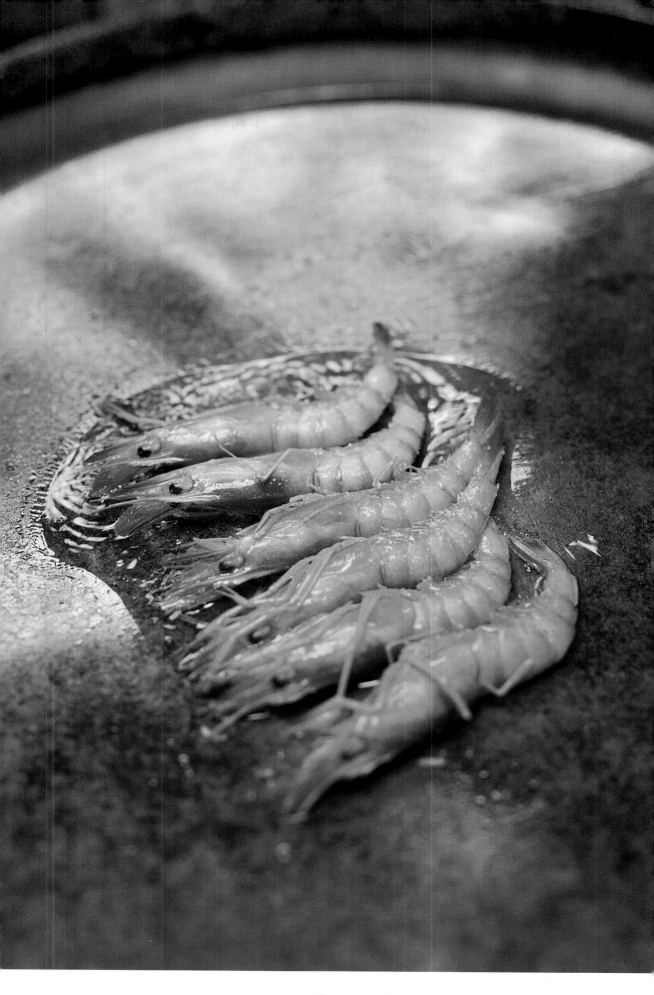

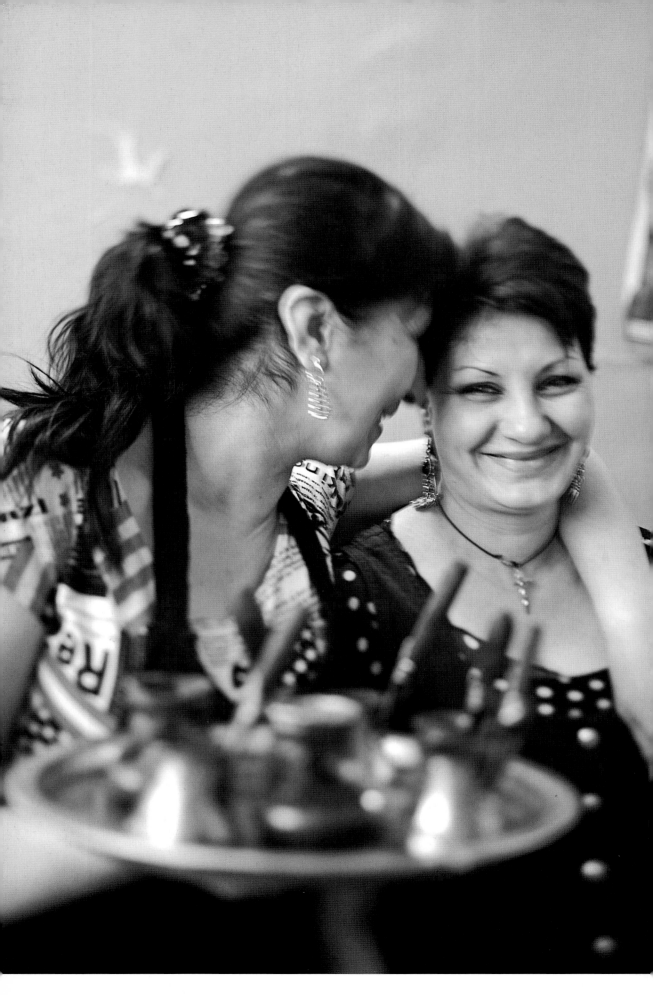

ARMENIA. SERVERS STROLL THROUGH THE MARKET STANDS SELLING COFFEE TO SHOPPERS.

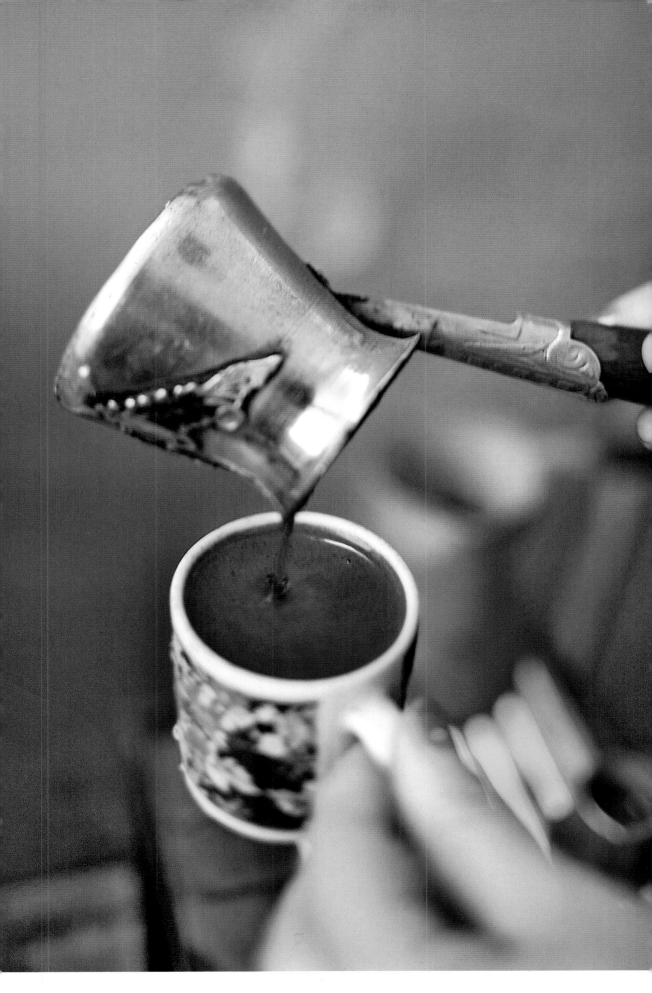

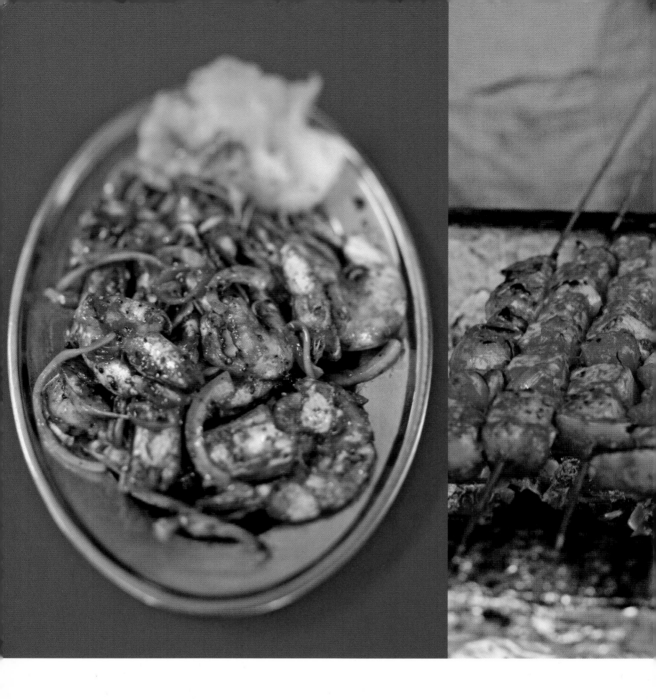

264 / **MALAYSIA.** (LEFT) SAUTÉED SHRIMP WITH BLACK PEPPER.
INDIA. (CENTER) VEGETARIAN TIKKA KEBABS.

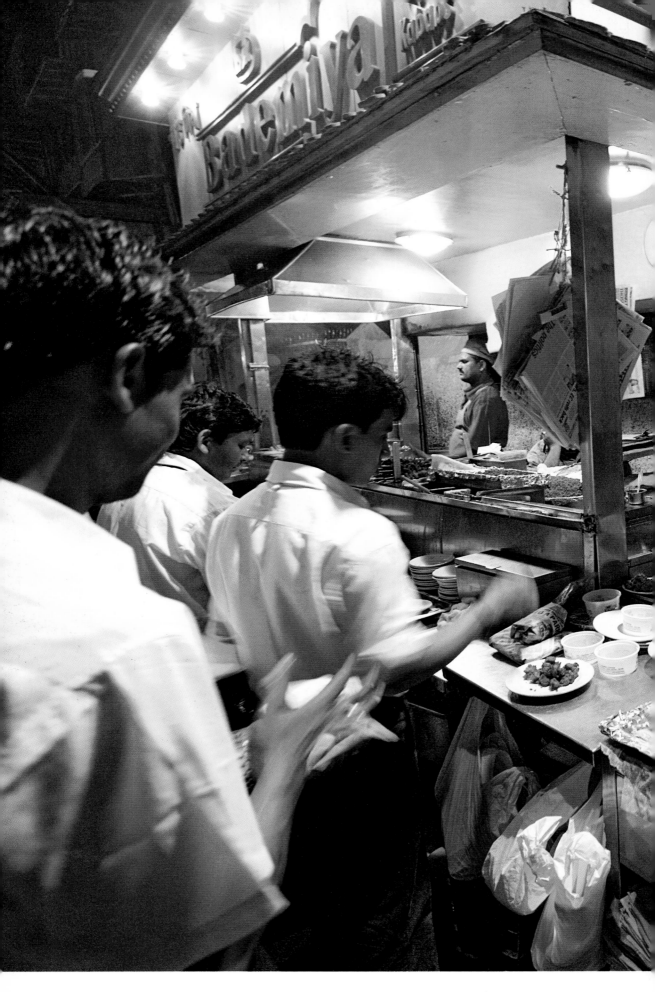

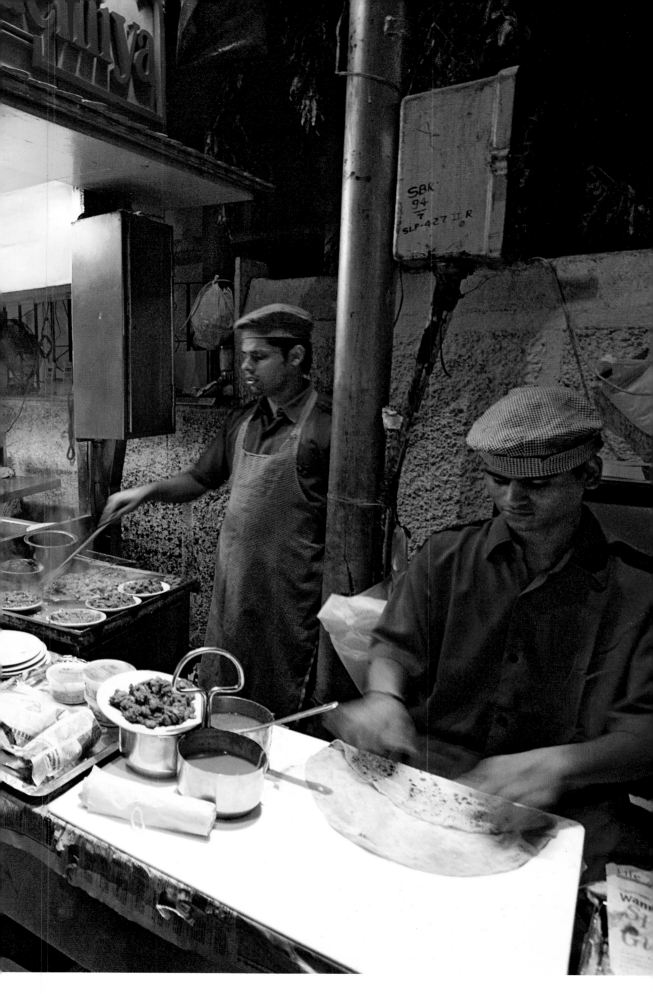

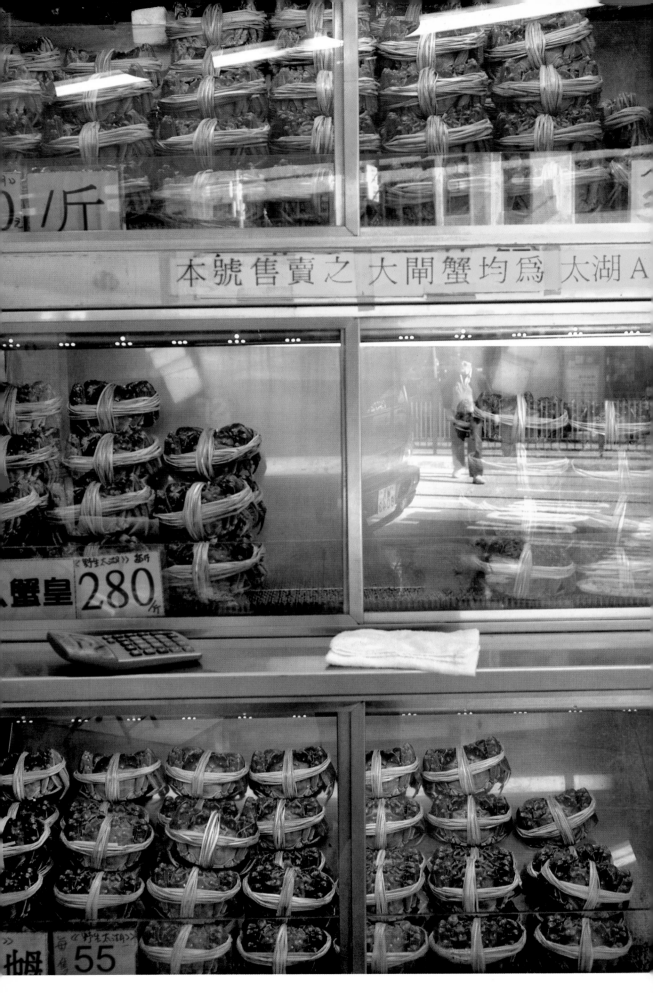

本號售賣之 大閘蟹均爲 太湖A

280/斤

55

HONG KONG. CHINESE MITTEN CRAB POACHED IN FRESH WATER IS AN EXPENSIVE DISH PRIZED FOR ITS APHRODISIAC PROPERTIES.

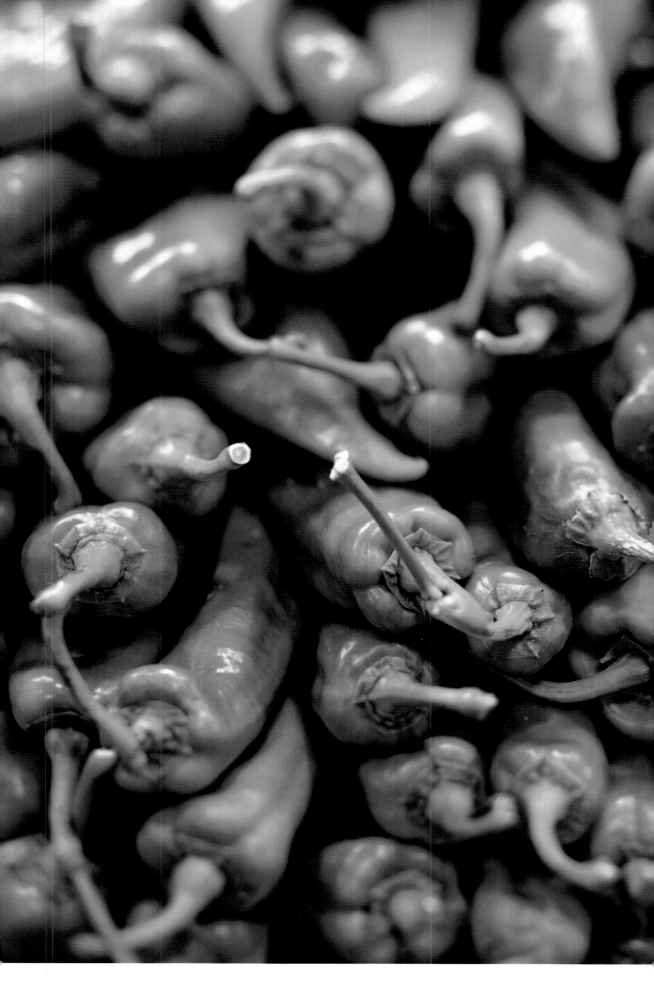

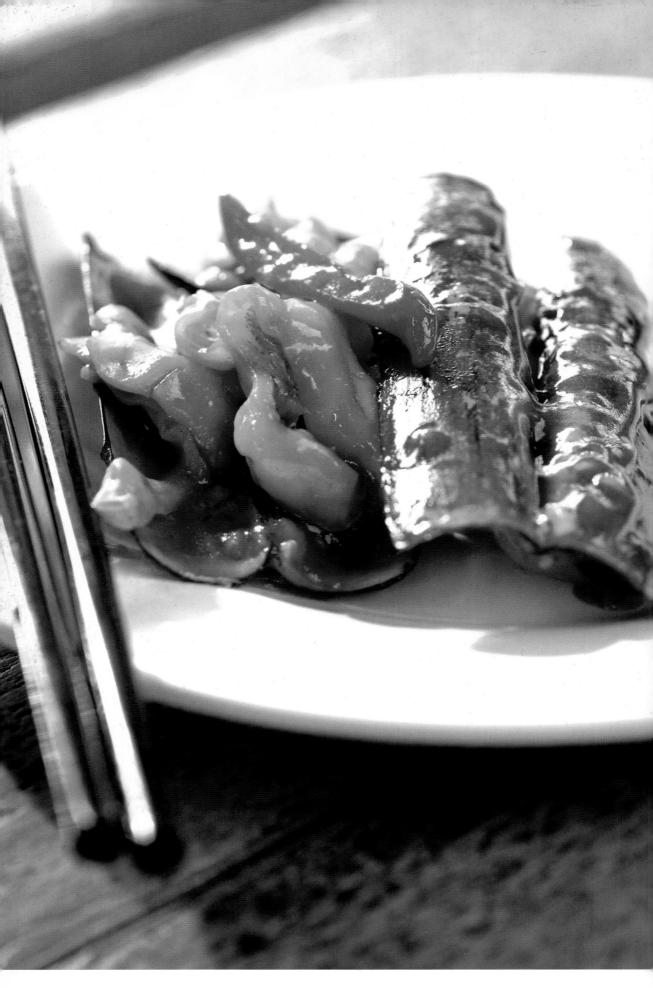

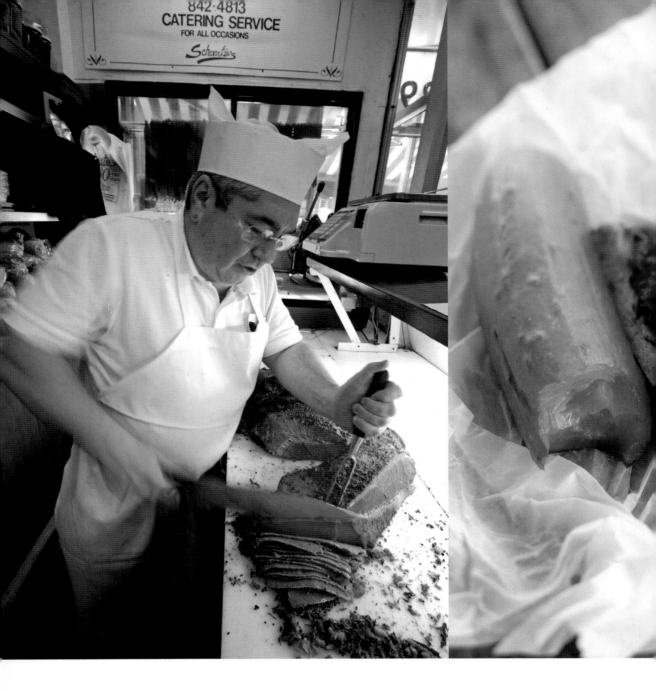

842-4813
CATERING SERVICE
FOR ALL OCCASIONS
Schwartz's

274 / **MONTREAL.** (LEFT AND CENTER) SLICING PASTRAMI FOR A SANDWICH AT SCHWARTZ'S.

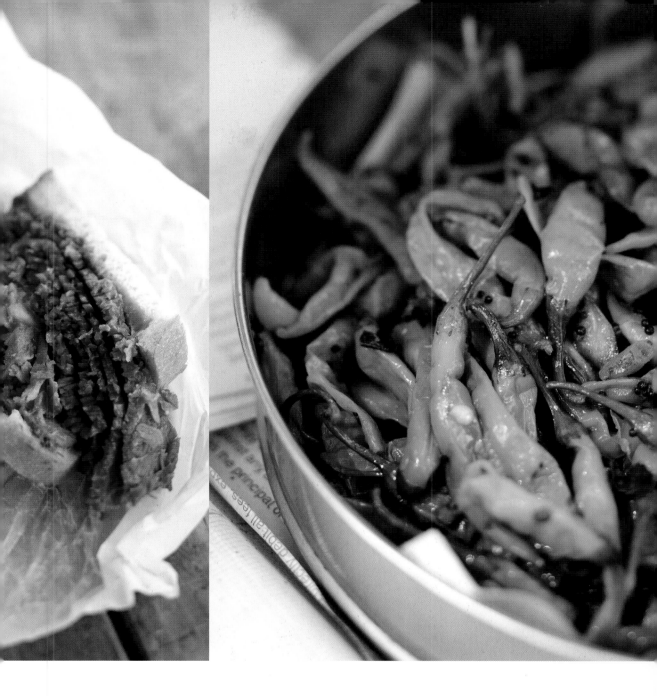

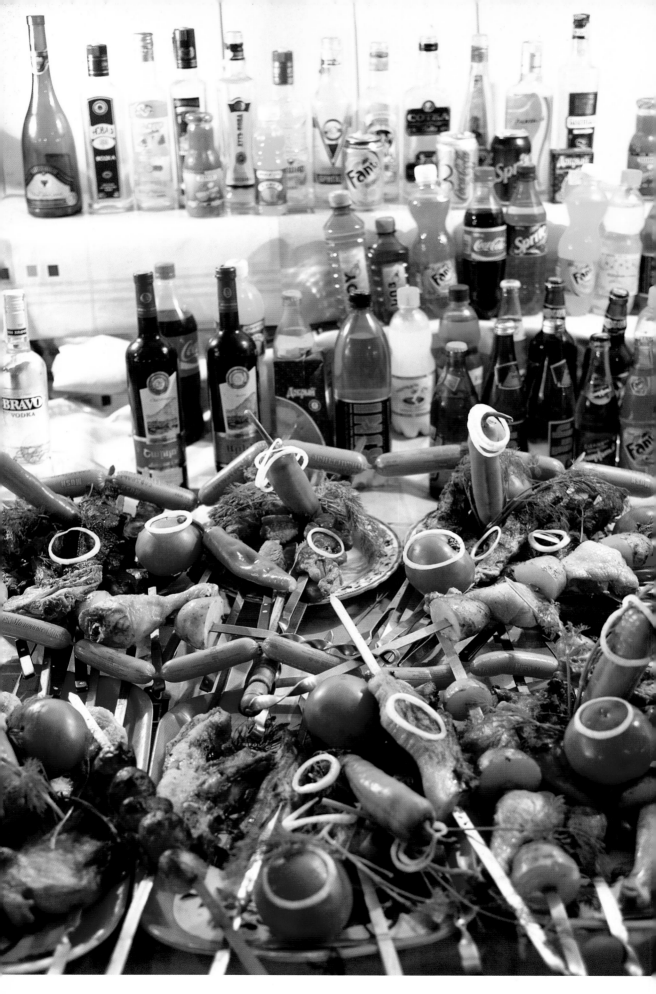

276 / **YEREVAN.** SHISH KEBABS FOR SALE AT A SUBWAY ENTRANCE.

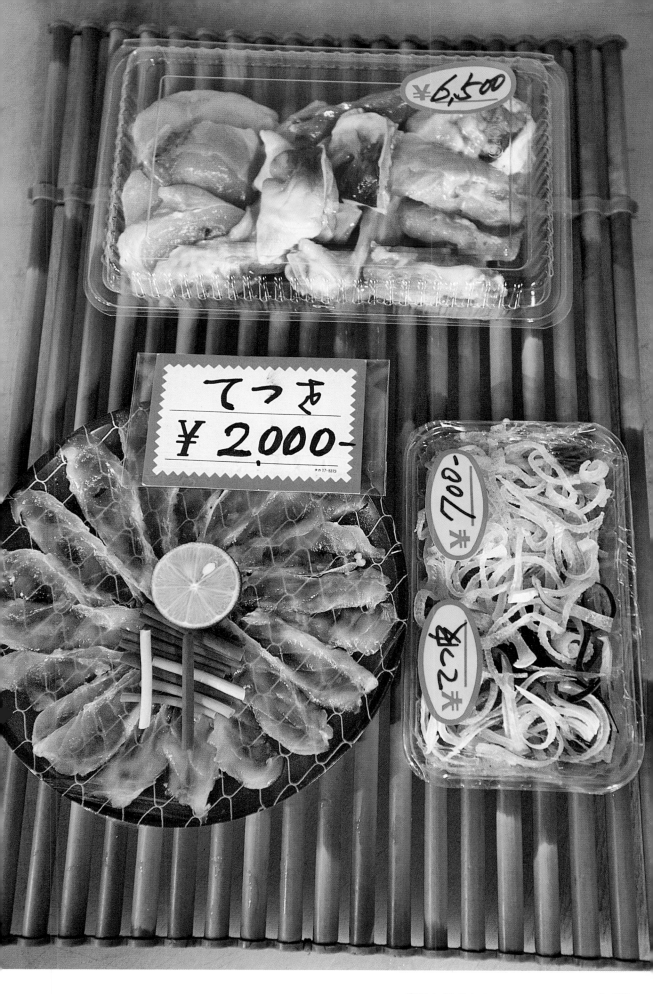

てつ身
¥2,000-

EATING THIS FISH CAN BE LETHAL UNLESS IT IS PREPARED BY AN EXPERT.

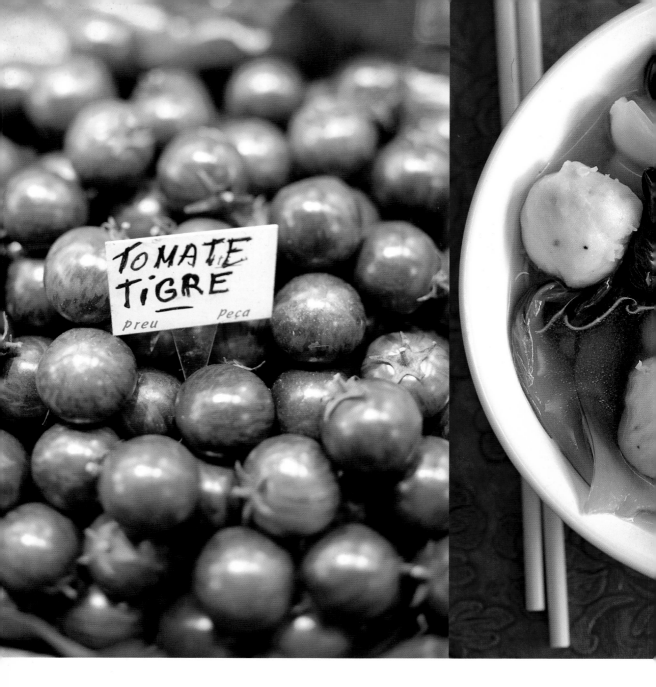

On the sign: TOMATE TIGRE *preu* *Peça*

278 / **SPAIN.** (LEFT) TIGER TOMATOES.
HONG KONG. (CENTER) BROTH WITH VERMICELLI, BOK CHOY, AND FISH BALLS.

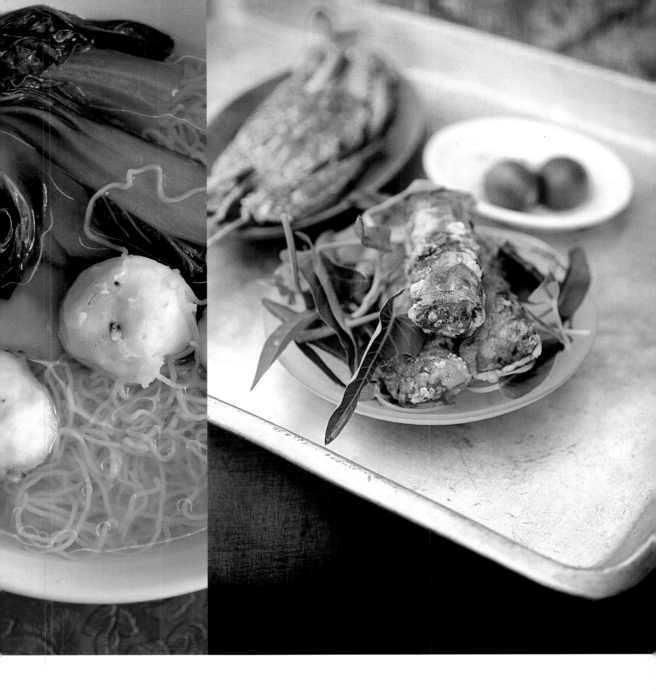

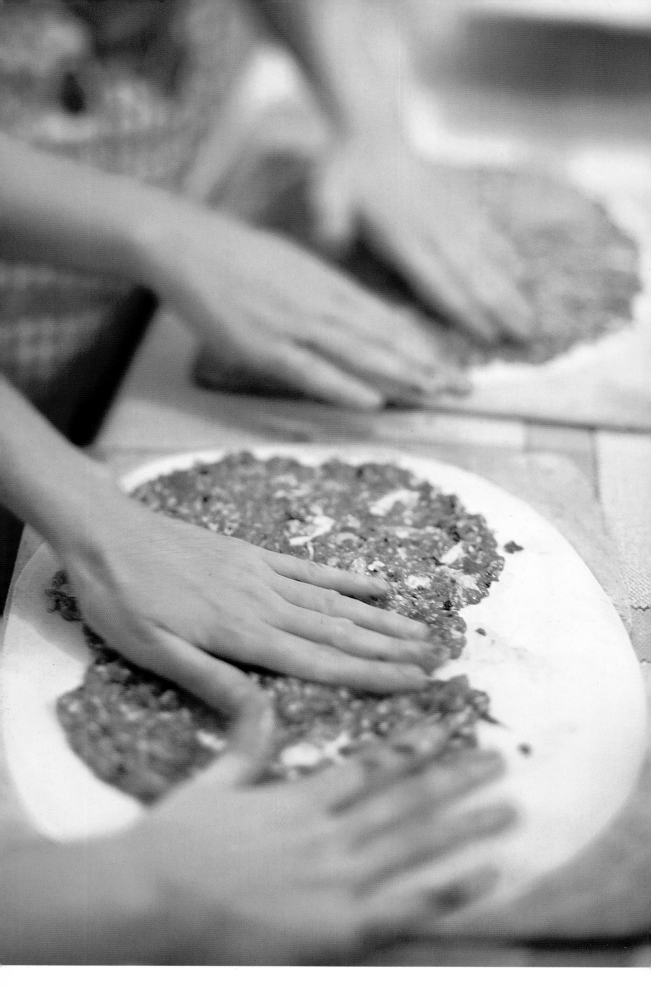

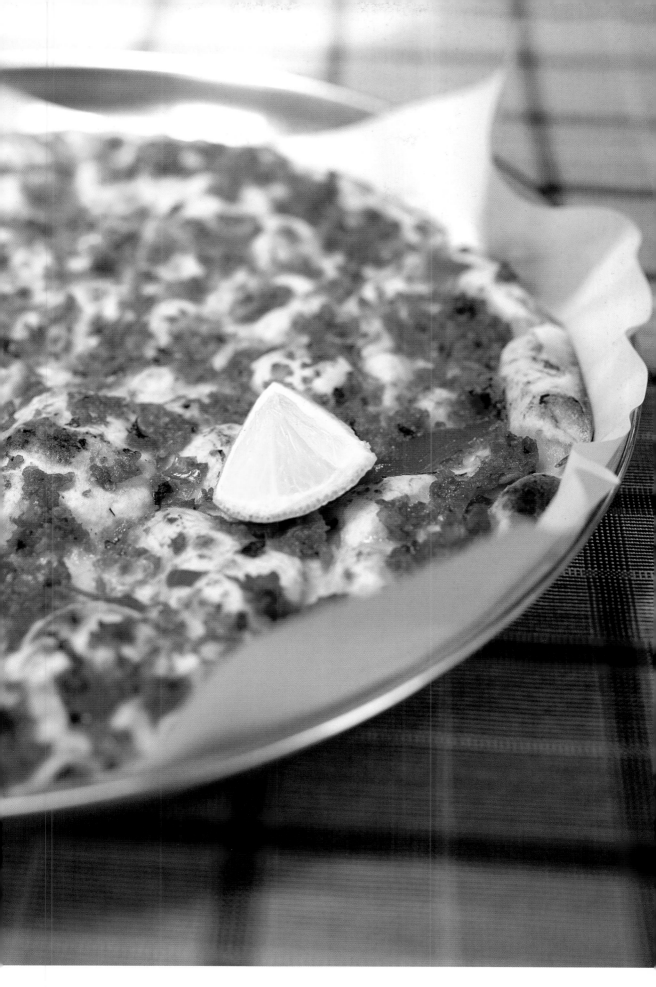

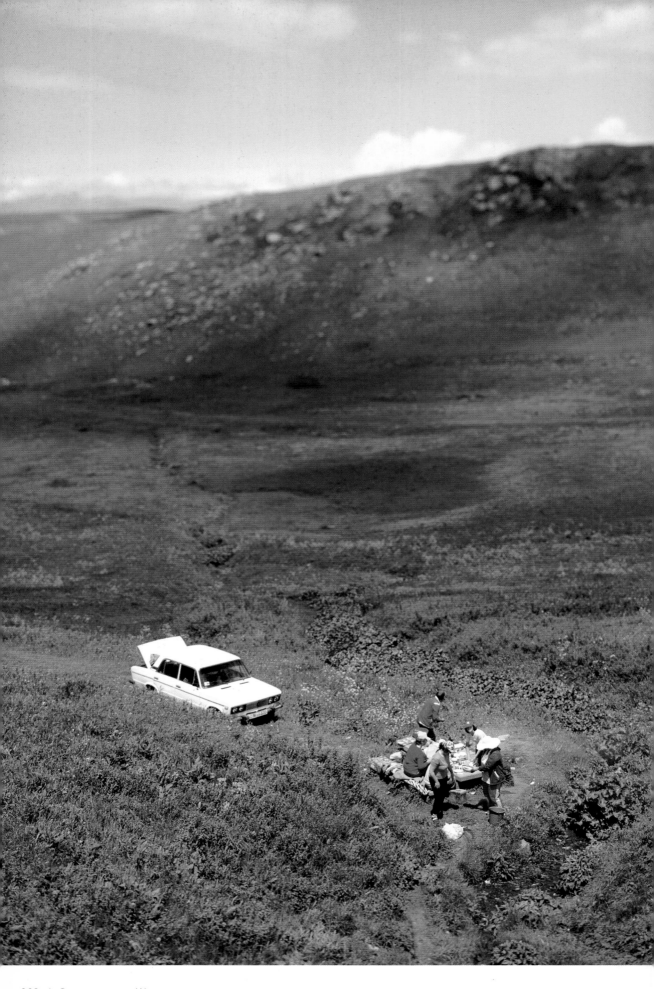

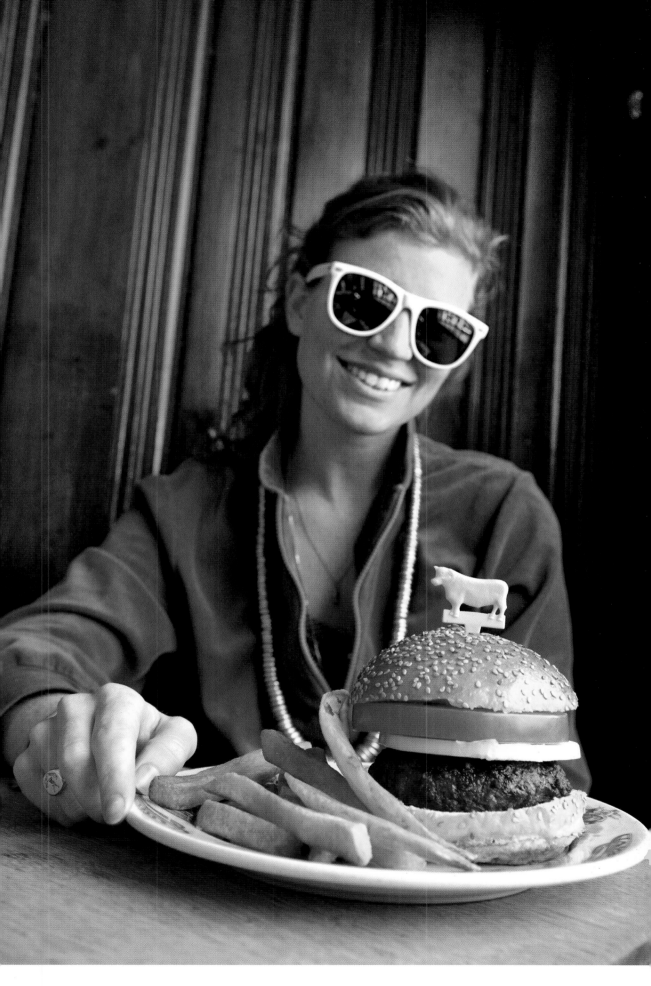

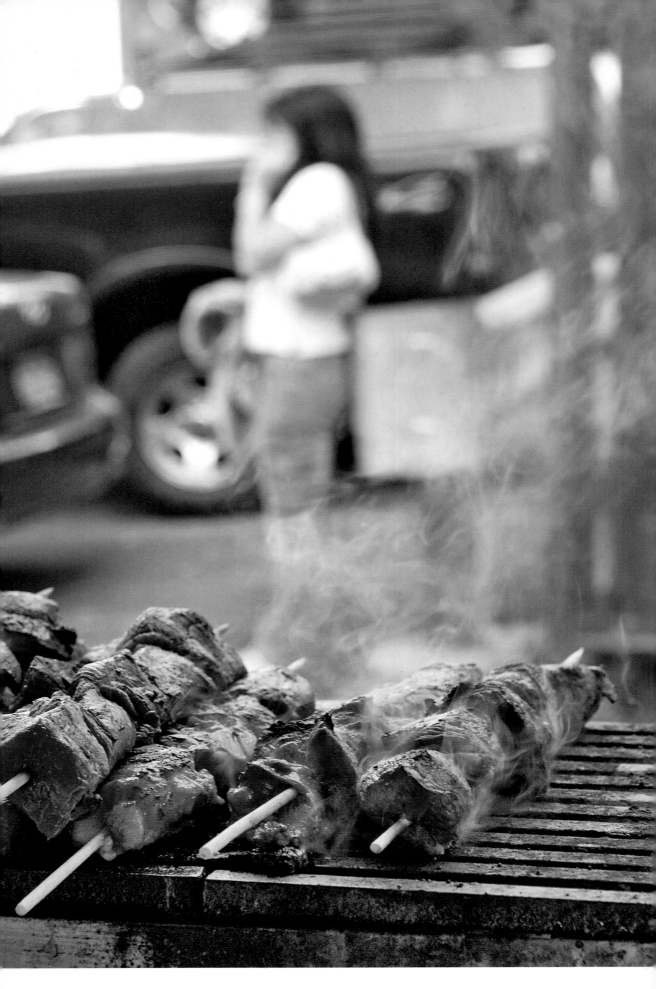

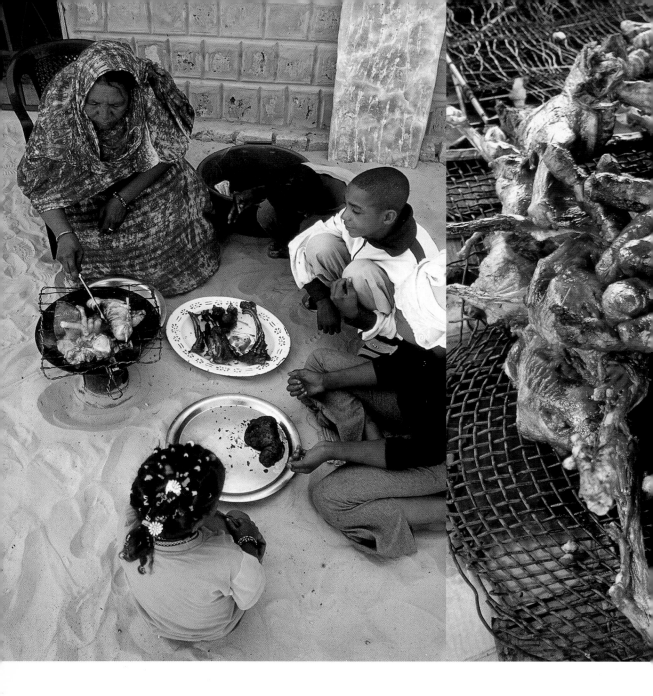

286 / **TIMBUKTU.** (LEFT) DURING THE AID EL KEBIR FESTIVAL, GRILLED SHEEP ENTRAILS, *DIBISOGO*, ARE FED TO CHILDREN. (CENTER) ALL THE GRILLED MUTTON PIECES ARE THE SAME PRICE; EARLY CUSTOMERS GET THE BEST CUTS.

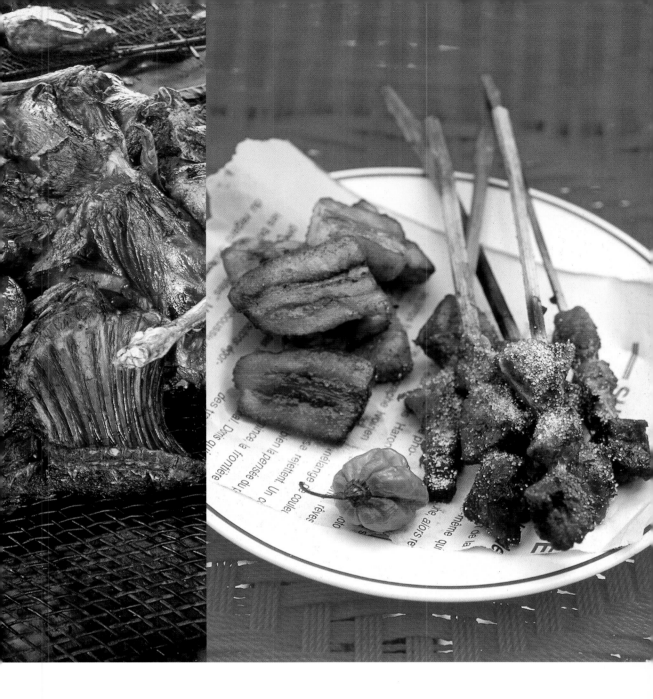

288 / **THAILAND.** COCKLES MARINATING IN SOY SAUCE.

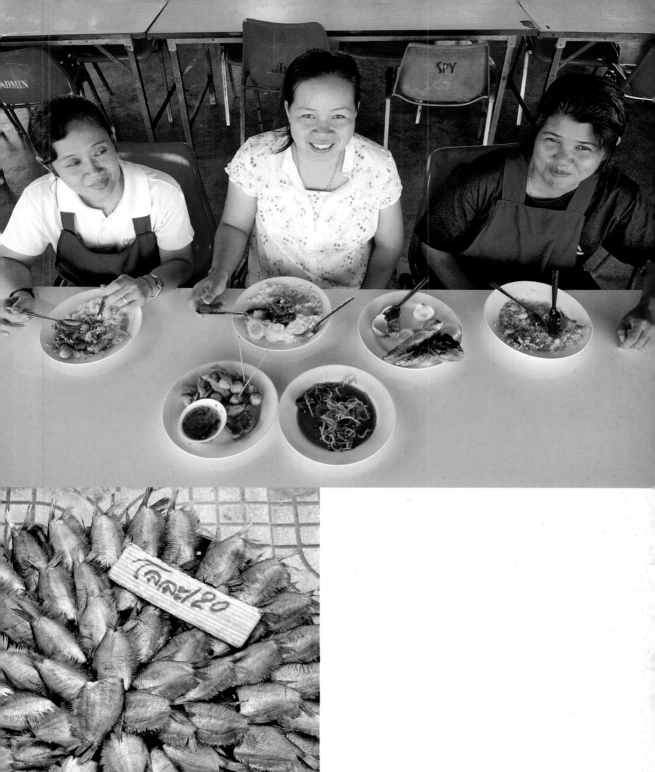

THAILAND. (TOP) A MEAL EATEN IN THE FACTORY LUNCHROOM. \ 289
(ABOVE) FISH DRYING IN THE STREET.

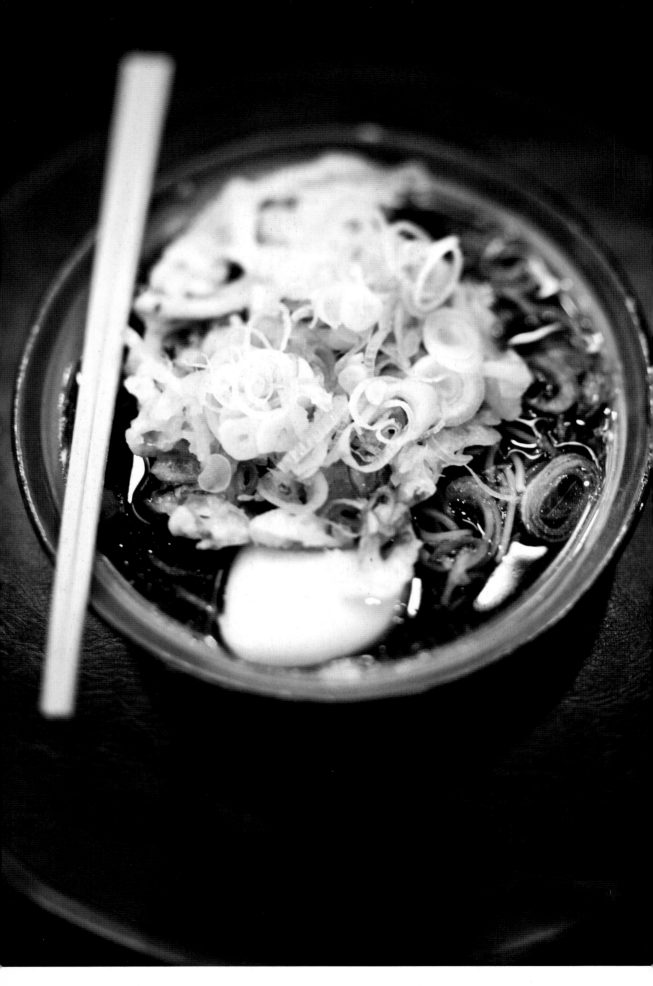

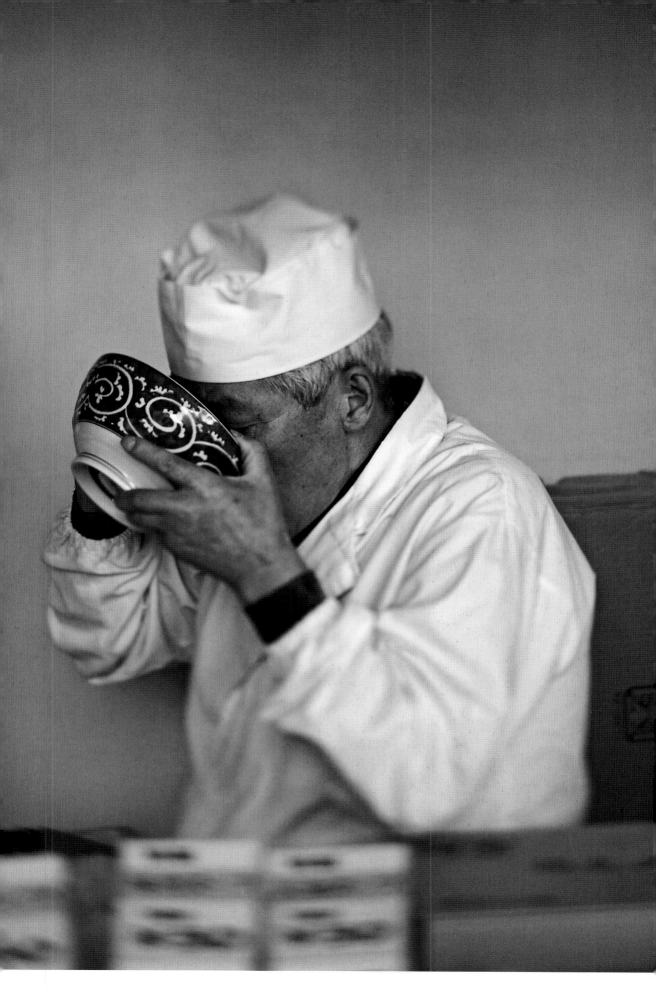

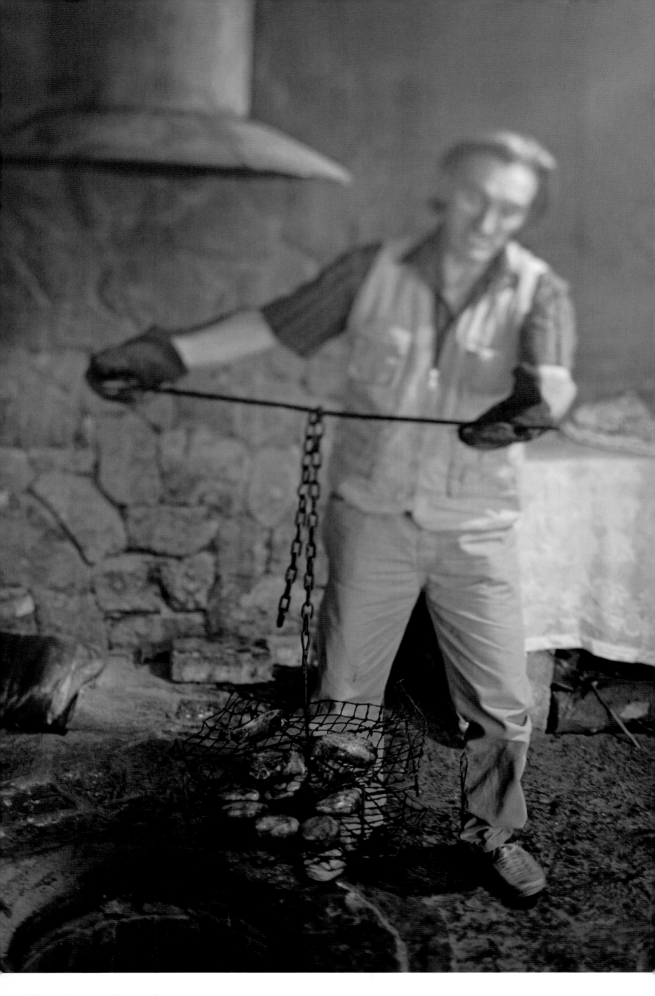

292 / **ARMENIA.** *TONIR* IS A KIND OF BARBECUE COOKED IN A GRILL BASKET.
HERE, PORK AND POTATOES.

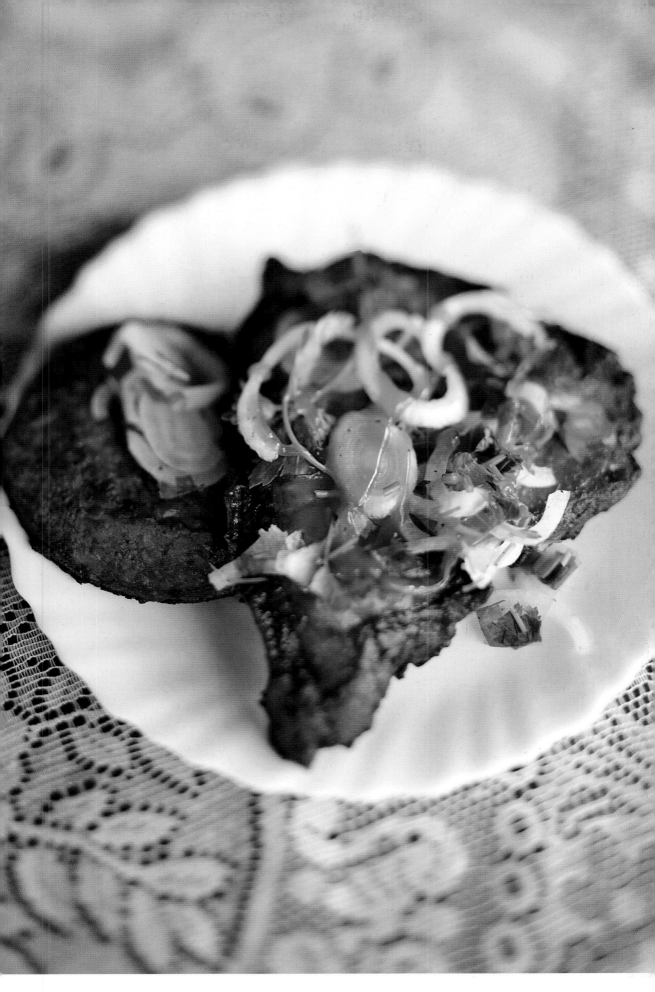

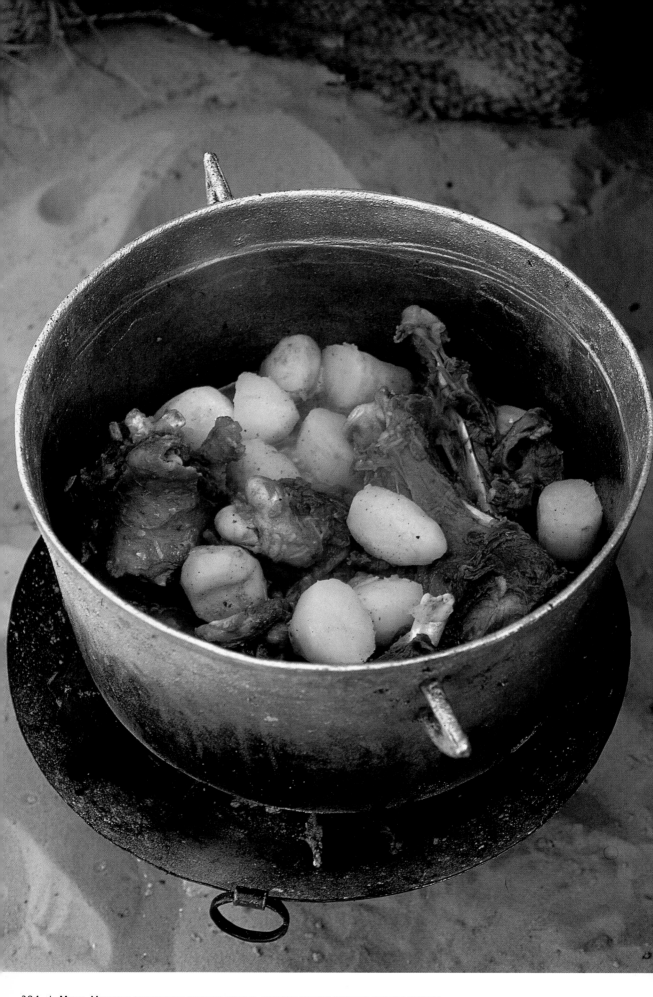

294 / **MALI.** MUTTON STEW WITH TWELVE SPICES, COOKED IN THE MIDDLE OF THE DESERT.

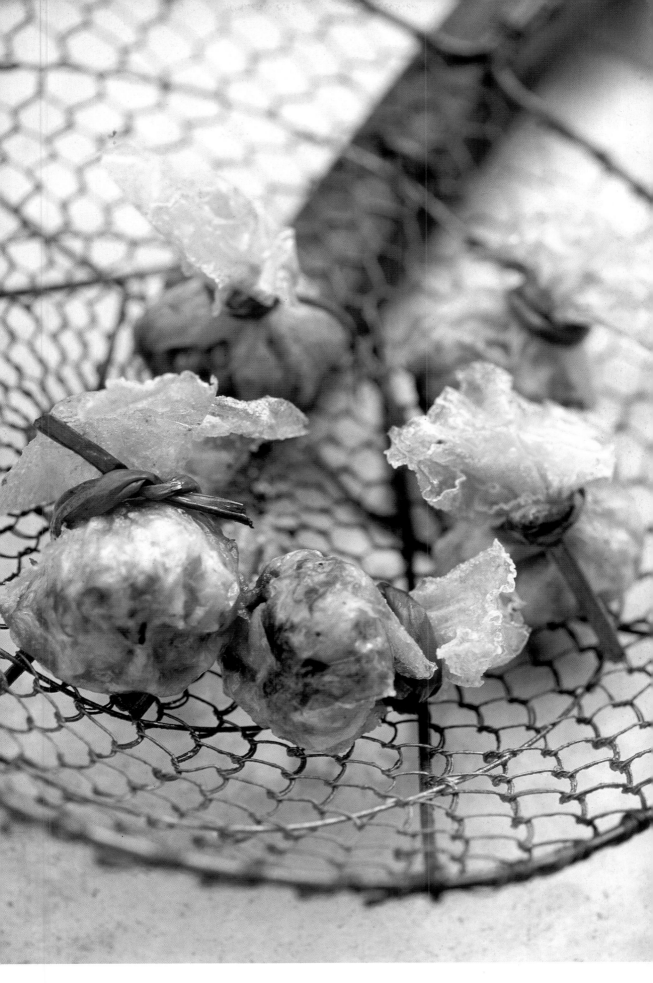

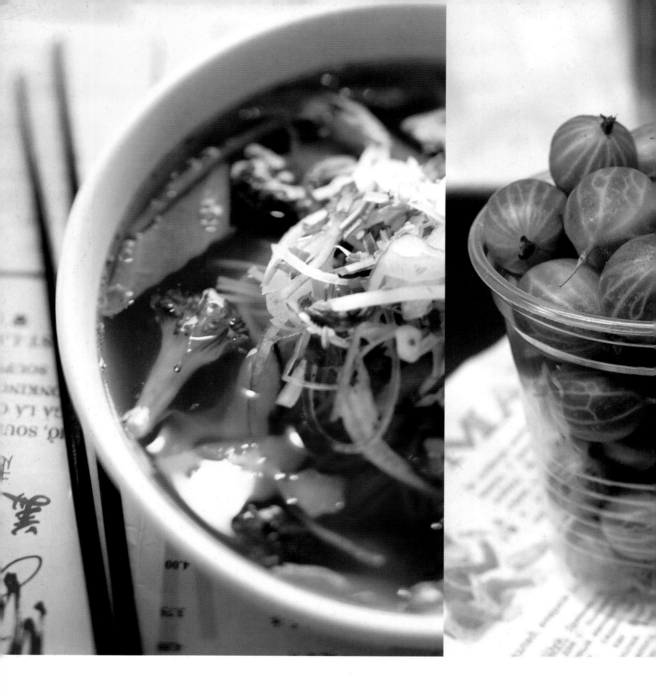

296 / **QUEBEC.** (LEFT) "VIET QUEBEC" SOUP WITH CHICKEN AND CRUNCHY VEGETABLES.
UKRAINE. (CENTER) A CUP OF GOOSEBERRIES.

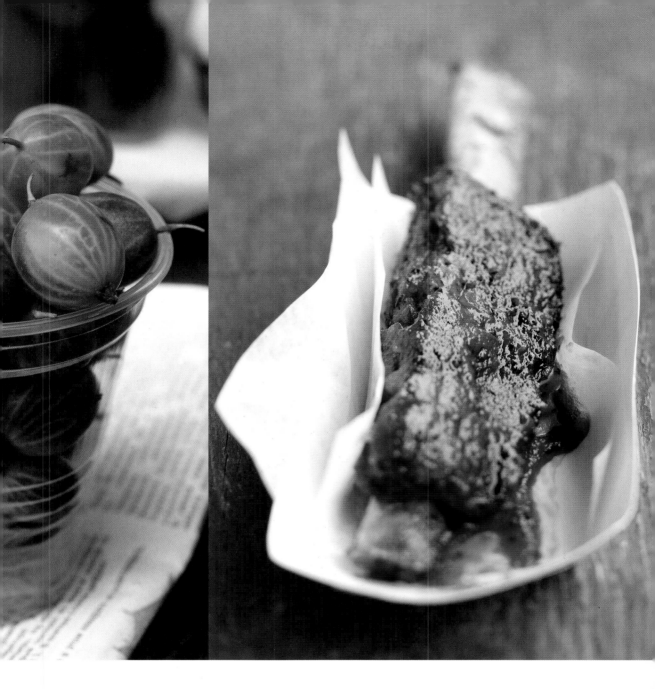

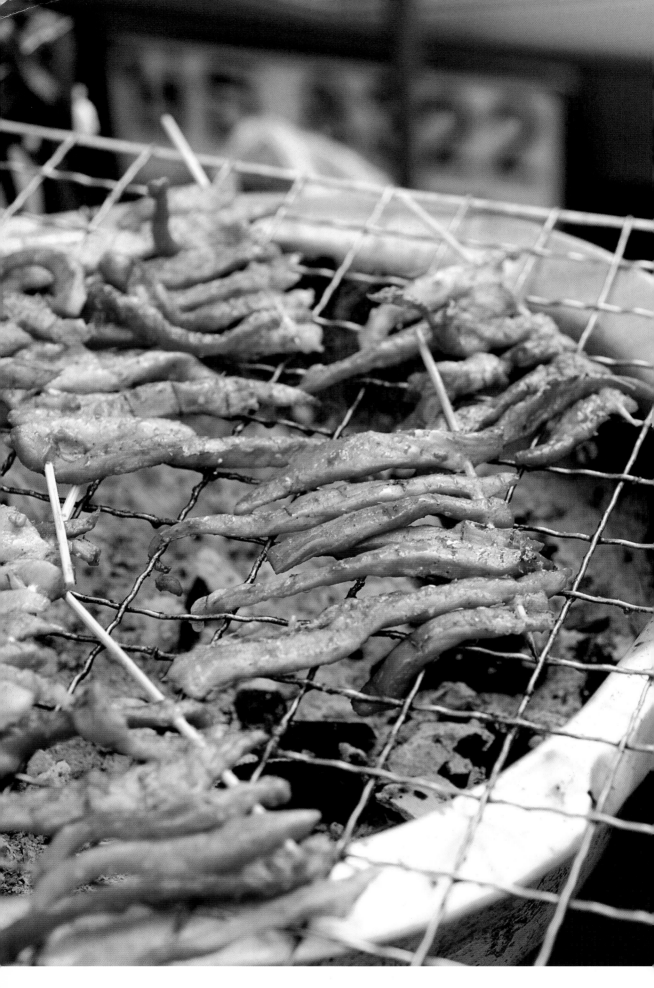

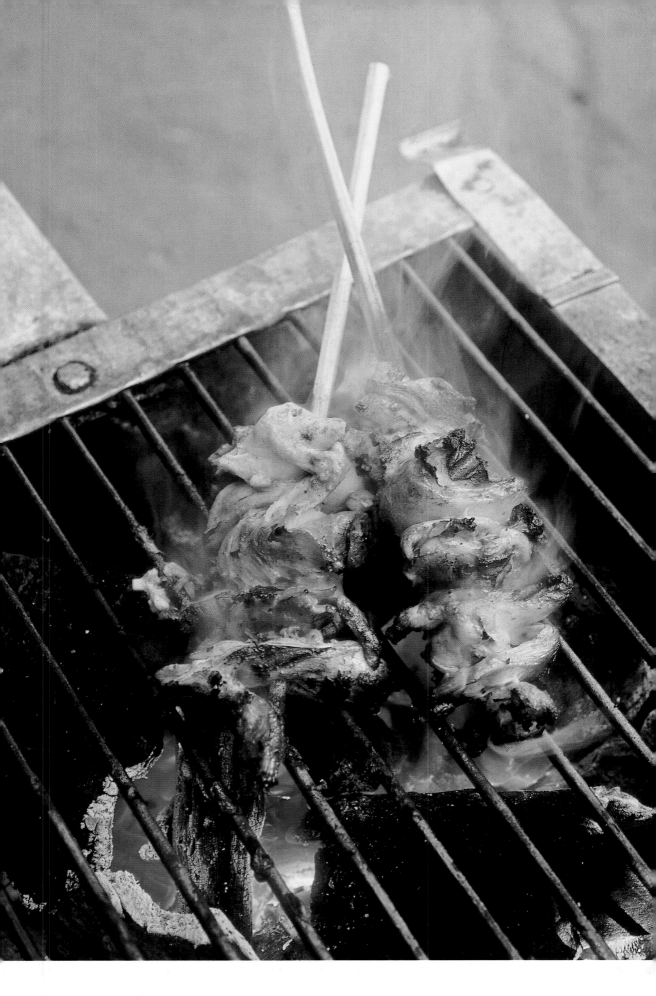

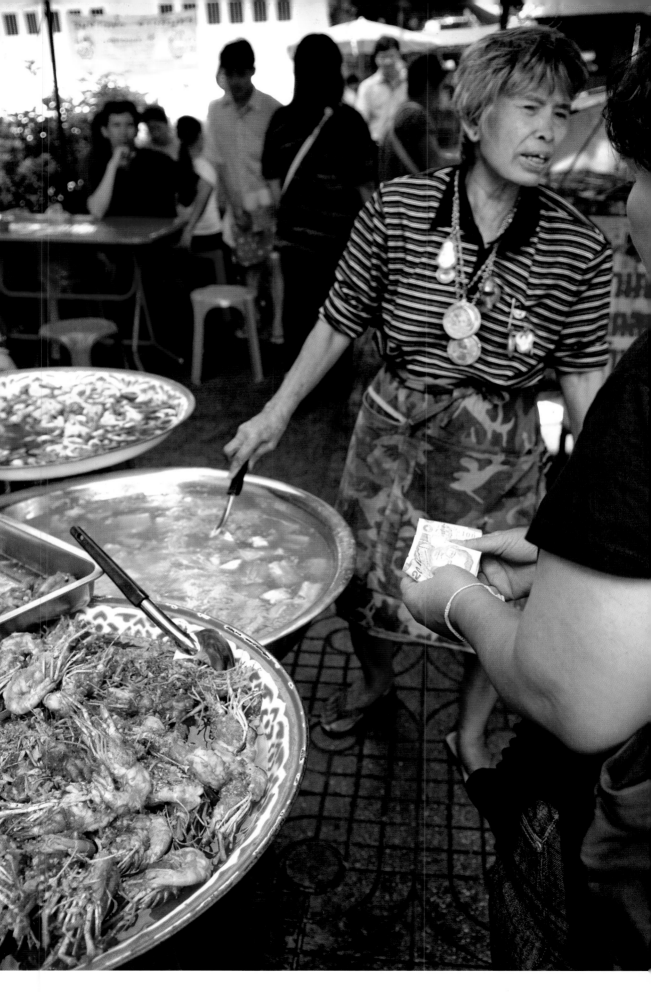

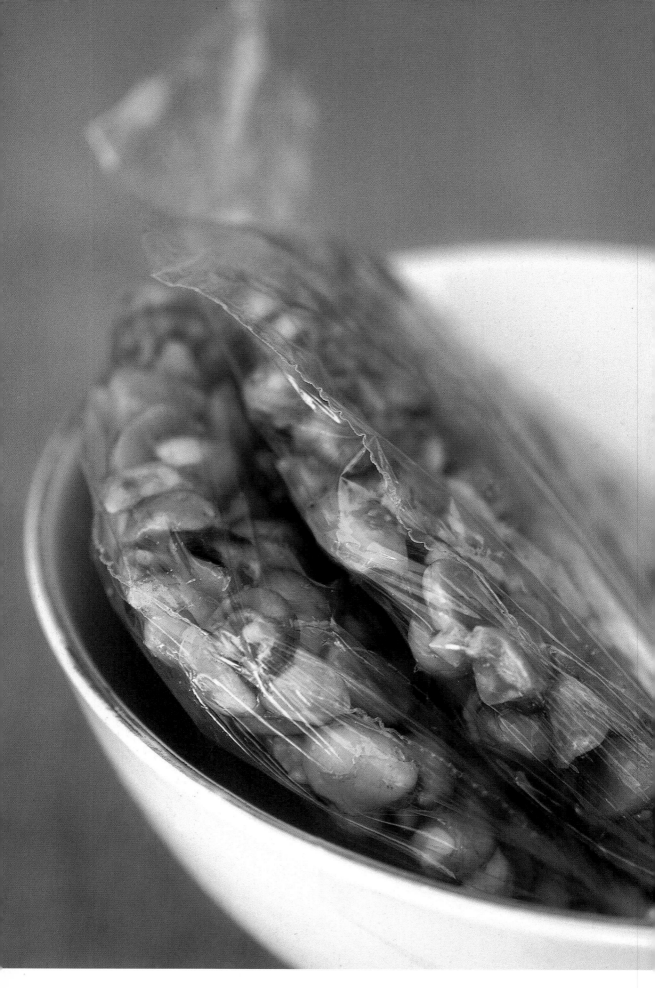

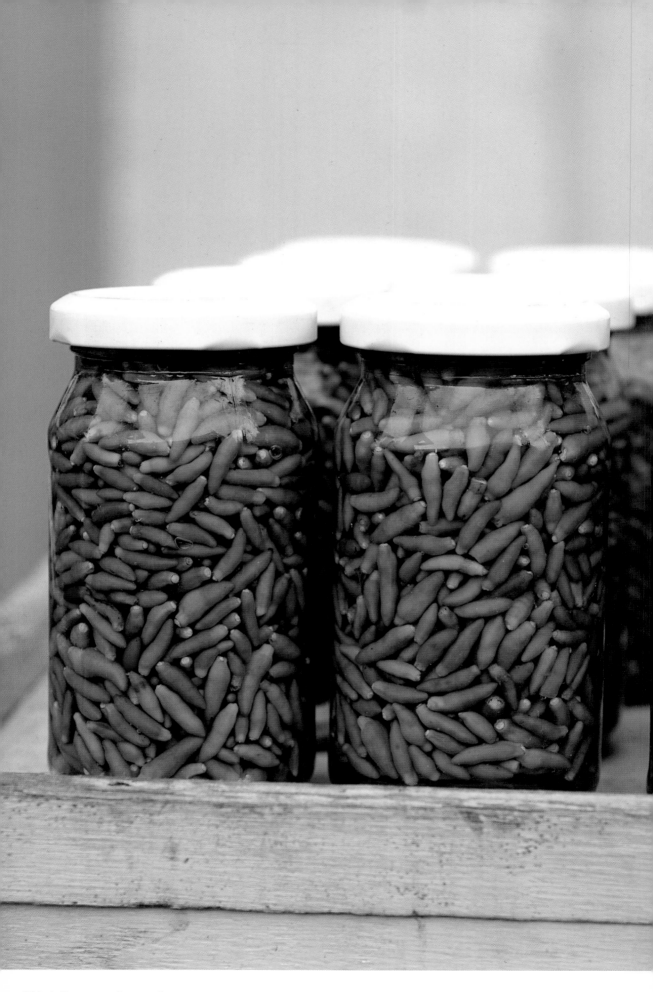

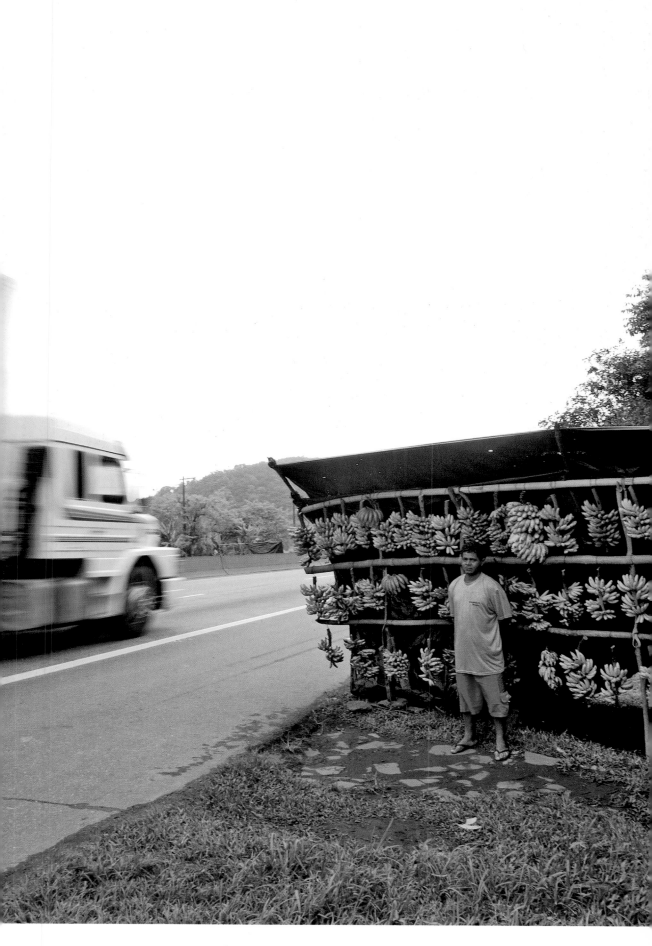

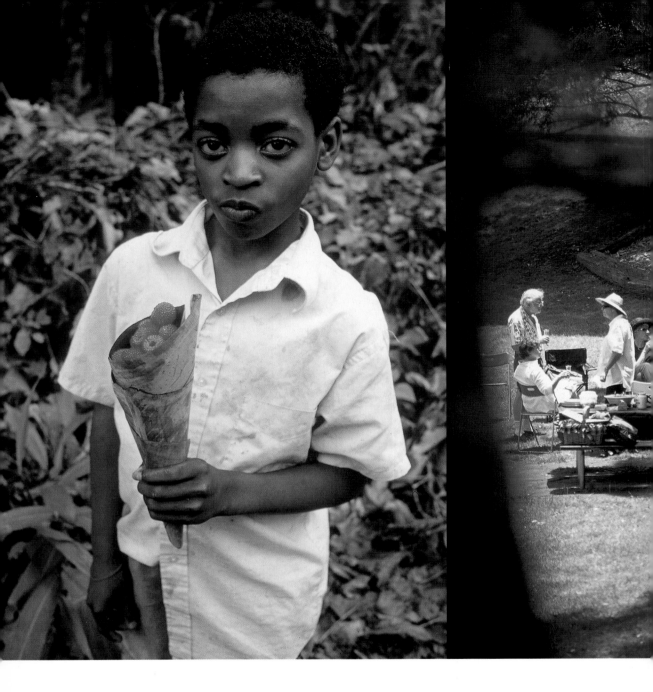

306 / **São Tomé.** (Left) Berry seller by the roadside.
Sydney. (Center) A picnic in the park.

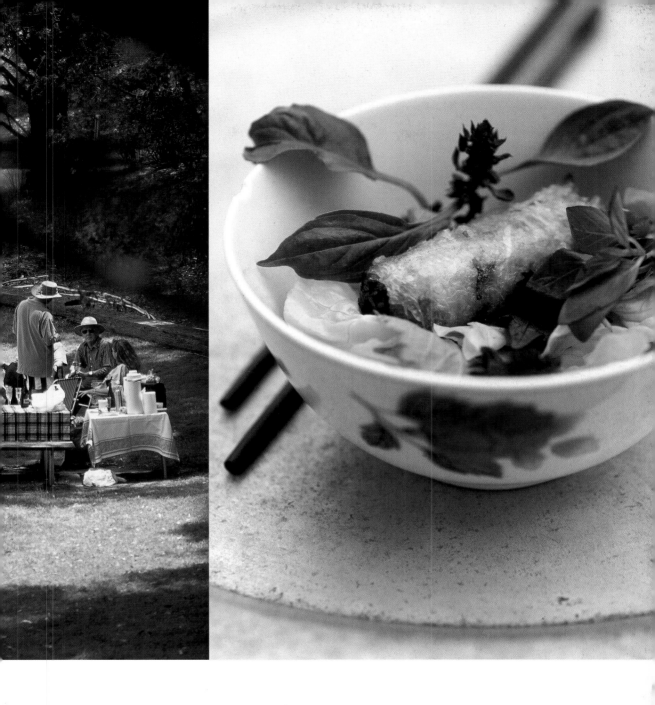

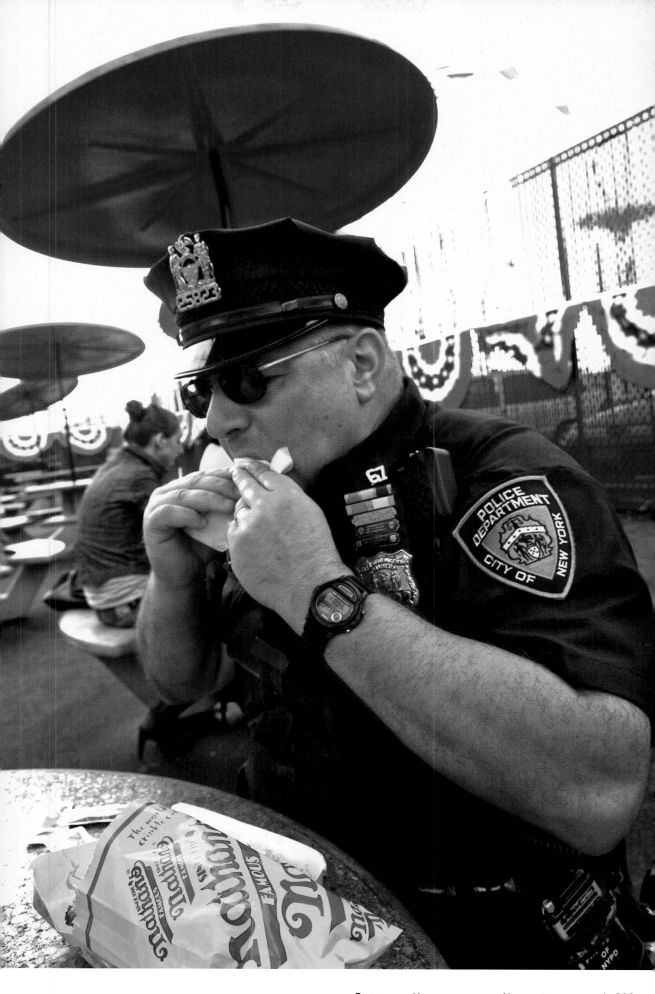

Costa Rica. In this country, fast foods are called "sodas."

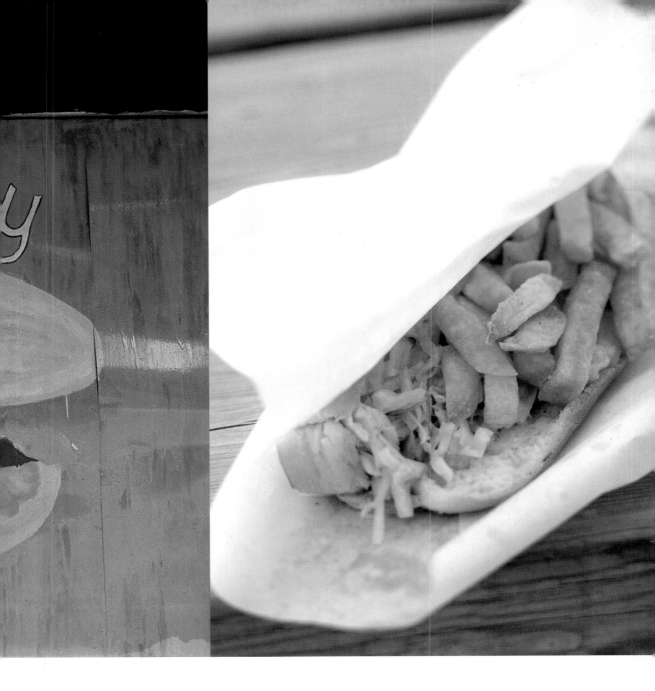

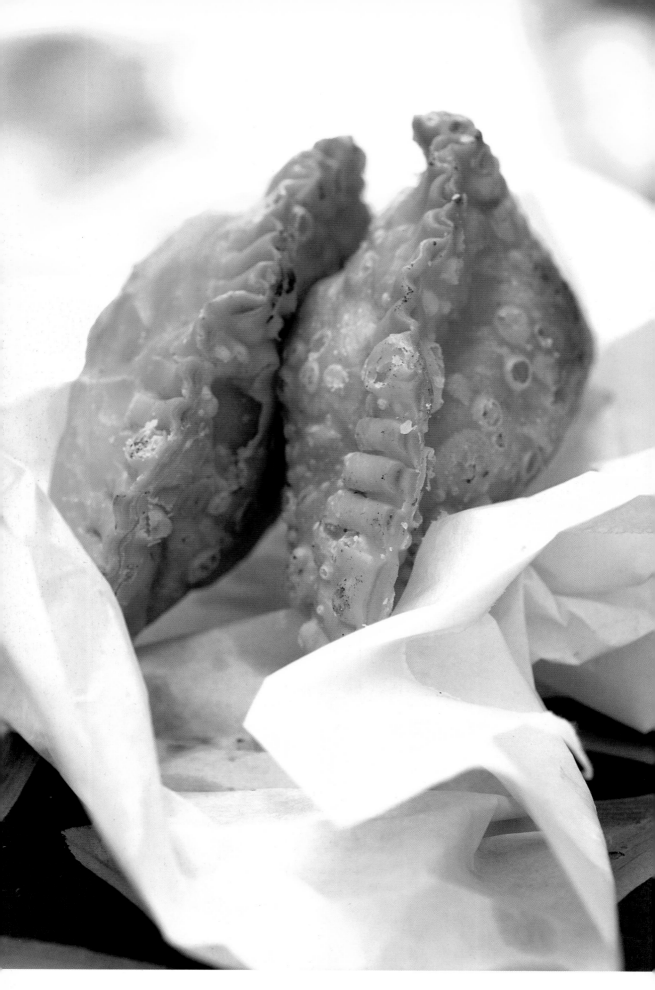

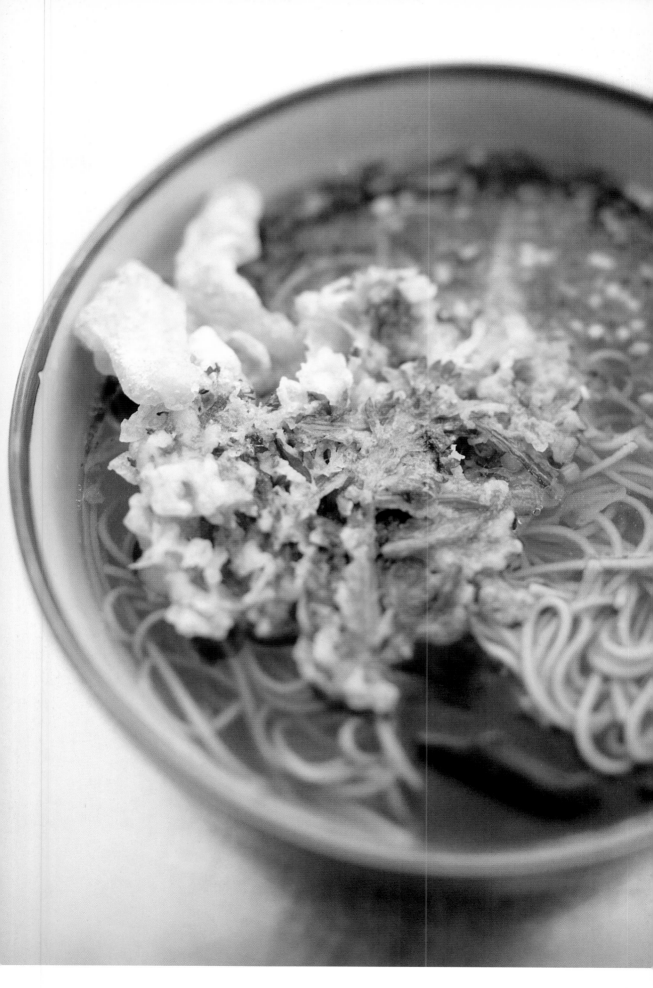

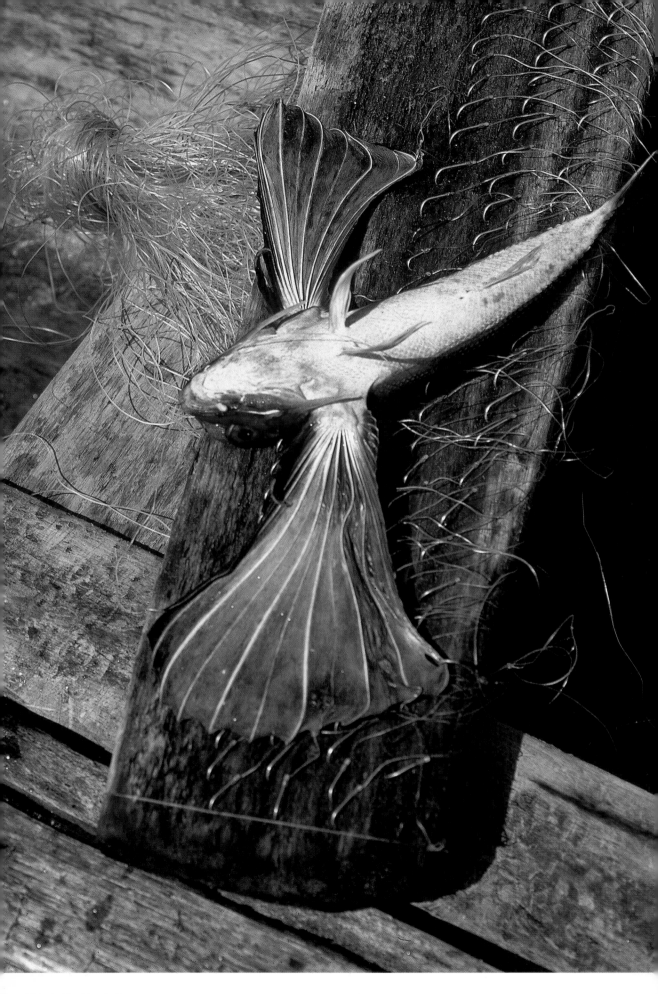

314 / **São Tomé.** Catching and cooking a flying fish called a *concon*.

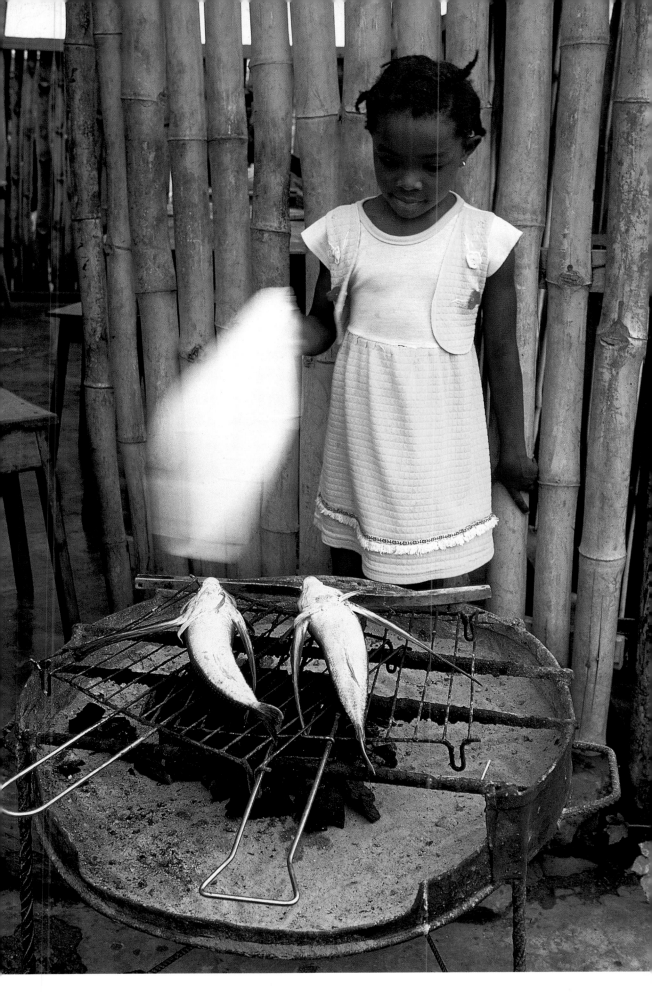

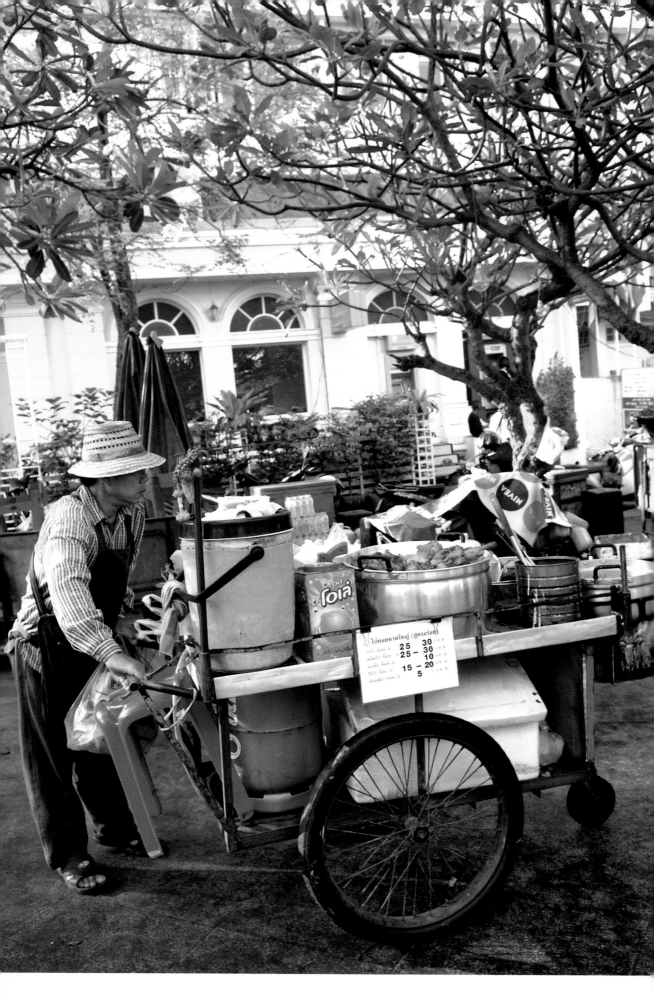

316 / **BANGKOK.** A ROLLING CANTEEN VENDOR WAITING FOR SCHOOL TO LET OUT, AND HIS CUSTOMERS.

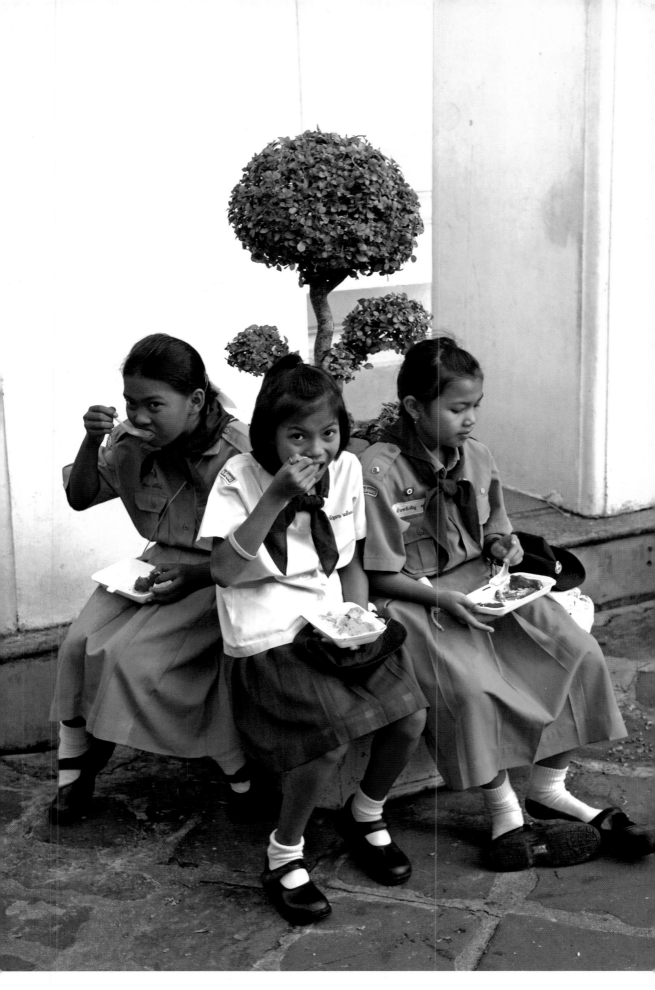

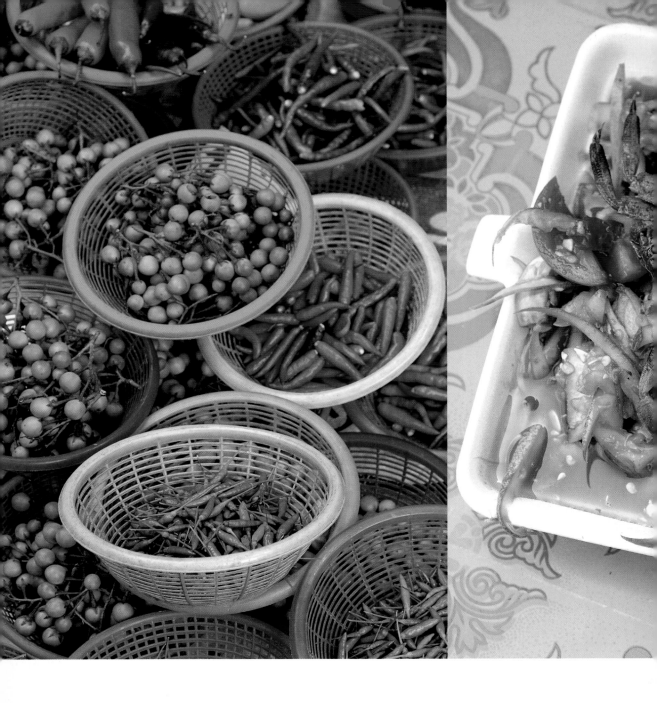

318 / **Bangkok.** (Left) Mini-eggplants and peppers.
(Center) Cut green papaya in crab broth. (Right) Smoked carp.

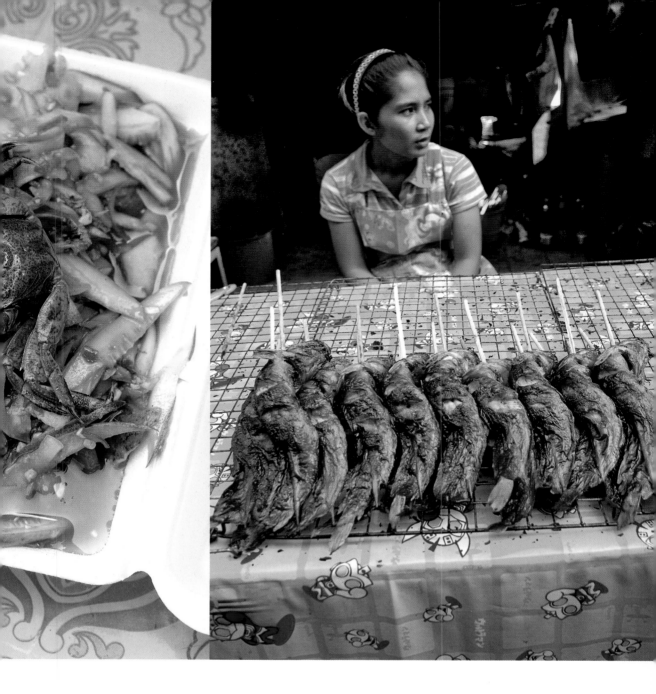

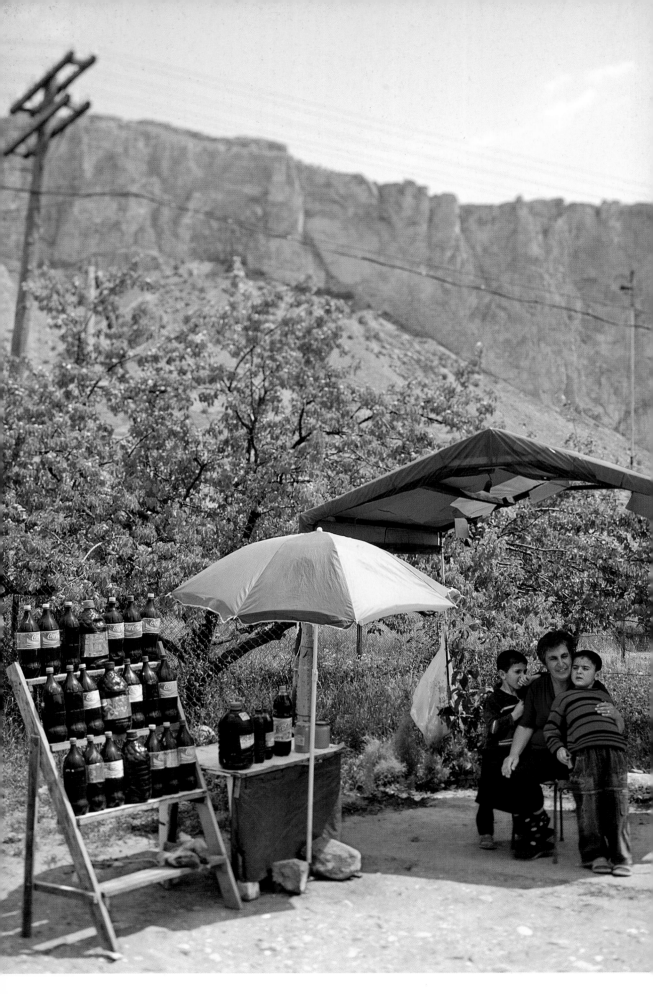

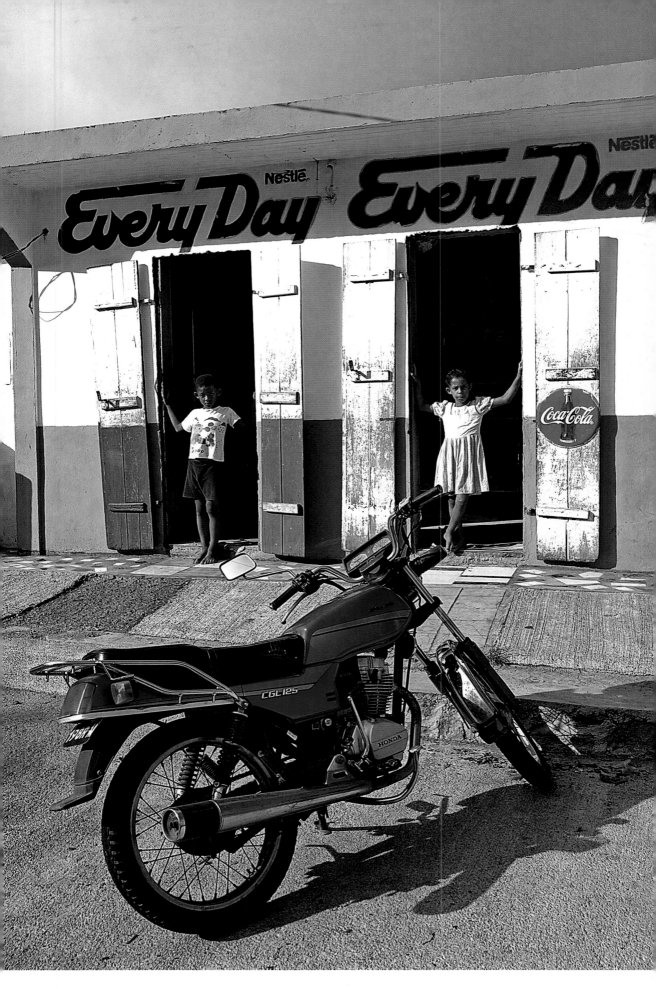

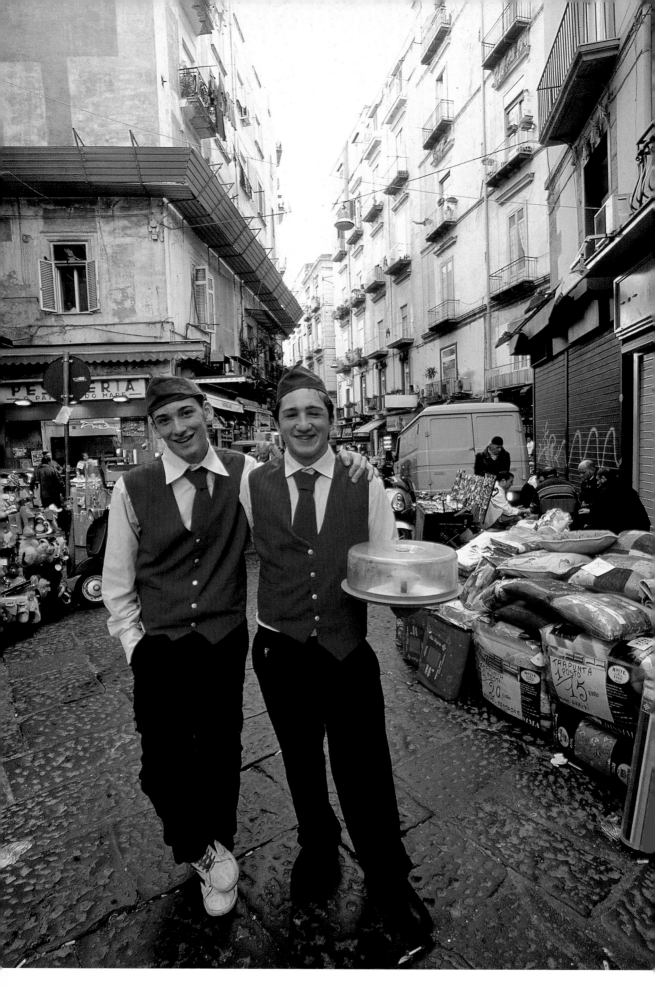

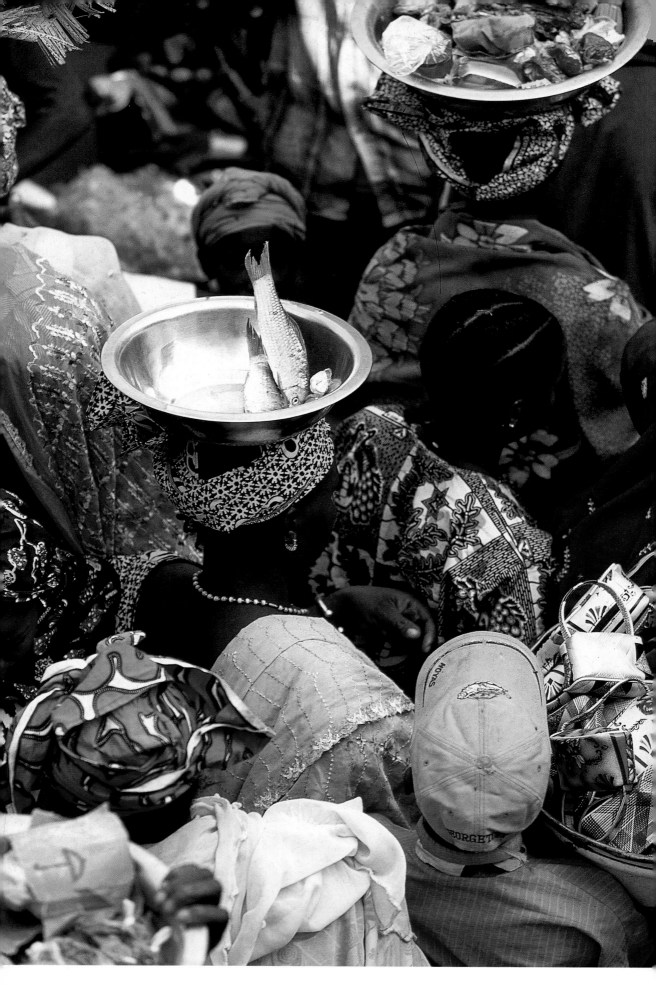

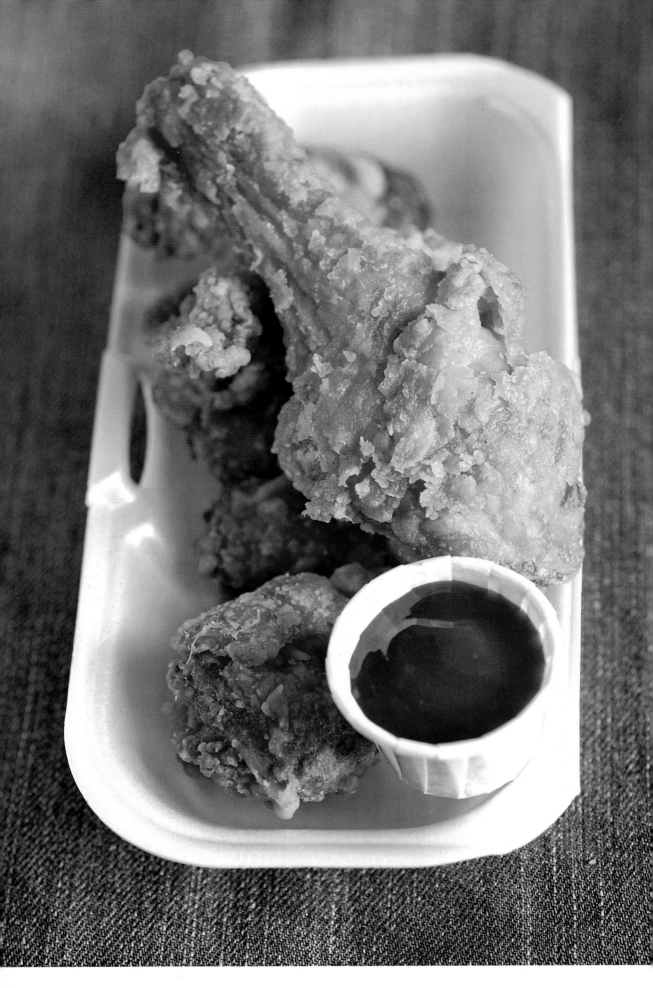

Brooklyn. The famous Kennedy Fried Chicken barbecue sauce, served in the restaurant of the same name.

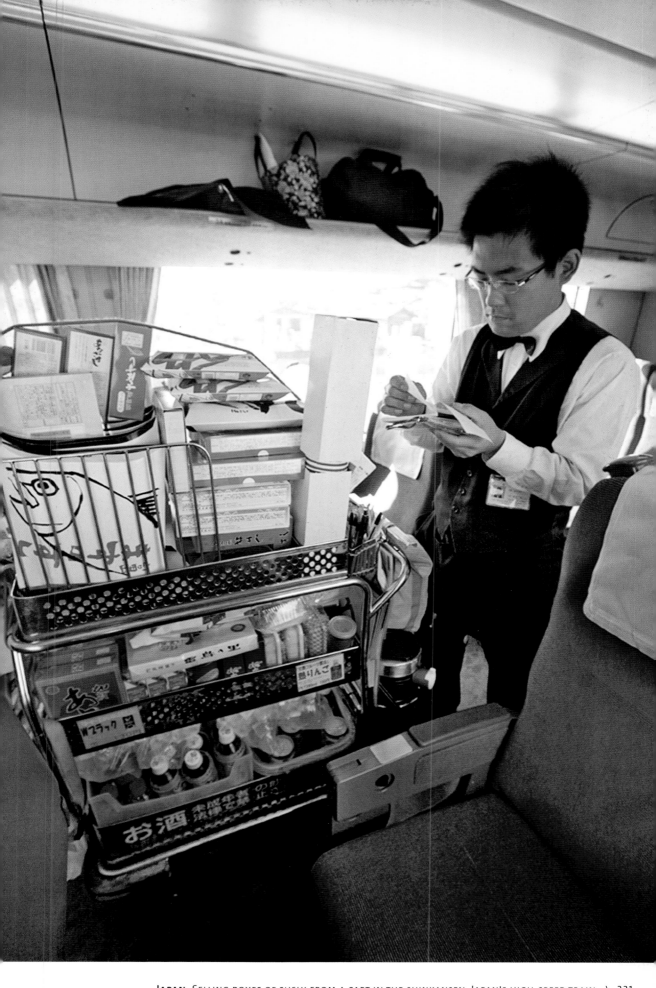

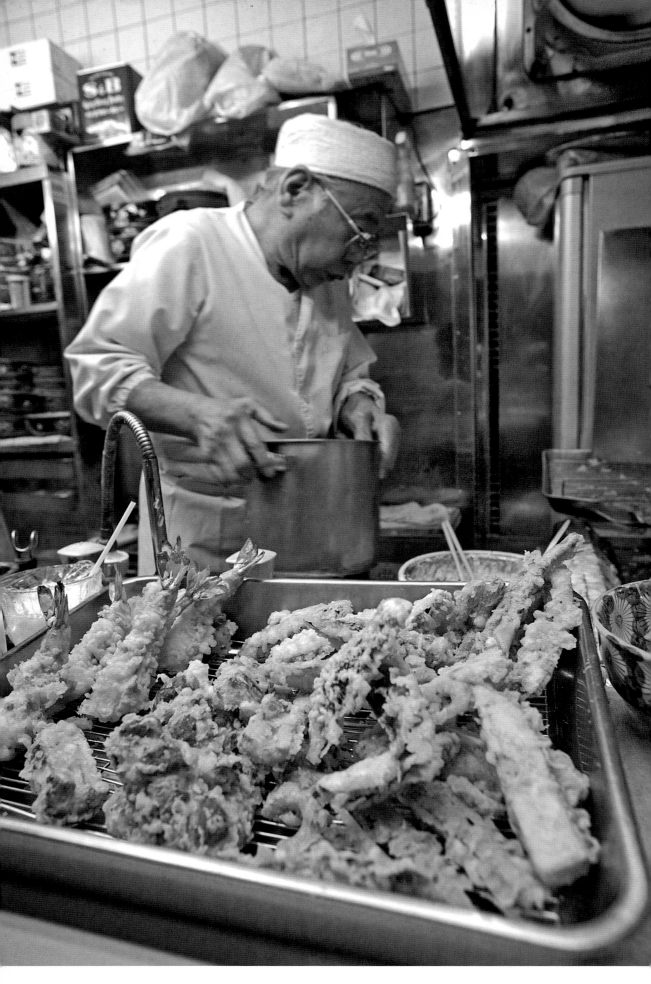

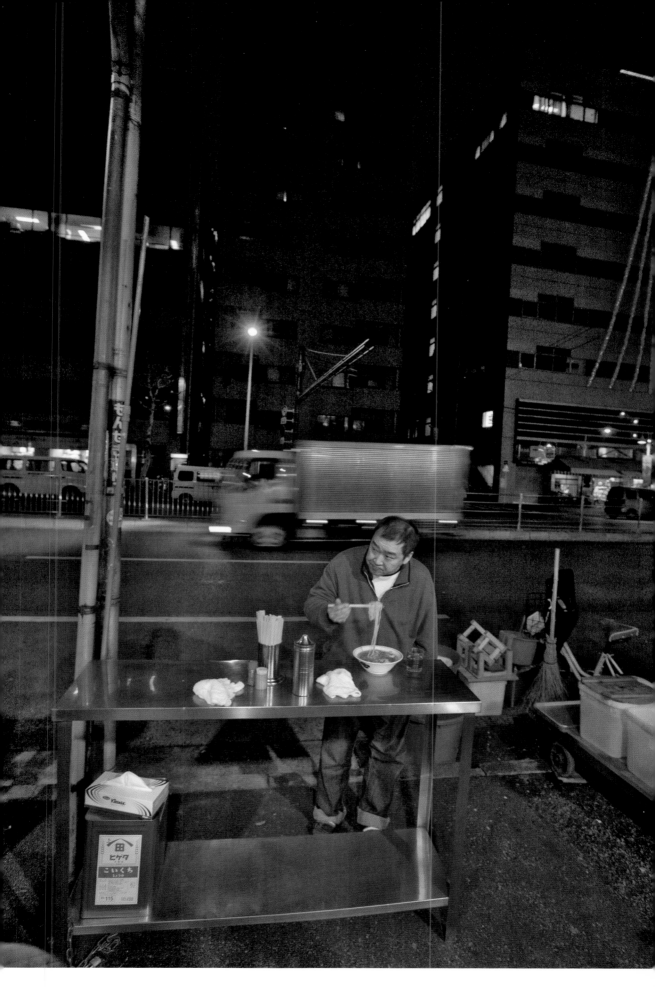

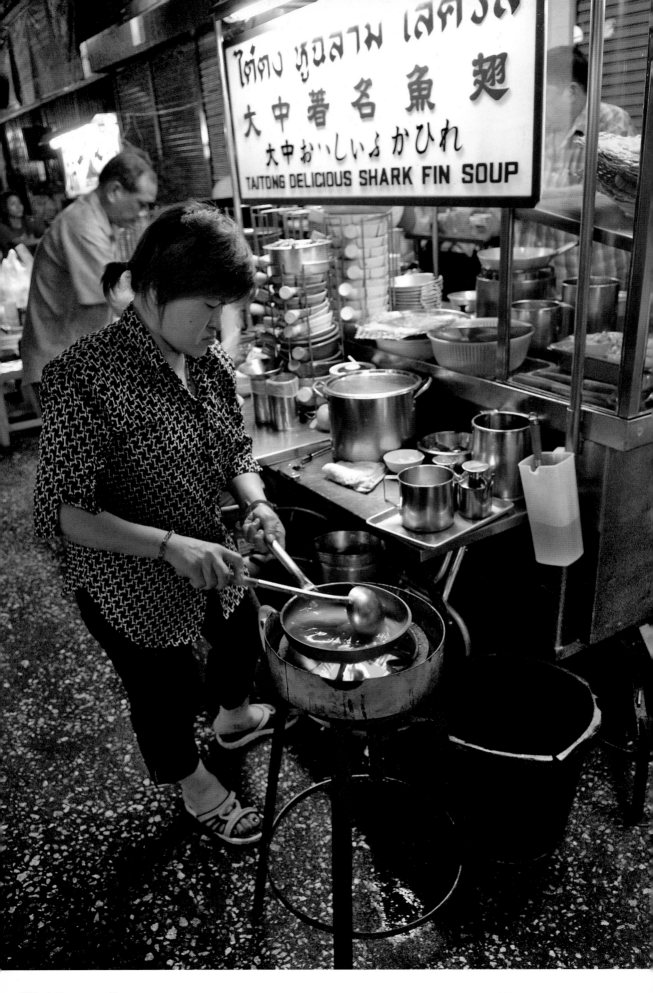

ใต้ตง หูฉลาม เลศรส
大中著名魚翅
大中おいしいふかひれ
TAITONG DELICIOUS SHARK FIN SOUP

BANGKOK. THIS SHOP OFFERS SHARK FIN SOUP, AN EXPENSIVE DISH WITH SERIOUS CONSEQUENCES FOR ENDANGERED SHARK POPULATIONS.

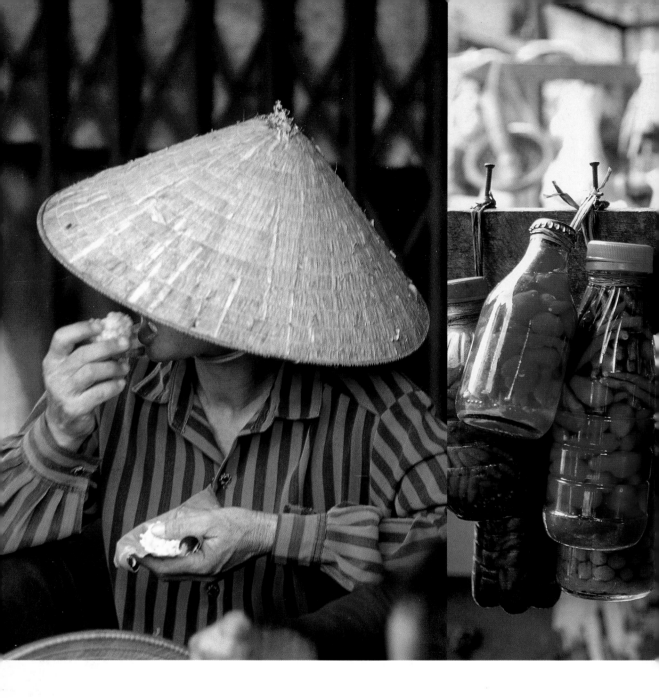

VIETNAM. (LEFT) A WOMAN EATS RICE WRAPPED IN A BANANA LEAF.
BAHIA. (CENTER) JARS OF OIL FLAVORED WITH BEANS AND PEPPERS.

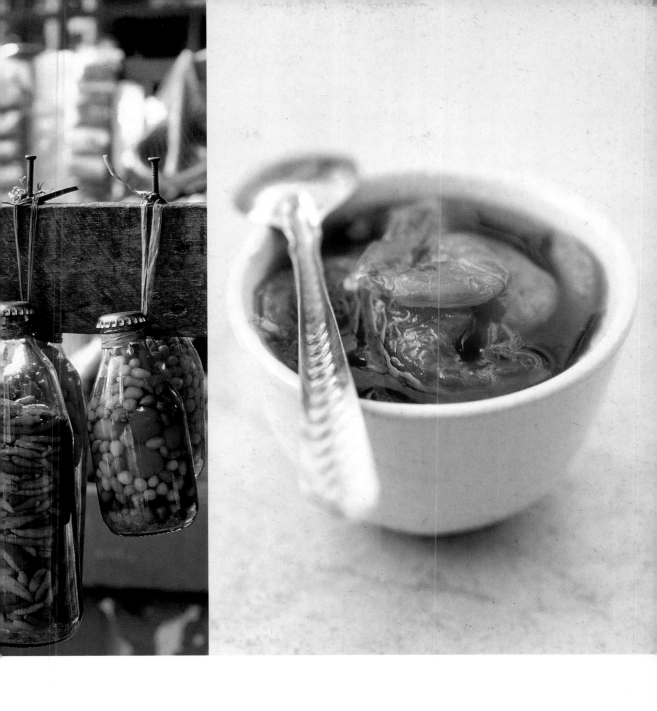

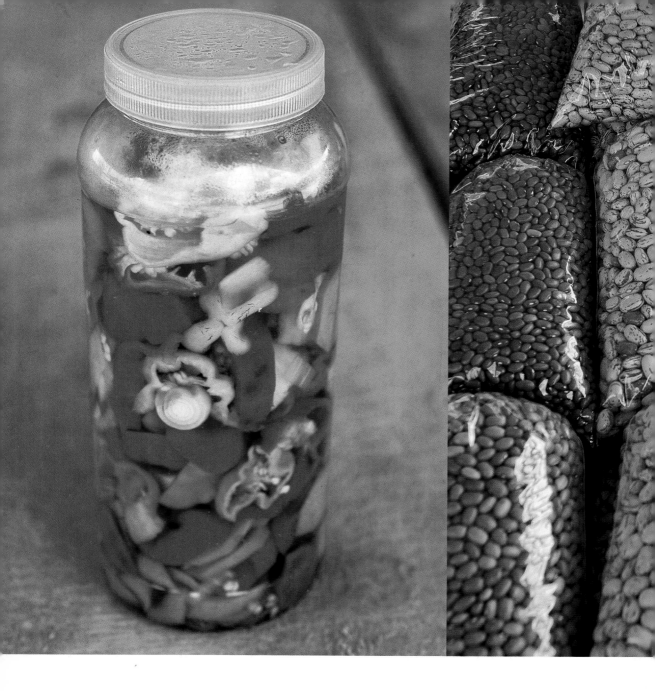

338 / **COSTA RICA.** (LEFT) PEPPERS IN VINEGAR.
BRAZIL. (CENTER) SEVERAL VARIETIES OF DRIED BEANS FOR *FEIJOADA*.

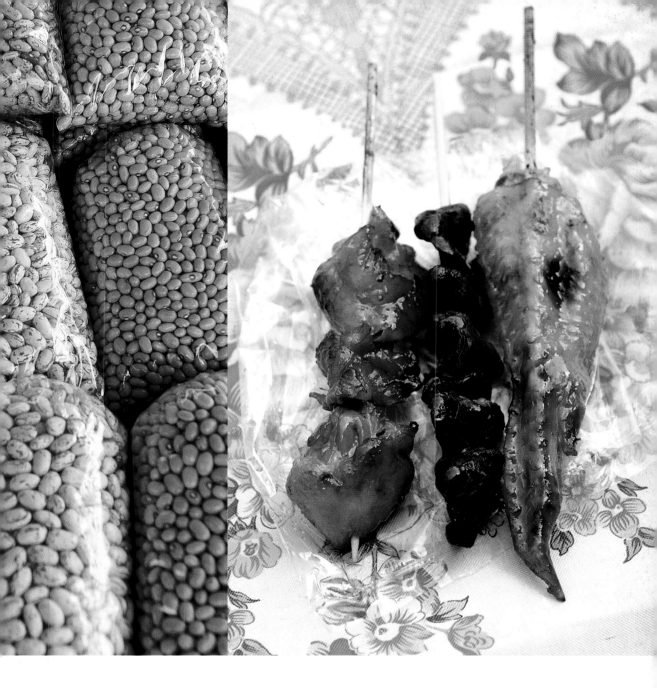

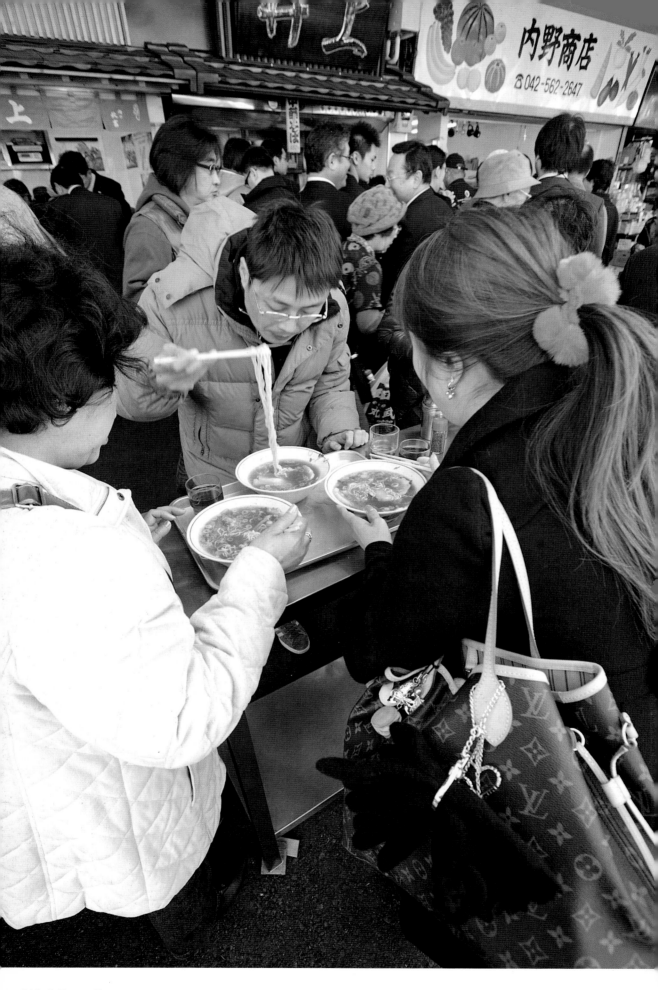

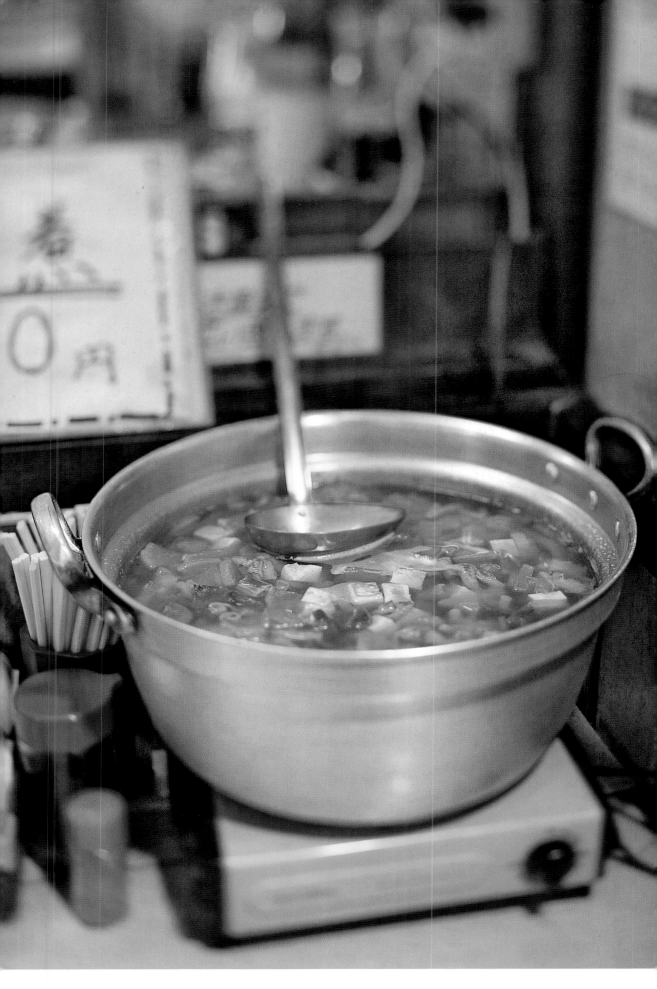

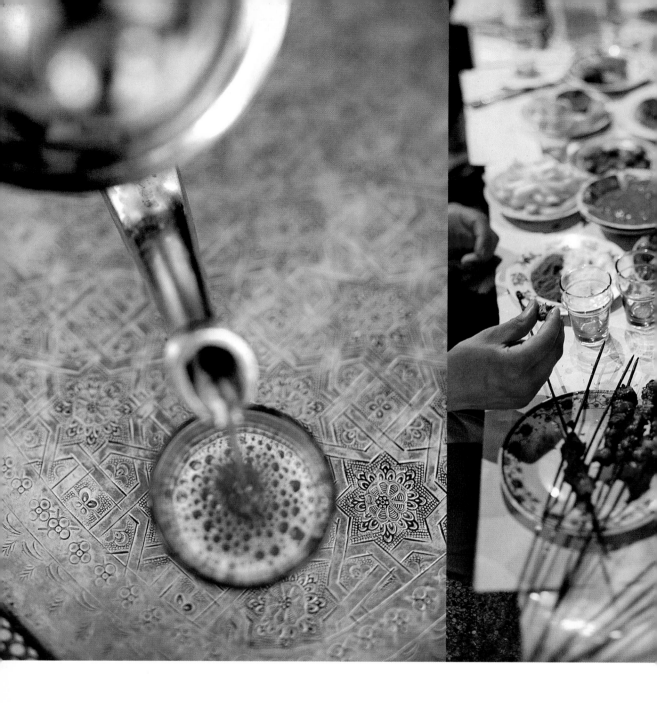

342 / **Morocco.** (Left) Mint tea is served.

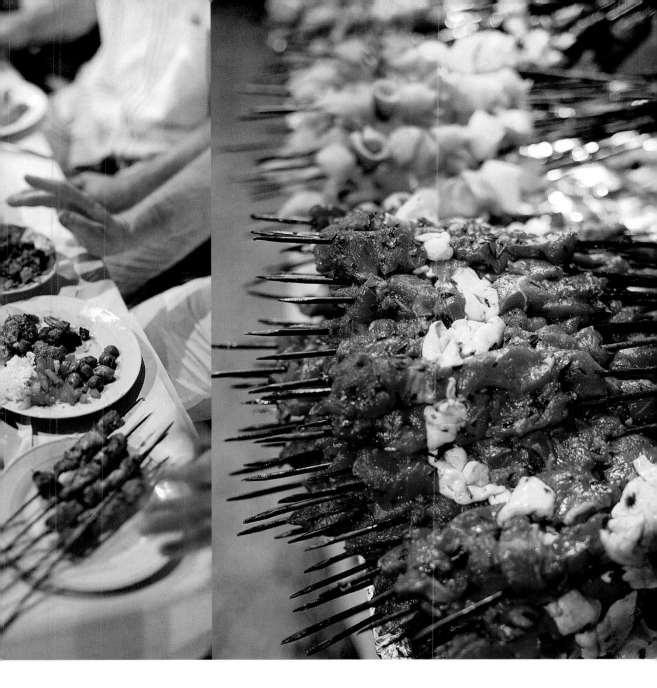

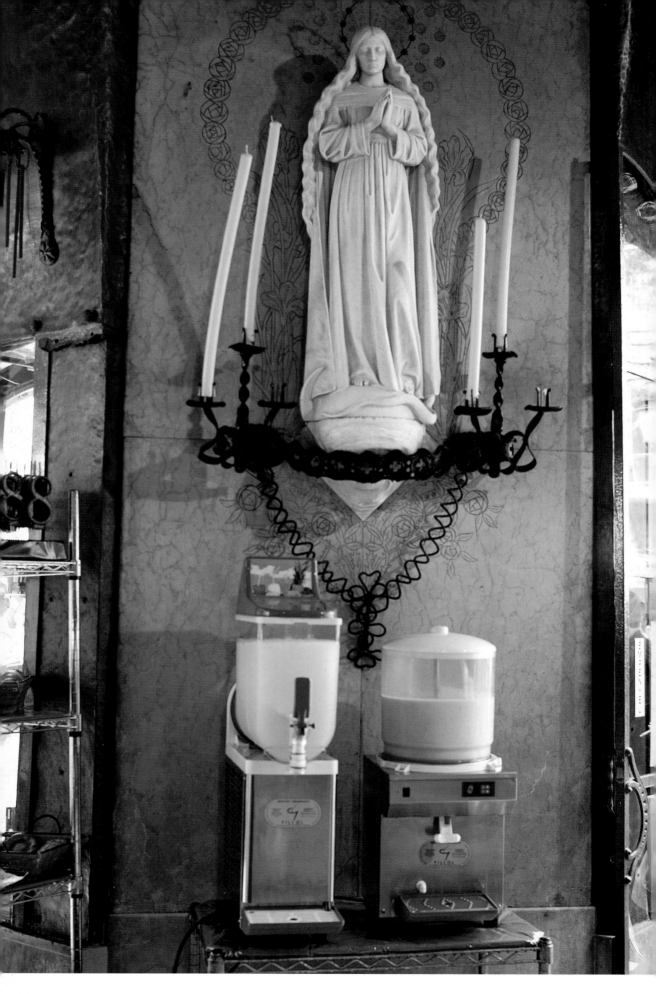

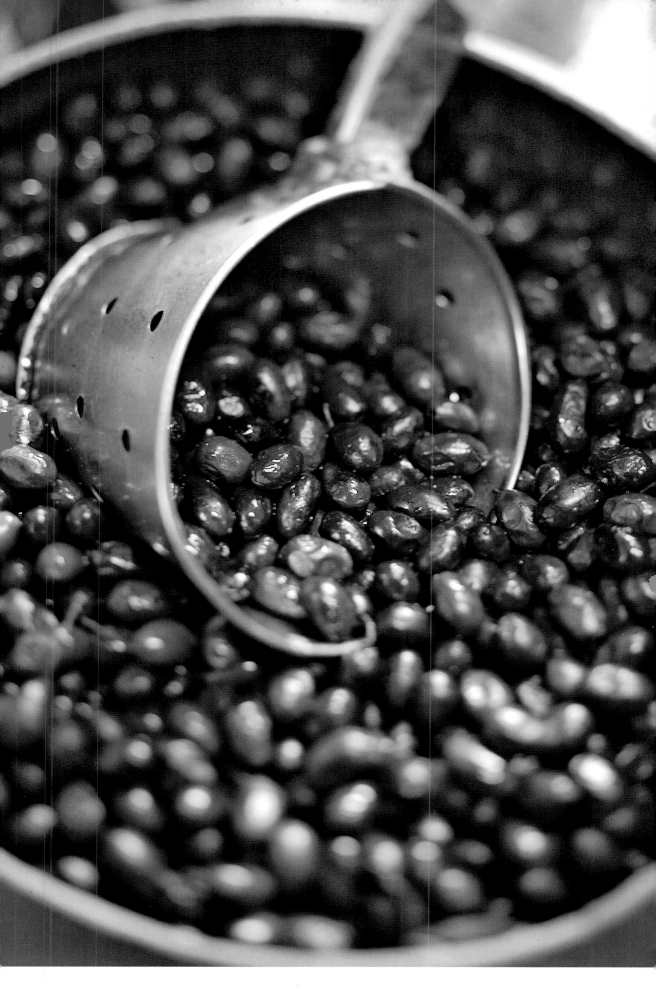

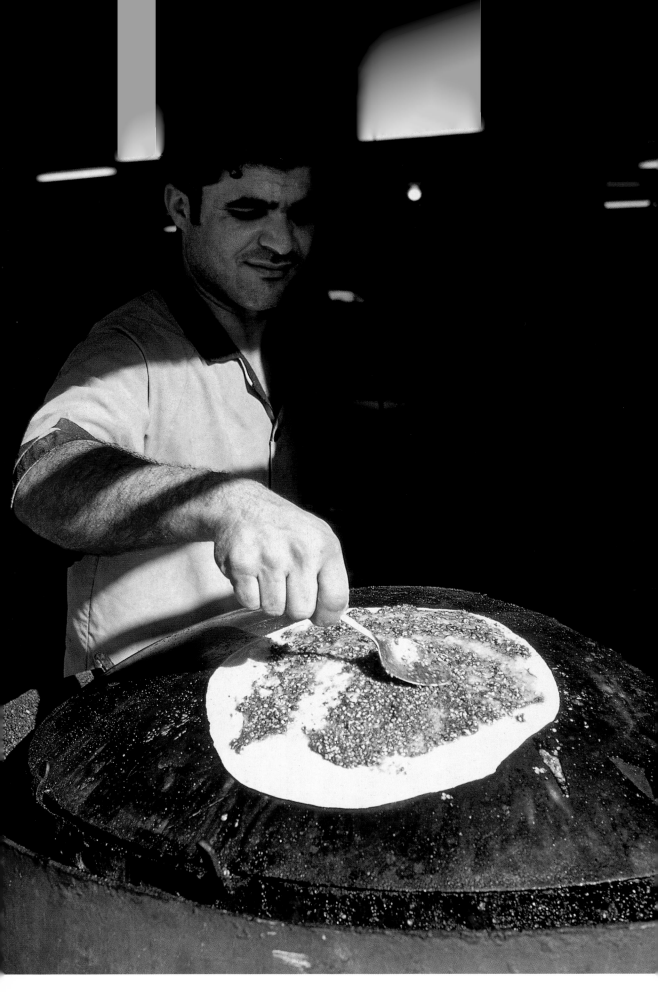

LEBANON. PREPARING *MANA'ICH,* PANCAKES THAT TASTE MUCH LIKE BRITTANY-STYLE CRÊPES. THE CRÊPE CONTAINS THYME, SUMAC, AND GRILLED SESAME SEEDS.

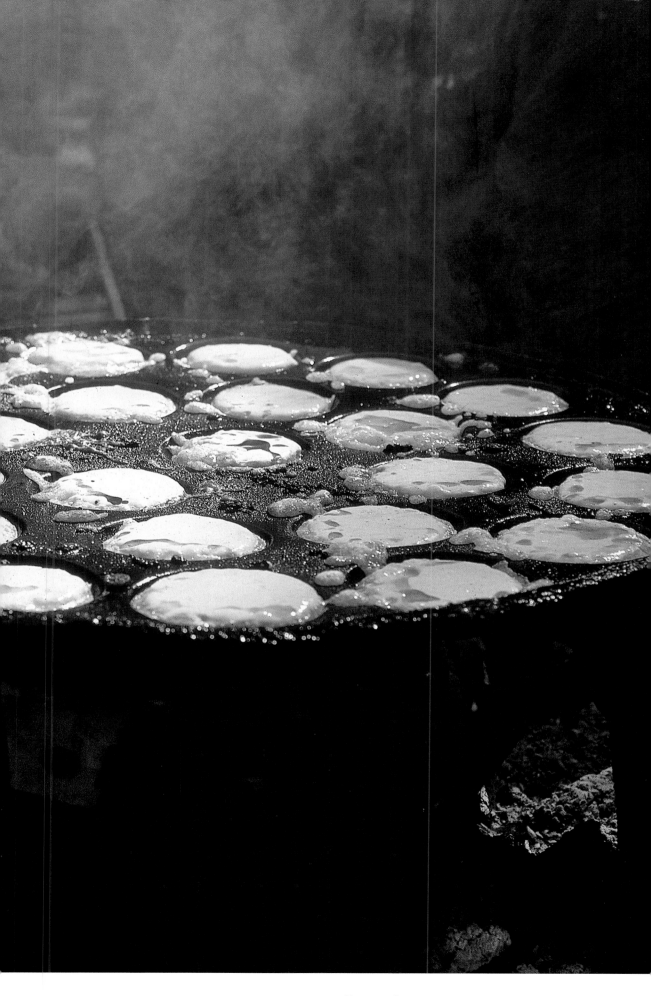

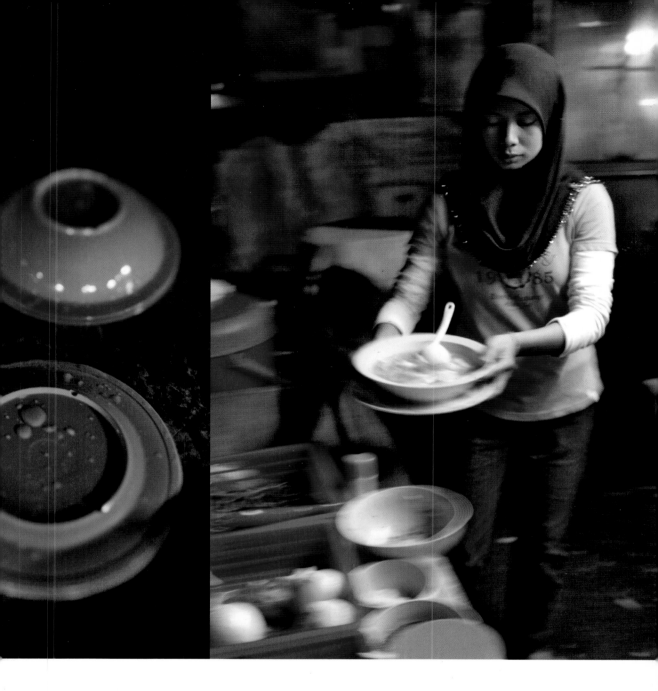

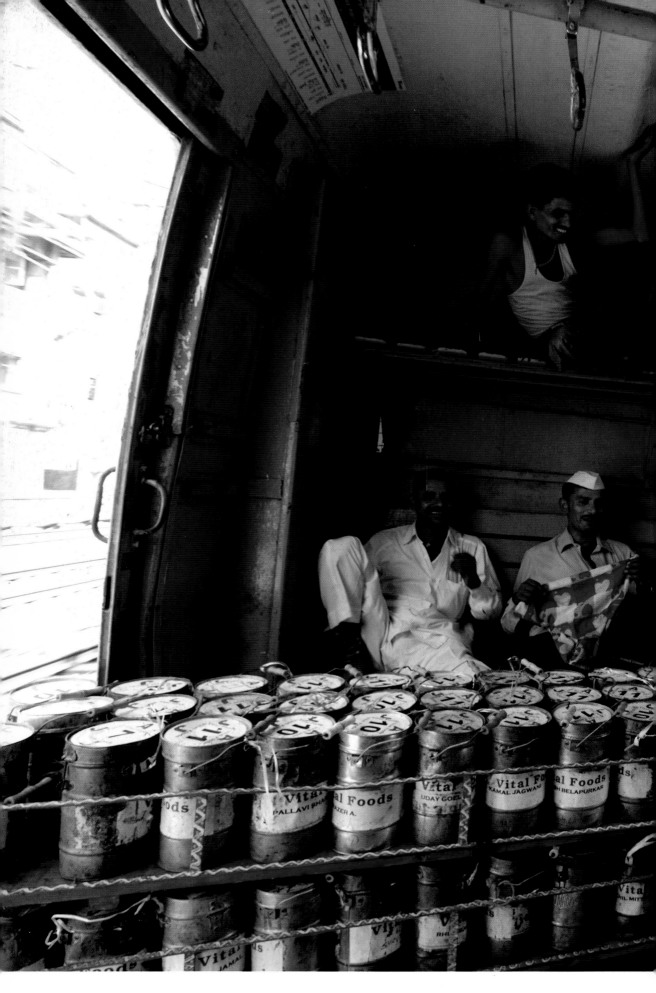

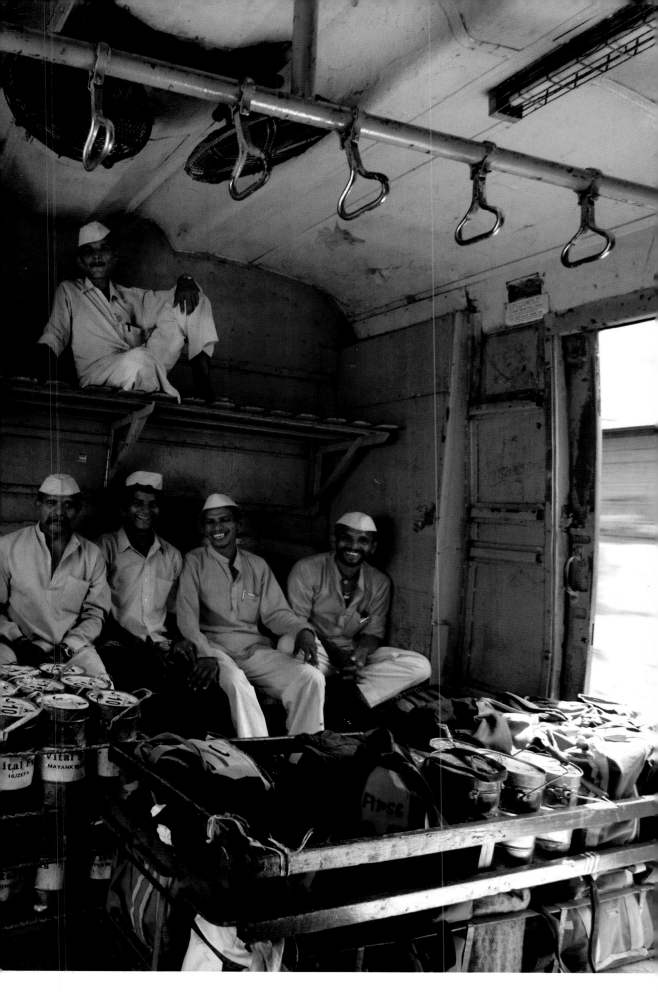

ACKNOWLEDGMENTS

My thanks to Emmanuelle Jary and Jean-Louis André,
my traveling companions, without whom, as the saying goes,
"this would not have been possible."

Thank you to the team at *Saveurs* magazine for their confidence
throughout all these years.

Thanks to Anne Serroy and Stéphanie Zweifel, who believed in
the project from the start.

And a huge thank-you to Harold Cornier, who introduced me to
Marie-Paule Jaulme, the talented graphic artist who designed the book.

—*Jean-François Mallet*